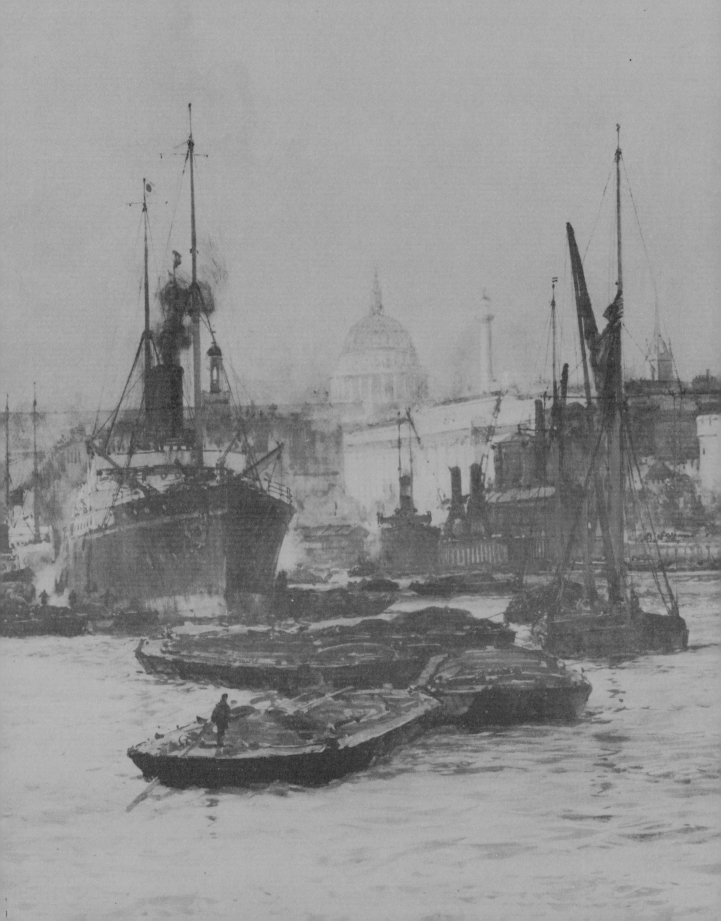

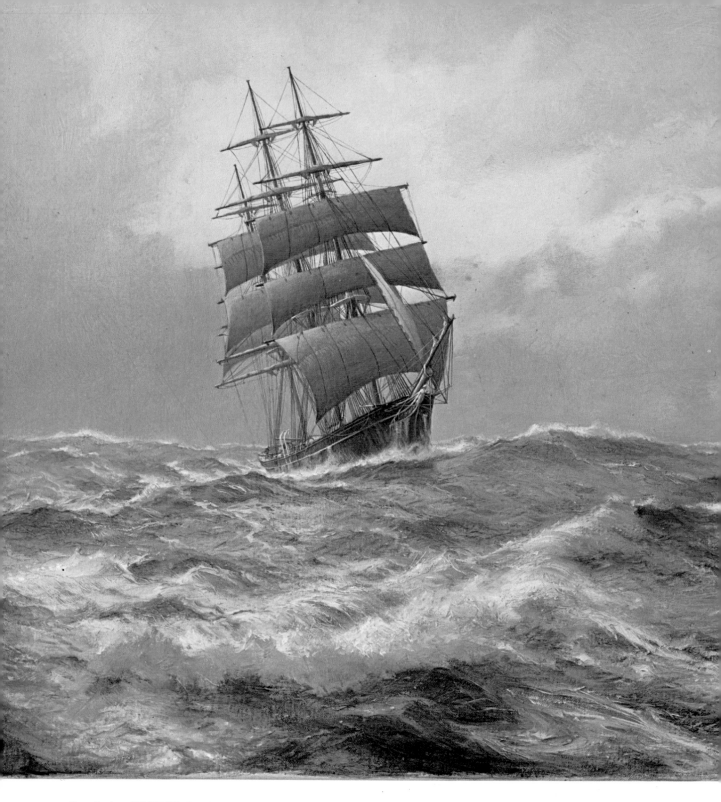

Frontispiece: **DEREK GEORGE MONTAGUE GARDNER, VRD, RSMA (b.1914)**

'**Winter North Atlantic**'. Oil on canvas, 32ins. x 48ins.

This painting shows the *Loch Tay* running before an Atlantic gale, outward bound for Adelaide, Australia. The *Loch Tay* was an iron-hulled vessel built in 1869, and she carried main skysail yard and stunsails. In this picture, the skysail yard at the main has been struck down to reduce top hamper. In later years she was converted to barque rig. On one voyage, this ship averaged 285 miles a day for nine consecutive days in the roaring forties. Derek Gardner aims for complete accuracy in his paintings, and always carries out considerable research.

20th Century

BRITISH
MARINE PAINTING

Denys Brook~Hart

Antique Collectors' Club Ltd.

British Library CIP Data
Brook-Hart, Denys
 20th century British marine painting.
 1. Marine painting, British
 I. Title II. Antique Collectors' Club
 758'.2'0941 ND1373.G/

Published for the Antique Collectors' Club
by the Antique Collectors' Club Ltd.

Printed in England by
Baron Publishing, Woodbridge, Suffolk

Dust Jacket:
Front: 'Homeward Bound — Picking up a tug off Dover', by LESLIE ARTHUR WILCOX, RI, RSMA.
(By courtesy of the artist and the Parker Gallery, London.)

Back: 'The yacht *Corinne* sailing out of Chichester Harbour, Sussex', by DERYCK FOSTER, RSMA.

End Papers:
'London Bridge' by CHARLES DIXON, RI (see Plate 67).
(By courtesy of Pyms Gallery, London.)

To my sons:
RICHARD BROOK-HART
Master Mariner
a truly professional sailor
and
GUY and WILLIAM BROOK-HART
who also enjoy and respect
both the sea and marine paintings

Contents

The decorative line drawings initialled 'W.G.' are by William Geller, S.G.A.

Foreword

Artists use paint, not words, to express their ideas, and so this unusual book is a great tribute to Denys Brook-Hart's tact and perception in assembling so much about their lives and work.

Marine art has a history as long as any, and much longer than most people realise. Scandinavian rock-carvings of craft are dated at 3,500 B.C. and the murals and ceramics of all the ancient civilizations show marine artists and designers at work. As well as these decorative uses, more recently the practical value of marine art has been clearly recognised. The Van de Velde partnership served both Dutch and British interests brilliantly, and since then the national effect of marine works of art has been appreciated by all seafaring nations. Marine artists in both World Wars combined their seamanship with their art to camouflage ships in search of tactical or even strategic advantage.

Sadly the wealth of varied working ships and craft which for centuries characterised the coasts of Europe and the British Isles has now almost completely vanished, but there is a continuing demand by the public for sea pictures of all kinds. To those who are anxious to learn more about marine painting in the 20th century, this book will be of the greatest help, and must become the standard work on the subject.

DAVID COBB, R.S.M.A., R.O.I.
President,
Royal Society of Marine Artists.

The Purpose

My purpose in writing this book is to try to draw the attention of more people to the very considerable talents of British 20th century marine artists.

19th century marine painting has become extraordinarily popular in the last 15 years. So much so, that prices have risen steeply in the auction rooms and really good quality work has become very scarce. And yet collectors and other buyers still pursue the 19th century and largely neglect the numerous, widely varied, and excellent 20th century marine pictures which are available at generally reasonable prices. Amongst the many painters there are some whose work is undoubtedly underrated and undervalued.

It is my hope, therefore, that the text and illustrations in this book will help to stimulate a fuller appreciation of this exciting field of art.

Antique Collectors' Club

The Antique Collectors' Club was formed in 1966 and now has a five figure membership spread throughout the world. It publishes the only independently run monthly antiques magazine *Antique Collecting* which caters for those collectors who are interested in widening their knowledge of antiques, both by increasing the members' knowledge of quality as well as in discussing the factors which influence the price that is likely to be asked. The Antique Collectors' Club pioneered the provision of information on prices for collectors and the magazine still leads in the provision of detailed articles on a variety of subjects.

It was in response to the enormous demand for information on "what to pay" that the price guide series was introduced in 1968 with the first edition of *The Price Guide to Antique Furniture* (completely revised, 1978), a book which broke new ground by illustrating the more common types of antique furniture, the sort that collectors could buy in shops and at auctions, rather than the rare museum pieces which had previously been used (and still to a large extent are used) to make up the limited amount of illustrations in books published by commercial publishers. Many other price guides have followed, all copiously illustrated, and greatly appreciated by collectors for the valuable information they contain, quite apart from prices. The Antique Collectors' Club also publishes other books on antiques, including horology and art reference works, and a full book list is available.

Club membership, which is open to all collectors, costs £8.95 per annum. Members receive free of charge *Antique Collecting*, the Club's magazine (published every month except August), which contains well-illustrated articles dealing with the practical aspects of collecting not normally dealt with by magazines. Prices, features of value, investment potential, fakes and forgeries are all given prominence in the magazine.

Among other facilities available to members are private buying and selling facilities, the longest list of "For Sales" of any antiques magazine, an annual ceramics conference and the opportunity to meet other collectors at their local antique collectors' clubs. There are nearly eighty in Britain and so far a dozen overseas. Members may also buy the Club's publications at special pre-publication prices.

As its motto implies, the Club is an amateur organisation designed to help collectors to get the most out of their hobby: it is informal and friendly and gives enormous enjoyment to all concerned.

For Collectors — By Collectors — About Collecting

Antique Collectors' Club, 5 Church Street, Woodbridge, Suffolk

Acknowledgements

The preparation of this book took some three years. During this time I received a great amount of assistance from the officers and members of the Royal Society of Marine Artists, and from other marine painters working in Britain. I am also indebted to the museums and art galleries whose names appear under some of the illustrations. In particular, I would like to record my gratitude to the following persons who generously gave me much of their time and advice. Officers of the RSMA: David Cobb, ROI (President); John Worsley (Vice-President); Mark Myers (Hon. Secretary) and Maurice Bradshaw, OBE (Secretary). Director of the Federation of British Artists: Carl de Winter. Members of the RSMA: Rodney J. Burn, RA, NEAC; Roy Cross; Ronald Dean; Richard Eurich, RA; Derek Gardner; Rowland Hilder, PPRI; Chris Mayger; Keith Shackleton, PPRSMA, SWLA; Terence Storey; W. Eric Thorp, PS; Edward Wesson, RI, RBA; Leslie A. Wilcox, RI; Leslie J. Watson, ARCA and Peter M. Wood.

In addition, my sincere thanks are due to the several hundreds of artists who supplied me with photographs and information and whose names appear with the illustrations or in the guide to artists at the end of this book. Also to Emma Hicks for valuable assistance with research.

Abbreviations Used

The following are the principal abbreviations used in the 'Guide to Artists' section and also in the main text of this book.

A.	=	Associate (e.g. A.R.A. = Associate of the Royal Academy).
A.F.S.	=	Auxiliary Fire Service.
A.I.N.A.	=	Associate of the Institute of Naval Architects.
A.S.M.A.	=	American Society of Marine Artists.
A.T.D.	=	Art Teachers Diploma.
B.W.S.	=	British Watercolour Society.
c.	=	*circa* ('about that date').
C. in C.	=	Commander in Chief.
Comp. T.I.	=	Companion of the Textile Institute.
D.A.	=	Diploma in Art.
Ex. or Exhib.	=	Exhibitor, exhibited, or exhibition.
F.	=	Fellow (e.g. F.R.I.B.A. = Fellow of the Royal Institute of British Architects).
F.B.A.	=	Federation of British Artists.
fl.	=	*Flourit* (flourished): denotes the period in which the artist was most actively painting or exhibiting pictures and is generally used when the dates of birth and death are not definitely known. Dates shown without this prefix (e.g. 1890-1956) are the years of birth and death.
F.R.S.A.	=	Fellow of the Royal Society of Arts.
F.S.A.E.	=	Fellow of the National Society of Art Education.
F.S.I.A.	=	Fellow of the Society of Industrial Artists and Designers.
G.I.	=	Glasgow Institute of Fine Arts.
H.	=	Honorary (e.g. H.R.W.S. = Honorary Member of the Royal Watercolour Society).
I.S.	=	International Society of Sculptors, Painters and Gravers.
M.L.	=	Motor Launch.
M.S.I.A.	=	Member of the Society of Industrial Artists.
M.T.B.	=	Motor Torpedo Boat.
N.D.D.	=	National Diploma in Design.
N.E.A.C.	=	New English Art Club.
N.S.	=	National Society of Painters, Sculptors and Gravers.
P.	=	President (e.g. P.R.O.I. = President, Royal Institute of Oil Painters).
P.L.A.	=	Port of London Authority.
P.O.	=	Petty Officer (Royal Navy).
P.P.	=	Past-President (e.g. P.P.R.M.S. = Past President, Royal Society of Miniature Painters).
P.S.	=	Pastel Society.
q.v.	=	*quod vide* ('which see')
R.A.	=	Royal Academy (founded 1789). The letters 'R.A.' after an artist's name denote election as a Royal Academician, which is a singular honour. The mere act of exhibiting at the R.A., however frequently, does not entitle the exhibitor to use these letters, as is erroneously and surprisingly widely believed.
R.B.A.	=	Royal Society of British Artists.
R.B.C.	=	Royal British Colonial Society of Artists.
R.B.S.A.	=	Royal Birmingham Society of Artists.
R.C.A.	=	Royal Cambrian Academy.

R.C.N.V.R.	=	Royal Canadian Naval Volunteer Reserve.
R.E.	=	Royal Society of Painter-Etchers and Engravers.
R.H.A.	=	Royal Hibernian Academy.
R.I.	=	Royal Institute of Painters in Watercolours.
R.I.B.A.	=	Royal Institute of British Architects.
R.M.S.	=	Royal Society of Miniature Painters.
R.N.	=	Royal Navy.
R.N.V.R.	=	Royal Naval Volunteer Reserve.
R.O.I.	=	Royal Institute of Oil Painters.
R.O.R.C.	=	Royal Ocean Racing Club.
R.P.	=	Royal Society of Portrait Painters.
R.D.I.	=	Royal Designer for Industry.
R.G.I.	=	Royal Glasgow Institute of Fine Art.
R.G.S.	=	Royal Geographical Society.
R.S.A.	=	Royal Scottish Academy.
R.S.M.A.	=	Royal Society of Marine Artists.
R.S.W.	=	Royal Scottish Society of Painters in Watercolours.
R.W.A.	=	Royal West of England Academy.
R.W.S.	=	Royal Society of Painters in Watercolours.
R.Y.A.	=	Royal Yachting Association.
R.Y.S.	=	Royal Yacht Squadron.
S.Av.A.	=	Society of Aviation Artists.
S.G.A.	=	Society of Graphic Art.
S.M.P.	=	Society of Mural Painters.
S.W.A.	=	Society of Women Artists.
S.WL.A.	=	Society of Wildlife Artists.
S.T.A.	=	Sail Training Association.
S.T.S.	=	Sail Training Ship.
U.A.	=	United Artists.
V. & A.	=	Victoria and Albert Museum, London.
V.P.	=	Vice-President (e.g. V.P.R.S.M.A. = Vice President, Royal Society of Marine Artists).
W.I.A.C.	=	Womens International Art Club.
W.R.N.S.	=	Womens Royal Naval Service.
Y.C.	=	Yacht Club.

Abbreviations used for some Art Galleries and Museums:

Liverpool	=	Walker Art Gallery, Liverpool.
Manchester	=	Manchester City Art Gallery.
Nottingham	=	Nottingham Society of Artists.
Imp. War Museum	=	Imperial War Museum, London.
Nat. Maritime Museum	=	National Maritime Museum, Greenwich, London.

Chapter 1.
The Historical Background

The British have been world leaders in many spheres, particularly in the arts and sciences. They are still pre-eminent in numerous fields of human endeavour, and one of these is the skill of marine painting which they have practised for some 300 years.

Strangely enough, although this island race had reigned and roved over large areas of the sea for several centuries, it was not until two Dutch artists came to Britain in 1672 that marine art blossomed.

These Dutchmen were the VAN DE VELDES, father and son. Both were named Willem and so the father became known as the Elder (1611 to 1693) and the son as the Younger (c.1633 to 1707). In 1674 they were made official marine painters to the monarch, King Charles II, and they practised their art in London for about 30 years. They were prolific artists and it is said that some 8,000 of the Younger's drawings were sold at auction between 1778 and 1780. He is also credited with over 600 paintings. They collaborated closely together, the father generally making drawings of ships and naval engagements and the son doing most of the painting, although this was not a rigid division of labour. The draughtsmanship was superb and their finished paintings magnificent. Some fine examples of their pictures may be seen in the National Maritime Museum at Greenwich, The National Gallery, London, the Rijksmuseum in Amsterdam, Holland, and the Peabody Museum in Salem, Massachusetts, U.S.A.

The influence of these two men on British marine painting was enormous and their 'Dutch style' was carried by succeeding generations of artists well into the early part of the 19th century. Their habit was to portray the sea in classical form, either with waves in well-ordered rows, if rough, or as a lightly marked level surface, if calm. This statement is an over-simplification, as there are examples of the Younger's work which show remarkable movements of the sea. Generally speaking, however, the convention of regarding the sea as a neatly ordered design was adopted by the many distinguished artists who were influenced by the Dutch tradition and followed the Van de Veldes. This style is seen in the work of a number of the great 18th century British marine painters such as ISAAC SAILMAKER (1633-1721); PETER MONAMY (1670-1749); the JOHN CLEVELEYS (father c.1712-1777, and son 1747-1786); FRANCIS SWAINE (fl.1762-1782); and CHARLES BROOKING (1723-1759) to mention only a few of the illustrious names from this period.

The fact that these Dutch-influenced pictures show a stylisation of the sea in no way detracts from their beauty or importance as works of art. They have their established place in artistic history which without them would be infinitely poorer. Furthermore, they provided the foundations and impetus for constructing the great edifice of British marine painting which was established towards the middle of the 19th century.

Although there were artists at the end of the 18th century who started to originate different techniques of painting sea, the fact that the Dutch influence continued into the 19th is clearly seen in works at the beginning of that century. Striking evidence of this is contained in the paintings of ROBERT SALMON (c.1775-1840) amongst others, whose carefully arranged seas often look closer to classic design than reality.

At the beginning of the 19th century there was, therefore, a flourishing and established school of British marine painting, based on the Dutch influence from which it had been born. Into this scene there then entered the brightest star ever to shine in

the firmament of marine art: JOSEPH MALLORD WILLIAM TURNER (1775-1851). The prodigious output, the range, the vision and the revolutionary techniques of this genius ensured that British art would never again be the same. One might say that Turner did for seascape painting what JOHN CONSTABLE (1776-1837) did for landscape, except that Turner was equally accomplished at painting English or European landscapes and Constable was capable of producing marine pictures of the highest order.

Amongst the upper echelons of 20th century marine painters it is quite rare to meet an artist who does not acknowledge the influence of Turner on his work at some stage or in some degree. Paradoxically, in spite of the acclaim he received in his lifetime, it is only since the late 1960s that the genius of Turner has again become fully appreciated by the artistic world in general.

Turner and Constable were Impressionists before that movement had been conceived, and their dramatic techniques, especially Turner's, were an influence upon many other artists. From the time of Turner and Constable, there originated an explosion of talent in Britain in landscape, marine and romantic subject painting, which reached its heights towards the end of the 19th century when there were no less than 20,000 painters exhibiting in London alone. These artists were painting in many styles; the majority being what we now regard as 'conventional' or representational, but others were experimenting more freely in the wake of Turner's pioneering. Thus, no study of 20th century marine art can be complete without first considering the wealth of talent which preceded it. In my companion book *British 19th Century Marine Painting*[1] I traced the course of that exciting and changing century and endeavoured to show how an entirely new and original British style of marine painting came into being. This new movement was concerned with showing the sea as it really was: a

1. Antique Collectors' Club, Woodbridge, Suffolk, 1974; 2nd edition 1978.

COLOUR PLATE 1: ROBERT TRENAMAN BACK, DA (Edin.) (b.1922)

'*Constitution* **leaving Boston, 1838'.** Oil on canvas, 24ins. x 34ins.

The U.S. 59-gun frigate *Constitution* was affectionately known as 'Old Ironsides'. In this painting she is seen leaving Boston Navy Yard in 1838 after an extensive refit for service as Flag Ship Mediterranean and African Squadron. To her record were 42 engagements, the capture of 20 vessels, and she never suffered defeat. She also made history by providing the first occasion on which a Pope set foot on American territory, when she was visited by Pope Pius IV. *Constitution's* keel was laid in 1794 at Hartts Shipyard, Boston, and she is still afloat in Boston docks, U.S.A.

Robert Back is a Gold Medallist of the Royal Drawing Society and has had extensive seafaring experience. He has exhibited at the RSMA since 1957 and specialises in 19th century American ships and naval scenes.

COLOUR PLATE 2: ARTHUR BRISCOE, RI, RE (1873-1943)

'**Heavy weather'.** Watercolour, 20¼ins. x 28¾ins. Painted in 1937.

Arthur Briscoe played a leading part in arranging a series of pre-war marine exhibitions which eventually led to the formation of the RSMA. His watercolours and etchings are greatly admired both for their atmosphere and their fine draughtsmanship. As he had had seafaring experience he knew his subject at first hand, and his work is keenly collected by connoisseurs and sailors.

Photograph courtesy: The Royal Exchange Art Gallery, London.

rough, powerful and terrifying force, although sometimes calm, sweet and deceptive; and it was concerned with the ships and men who strove in salt water around our shores or in far off oceans. The 19th century produced romantic and powerful marine pictures and romantic and powerful painters many of whom were lionised in their lifetime but fell largely into neglect by all but a small part of the public between the two world wars. Happily, since the 1960s there has been a revival of interest almost without parallel. Today, British marine art of the 19th century is sought and prized by buyers and collectors from London to Tokyo and from New York to Berlin.

The romance and variety of styles amongst 19th century marine painters may be seen by looking at paintings from the hands of, for instance, CLARKSON STANFIELD (1793-1867); EDWARD WILLIAM COOKE (1811-1880); RICHARD HENRY NIBBS (1816-1893); JOHN MOORE OF IPSWICH (1820-1902); JAMES WILSON CARMICHAEL (1800-1868); ARTHUR JOSEPH MEADOWS (1843-1907); WILLIAM McTAGGART (1835-1910); HENRY MOORE (1831-1895) and HENRY REDMORE (1820-1887). I have picked these nine artists, almost at random, from several hundreds, but many similar selections could be made to further illustrate the point.

This fund of talent was carried over into the beginning of the 20th century by a fairly considerable galaxy of artists who worked in the 19th century style. A leader amongst the great artists who bridged the two centuries was WILLIAM LIONEL WYLLIE (1851-1931) whose pictures were hung in the Royal Academy from 1868 onwards. Others included FRANK BRANGWYN (1867-1956) who exhibited at the Royal Academy from 1885, THOMAS SOMERSCALES (1842-1927) noted for his beautiful pictures of clipper ships, and JULIUS OLSSON (1864-1942) whose name and pure sea paintings are strangely neglected today in spite of his undoubted genius. These are only a few names given as examples from amongst the many who laid the foundations for the marine art of the present day.

There were in fact two age groups of marine painters who bridged the centuries. There were those who had been painting and exhibiting mainly in the last half of the 19th century, but who lived on and painted into the first ten years or so of the 20th. This group belongs properly to the 19th century and their names and deeds are recorded in my book dealing with that period, so that I do not need to recite them again here. Then there were those who were born in the last 20 years of the 19th and painted most of their pictures in the early part of the next century. This group belongs correctly to the 20th century.

Towards the end of the 19th century a highly significant development took place on the other side of the English Channel when the French Impressionist movement rose to its height. And yet this movement made little impact on the overall attitude of British marine painters at that time, who were quite pleased with their own romantic and realistic sea pieces. Only a few well known artists such as WALTER RICHARD SICKERT (1860-1942), PHILIP WILSON STEER (also 1860-1942) and JOHN SINGER SARGENT (1856-1925) made serious attempts to introduce impressionist ideas into Britain. They were leading members of the New English Art Club (N.E.A.C.) whose intention in the 1890s was to foster the impressionist ideal of painting directly from nature, using primary colours to depict the effects of light and atmosphere on the subject. (Years earlier John Constable, who had painted directly from nature and was intensely concerned with the interplay of light and shade and the changing colours of the atmosphere, was in effect a forerunner of the Impressionists, as I have already mentioned. Paradoxically, he was greatly admired by the French but comparatively neglected at that time in England.)

Perhaps it is only in the last decade that both the French and British Impressionists have been fully appreciated by marine artists in the U.K., although there has always been a small minority of artistic prophets arguing in the wilderness during the intervening years. Today, the influence of the Impressionists may be seen in many excellent sea pieces, and modern art is a great deal more interesting for this fact.

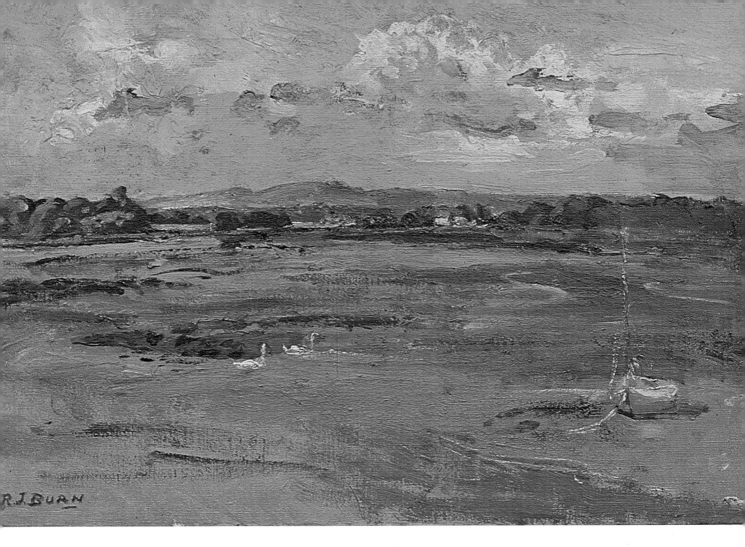

COLOUR PLATE 3: RODNEY JOSEPH BURN, RA, NEAC, Hon. RSMA (b.1899)

'Birdham and Dell Quay, Near Chichester, Sussex'. Oils, 18ins. x 24ins. Painted c.1967. *Photograph courtesy: Maurice J. Burn, Esq.*

This serene and sunny painting has fully captured the special atmosphere of Chichester harbour. The artist had a motor yacht based at Birdham Pool, Chichester harbour, between the years 1947 to 1965. This enabled him to observe and paint marine subjects in that area and in the Solent and West Country together with some visits to France.

Rodney Burn was a pupil of Wilson Steer at the Slade, and an admirer of his work which had a great influence on him. He has been a teacher at the Royal College of Art (1929-31) and Director of Drawing and Painting at the Museum of Fine Arts, Boston, U.S.A. (1931-34). Elected RA 1962 and President of the St. Ives Society of Artists from 1963.

COLOUR PLATE 4: KEVIN GEORGE CHAPMAN (b.1947)

'Rocks on Doom Bar, Cornwall'. Oils, 28¼ins. x 20½ins. Painted in 1977.

About this picture the artist says: 'These rocks and this sand and surroundings, although beautiful, are the graveyard of hundreds of sailors from ships driven ashore in rough seas. Doom Bar is aptly named.'

Kevin Chapman was born in New Zealand but has found an immediate attraction to Cornwall where he has a lifetime's painting ahead of him in the sea, the land and the people there.

The influence of the Post-Impressionists on modern marine painting is more difficult to discern. The wide scope and great variety of their work, together with the new freedom with which they painted, must have affected the outlook of many 20th century British artists. But perhaps because they covered so great a field of endeavour — as displayed brilliantly in the Royal Academy exhibition of Post-Impressionism early in 1980 — their real effect has possibly been more psychological and subtle than immediately apparent in today's marine art.

It would also be a notable omission not to mention JAMES ABBOTT McNEILL WHISTLER (1834-1903) as the pioneer of a new type of impressionist painting at the end of the 19th century. His exquisite Thames 'nocturnes' followed by some small beach scenes and seascapes created a sensation at the time, some of it far from favourable. His delicate handling of a few soft colours (his painting has been compared to Debussy's music) is fully understood and admired today, and has had an influence on marine and many other artists.

As it happened, British 19th century marine painting continued its majestic voyage into the 20th century with a great output of realistic and romantic pieces, many of them beautifully executed. The majority of artists felt secure in pursuing the paths pioneered for them on the one hand by Turner and Constable, and on the other hand the more conventional course (although often not without some of Turner's influence) as shown by artists such as E.W. Cooke, Clarkson Stanfield and numerous other celebrities of the powerful 19th century marine school. In addition, many artists at the turn of the century were undoubtedly still influenced to some extent by the meticulous techniques of the Pre-Raphaelites.

Thus it was that in the early years of this century there was the interesting, perhaps unique, co-existence of impressionist and traditional methods and outlooks in marine painting which has continued right up to the present day.

COLOUR PLATE 5: DAVID COBB, PRSMA, ROI (b.1921)

'**Short cut through sands. Follow me!**'. Oils, 18ins. x 26ins.

This dramatic painting shows the vital episode in Erskine Childers' famous book *The Riddle of the Sands.* A north-west gale blows on to the shoals of the Frisian Islands which lie close to leeward. The two yachts are about to run for shelter into a channel through the sands, but the pilot intends that only one shall survive.

David Cobb is a painter in oils of 'everything, of any period, that floats'. He has had a lifetime of seafaring experience, has exhibited at the RSMA since the inaugural exhibition in 1946, and is now President of the Society.

COLOUR PLATE 6: DAVID COBB, PRSMA, ROI (b.1921)

'**The tanker *Ohio* entering Malta**'. Oil on artist's board, 18ins. x 26ins.

This severely damaged ship was the key survivor of the famous 'Pedestal' convoy of August, 1942. Had supplies to Malta not been replenished at this time, the island, so vital to the allied war effort in the Mediterranean, would have been forced to surrender. Few ships of any class were fought more bravely in World War II than *Ohio* and her survival was immensely important.

This painting is one of a series of pictures showing the Navy in action in the Mediterranean from 1939 to 1945 which, together with a similar series covering the Battles of the Atlantic and the Pacific, were specially commissioned from David Cobb for the permanent collection at the Royal Naval Museum, Portsmouth.

Chapter 2.
Early 20th Century Marine Painters

To understand why 19th century marine art continued in its same style quite smoothly into the early years of the 20th, one has to remember that although subtle changes were starting in Britain when Queen Victoria died, Edwardian England still felt herself a secure and confident land. Sail was giving way increasingly to steam, but there was still plenty of picturesque off-white canvas on the seas and in harbours and estuaries. At the same time, the mixture of ships with different motive forces, together with a certain amount of smoke from coal-fired boilers, provided new subject matter of a romantic nature to artists. The brave and rusty tramp ships beloved of Rudyard Kipling were at once acceptable as good visual material as well as being symbols of Britain's trade across the seas of the world. (It is an interesting comparison that a stained and rusty super-tanker only rarely makes an acceptable painting in the 1980s.)

Whilst it would not be particularly useful to list here all the names of early 20th century artists (most of which are contained in the 'Guide to Artists' section at the end of this book) it is perhaps interesting to note some of those whose work is most remarked upon amongst the more senior of our living professional marine painters today.

THOMAS SOMERSCALES (1842-1927), a 'bridge builder' already mentioned in the previous chapter, is often admired by present day artists and is best remembered for his beautiful compositions of sailing ships in deep blue oceans (in fact, he also painted some naval engagements and marine narrative pictures, now rather forgotten). His mantle was perhaps taken over by MONTAGUE DAWSON (1895-1973) much of whose work has a similar idiom and is probably better known by the public. Montague Dawson's work is highly praised by many artists, particularly those who aspire to emulate his painting, but his pictures are sometimes regarded with more reserve by others. The latter category usually acknowledge his earlier work as outstanding but say that in his later years he tended to paint his ships in rather exaggerated attitudes of sailing.

CHARLES NAPIER HEMY (1841-1917) is a good example of a truly 19th century artist who ran on into this century. He was a powerful and dramatic sea painter, especially of fishing boats in strong winds, and was a teacher of Montague Dawson, although their subject matter became poles apart. Hemy had a freedom of style which gave great movement to his sea and the small boats on it. He had one strange idiosyncrasy: his horizons were often towards the upper third of the picture and consequently the masts of his fishing boats were cut off at the top.

An isolated artist who just entered the 20th century and who painted very beautiful seascapes was CHARLES CONDER (1868-1909) who was at one time well known for painting fans. His few heavily loaded oils of Swansea Bay, for instance, were perhaps as good as anything done by the Impressionists. But he painted only a few sea pictures and died young, so his name is little remembered.

JULIUS OLSSON (1864-1942), whom I have already noted as a painter of pure sea, is highly regarded by many marine artists, but almost forgotten elsewhere and his work is rarely seen. In a Royal Academy banquet speech some years ago, Lord (then Sir Kenneth) Clark asked 'Who remembers the great Julius Olsson?'. His pictures are very beautiful and insufficiently appreciated. He was in the same class as a painter of

pure sea as his 19th century predecessor HENRY MOORE (1831-1895), a great and also under-appreciated artist. Moore painted too blue for the present tastes of many people, and his seas are too lonely for the comfort of those who find solace in front of television sets.

NORMAN WILKINSON (1878-1971) seems to be universally admired by today's distinguished marine artists. Some believe he knew more about the mechanics of moving water than the old master sea painters. His paintings are painterly; they show an accomplished handling of colour, and the feel of the ships and the sea is nearly always right.

Few people think of EDWARD SEAGO (1910-1974) as a marine artist, but he was a keen yachtsman and produced some splendid sea pieces. He once went down to the Antarctic in the *Britannia* and painted some great seascapes near Georgia. He had many talents and his excellent figures could be produced with a few flicks of his brush.

About the work of CHARLES PEARS (1873-1958) there is a small divergence of opinion. His name is pronounced with regard by many artists, some of whom say he understood the sea deeply, whilst others say that his formula for painting salt water was too mechanical and rigid. Nevertheless, he was a marine artist of considerable achievement in this century, as well as being the first President of the Royal Society of Marine Artists.

ARTHUR BURGESS (1879-1957) is another talented early 20th century artist much admired by many other artists, but whose pictures are little seen today.

STANHOPE FORBES (1857-1947), founder of the Newlyn School, was a harbour artist of great distinction, in addition to his coastal, landscape and rural genre pictures.

The 1920s brought to fruition a flourishing crop of marine artists whose work is now quite widely admired. A few names must be mentioned. Amongst these is CHARLES DIXON (1872-1934), whose tidal Thames scenes are well known and are now collectors' items. He had a great capacity for drawing and a sense for brilliant colour — so much so that the Solent often looks like the Mediterranean in some of his pictures.

FRANK MASON (1876-1965) was an artist whose paintings ranged from the London river to Venice and, incidentally, showed quite different styles between the two locations.

The work of ARTHUR BRISCOE (1873-1943) is much admired for his draughtsmanship and excellent drawing and is now eagerly sought after. As a yachtsman and an etcher he was able to bring all these talents to the benefit of his paintings.

FRANK BRANGWYN (1867-1956), the third of the artists I categorised in the last chapter as a 'bridge builder', is held in high esteem amongst those who understand marine art and those who practise it. He had no formal art training but scaled the heights of fame in the first quarter of the century.

One has to repeat the name of W.L. WYLLIE (1851-1931) because although he had climbed to the top of the ladder by the end of the 19th century his success continued right up to the 1930s. He is so highly regarded that some people rate him as the greatest of the early 20th century sea painters.

The name of JACK SPURLING (1871-1933) is rarely heard today yet he was a marvellous painter of sailing ships for which he drew upon his experiences as a former seafarer. He painted perhaps 70 or 80 covers, one a month, for the magazine *Blue Peter.* The reason why his work is rarely seen is that most of the originals were destroyed during the last war.

TERRICK WILLIAMS (1860-1936), a marvellous painter of harbour and coastal scenes (and also a landscape painter) has still to be fully appreciated, although several collectors have been amassing his work in recent years.

ERNEST DADE (1868-c.1930), whose work is now rarely seen, went to sea before taking up painting. His work is admired by the older school of 20th century marine artists.

The artists I have mentioned are some of those who (apart from the great masters

ROY CROSS
©1979

such as Turner and Constable and the Impressionists) have influenced other marine painters in the past 70 years. The list of names could well continue, but it is not my purpose to give a directory of the more talented early 20th century marine artists in this chapter, but rather to indicate the areas in which the reader might well seek inspiration and pleasure. If you start looking for (and at) the paintings of some of the artists I have indicated, in the course of your journeys you will almost surely encounter the work of equally good but perhaps lesser known artists of merit. You will begin to make your own discoveries amongst the wealth of material produced during the first 40 years of this century, and you will find it immensely rewarding.

In those first 40 years Britain had fought, endured and survived two global wars. Official history says she won them both, but nonetheless her empire has gone and these islands now see sweeping and continuing social and economic changes. These changed climates and attitudes inevitably affect art and artists, who are as much a part of the population as those in any other occupation.

It is my endeavour to try to place before you, in a simple chronological order, the progression of marine painting from the 19th into the late 20th century, but as no one drew a line across a page on 1st January 1900, there is a great deal of overlapping and continuity between the two centuries. However, there were two great physical dividers of time: the World Wars. And so in order to see a complete picture of this century we must at this point look at marine art in the two wars before we look at the effects and results in our own times.

COLOUR PLATE 7: ROY CROSS, RSMA, SAvA (b.1924)

'*Constellation* in the Charles river, Boston, c.1800'. Gouache, 21ins. x 30ins.

This painting shows the Federal Navy 38-gun frigate *Constellation* opposite the Charlestown Navy Yard in the Charles river, Boston, about 1800. In the right background is Charlestown and, beyond, the Charles river toll bridge which was completed in 1786 to connect Boston with Charlestown. Since present-day Boston has altered out of recognition, with levellings and miles of fill-ins, Roy Cross had to consult old maps and prints of the period. The painting of *Constellation* was a reconstruction from draughts of the ship, as the vessel at present preserved in Baltimore has been almost completely rebuilt over the years and now bears only a superficial resemblance to the original ship.

The artist specialises in historical reconstructions of famous ships, old harbours, historical sea scenes, etc., and travels extensively in Europe and the U.S.A. researching his subjects in order to achieve accuracy and the correct atmosphere.

Chapter 3.
The War Artists

The work of the war artists is surprisingly neglected and largely forgotten. I use the word 'surprisingly' because of the great amount of interest still shown in stories, films and television features concerning the last war, if not the first World War. Perhaps the reason is that painting now seems too static a medium for conveying the dramatic actions of war to modern eyes accustomed to seeing these events recalled in swift motion and woven into fictional accounts on film and television. Also, there are few people who want to decorate a wall at home with a painting of a battleship being dive bombed, although they might be interested in looking at the same picture in a museum.

All the same, some memorable art was produced during the two great wars of the 20th century, sometimes under extremely difficult conditions, both by notable and by almost unknown artists. Certainly, no account of marine painting in this century would be complete without reference to the work carried out in those abnormal years.

In the first World War the British Government operated a system through the Ministry of Information whereby a number of artists were commissioned to produce paintings and drawings. In addition, the Imperial War Museum, London, was engaged in collecting together various pictures and other visual materials concerning war operations. At the end of that war all these items were gathered into the charge of the Museum where they remain today. This World War I collection was then very considerably augmented by the numerous and varying works of those artists who recorded events and people in World War II. The combined collection in the Museum relating to the two wars now totals about 9,000 items.

In 1939, at the outset of the second World War, the War Artists Advisory Committee was formed under the chairmanship of Sir Kenneth Clark (Lord Clark) who was then Director of the National Gallery. This organisation, in conjunction with the Ministry of Information, concerned itself with the appointment of official war artists and supervised their work; it also encouraged work from other artists serving with the forces.

One of the first naval artist appointments was SIR MUIRHEAD BONE (1876-1953) who had already distinguished himself in the first World War. As it was Admiralty practice to give their official artists a temporary rank either in the Royal Marines or the R.N.V.R., Sir Muirhead was made an Hon. Major, R.M., and although then in his sixties, at his own request he soon went to sea with minelayers in 1940 and continued actively with the Navy until 1943 and thereafter in an advisory role. He produced some fine pictures both afloat and ashore, examples of which may be seen in the Imperial War Museum together with work by all the other war artists mentioned here.

Amongst the first appointments were CHARLES CUNDALL (1890-1971) and RICHARD EURICH (born 1903) . Charles Cundall, Hon. Capt., R.M., painted at sea and in harbour from 1940. Richard Eurich was also made an Hon Captain, R.M., and became noted for his dramatic and moving reconstructions of key actions and events. He served from 1940 until nearly the end of the war.

Another early appointment to the rank of Hon. Captain, Royal Marines, was a watercolour painter: ROLAND PITCHFORTH (born 1895). He spent a great deal of time at sea, first in the Atlantic and Mediterranean and subsequently in the Far East.

Other marine artists were either appointed from the branch in which they were then

serving, or submitted work independently, or were asked to paint specific pictures. The first category included JOHN WORSLEY (born 1919) who had already been an executive officer in the R.N.V.R. from 1940 and was appointed an official artist on the Staff of the C. in C. Mediterranean in 1943. He was subsequently captured whilst on a partisan operation in the Adriatic and then continued to record war-time episodes from a prison camp as well as being the instigator of the famous escape dummy 'Albert, R.N.', subsequently featured in a film. No less than 60 of his pictures are in the Imperial War Museum.

JAMES MORRIS, a signalman in the R.N., was promoted to Hon. Lieutenant, R.N.V.R., and recorded many scenes from the end of the war in the Far East. Prior to this, he had made a notable sketch book of a convoy to Russia, in which he had served in 1942.

In all, the War Artists Advisory Committee either bought or commissioned the incredible total of over 5,000 pictures. Only a proportion of these were marine subjects, of course, but all the same the sea was well covered. In addition to the Royal Navy, the vital role of the Merchant Navy was recorded in many pictures, including those specially commissioned from artists such as JOHN PIPER (born 1903), JOHN EDGAR PLATT (born 1886) and BERNARD HAILSTONE (born 1910).

Yet another group of artists was attached to the Royal Navy by the Ministry of Information. These included BARNETT FREEDMAN (1901-1958) who, like EDWARD SEAGO (1910-1974) had been an invalid for part of his childhood. Freedman served with distinction first with the Army in 1940 and then from 1941 with the Navy as an Hon. Captain, R.M. He went to sea in H.M.S. *Repulse* and in submarines; he also recorded scenes at Arromanches, site of the famous Mulberry harbour.

ERIC RAVILIOUS (1903-1942) was one more of that select band of Hon. Captains, Royal Marines. Appointed in 1939, he gave the nation many naval watercolours of great talent painted in a modern distinctive style. He was killed on active service in an aircraft off Iceland in 1942. STEPHEN BONE (1904-1958), son of Sir Muirhead Bone, was made an Hon. Lieutenant, R.N.V.R., in 1942 and produced marine pictures whose subjects varied from mine sweeping to U-Boat prisoners and covered theatres of war which ranged from Norway to the beaches of Normandy.

An artist who started his war service with the National Fire Service and became an Hon. Captain, R.M., was LEONARD ROSOMAN (born 1913) and at the end of the war he went to the Far East with the British Pacific Fleet. His war paintings started out with subjects such as 'A house collapsing on two firemen, Shoe Lane, London, E.C.4.' and at the end of hostilities contained 'A sunken ship in Hong Kong harbour'.

One more painter who joined the ranks of honorary appointments in the Royal Marines as Captain was JOHN NORTHCOTE NASH (born 1893) who had already been an official war artist in the first World War. ROWLAND LANGMAID (1897-1956), like John Worsley, was an executive officer in the R.N. and became a 'local' war artist appointed by the C. in C. Mediterranean. For this reason his name is often omitted from lists of the war artists although in fact he recorded many war-time naval scenes. His pictures are not to be found in the Imperial War Museum but there are nearly 20 examples of his work in the National Maritime Museum. These are mainly of naval actions in the Mediterranean but there are also two of 16th June, 1944, under the title 'H.M. The King visiting the Normandy beachheads in H.M.S. *Arethusa*'.

Perhaps one of the most significant collections of World War II marine paintings[2]

2. A re-awakening of public interest in British naval achievements of some 40 years ago is shown by two major painting projects which were well under way in 1979 and 1980. First, there is a large commission by DAVID COBB covering operations in the Atlantic, Mediterranean and Pacific; then there is another large undertaking by JOHN HAMILTON. Both these are described in Chapter 13.

made at the time is the one created by NORMAN WILKINSON (1878-1971) and which he presented to the nation. Consisting of some 60 paintings of naval actions, this collection is now in the National Maritime Museum. In contrast to this achievement it is perhaps fitting to mention the numerous 'one-off' submissions by artists who, in spite of the obvious difficulties of life in the services, and often in action, were sufficiently devoted to painting to overcome the obstacles of their environment. I particularly like to think of RUDOLF A. HAYBROOK (born in 1898) who went to Dunkirk with the fire-fighting vessel *Massey Shaw* and submitted pictures both in 1940 and 1941.

In all, some 30 artists were recording marine events, scenes and personnel in the 1914-1918 War, and about 40 more in the Second World War between 1939 and 1945.[3] Their art, as well as providing a lasting record, must have had some influence on post-war marine painting. At the very least it kept alive in those crucial years the long line of tradition which had started with the Van de Veldes in 1674 and which had become a great romantic art in the 19th century.

Between the wars the progress of marine art became a thinner line of continuation, although practised by some distinguished and enduring painters. But by 1938 the presence of a wealth of talent and the absence of a coherent movement had been noted and, as a result, the Society of Marine Artists (later the R.S.M.A.) came into being (see Chapter 14).

A small booklet of some 64 pages was printed in 1942 with the title *War at Sea*.[4] In a brief pre-amble, the following prophetic words were used: '*What did it look like?* they will ask in 1981, and no amount of description or documentation will answer them. Nor will big, formal compositions like the battle pictures which hang in palaces; and even photographs, which tell us so much, will leave out the colour and the peculiar feeling of events in these extraordinary years. Only the artist with his heightened powers of perception can recognise which elements in a scene can be pickled for posterity in the magical essence of style. And as new subjects begin to saturate his imagination, they create a new style, so that from the destruction of war something of lasting value emerges.'

In his introduction to this long-forgotten booklet, Admiral Sir Herbert Richmond wrote of the importance of the war artist not only in recording key events for posterity, but also in showing the serving men and women and those backing them up what was going on in the sea battles. He also made another important point: the war artist's job included the portrayal of the individual seamen who manned the ships of the Royal and Merchant Navies. This is a vital element, almost entirely absent from paintings of ships and sea battles in the 18th and 19th centuries — an element which many of the artists of both world wars supplied.

In the first war, some portraits of distinguished sailors were painted by SIR JOHN LAVERY (1856-1941), FRANCIS DODD (1874-1949), JOHN WHEATLEY (1892-1955) and others. In World War II there were also some fine portraits and studies at work of commanders and men, by artists of the calibre of ERIC KENNINGTON, HENRY LAMB, HUBERT A. FREETH and JOHN WORSLEY. A picture by John Worsley entitled 'Sailor peeling potatoes' conveys a whole whiff of the atmosphere of those days, as does another drawing by this artist 'An earnest game' which he inscribed 'Study taken on the mess deck during a watch below. The types of men are many and varied and infinitely rich in character'. The portraits by Eric Kennington of men like Stoker A. Martin of H.M.S. *Exeter,* Leading Seaman Walker

3. A distinguished few artists who painted and drew marine subjects managed to serve in both wars. These included Sir Muirhead Bone, Philip Connard, Francis Dodd, Eric Kennington, Frank Mason, John Nash, Charles Pears, Sir Stanley Spencer, John Wheatley and Norman Wilkinson.

4. Published by Oxford University Press.

and Petty Officer R. Barnes of H.M.S. *Eclipse,* and Able Seaman Povey of H.M.S. *Gurkha* tell more clearly than any words the reason why Britain was undefeated.

Also illustrated in *The War at Sea* booklet was a painting by Richard Eurich entitled 'The withdrawal from Dunkirk'[5] which was described by Oliver Warner as 'perhaps the best artistic monument of that prime disaster'[6]. In contrast, another illustration shows a picture by Sir Muirhead Bone, of H.M.S. *Victory* in her war time dry dock. The comment made in the foreword regarding this picture says that 'an enemy who has not spared historic buildings was not to be expected to leave this naval treasure alone, so it is well to have a picture of the old ship as she now lies with her masts housed and her yards down in her dock in Portsmouth Yard ... it is to be hoped that this survivor of the great wars of the eighteenth century may also survive the present one ...' This last sentence brings back most vividly the fact that in those days the future of Britain as a free democracy was as uncertain as the survival of H.M.S. *Victory,* and hope, faith and a powerful determination shared by the whole population were our best assets.

5. Now in the Imperial War Museum.
6. *An Introduction to British Marine Painting,* B.T. Batsford Ltd., 1948.

Chapter 4.
20th Century Marine Painting Today

Nowadays, one of the best places to see a wide range of modern 20th century marine painting is at the annual exhibition of the Royal Society of Marine Artists[7] which is usually held in October or November in London. Between 200 and 300 pictures, both oils and watercolours, are normally on view and the work is representative both of the Members of the Society and non-members. There is also a selection of sculpture and some etchings. Thus, it is possible to get a good idea of what is going on in British marine art today.

The first thing that always strikes me is the high standard of painting. It also seems clear that marine painters on the whole have not departed very far from the traditions of subject matter and composition founded in the last half of the 19th century, whether their style is representational or impressionistic. You will find a good selection of sailing ship subjects, ranging from spritsail barges to tall ships; harbour, coastal, and beach scenes; the tidal Thames; not many portraits or subject pictures of sailormen or fishergirls, it is true (and this seems a strange deficiency); and a fair sprinkling of ships and naval events from the 18th and 19th centuries. In addition, there will be some modern ships, perhaps a few specially commissioned pictures of warships or naval events from the last war, and maybe an oil rig, some dolphins, or an iceberg or two, and certainly some yachts, which have introduced new and stimulating shapes into art in the form of spinnakers and modern hull design. Otherwise, the concessions to so-called 'progress' in art seem to be few; rarely any puzzling cubes or abstracts to cause controversy or dismay (and certainly no piles of bricks or twisted ironwork in the centre of the gallery). It is difficult to see any radically new movement or divergence from past practice during the last few years. Those who have ventured towards or into impressionism are, in any case, still following the 19th and early 20th century Impressionists. It has to be remembered that whilst Turner and the later Impressionists created a revolution in marine painting as well as in painting generally, both the old traditional styles and the newer impressionist methods have carried on side by side up to the present time. No criticism is intended in these comments; on the contrary, I personally feel it heartening to see the continuance of art forms which have been so successful in the past. Striving for something different purely in order to be different is not inevitably laudable.

The questions which arise in one's mind stem from other aspects of this phenomenon of traditional continuity. Why, for instance, is 19th century marine painting so avidly sought and bought on an international basis, whilst its modern 20th century counterpart remains comparatively neglected?

One reason advanced for the commercial popularity of 19th century sea pieces is that the artists are all dead. Whatever a particular artist painted, therefore, is unrepeatable by him and thus achieves exclusivity of a special nature. Then there is the matter of record: the dead artist's details in a dictionary, however slender the entry, seem to give a buyer confidence (sometimes ill-founded). Another cogent reason seems to be that

7. Details about the Royal Society of Marine Artists, its purpose, exhibitions, etc., are given in Chapter 14.

these old pictures have withstood the passage of time and have reached down to us today; and provided they have not been scrubbed off and brightened up with new paint by some demon restorer, they have a patina, a translucence, a mellowness, endowed by age.

Modern marine paintings often have a newness, a brightness, a strongness, and sometimes a brashness which the Victorian counterpart does not have. Even when 19th century oils are carefully cleaned back to their original bright colours, they do not have this 'new' look. Time will help many of these modern pictures, because after 25 years or more the physical characteristics of the oils change and a translucent process begins.[8]

However, there are a few artists painting today who achieve a feeling and mellowness akin to the Victorian painters. One of the leading exponents is DEREK GARDNER who specialises in painting 18th and 19th century naval engagements and sea scenes. He says that his work is a continuation of traditional methods of painting developed over the last two centuries in an orderly progression from one generation of marine painters to the next (apart from the explosion caused by J.M.W. Turner). He believes that successful marine art is essentially conservative and is therefore best rendered by conservative methods: when abstract forms have been used, for example, he contends that the results have been neither satisfactory nor convincing. Certainly his pictures have a beauty and mellowness quite close to their 19th century counterparts, and he achieves this by what he calls academic methods and long slow hours of building up.

The demand for paintings of this calibre is very great and thus points towards the present yearning for past times and old things. (The view that marine art should remain conservative is, of course, debatable. Some very fine seascapes by L.S. LOWRY for instance — better known for his industrial scenes — broke new and original ground. On the other hand, as ROWLAND HILDER has remarked to me, we have seen a lot of revolutionary stuff in this century, but it is not always an improvement — sometimes it takes you backwards.)

There is a divergence of opinion amongst present day artists as to whether the Victorian painters were universally so much better than their modern counterparts. Some are adamant that 19th century standards were generally much higher, whilst others say that the best marine artists of this century are just as good as those of 100 years ago. One difficulty is that we cannot stand far enough back from what is created today; often, ten or more years after an artist has died (sometimes sooner) there is a sudden appreciation of his or her achievements, probably because someone with the power to influence opinion has stopped for a moment to look backwards, to think carefully, and then draw the attention of critics and collectors to this artist's paintings. A major retrospective exhibition of a deceased artist's pictures may suddenly establish his work at a higher price level than he attained during his life.

The role of the promoter is of course a powerful one. There have been many instances in recent years of galleries promoting the work of a living artist so that his name has become widely known in a comparatively short time.[9] Perhaps modern marine painting could do with even wider promotion, because I feel sure that there are many excellent artists whose work in this field is greatly undervalued. The competition from the 19th century remains intense, and one reason is that the big auction houses and galleries in London and New York have been displaying and selling art from this period on a scale greater than ever before. Indeed, the supply of good quality 19th century marine paintings has considerably diminished due to world-wide buying and I

8. See: 'Techniques of Marine Painting' — Chapter 7.
9. The role of galleries and agents is discussed in Chapter 13.

have noted that works by early 20th century artists are often included in important sales of 'Victorian' pictures, even when the pictures concerned bear dates such as 1920 or 1930! Perhaps the justification is that the painter was born before 1900 and his 1920 or 1930 work was executed in the 19th century style?

The lesson to be learned is that potential buyers of sea pictures should turn their attention towards some of the excellent paintings they can still get for a reasonable price from artists who are alive and well. Art needs patronage in order to flourish and progress, and patronage in the form of private purchase is one of the better forms. An attractive bonus for buying a modern marine picture is that, if selected with good judgement, it stands a fair chance of being an appreciating investment.

There is another side to this coin of competing with the past. Many people do not want soft or mellow or aged-looking sea pieces: they prefer brighter and stronger compositions for their decor. Since the spread of colour television and mass advertising, there are those who have become conditioned to requiring bright colour, so that a gentle picture is often overlooked. However, those who are afraid of the brightness of some new painting should again be reminded that oils will usually mellow and improve in tone with the passage of time.

Another aspect of modern painting is that whilst most artists prefer restrained colours, some of them do not believe that marine art needs to be highly polished and finished and they prefer a broader approach. Often they are saying the same thing as their 19th century ancestors but in a looser, freer style.

The national habit of continuously looking backwards is not altogether good. Whilst our foundations are in the past, from which we have many lessons to learn, it is the present and future which lie before us each day, and it is here perhaps that we should be looking more carefully when considering marine painting. There is an argument which says that painters have a moral obligation to paint life as it is around them and not to hark back to the past. Giant tankers or bulk carriers may, to the average eye, look like hideous pieces of hardware today, but if they are not recorded in their natural surroundings now, how will future generations view them? A photographic record cannot be a substitute for an artist's interpretation. Why should the shape of a great oil tanker not be transformed on canvas into a powerful and dramatic picture, both moving and decorative? It is only the marine artist of high calibre who could achieve this, not the camera. The public may not wish to buy such paintings now, but should

COLOUR PLATE 8: MONTAGUE DAWSON, RSMA (1895-1973)

'Rolling Seas: the *Albion* Blackball Packet'. Oils, 27¼ ins. x 41¼ ins.

Many people connect the name of Montague Dawson with pictures of large clipper ships under full sail. This painting shows that he could paint the deep sea with absolute assurance and effectiveness. He understood the sea — his father was a sea captain and he himself served in the Royal Navy in World War I — and he has become one of the best known of 20th century British marine painters. His work enjoys enormous popularity today.

Photograph courtesy: Sotheby Parke Bernet & Co.

COLOUR PLATE 9: MONTAGUE DAWSON, RSMA (1895-1973)

'A windy day'. Watercolour and bodycolour, 21ins. x 28½ ins.

This beautiful picture of yachts racing in the Solent, c.1930, is very different in subject matter to Montague Dawson's main work. He became well known from the 1950s onwards for his rather spectacular oil paintings of clipper ships under full sail in deep blue seas. He was a pupil of Charles Napier Hemy whose influence may often be seen in Dawson's treatment of the sea.

Photograph courtesy: Old Solent House Galleries, Lymington.

the artist paint only what the public demands? History shows clearly that art made most progress when artists painted what the public quite definitely did not want.

The present day buyers of ship paintings (as distinct from the wider range of marine subjects) seem to fall into two categories. Those who want a stunning picture over the fireplace and do not bother too much about absolute accuracy, and those who know something about ships and want to be able to see all the bunt lines and check the main tops'l halyards. There were numerous ways of rigging an old ship which not many people know about today. The few marine artists who have been to sea in square riggers or schooners have some advantage here. The rest have to rely on careful research. All the same, I feel that close contact with salt water for a few years must be a considerable asset to a marine painter whether he paints tall ships or dinghies sailing in a harbour.

Although sail may still dominate the thoughts of many marine painters, the range of subject matter available to modern artists has never been greater. Whilst the development of television and photography generally has brought to the viewing public a far wider awareness of the so-called real world, modern air and sea travel must also help the artist into new fields.

Perhaps living artists are too close to their own work to realise the extent of and opportunities in marine painting today. They tend to speak of its limitations, of their own frustrations, and its obscure future. This perhaps is symptomatic of the artistic temperament, but I for one, who have had the good fortune to look over most of this field, have the strong impression that British 20th century marine painting is alive and kicking and that it is high time that a larger number of the public (and the critics) paid more attention to it.

Chapter 5.
What Constitutes Modern Marine Painting?

There is a clear division of opinion amongst marine artists as to what subjects 20th century marine painting should comprise. There are two quite definite schools of thought. One school contends that a true marine artist should be generally concerned only with the sea, the ships that sail on the sea, and the small craft and equipment which complement these ships. DEREK GARDNER put this view to me: 'The great marine painters of the past were painters of the sky, the sea and shipping. If coast scenery or figures were introduced into their work these were always subordinate to the main marine theme. Nowadays, much that passes as marine painting could equally be called landscape because the salt water element has been made secondary to something else: harbour and coast scenery perhaps, or flora and fauna. Impressive and competent as much of this work is, it does not rank as marine art in the true sense. When I talk about marine painting, I regard it in the traditional sense as handled by the Van de Veldes, Brooking, Monamy, Serres, Pocock, Luny, Turner and many others of that long line.'

This viewpoint has substantial support. However, the second school of thought — which perhaps has more active followers and practitioners than the first — says that marine painting can cover every aspect of salt and tidal waters, and all the craft and activities and forms of life and flotsam and jetsam and equipment, ancient and modern, which accompany or use this salt water. This obviously covers a very wide range. But is art the worse for that? Was not Turner, the greatest of all marine artists, capable of drawing and painting the widest range of these activities (in his world) ever achieved by an artist?

The extensive variety of subjects to be found on coasts and in harbours and estuaries usually has a strong sea flavour and must make marine painting as a whole more varied and therefore more interesting to the viewer. Without these subjects would the story of the sea be complete? Moreover, many marine artists also paint landscapes and many landscape artists paint marine subjects; a habit which has considerable merits.

There is one aspect of marine painting on which there is a large measure of agreement amongst marine artists: to have been to sea in ships or in small craft gives an understanding of that great element which provides an enormous advantage in portraying its many moods correctly. ROWLAND HILDER, for instance, told me that he did not see how it was possible for people who had not been on salt water to paint it — he called them longshore painters. However, he pointed out that fishing boats or rowing boats at anchor are still an aspect of marine painting — provided the boats look like boats and are not wrongly drawn.

The case for a wide range of marine painting was summarised by KEITH SHACKLETON, President of the R.S.M.A. in 1978, when he wrote: 'There is more to the sea than ships and more to ships than spritsail barges and square-riggers. Britain has more than one paintable pub with a foreground of boats. There is more under the sea than on the surface. There are more 'marine' subjects around the farthest limits of the land than have ever been attempted in paint. They can even be found indoors and by the thousand — there are 'marine' people for portraits.'[10]

10. Foreword to the official catalogue of the 1978 R.S.M.A. Guildhall Exhibition.

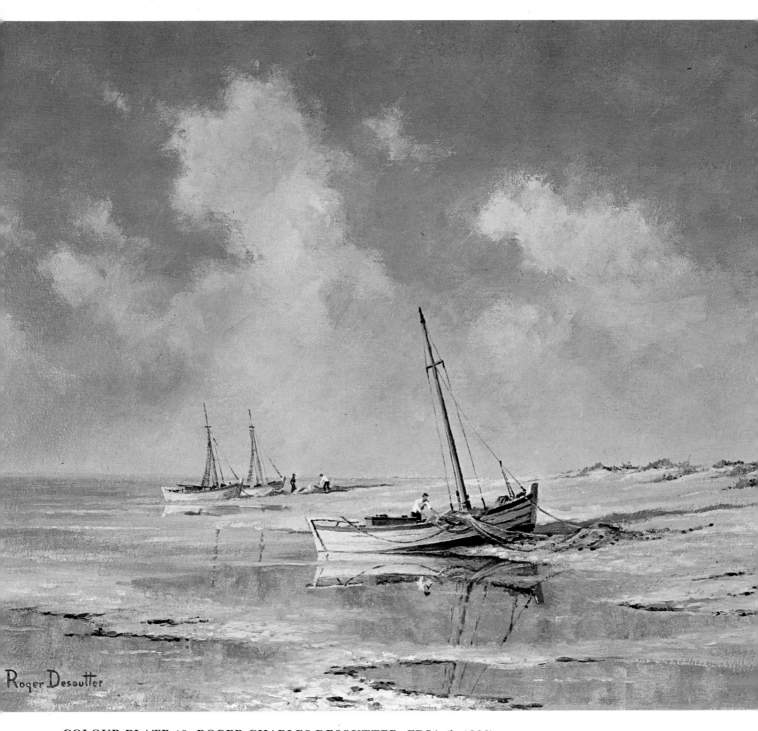

COLOUR PLATE 10: ROGER CHARLES DESOUTTER, FRSA (b.1923)

'Mediterranean fishing craft'. Oils, 20ins. x 24ins. Painted in October, 1979.

This painting shows a scene on the southern tip of Corfu where there are miles of flat sandy stretches with scrub and grassland. In the heat haze of the afternoon, cumulus clouds form over the mainland whilst the locals attend to their nets in preparation for a night's fishing. The artist made sketches on site and completed the painting back home on a cold, foggy day in October.

Roger Desoutter has been a keen yachtsman for many years. He has exhibited his paintings at the Society of Aviation Artists since 1955 and the RSMA since 1974. He specialises in sailing ships, coastal and estuary scenes, and landscapes.

38

Another view of the scope of marine painting was given to me by DAVID COBB, the President of the R.S.M.A. in 1980, who put the point that we now have many marine artists who are painting scenes from the past that they have never seen, and ships from the period of about 1850 to 1900. Since neither the artists nor the buyers of these pictures have seen these ships, who can be the final arbiter of what has been well observed and researched and what has not? Criticism of these paintings may call for special skills over and above a wide knowledge of art.

An extension of those ideas was made by another artist who posed what he termed a philosophical question. Should anyone today be painting a sailing vessel he or she has never actually seen? He showed me a picture which he had painted of a square-rigger which sailed from the west coast of the U.S.A. in 1940 with the last cargo of timber ever to leave in such a ship for South Africa. He had seen this ship and studied photographs. But still, he asked himself, would he be better occupied in painting what he sees around him? Then he thought he would not be too happy painting supertankers. But, he said, if one calls oneself an artist, surely one should paint scenes of one's own times and not past history? He had terrible feelings of guilt about this quandary, but in the end he settled for his own solution: that perhaps it is permissible to paint old subjects in a modern style.

Well, I would think that the answer to all this is for the artist to paint whatever he is best at, to strive continuously for improvement (if not for perfection) and to paint with integrity and self-respect as well as with passion and despair. If, then, his pictures are works of art from which people derive true pleasure, and which many people would like to hang in their homes or in art galleries, why should we worry too much, if at all, about defining boundaries for the subject matter or its period?

In my book *British 19th Century Marine Painting* I took the widest view and, without adjudicating on the pros and cons of the argument, I am taking the widest possible view of marine painting in this book. My chief criterion in assessing a marine picture is: does this artist really understand the sea and the sky and their interrelationship? If the answer is 'Yes' then I would be happy to accept as a marine painting a picture of children playing on sand dunes with the sea beyond, or a dinghy at anchor, or a view of Brixham harbour, or a tern diving, or a tall ship racing.

The 19th century artist had a comparatively simple, if large, choice of subjects. He could take a comfortable train to the seaside and paint coastal scenes, or harbours, or ships entering and leaving harbour. Or he could go to sea in a ship (which a small number of them did) and then set down on canvas his record of sail, storm and calm. Another source of marine art arose from the habit of officers in the Royal Navy being required to record certain details and incidents, or voluntarily doing so, either by drawing in pencil, in pen and ink, or in watercolour.

Today, as ever in the 20th century, we have a more complicated situation. We have supertankers, hovercraft, hydrofoils, fast world-encircling freighters, missile cruisers, nuclear submarines, oil rigs, weather ships — and even the disappearing passenger ship — to name just a few of our modern marine subjects. It is perhaps useful to examine some of the broad categories within this large conglomeration.

Pure Sea

The last part of the 19th century produced some outstanding painters of pure sea, and I make no apology for repeating the names of HENRY MOORE and JULIUS OLSSON. Although they were successful and acclaimed in their day, their pictures do not in these times have the degree of popularity they deserve as works of art. People now require some vehicle which symbolises human activity, e.g., a ship, and are not comfortable with the sea alone, whether wild or calm.

Little wonder then, that there are not many modern painters of pure sea. Just as landscape artists have found that a landscape without figures is empty and static, in another way the marine artist usually needs a ship, a headland, a lighthouse or some other feature to focus his viewers' attention on the overall seascape. Many good artists

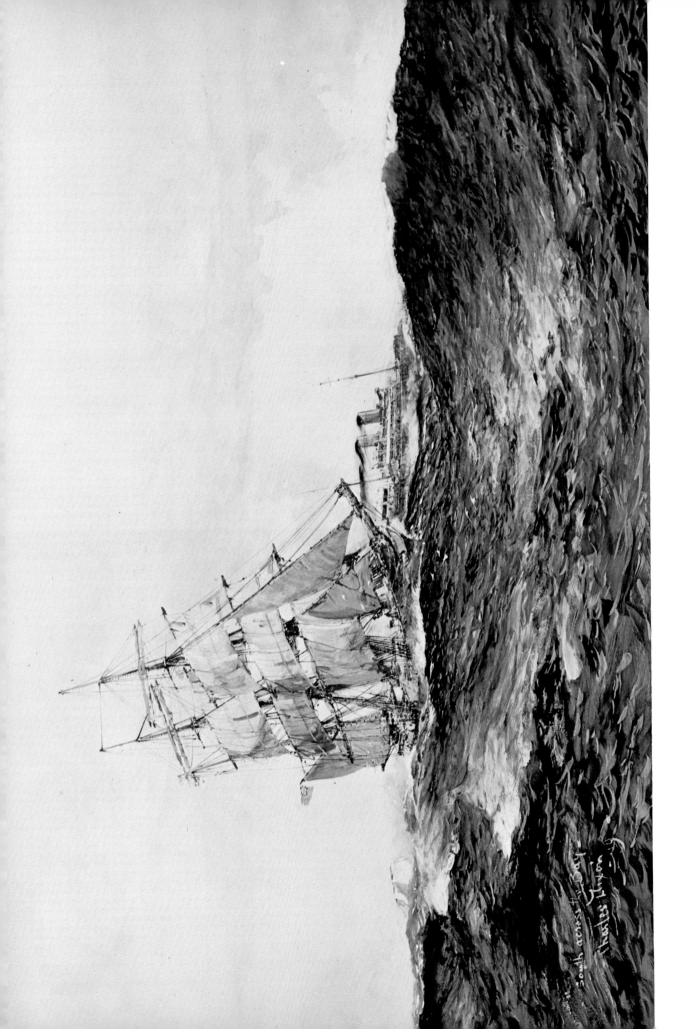

South across the Bay
Charles Pears

would like to paint pure sea, but as there is a poor market for this subject they prefer to earn money to live, eat and clothe themselves.

Ships

No one can argue about a ship or boat of any size being a marine subject. Its interpretation into a thing of drama or beauty is another matter. Fortunately, there are some outstanding artists alive today who paint ships and boats of every type with knowledge, faithfulness and considerable artistry. The illustrations in this book should be sufficient proof of this.

The type of ship picture to beware of lies amongst the numerous imitations of the Montague Dawson tradition and poor representations of clipper ships by some of the lesser artists. As it has all been done so well in the past, it is ever more difficult for beginners to even approach the standards which have been set in this category.

Modern ships present their own peculiar problems. A supertanker may be an object of beauty to her owners and captain, but how would you like one on the wall of your drawing-room? A great deal of vision and artistry needs to go into a supertanker painting to make it acceptable as a dramatic or alluring work of art. But perhaps in 100 or 200 years' time, such pictures will look as quaint and old-fashioned as a picture of the *Cutty Sark*. One of the few artists who have succeeded in making a giant tanker look like an essential component in a work of marine art is RICHARD EURICH, R.A., whose paintings such as 'The Great Tanker' (1968)[11] and 'Lovers on a Beach' (1969) whilst dominated by figures would be incomplete without the ships.

Nuclear submarines? An artist who has been successful in painting them confessed that even a whale is prettier.

In making modern ship pictures attractive therefore, the good marine artist will almost certainly use the sea and sky to get his exciting effects, his draughtsmanship to make the submarine or tanker a living reality in those two elements, and perhaps some figures to introduce human life.

Oil rigs

There is a sense of drama and some majesty about oil rigs. There is toughness, the sweat of toiling men, the spray and spume of Force 8 and over in the North sea, the great steel and concrete erection towering above the crashing waves, the tossing supply vessels below, the reeling grey cloud-torn skies. Here, surely, is scope for exciting painting. Once again, one sees clearly that it is the sea and sky, against which human endeavour sets itself, which would make the subject worthwhile. The rig itself on land, for instance, would not arouse much artistic enthusiasm. But how many artists today are painting oil rigs? Very few, and so there is a danger that a good artistic record of these monsters will not be left to posterity.

Harbour and coastal scenes

There is no lack of talent in this category, but there is perhaps one subject which is not often dealt with: the 'seaside holiday beach' scene. Surprisingly few Victorian

11. See Plate 73.

COLOUR PLATE 11: CHARLES DIXON, RI (1872-1934)

'**South across the Bay**'. Watercolours, 17½ ins. x 27ins.

This dramatic picture of sail and steam in the famous (and sometimes notorious) Bay of Biscay is an interesting contrast to the artist's popular London River scenes. Charles Dixon's painting has become increasingly appreciated since 1973, when three major exhibitions of his work were held and re-established his status as an important 20th century artist.

Photograph courtesy: The Royal Exchange Art Gallery, London.

artists did this, with one or two exceptions (notable examples were the famous 'Life at the seaside' by WILLIAM POWELL FRITH, R.A. and 'Pegwell Bay, Kent' by WILLIAM DYCE, R.A.).

Whatever the marine painter who deals only with deep sea and ships may say, there has been a long-standing affection and demand for harbour and coast scenes for well over 120 years. Furthermore, there is an impressive background of painters over that time who have been well accepted as marine artists. The trawler crew washing down decks or unloading their catch in harbour are still as much part of the sea as they were when they were steaming 50 or 100 miles off shore. Indeed, a well known marine painter told me that he thought there was more future for harbour and estuary scenes than deep sea pictures.

By the same token, estuaries and tidal rivers yield a fine crop of atmospheric pictures although, as mentioned elsewhere, the absence of smoke and ships in the modern Thames has made the artist's job difficult in that locality. Up to the 19th century the ships in the Thames had not altered in many ways between the time of Henry VIII and the days of Nelson. After that there was a big change, but the tidal Thames remained full of sail right into the first part of the 20th century. Sixty years ago there was an enormous wealth of picturesque material still around: sail, plenty of barges, smoke, and the muddy river. The artist today has to decide whether to look back nostalgically to the days when sail was there, or to go around trying to find places which have not changed too much, or to paint the new scene, no longer picturesque, but with new methods.

Today's artist may perhaps need to develop a different technique or style for modern subjects. A lesson to be learned from the past is the way in which some of the Impressionists could make a timber wharf and a distant factory on the river Seine look (to present-day eyes, anyway) a composition of outstanding beauty. That was the result of manipulating light and colour with keen observation on the spot and a magic touch. But no doubt, at the time, those timber yards and factory chimneys looked as ugly to the passer-by as the Battersea Power Station may look to some of today's motorists who pass along the London Embankment.

Figure subjects and portraits

Portraits of sailors painted by marine artists are not seen frequently. Perhaps this task is left more to members of the Royal Society of Portrait Painters. Yet the marine panorama seems incomplete without representations of the men who man ships and sail yachts.

There appears to be an even greater need for pictures showing the activities of people in seafaring occupations, or yacht racing, or harbour or dock installations, or fishing, or merchant navy or naval ships, or ship building, and so on. A very few deck scenes are produced (and do not sell too well) but there seems to be no 20th century counterpart to the prolific output of the 19th century figure and genre painters who recorded for us the sailors and fishermen and women who dealt with the sea in those days. Here, surely, in the differing environments of ocean racing yachts, off-shore trawling vessels, or modern naval ships — to take only three areas — there must be a vast choice of human subject at work and relaxing both above and below decks. How will our grandchildren and their children know the atmosphere of human occupation on the seas of the 1980s unless some artists record these activities now?

In this field there is much to be said for painting what is happening in present times and not letting just the old, the romantic and the purely picturesque subjects monopolise marine art.

Illustrations of the work of two modern artists who specialise in painting ships and historical marine subjects of the 18th and 19th centuries.

Above: 'Out from Plymouth' by Derek G.M. Gardner, VRD, RSMA. This oil painting, size 11½ ins. x 29½ ins., was exhibited at the R.S.M.A. Annual Exhibition at the Guildhall, London, in 1977.
Below: 'H.M.S. *Ranger* in the Hamoaze', a watercolour size 15ins. x 22ins. by Mark R. Myers, RSMA, ASMA.

There is an amicable difference of opinion amongst many artists as to the boundaries of marine painting. Some artists contend that marine painters should confine themselves chiefly to the sea and ships, whether the vessels be those of former times or the supertankers of today. Others, more numerous, say that the subject matter can validly comprise not only ships, but dinghies, rowing boats, harbours, beaches, coastal scenes, estuaries, seafaring people, and all the flora and fauna which go with salt water.

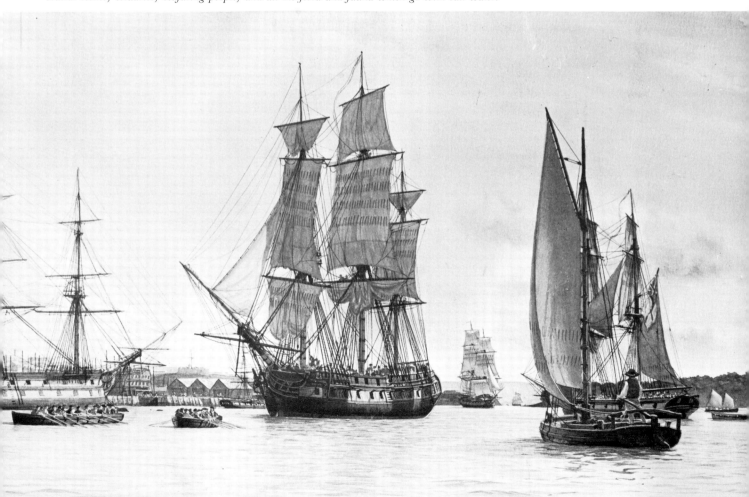

Chapter 6.
What Makes a Marine Artist?

Some artists have been dedicated to drawing and painting from childhood onwards — they seem to have been born with this urge. Others have taken up painting much later in life, perhaps after following a career which they found unfulfilling, or in some cases they have switched from a job in commercial art such as, for example, a technical illustrator.

Whatever their background, marine artists all seem to have one thing in common: their love of salt water, no matter whether it comes from the deep oceans or the tidal Thames or the coasts around our island.

A surprising number of successful 20th century marine painters have been self-taught and it is interesting to consider the value or otherwise of a formal art training.

A distinguished artist has summarised the benefits of training in this way: 'I believe in a formal art training, if only for the number of short cuts you can learn. The advantage of a good teacher's experience can save you a tremendous lot of thrashing around trying to arrive at the same result. The chief benefit is to one's mental approach to painting; training gives you a much wider concept of pictures, compositions, tones, etc. However, the problem today is to find good teachers, and unless one can do so the advantages appear to be greatly diminished.'

Another well-known artist said that when he was at art school in the 1930s the students almost worshipped their masters — probably the last generation of students to have that attitude, because today's art students often regard their teachers as silly old fools. In those days, pure drawing was practised and admired; whereas many of today's students do not care about drawing properly, they just want to 'express themselves freely'.

One of our best known marine painters who had a considerable formal art training when young, was quite outspoken when discussing this question with me. He made the point that artists now have more problems than ever before, because there are so many conflicting ideas about what art is. He said: 'In the old days there was a general concensus of opinion as to what a piece of art was. Now, when half-a-dozen people get together, there is no agreement whatsoever. And where now can you get good training? At one time you had a master who practised and if you were lucky you joined him. Now, many teachers in art schools do not know how to draw correctly; they are teaching because they cannot earn a living from painting. If you go to art school today, the chances are that you will be taught how to tie tin cans together, or make a mobile, or peel potato cuts. There is no longer any room for part-time instructors, which ensures that there are few competent art teachers, because the teachers teach teachers who teach teachers — like incest.' This particular artist's advice to any young person who is keen on art is 'For God's sake don't go anywhere near art school, for you will not learn anything at all except how to grow your hair long and smoke marijuana!' An emphatic statement, but perhaps with more than a few grains of truth in it. Another marine artist who had had formal art training gave similar but more qualified advice: 'Don't bother about art school, you will learn far more from experience, and the school may well spoil your natural style.'

But even 40 or 50 years ago, although draughtsmanship and traditional methods were still strongly taught, many of the basic technical aspects of painting had to be

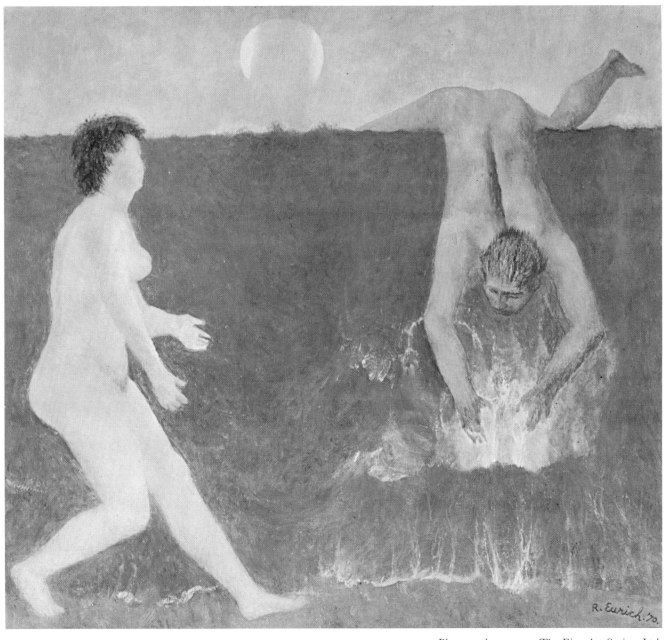

Photograph courtesy: The Fine Art Society Ltd.

COLOUR PLATE 12: RICHARD EURICH, RA, Hon. RSMA, Hon. NEAC (b.1903)

'Gathering of the Waters'. Oil on board, 17¾ ins. x 19¾ ins. Painted in 1970.
(Exhibited at the Royal Academy, 1971).

Richard Eurich studied at Bradford School of Art and at the Slade, London. His work is in many public collections and in 1979 and 1980 major Retrospective Exhibitions of his pictures took place in Bradford, Glasgow, London and Southampton. His wide range of subjects includes figures, still-life and landscapes, but he has also established his name as one of the leading marine painters of the present day. The subject illustrated here has a dream-like quality which draws one back to it time and again. About this picture, the artist says that 'it is one of those things which one can't explain to anyone, or to oneself'.

acquired by relying on the generous attitudes of then successful painters in occasionally allowing the student into their studios to watch their methods.

Some successful artists who have had no formal training feel that they may have missed the opportunity to learn techniques which subsequently they have had to acquire by extensive reading and trial and error. Books and articles on painting can tend to confuse the beginner because one author will propose one method and another will refute it and suggest something quite different. At the end of the day, a budding marine artist with talent and a few basic principles in his mind may do best to go ahead in his own way.

A more unusual reason for regretting not having been to art school was given by an artist who felt he had missed the chance to make friends and grow up with other artists from whom he might have learnt much. He also believed that artists who have been to art school together are more likely to keep in touch and recommend each other's work. I have not seen much evidence that this is true; in fact, in interviewing many marine artists I have been surprised to find how little they are normally in touch with each other, tending to pursue their own lives and their own paths.

Several artists started painting as amateurs in that most difficult of all the media, watercolours, and later took up oils. One of them felt that watercolour is the medium most needing instruction and said what a pity it is that children are often given water-colours to start with. They are so difficult to use effectively that a child can easily become disappointed and give up. If they were given oils they would find them far easier and could produce better effects. The trouble is that oils are messy, and children tend to get them on their clothes and on the wall paper.

From my investigations, I can summarise the pros and cons of art training as follows. As I have already said, a large number of successful present day marine artists were self-taught. Most of these wish they had had access to instruction in the basic mechanics and techniques, which would have saved them time and effort at the outset. On the other hand, many of those who have been to art school advise beginners not to do so because of poor teaching and the possibility of spoiling their originality.

In theory, therefore, the near ideal solution would appear to be a comparatively short course of instruction in the basic techniques of how best to deal with and handle the materials of the art, i.e. papers, boards, canvases, watercolours, gouache, egg tempera, oils, brushes, etc., how colours are mixed and effects achieved, and how to construct a picture from its foundations. In other words, a wholly practical and work-manlike course. This would be followed by the artist going off and developing his own style and originality, using his own talents and ideas unborrowed from others. Some-where along the line, the artist would need to be exposed to the work of his forerunners, because the Dutch painters, the English marine school of the 19th century, the Impressionists and famous painters like Turner and Constable cannot be ignored and must all have some degree of influence. Finally, having developed an individual style and approach, the artist should be able to return briefly to school to check that the methods he has developed are the most practical for his intended pursuit.

Apart from the question of training or no training, there is one additional qualification available to marine painters: experience of the sea. Here again, opinion is divided on how much this is necessary. Some of the 19th century artists had been practical seamen before they took to painting, although the seamen-artists were quite a small minority. The same applies in the 20th century, but the opportunities for coming into close contact with salt water have been far greater, with the large-scale develop-ment of all kinds of pleasure craft, both sail and power. At the beginning of this century, great marine artists like W.L. Wyllie spent a considerable time in small boats, often in difficult conditions, observing and recording the sea.

Those 20th century artists who have served at sea in the Royal Navy or Merchant Navy saw plenty of water. As one of them told me: 'There's no doubt that the Atlantic and Arctic oceans in winter impress the memory most wonderfully!'

However, it depends on the definition of marine painting (dealt with in Chapter 5) as to how much direct experience of the sea is essential to the marine artist. It is not necessary to go to sea in order to paint harbours or coastal scenes. You can observe sea from a beach, for instance, and RICHARD EURICH told me how as a young man he sketched on Chesil Beach with the spray flying, his glasses coated with salt and his paint box weighed down with pebbles to stop it blowing away. This artist felt it essential to study the actual structure of water in order to be a marine painter, and quoted the extraordinary capacity of J.M.W. Turner to analyse the formation of a wave.

Some 30 years ago about half the members of the R.S.M.A. were or had been practical seamen whereas today less than a quarter have been to sea. Perhaps it is because the availability and accessibility of the sea are now so much greater than was the case 30 or 50 years ago, and the visual recording of it by photographs and films so much easier, that it is no longer necessary to go to the length of shipping aboard a freighter or clinging to the rail of a trawler in order to get the visual material for sea pictures.

Another essential ingredient for a particular class of marine artists is the ability to carry out painstaking and meticulous research. Today, there are a number of well-known artists who devote their lives to painting old ships and historical marine events which took place a hundred years ago both in European waters and on the other side of the Atlantic. Collectors, particularly Americans, want paintings of 19th century ships and these artists fill this need with great ability. Obviously, the artist cannot have seen such ships at sea and so other qualifications are necessary. Namely, an intense study of the maritime history of that period, including the use of ship models, plans and paintings in maritime museums at home and overseas. (One marine artist who was once a civil engineer has devised a special way of interpreting old ship's plans to obtain a perspective result.)

The study of ships' rigs is in itself a time-consuming and patient task. For instance, ROY CROSS, an artist who specialises in 19th century-type pictures has travelled as far south as Barcelona and as far north as Gothenburg to observe and record the enormous and fascinating variety of rigs. To undertake one or two painting commissions, he may also have to travel extensively in the U.S.A. to get details of a particular ship from the maritime museums and to visit historic ports to observe the lighting, the sea and the sky in conditions which were much the same as when the ship was in those harbours. In addition, this artist has built up his own considerable library of books, photographs, plans and cuttings. If he paints a specific 19th century ship in harbour, all the other shipping must be accurately contemporary to it; if the scene is set in 1850 it is no use having an 1880 steel ship near an 1850 wooden schooner. (There are some artists painting 19th century-type pictures who do not study and prepare their material as intensively as described here. As they are painting ships they have never seen for a public that has not seen them either, there are in circulation quite a lot of marine pictures of this type which are technically inaccurate or have other historic defects.)

The demands on the painter of historic marine subjects are therefore quite obviously different from those placed on the painter of coastal scenes or the tidal Thames. The painter of the Thames is probably quite another sort of person in make-up and temperament anyway, although a few artists paint both the deep sea and the London river (as was the case with some of the 19th century painters).

The Thames painters have their own group (The Wapping Group, founded in 1947) which grows modestly and successfully year by year. But two of the older generation of marine artists spoke of the modern tidal Thames as a barren place for painting in comparison to the pre-war years. One, EDWARD WESSON, who was born near Greenwich, spent his schoolboy holidays going back and forth on the free ferry at Woolwich, watching the big ships from the Royal and Surrey docks. He described how, in those days, spritsail barges and lighters drifted down like crabs on the tide, and

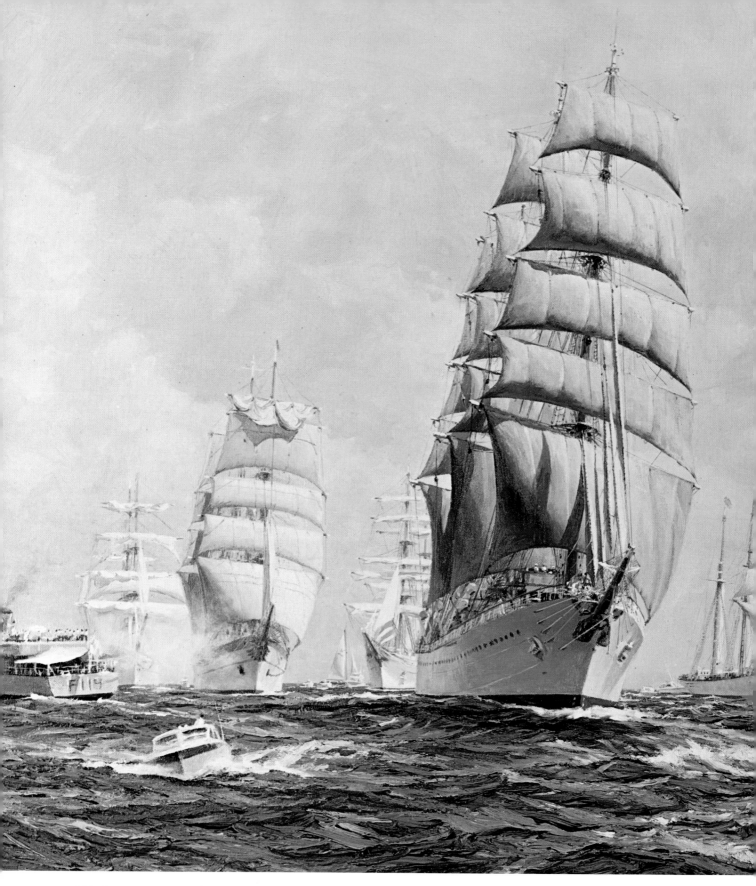

COLOUR PLATE 13: DERYCK FOSTER, RSMA (b.1924) 'The start of the Tall Ships Race, Bermuda to New Yo

This fine painting was commissioned by Jerome Hollis, Bermuda.

Deryck Foster has been a keen sailor all his life and for four years was a member of the Yarmouth, Isle of Wight, lifeboat crew. He became well known for his paintings of private yachts, but a few years ago he turned from this to sail training ships

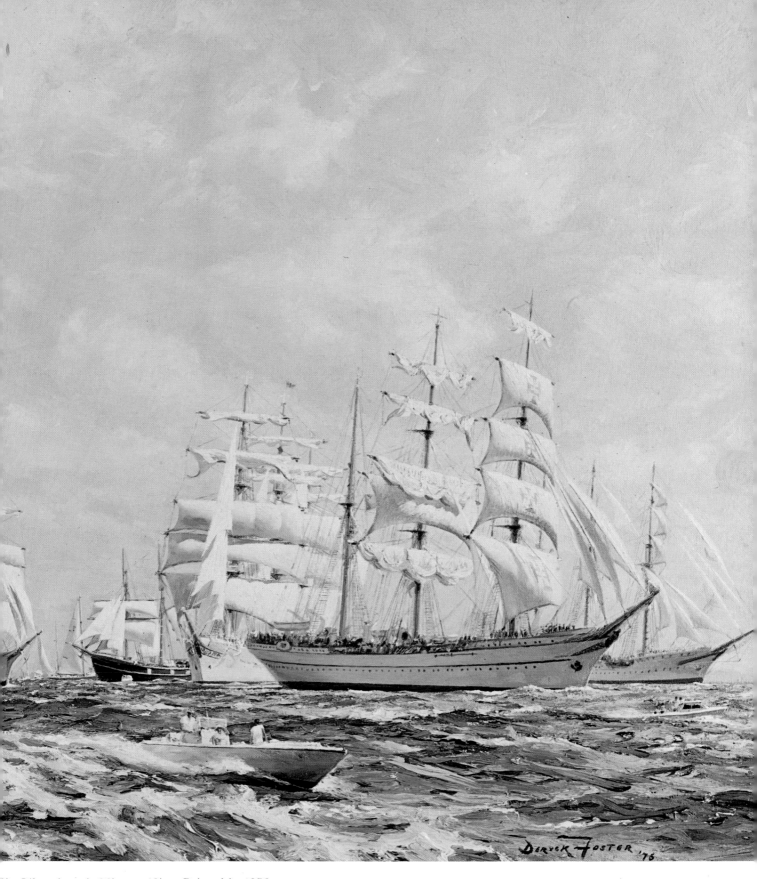

'. Oil on board, 26ins. x 48ins. Painted in 1976.

and historical marine painting. To obtain the detail and atmosphere of the Tall Ships Race he was in a boat at the start. The start line was about 1½ miles long, with all the ships and many spectator vessels crowded together like dinghies at the windward end and there were several quite nasty collisions. The reality of the start was something of a shambles, and so the artist had to edit it into a more orderly progression over the line, which entailed a lot of careful drawing of every single ship in the picture.

Two examples of the many and varied ways in which present day artists deal with modern marine subjects.

Above: 'Evening, Southampton Water' by Robert King, RI. This picture is in oils on canvas, 20ins. x 24ins. It resulted from an oil sketch made during a painting holiday at Southampton in November, 1978. The artist found an exciting and dramatic effect, caused by the evening sunlight breaking through a cloudy sky and turning the colour of the sea to silver.

Below: 'Royal Occasion' by Harry Hudson Rodmell, RI, RSMA. This painting is in oils, size 26ins. x 33½ ins. and shows a view of the *Britannia* with her escort vessel at Kingston-upon-Hull when the Queen visited that city in order to open the new Queen Elizabeth Dock on 4th August, 1969. *(Photograph courtesy: National Maritime Museum, London.)*

the great river was full of the noise of ships, small and large, with its mysterious atmosphere of smoke, mist and fog. Those were the days of W.L. Wyllie and Charles Dixon's work. Now the great river has been cleaned up and there is very little shipping or smoke. Another marine artist who still lives near Greenwich complained that there is not only no smoke, there is nothing else to see — in his eyes it is now absolutely bare.

Although Britain still appears to have more professional marine artists than any other country, there are now considerably fewer who paint full-time in comparison to the 19th century (when more than 500 were at work, including, as today, many who also painted landscapes, etc.) Several reasons have been advanced for this state of affairs.

First, although many people paint in their spare time, they either cannot or do not wish to give more time striving towards a better technique. If you want to paint well you have got to spend a lot of time at it, there are no short cuts. Like other art forms, it is sheer hard work if you do it professionally — however much you may enjoy it. The more you paint, the more you learn, but success is often measured by experience and years.

Another reason may be the sudden collapse of enthusiasm for the sea which took place in about 1945. It is difficult to remember this phenomenon now, after the explosion of pleasure sailing which started in the 1960s. Nevertheless, at the end of the war, men flocked out of the Navy and Merchant Navy and became involved in family life and the task of trying to scratch a living. For 300 years before this time, we had been a great sea power throughout the world, with all the background and attraction which this meant for marine artists. The small dedicated band who struggled with marine painting in the post-war years largely lacked the patronage of former times — another handicap. The buying public did not have much money and were then widely uneducated in the matter of appreciating original art, let alone purchasing it. And so marine artists to some extent turned towards subjects which they thought they could sell (and inevitably there are still some artists who continue to paint what the buyers want rather than exploring new vistas). Thus the marine painting scene diminished after World War II, and although it has been expanding again in the past decade it has not yet reached the proportions it attained in the late 19th century.

When considering what sort of a person makes a marine artist today, it is important to remember that a large number of their 19th century predecessors painted what they wanted to paint, regardless of whether they could sell it. In consequence, many lived in poverty. Today, artists do not wish to live in poverty and they do not need to do so if they have the necessary talent. There is now a great interest in contemporary art, the overall climate of appreciation for pictures and the wish to own original paintings, together with a certain good taste, have all developed tremendously since 1970. Many people who 15 or 20 years ago would have been happy to buy a print from 'Boots' would now rather buy an original drawing. There are few cases any more of a *good* painter who cannot make a living.

This general background of a more secure livelihood amongst talented marine painters is perhaps reflected in their generally relaxed manner, their reasonable standards of living, and their absence of temperament. Nowadays there are rarely the rows and tantrums which sometimes enlivened the Victorian scene when artists, critics and the public were seen in dispute. Modern marine painting may be none the worse for that, and the painters themselves probably have a calmer atmosphere in which to work. At the same time, I wonder whether the unaggressive and retiring attitudes of many modern marine painters result in a disservice to themselves in failing to project their art more strongly to the public? Large numbers of marine painters and paintings are in existence — yet the public seems only dimly aware of what is going on and what is available. It is clear that there are many undervalued artists and too little appreciation of their work, yet one of the causes of this might be the comparative equanimity with which marine artists face life today.

Chapter 7.
Techniques of Marine Painting

As this is not a textbook on how to paint, of which there are many admirable examples, I have used the word 'techniques' to cover the different views expressed by a number of professional artists during wide-ranging discussions on subjects such as materials, disciplines, subject matter and effects. Perhaps the words 'the practice of marine painting today' will help to convey what I would like to deal with in this chapter.

Historical and academic painting

As I have already said, and as will be evident from the illustrations in this book, there are a number of artists who paint 19th century (and sometimes 18th century) ships, naval engagements, historical harbour scenes, etc.

There are some critics of this practice who say that the end of the 19th century marked virtually the end of sail and was therefore the end of a particular art period. It is claimed that if you continue to carry this into another period, art will make no progress. These critics also say that it is not just that they object to the deliberate copying of tone and mellowness, but that they feel that the whole technique and outlook of marine painting should be different to that of the 19th century.

On the other side of the debate, a highly acclaimed painter who started with landscapes and now, 37 years later, devotes nearly all his time to naval subjects from the

COLOUR PLATE 14: JOHN RUSSELL CHANCELLOR (b.1925)

'*Beagle* in the Galapagos'. Oil on canvas, 28ins. x 42ins.

This painting depicts H.M. Barque *Beagle* at 2.15 p.m. on 17th October, 1835, running up the north-west coast of James Island, Galapagos. She has taken in practically all sail to reduce speed and, having put a single reef in her foretops'l, hands are aloft doing likewise to the main tops'l. The quarter boats are being prepared for launching to collect Darwin and his party who have been on the island for the past nine days. Capt. Fitzroy, steadying his telescope against the mizzen mast, is scanning the shore near Cape Cowan for signs of the shore party, while a seaman near him on the poop is preparing to hoist colours to an American whaler anchored in the bay.

John Chancellor served at sea until 1972, and has been practising very successfully as a professional marine artist since then. He takes tremendous care with detail and accuracy. The picture illustrated here involved him in some 250 hours of research and 700 hours in execution. It was completed in October, 1980, and is probably the most authoritative study of the *Beagle* yet made.

COLOUR PLATE 15: DEREK GEORGE MONTAGUE GARDNER, VRD, RSMA (b.1914)

'Thurot's last fight'. Oil on canvas, 24ins. x 36ins.

During the wars of the 18th century, Francois Thurot, a young French officer, arrived in Belfast Lough in February 1760 with three ships (the other three ships of his squadron having been separated from his force in gales). He landed troops which took the castle at Carrickfergus, but three British frigates arrived on 28th February and although Thurot got his ships to sea he was overtaken and engaged. The French ships were overpowered in a fierce fight and Thurot himself was killed. The ships in this action were: British: *Aeolus*, 32; *Pallas*, 38; *Brilliant*, 36. French: *Blonde*, 32; *Terpsichore*, 24; *Maréchal de Belleisle*, 44. (This painting was exhibited in Derek Gardner's one-man exhibition at the Polak Gallery, London, in June, 1979.)

18th and 19th centuries, stoutly defends this practice. A large part of his success can no doubt be credited not just to painstaking and exhaustive research but especially to his ability to paint using the academic methods of the last century. This artist made the point to me that up to the end of the 19th century painters had received knowledge and training in certain methods which had been handed down through successive generations, the greatest amongst them bringing the total sum of knowledge a stage further, and thus passing it on to those who followed. This knowledge was available to and fully used by 19th century artists in an almost unbroken line. But in the more recent years of the 20th century, various forms of modern art have caused the old treasury to become largely neglected except by a few devotees.

Squeezing colour out of a tube and brushing it on to the canvas with the addition of a little oil or spirit is not difficult and requires no special skills. There are some artists who do this and still produce a work of art because their imagination, vision, and drive in some way transcend the techniques they use. But to paint in the traditional manner requires time and patience, a gradual building up of the picture over many weeks or months. When artists of lesser ability are in a hurry, the result is often mediocre; and yet if they studied and practiced academic methods their work might well be of greater merit.

Much late 20th century marine painting has considerable quality — sometimes outstanding — and again I have to refer to annual exhibitions of the Royal Society of Marine Artists to give positive proof of this statement. However, the rejections for this exhibition far outnumber the acceptances, and I wonder whether some of the unsuccessful candidates would do well to study older methods. Just by examining the work of some of the top Victorian painters it is easy to see that their ability was sometimes quite incredible. They studied, they devoted their whole energies to it, and they often took a lot of time to execute one picture.

Of course, in fairness it must be pointed out that 19th century art has the advantage of being assessed after a longish passage of time; it has its established records; and as the artists have now left us, their work has a certain scarcity value. In addition, the work has had the physical benefit of ageing. Time endows these paintings with its own mystical qualities,[12] visible when carefully cleaned until their original colours appear from beneath dirty varnish. Oil paints undergo certain chemical changes until, after 25 years or more, they start obtaining their much prized translucent quality. An example may be taken from the work of VAN GOGH (commercially unsuccessful in his lifetime); there are some people still living who remember his work when it first became known and they say it looked very raw then. Now it has settled down and has a jewel-like quality. However, whilst ageing may account for the mellowness of many 19th century pictures, it is also true that a lot of 20th century artists paint more strongly.

The discipline of set hours of work

The amount of time spent on each picture by modern marine painters compared to those of the last century is arguable. What is more certain is that today's most successful artists give nearly all their available time to painting. It is true of all forms of art, and particularly true of writing, music, sculpture and painting, that you need to have a firm self-discipline in the matter of working hours. Art is hard work, it is exhausting, it mentally and physically drains human energy, it requires that you do it every day whether you feel like it or not. Perhaps it is even more important to force yourself to do it when you do not feel like it. Finally, it is a lonely occupation — it necessitates being entirely by oneself in a room or studio for long unbroken hours of thought.

Many artists work 'office hours' or longer, and go on for years struggling to convey

12. These qualities endowed by age are often described as 'patina', but whilst this may be an acceptable term when applied to antique furniture it is, I feel, too simple a description of the effects seen on old oil paintings.

their ideas; and success does not necessarily make the struggle easier, it just decreases the amount of worry about the mortgage or the gas bill. Artists who start by earning very little are not necessarily spurred on by poverty today as their counterparts might have been a hundred years ago. Inflation has altered the entire scene; the artist who is starting out often cannot afford to turn away work which he does not like, because rising costs and other pressures compel him to earn money. This need to earn more money is one of the modern seducers of art. Where the cheque comes from so often determines the type of art produced. Most Victorian painters could 'get by' and steadfastly stick to their own ideas; today, a lot of good painters are diverted by the necessity to keep up a standard of living which is being constantly assailed by roaring inflation. It is then that they get into the habit of painting what the public wants, rather than seeking to break fresh and original ground.

Craftsmanship

When discussing the disciplines with modern artists, those at the top all stress the virtues of craftsmanship, draughtsmanship and drawing. If you want to be a musician you have to learn and practise scales; if you want to be an artist you need to learn the use of your media.

Self-criticism is another essential if painful discipline. The difference between the amateur and the professional painter is that the amateur keeps everything because he has not enough painting time. The professional will recognise a dud and throw it out. The longer an amateur spends on a picture the more valuable it becomes to him and he cannot bear to throw it away.

Painting from life or in the studio

Whilst many members of the public imagine that marine artists sit on the coast in all weathers or take their easels to sea, this is no more true today than it was in Victorian times. The greatest part of the work is often done in the artist's studio, for obvious practical reasons. Apart from interference from the weather, little crowds tend to gather around painters. As one artist put it, you are a sitting target for any nut who has nothing better to do than come along and challenge you on a subject such as religion.

Studio painting must rely on prior intensive note-taking and a good visual memory. When starting out, painting on the spot has great merit in order to establish the artist's values of liveliness, touch and accuracy, which do not come with pure invention. Later, the constant use of sketching augmented with the camera can be sufficient to provide material for working up and finishing in the studio. One artist told me that, whilst he cannot paint on the spot — he said he could not even mix the right colour out of doors — he gazes at seas so long and so often that he has only to close his eyes in the studio and its detailed movement and force appear in his mind in sufficient clarity to make him feel seasick!

The majority of artists agree that sketching and some painting from life are essential. A very successful watercolour painter told me that his best work has always been done on the spot, standing in snow or rain to paint. He produces some 600 watercolours each year, working quickly. He does not use Chinese white or poster colours, nor does he use masking fluid. If he wants clouds, he uses a piece of candle wax to score the paper and then paints the sky on top and he does the same to produce half-a-dozen masts in a blue sky. He does not carry a rubber, does not draw, and if a line is wrong it stays wrong. He sells every watercolour he paints.

Modern painting materials

The materials of painting have possibly never been better or more wide ranging than today. Perhaps, in some ways, too much scope is offered to the beginner and this certainly applies to the number of colours available. When a keen student first turns up at art school with a box full of 40 different tubes of colour, the art master, if he is any good, will tell him to throw away at least 30 of them. All the leading marine artists agree on the benefits of training oneself to use a restricted palette (see Chapter 9) and

many of them try to restrict their range of colours more and more. One of them said to me 'As I get older, I feel that really good colour is not a question of bright colour — it is a question of the use of very few colours and how you play them, one against another. The great masters like TITIAN and REMBRANDT restricted themselves enormously as they got older. In Titian's later works, he cut down very considerably on the number of colours he used and the result was that he achieved his most beautiful effects.'

Good painters are fascinated by the possibilities contained in using few colours. This discipline also simplifies the task of painting because, for example, if you were to paint with only one colour, all you would need to get right would be the tones of that colour. With only one colour and its tones you would be certain to get unity; conversely, the more colours you introduce, the more difficult it will become to achieve complete unity. As David Cobb commented, the person who faces the greatest difficulty is the amateur who arms himself with an entire box of paints, which means that he has a whole battery of colours which simply do not fit together.

Not only has the modern artist a far greater variety of colours and types of paint to choose from, he also has more materials upon which to paint. Canvas, generally still the most popular vehicle, needs no explanation. But other materials are becoming more widely used for practical purposes and one of these is an artist's hardboard, or canvas bonded to hardboard. The advantage of this type of hardboard is that it is less susceptible to damage than canvas (except that damp or excessive heat will affect it) and can yield similar effects. It needs to be treated, first of all with size, then with a special undercoat, and then a surface. Another advantage is that the artist can allow

COLOUR PLATE 16: JOHN MICHAEL GROVES, RSMA (b.1937)

'Strong wind on the Port Quarter'. Pastels, 20ins. x 30ins. Drawn in 1977.

This fine picture has the merit of showing seamen in action on their ship — a strangely rare sight in marine painting, where there is a notable absence of portrayal of the men who build ships and the men who sail them. John Groves also paints portraits, which perhaps accounts for his highly successful treatment of the figures shown here. The ship is under full sail in a strong wind in fine weather; four men are struggling with the wheel, but their different facial expressions all show the excitement and intensity of concentration which is felt when handling a sailing vessel which is driving through the water at her maximum speed.

A special print of this picture has been produced by Solomon & Whitehead (Guild Prints) Ltd. of London.

COLOUR PLATE 17: JOHN ALAN HAMILTON, MC (b.1919)

'U-309 on Atlantic patrol'. Oil on wood panel, 24ins. x 36ins.

This class VII U-boat was one of the numerous German submarines which attempted to cut off Britain's supply lines in World War II. The scene illustrated here symbolises the cold grey loneliness of the Atlantic ocean. U-309 inflicted much damage before she was sunk by the Canadian frigate *St. John,* off Cromarty in North-East Scotland on 16th February, 1945.

This picture is one of 60 oil paintings by John Hamilton showing events from the war at sea 1939-45. These paintings are now permanently displayed in a special gallery on board H.M.S. *Belfast* in London, under the auspices of the Imperial War Museum.

About this collection, which took over three years to research and paint, the artist says: 'The paintings seek to show the futility of man's inhumanity to man set against a common enemy: the merciless sea... In working on this project, one could not help but shudder at what men were called upon to suffer... 30,248 merchant seamen died, 4,654 went missing, 4,707 were wounded and 5,720 were taken prisoner... Over 80 per cent of all operational U-boat crews at sea died.'

Photograph courtesy: The artist and the Imperial War Museum, London.

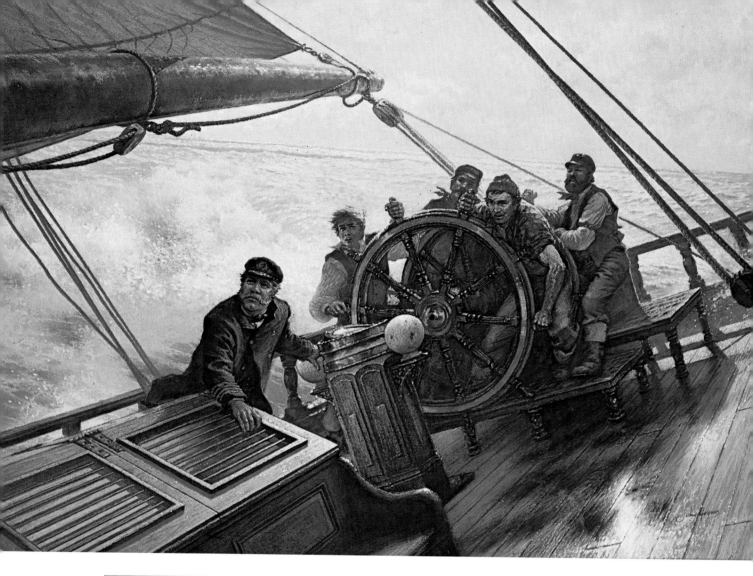

generous margins and then trim the edges of the finished picture so as to shift the focus of the picture by an inch or more.[13]

Atmosphere

At the other end of the scale from the artist's materials lies that elusive but vital ingredient: atmosphere. Of course, atmosphere must primarily emanate from the artist's own personality and talent. But there are some constituents which are of positive value and to which one can put a name. First, the use of figures. In coastal and harbour scenes particularly, as in landscapes, one or more figures can make the difference between an 'empty' picture and one with life in it. They not only give life, but also perspective and scale. Other human touches can also help: the odd coil of rope on a quay, or a pair of oars left haphazardly across the thwart of a rowing boat; an anchor in the sand. The 19th century marine artist frequently put bits of flotsam in the sea, or a broken lobster pot, or a barrel-buoy. A few touches are enough, too many result in clutter and distraction.

The sky is a major creator of atmosphere. The sea reflects the sky and the clouds and all their tones and changing moods. Thus, the painting of sky, clouds and sea cannot be separated, they go together like marriage or a horse and carriage. Students and buyers of modern marine paintings would do well to assess the merits of the sky in any picture they are contemplating — they will undoubtedly find that it holds the key to the merit or otherwise of the whole creation.

Sketches and note-taking

Just as there is general agreement about the need to use a restricted palette, there is broad agreement on the need to visit and see the scene of action and to take numerous sketch notes, possibly supplemented with camera notes. This practice is obviously not possible in the case of historical pictures, except to visit and sketch the relevant harbours or coasts, when they have remained comparatively unchanged, and to photograph models, ship plans, etc., in museums. If anyone has doubts about the usefulness of sketchbooks today, it is surely only necessary to point to the fantastic small sketch books meticulously kept by Turner. If Turner relied on his sketch books, who can dispense with them today? The camera is not the entire answer to note-taking.

13. Notes on the preparation of wood panels for oil painting are given at APPENDIX D on page 104.

Chapter 8.
The Media of Marine Painting

Oils, watercolours, gouache, egg tempera, acrylic paints... The choice seems wide, both for the artist and the buyer of finished art. In practice, the majority of marine artists and buyers prefer oils. From the artist's viewpoint the reasons seem clear. Oils constitute a robust medium, capable of alteration by scraping out or over-painting and thus allowing a wide latitude for experiment. Then, the finished results appear to be more substantial, perhaps also giving a greater feeling of depth and warmth than watercolours.

With watercolours, the technique is comparatively difficult and causes the artist to carefully consider his methods at every stage. The purists among the watercolour painters will not use bodycolour (gouache) to outline an object, heighten a wave or to paint in white clouds, for instance. They regard this as a short cut or an admission of defeat, and contend that where white is needed the white of the paper itself should be left showing. This view was also taken by many distinguished 18th and 19th century watercolourists. On the other hand, it must be pointed out that Turner, the supreme master of painting sea pieces in watercolour, not only used bodycolour and heightened with white but scratched his skies with his thumbnail and washed them under the pump. Many other excellent marine painters have used bodycolour on their water-colours right up to the present day, and so the final decision on its use must be a matter of taste and personal feeling. Buyers of watercolours do not worry too much about this distinction, except for a minority of purists.

The reasons why buyers tend to prefer oils are more difficult to determine than the reasons for the artist's preference for this medium. Over many years I have tried to get buyers to explain clearly why they want an oil rather than a watercolour, bearing in mind that the selling price of the oil may be twice or three times as much as the water-colour, although the former is easier to execute. Sometimes the oil will not even be such a good work of art, in the rare cases where it is possible to make a direct comparison between similar pictures in the two different media.

There are, as is well known, avid admirers and collectors of watercolours who prefer the medium to oils, but all the evidence shows that they are a minority, albeit a strong and important one. It would be a big mistake, moreover, to underrate the contribution of 20th century watercolourists to marine painting. Their work frequently has a quality, a delicacy or a richness, and certainly an atmosphere which is lacking in many oils. There is no doubt that those of excellence are nearly always unjustly undervalued, and one can only go on repeating the advice to potential buyers that they should think more deeply before spurning them.

A distinguished artist who paints in both media told me that he cannot sell his water-colours in the U.S.A., although he gets high prices for his oils over there. The Americans have the idea that watercolours are 'fugitive'. 'In fact', this artist said 'mine are more permanent than oils. Oils oxidise, crack ... you name it. But the public think they are more desirable because they can wipe the dust off them.' It is true that this artist put his finger on one reason why watercolours are considered delicate: people believe they fade and are also more easily susceptible to damage by damp, mildew or bacterial action (foxing). There is a certain element of truth in these doubts, but not enough to cause undue caution. Modern papers are bacteria-resistant; the effects of

damp can be avoided by correct framing and backing; and whilst fading will occur if the picture is left continuously in strong sunlight, I can say that I have handled numerous watercolours over 100 years old in which the degree of fading from their original colours has been negligible. (This is easily seen by removing the wide gilt Victorian mount and comparing the covered edge of the picture with the remainder of the exposed surface.)

In my quest to find the basic answers from buyers, I have found most of them to be fairly hazy or inarticulate about their reasons for wanting oils. The overall impression is that they feel they are getting more for their money; that an oil will look more important; that it is more of a status symbol (this they never admit — it is my own deduction); that it fits better into their furnishing scheme. The latter seems to be one of the strongest reasons; many living rooms today have antique or reproduction antique furniture, and oil paintings appear to complement this decor. In brief, one is left with the feeling that if people can afford oils, most will buy them because they 'do more' for their houses.

To add to the paradox, successful marine oil painters have spoken to me about their great admiration of watercolours — the degree of skill and patience needed, and the results that have been obtained in the way of magic, transparent, luminous effects by the great exponents of this art. An artist who has made his name with his watercolours said that he thinks it is the hardest medium of all, but a splendid challenge. He is one of the purists who try to avoid using bodycolour and never mixes it in with his water-colour paints; all the same, he admitted that there are times when it is pointless to scrape away the paper to make a small white seagull when a flick of white gouache would do it better. In fact, a seagull in winter, for example, has a stark brightness, an intensity of light, which would be nearly impossible to represent by just leaving the white of the paper untouched.

Several marine artists who paint in gouache have a strong market in the U.S.A. where the results in this medium are much admired. Many Americans who buy 'modern' marine pictures want paintings of famous old ships in historic U.S. seaports and although gouache is not an easy medium to use, it enables the painting of fine detail, such as accurate ships' rigging. The durability of gouache is reasonable, although water directly spilt on it would be a disaster and strong light can cause fading. One specialist in gouache claims that he has examples of his work which are now 30 years old and they are as fresh as when they were first painted. But another artist who uses the same medium confessed that the question of durability worries him and for this reason he would like to go back to oil painting.

Egg tempera, a medium almost as ancient as painting itself, is used by a few marine artists. It will stand up to spilt water better than gouache, and lasts well. As a medium, it falls about half-way between oils and gouache. It has advantages, such as drying almost immediately, which oils do not, and it is possible to paint delicate tints on to its surface in the same way as it is with oil painting.

Acrylic paints dry very quickly indeed and tend to give a somewhat hard and over-bright effect unless used with considerable skill. They have not achieved much popularity with professional marine painters, although some artists use them satisfactorily for under-painting oils. Because of their simplicity and quick drying properties, they are quite useful for making on-the-spot colour notes.

COLOUR PLATE 18: ROWLAND HILDER, PRI, RSMA (b.1905)

'Limehouse Reach'. Oil on canvas, 24ins. x 36ins. Painted in 1975.

This painting owes its origin to Rowland Hilder's recollections of the Limehouse waterfront in the period after World War I. In those days, Baltic timber ships and other great sailing vessels were still to be seen in the Thames. The scene is lit by a low early morning sun, giving a beautiful effect in the sky and the shadows.

Chapter 9.
The Marine Artist's Palette

A number of artists have told me that they are greatly interested in the palettes used by their contemporaries and I feel it may also be of wider interest to publish a small selection of these. Accordingly, I hoisted the proposers with their own petards, so to speak, and asked them to describe the range of colours they normally use.

First of all, I must refer again to the general agreement amongst leading marine painters on the desirability of using a restricted range of colours. A good professional artist will try to see how he can achieve satisfying effects by using the least number of colours; the enthusiastic amateur, in contrast, will often begin by buying large numbers of colours thereby confusing himself and making his task unnecessarily difficult.

An artist who specially requested me to deal with the marine colour range in this book said that painters are always interested in a palette. A portrait painter will have one palette, a landscape painter will have another, and a marine artist will have a slightly different palette to either of them. This artist offered the tip that if you want a very brilliant colour, you can paint it white and glaze over the top of it — it will come out stronger and produce a singular colour.

LESLIE J. WATSON
Says that his palette is fairly restrained and that he does not use any fancy colours. His normal range consists of:
Oils:

YELLOW OCHRE	FRENCH ULTRAMARINE
CRIMSON ALIZARIN	VIRIDIAN (GREEN)
VERMILION	FLAKE WHITE
TRANSPARENT GOLD OCHRE	NAPLES YELLOW
COBALT BLUE	RAW UMBER
COERULEUM BLUE	CADMIUM YELLOW

RODNEY J. BURN
Uses the same palette as above, but adds all the UMBERS, i.e., BURNT UMBER, RAW UMBER, BURNT SIENNA, etc.

W. ERIC THORP
Oils:

FLAKE WHITE	MANGANESE BLUE
YELLOW OCHRE	VIRIDIAN (GREEN)
CRIMSON ALIZARIN	BURNT SIENNA
ULTRAMARINE BLUE	BLACK

At the back of the YELLOW OCHRE, he puts a small spot of CADMIUM LEMON. He also keeps VERMILION for some special touch, if needed. This artist believes that he can obtain 'every colour under the sun from this palette'. (If painting flowers he may also use COBALT VIOLET.)

TERENCE STOREY

Has a fairly extensive palette which is described below. Of course he does not use all these colours in one painting, but it is the range from which he usually makes his selection.

Oils:

TITANIUM WHITE	LIGHT RED
CHROME YELLOW	ULTRAMARINE BLUE
AUREOLIN YELLOW	COBALT BLUE
YELLOW OCHRE	COERULEUM BLUE
RAW SIENNA	SCARLET LAKE
BURNT SIENNA	CRIMSON LAKE
BURNT UMBER	VIRIDIAN (GREEN)
(NOT Vandyke Brown)	PAYNE'S GREY

EDWARD WESSON

Limits his oil and watercolour palettes to a maximum of eight or nine colours whenever possible.

Oils:

WINSOR (OR MONESTIAL) BLUE	YELLOW OCHRE
ULTRAMARINE BLUE	CADMIUM LEMON
COBALT BLUE	CADMIUM RED (OR SCARLET)
BURNT UMBER	CADMIUM YELLOW
BURNT SIENNA	

Occasionally BLUE BLACK, OLIVE GREEN.

Watercolours

WINSOR BLUE	BURNT SIENNA
ULTRAMARINE BLUE	RAW SIENNA
COBALT BLUE	CADMIUM LEMON
BURNT UMBER	LIGHT RED

Occasionally he uses PAYNE'S GREY in place of the other blues when using a pen and wash technique.

ROY CROSS

Gouache

It is a good idea to start with very few colours — not red, yellow or blue, but subtle colours like PAYNE'S GREY instead of blue, and perhaps an UMBER and a dull GREEN.

Reference books give lists of mixtures which will yield any required colour, and this saves a lot of time experimenting on the palette to get a right colour.

Favourite colours:

NAPLES YELLOW, very useful	ULTRAMARINE
PURPLE LAKE	PAYNE'S GREY
TURQUOISE	

and of course, many mixtures.

WATERCOLOUR VERMILION for tinting skies (a lovely colour).

Larger works are done on canvas with artist-quality acrylics, which have most of the qualities of oils with the advantage of quick drying for the rendering of fine detail.

CHRIS MAYGER

Gouache

This artist made the point that the sails on old ships need particular care in painting. The painter must realise that sails were not white — they were yellow, because the canvas was coarse, especially the storm sails. The only nearly white sails were the light fair weather sails which were much thinner. Today, people think of nylon and terylene, but the old sails — and sailors' clothes and breeches — were never really white. They were bleached from the sea air and winds and, combined with soaking, they were quite discoloured.

Sails also had discolouring stains from weather or rust streaks, especially on windjammers where chains were used to hold the spars, so that rust ran down the canvas.

Thus, to get the effect of light or sunlight on these sails one needs a palette which will cope with the conditions described here.

KEITH SHACKLETON
Oils

He uses very few colours; a very simple palette consisting more or less of six primary colours plus a few that cannot be mixed such as VERIDIAN and INDIGO. Otherwise his range usually consists of the colours of the spectrum. He believes in a restrained range and cannot see the point of having extra colours, such as orange which can be made from the yellow and red of your primary range. He uses a lot of WHITE (TITANIUM) and BLACK.

 * * * *

Not all artists are interested in other artist's palettes. When I mentioned this interest to one of the members of the R.S.M.A. selection committee, he made the simple comment 'They must be nuts!' However, he went on to explain his viewpoint which was, unless you always paint in the same idiom and stick to the same seven colours, the palette must vary according to the subject of the picture. At the same time, he did agree with the use of a restrained palette.

Chapter 10.
The Role of the Camera

The advent and development of the camera have had marked effects on marine painting in the 20th century, especially in recent years.

Many artists use the camera for note-taking and recording and KEITH SHACKLETON gave me this view: 'It is like a chain saw: it's a hell of a good tool, but needs to be used with extreme caution. The artist can learn a lot from looking at photographs. At the same time, a terrible trap people can fall into is the idea that because it is a photograph it must be right, and so all you have to do is to reproduce it in paint and you will have an accurate picture. They completely lose sight of the split-second syndrome where you don't know what has led up to this moment and what follows on. The result is that a painting copied from a photo is really a standing falsehood.'

Most leading artists seem to agree with the use of the camera as an *aide memoire,* but condemn the practice of copying directly from a photograph. The camera is excellent as a means of collecting information and analysing it, particularly when it is used in conjunction with sketches and notes taken on the spot. It has been used as an aid by artists ever since its invention — even the Impressionists enlisted its help. But in sea painting the fleeting moments which combine to form atmosphere cannot be captured by the camera alone; at sea, everything passes and is gone, light changes, skies change, the sea itself changes all the time — everything moves and nothing is static.

Some 20th century marine artists who specialise in painting events and scenes with 19th century ships find the camera invaluable for recording in museums. It would be tedious and impractical, for example, to sketch 50 ship models or copy rigging plans by hand. And there are other situations today where the use of a camera for note-taking could be regarded as almost essential. Although Turner had himself lashed to the mast of the steam packet *Ariel* in order to make direct observations for one of his famous paintings[14], today it might be thought more practical on the deck of a heaving tug, for instance, to use a camera for noting aspects of an oil rig in a tossy sea. A fair example is the aerial view of Dubai creek by JOHN WORSLEY (see Plate 206). The artist had to use a helicopter and obviously could not hover overhead for hours on end, so he took a number of colour transparencies as *aides memoire* as well as making sketch notes. In this context, he made the point to me that the painter must go and see the subject himself and take his own photographs — to use someone else's photographs for reference is absolutely unsound, because you are then just copying.

In action situations the colour transparency can note detail quickly — the geographical relationship of harbour buildings to each other, or the colour of a ship's funnel, or the positioning of some rigging, for instance. But it will rarely contain the atmosphere, depth or movement of a painting.

14. *'Snowstorm — steam-boat off a harbour's mouth making signals in shallow water, and going by the lead.'* (1842). Turner got the sailors to lash him to the mast of this vessel, where he remained for some four hours in frightening conditions from which he did not expect to escape. The resulting picture is a masterpiece, but at the time a critic derided it as 'soapsuds and whitewash'. Turner's very reasonable reaction to this criticism was to wish that the critic had been in that sea.

ERIC THORP described how he wanted to paint a P. & O. ship leaving Tilbury docks one summer's afternoon. He watched the tugs and sketched them and the river environment. Then the ship emerged from the dock and there were not more than ten minutes for note-taking. The artist therefore took about a dozen photos from every angle for reference. He emphasised, however, that unless he had been there, done his background sketches, noted the colours and roughly decided on the composition, the photographs themselves, however numerous, would have been virtually useless.

It is arguable as to how much detail should be taken from photographs. At one end of the scale there is the acceptable practice of getting rigging correct by making photographic notes; at the other end is the aspiring young marine artist who may paint the entire fleet review at Spithead from one or two giant photographic enlargements. In the latter case, the result may look superficially impressive but is likely to be as flat as the colour photograph itself. The artist may argue that he used this method to achieve accuracy and detail; but art is not a matter of just recording impressive scenes with detail and accuracy — the camera may do that better, and therefore why not be content with a framed colour photograph in such cases?

Photography in itself is an art, and has been so from its infancy. Early 19th century photographs have now become admired collectors' pieces and the names of some of the pioneer photographers have taken their places in the history of art. Not only have artists used the camera since its invention, but, earlier, the camera obscura was used to help them with detail. CANELLETO, ATKINSON GRIMSHAW and others employed the latter apparatus quite frequently.

However, although directly painting (copying) from photographs is heavily frowned upon, it is practised surprisingly often. Artists who have been members of the selection committees of famous societies have told me that amongst the hundreds of paintings submitted, there is invariably a number, albeit a small percentage, copied directly from colour photographs. They are easy to spot (and reject) because of their lack of depth and feeling. Some of them are so perfect that they could pass for an enlargement of the original photo — in which case the photo itself would have been a quicker and easier medium to use. Such a picture might have been a work of art as a photograph; as a painting it is usually artistically worthless.

One of the problems in generally condemning the practice of copying colour photographs is that some buyers of art want photographic-type paintings. Photography has encouraged people to believe that the photograph is actually a reality. Thus, you get painters who copy a colour slide as a short cut to truth. Of course it is not truth at all — it is only an artificial reproduction of what was happening at one split second. Unfortunately, people have become so accustomed to looking at photographs that they forget to look at life as it really exists, in change and movement. When someone says to a marine artist, intending a compliment 'What a marvellous picture — it is just like a photograph!' they are actually insulting the artist, whose dearest wish is that the painting should look nothing like a photo.

One of the dangers of copying from a photograph is that the artist is tempted to pack in a lot of detail which may bear no relationship to the composition. For instance, the camera can record a leafy tree quite accurately. But how can the artist paint in every leaf? And if he did, what sort of a picture would result? In the same way, copying the minute detail of sea, frozen in one instant by the camera, would most probably result in an absurdity, because as already noted, the sea is not static but moves and changes not only in shape but also in texture, colour, depth and tone — and only the true marine artist can evoke some feeling of this continuous change.

When I was talking to RODNEY BURN, he told me that he believes that the modern use of the camera has spoiled painting. He asserted that the basic drawing models are no longer much used in the famous art schools. Instead, they have flourishing photographic classes using expensive cameras. This leads some students to the belief that the camera can provide a study which is as good as if not better than a drawing.

They have to interpret their photographs, but in the process they have missed the opportunity to exercise from the outset the basic drawing skills and their imagination.

There are differences of opinion as to whether the painting of the sea itself has improved or deteriorated since the 19th century and the early part of this century. One hundred years ago the marine artist had to spend hours and days studying the form, structure and movement of the sea. Now, his counterpart can take still or moving photographs, freezing an instant record of a wave or a seascape. The mere copying of this in paint will produce a dead visual; but there is much evidence that seas in many present day marine pictures have become more credible by using the camera as a reference tool.

Moving film appears to be used surprisingly little for reference purposes by marine artists. Perhaps the apparatus does not lend itself sufficiently to quick shooting and easy viewing. CHRIS MAYGER, who specialises in 19th century historical marine subjects, went on a cruise some years ago and took a lot of moving film of the sea. Although he regularly visits the sea to watch it and make sketches, all his painting is done in his studio. If he gets stuck, he works his movie film slowly through a film editing machine so that he can watch waves building up and falling away. He finds that this refreshes and regenerates his memory. When he paints sea he works across it, but sometimes when it is nearly complete he may find a place in the middle where it is not connecting properly. This is when he turns to his moving film, which will remind him of how certain movements connect one bit of sea with another.

The camera, films and television have probably had a more far-reaching and subtler effect on marine painting than the simple aspects of recording or copying. Young people today, and indeed middle-aged viewers of art, have been subjected to the ubiquitous photograph from birth. Still and moving pictures — contrived, edited and presented — have surrounded them in newspapers, magazines, books, films and television from the beginning of their lives. Thus, their conception and appreciation of art must frequently be conditioned by a subconscious comparison of the photographic pictures they live amongst. There are instances, by no means infrequent, where the viewer or potential buyer of a marine painting does not fully understand what he or she is looking at or what the artist is trying to convey. This phenomenon most often manifests itself in the desire for 'realism'. When you see people eyeing a picture from a few inches distance, nearly always they are not seeking the signature, but are looking for the detail of each drop of water in a breaking wave, the rivets in a ship's side, or the thread-by-thread portrayal of a mooring rope. In other words, they are looking for the ingredients which a life surrounded by photographs has taught them to expect.

There is another, perhaps rarer, modern phenomenon. This is the inability to appreciate fine line drawings or etchings.[15] Much of the decline in the popularity of etchings since the 1920s must be blamed on colour photographs and television. People now want their art coloured and 'filled in'. An unusual example of this was given me by an artist who does some identikit drawings for the police. Originally, these were drawn in line, but this had to be abandoned because it was found that the average person today cannot fully understand a line drawing. They cannot 'read' lines and visualise a face because this is not how they see it in a photograph, and so the pictures have to be done in tone in order that an effect more like a photograph can be achieved.

The discussion about the effects of the camera on marine painting can be carried even further when one considers that some young people now prefer a modernistic treatment simply because they can immediately accept it as a painting, i.e., a work of the imagination, and not just an alternative representation of a scene which might have been recorded by a camera.

15. The subject of etchings is discussed more fully in Chapter 11.

For better or worse, the camera has also taken over many of the tasks that skilled marine artists used to undertake. The artists who sailed with Darwin and Captain Cook, and numerous midshipmen and other sailors in the 19th century, drew and painted multitudes of scenes and items of marine life until photography became the acknowledged method of recording.

The sketch books of famous 19th century artists are often little masterpieces in themselves. No doubt if they had had 35 mm. cameras available they would have used them, but I am certain they would not have sketched less or taken fewer notes. ROWLAND HILDER said that when he was young he learnt from CHARLES PEARS and NORMAN WILKINSON how to paint skies. Wilkinson made tiny watercolour sketches on the spot. He had them in great heaps around his studio, like hundreds of cigarette cards. Hilder asked him why they were so small and Wilkinson said 'Well, when you are out on the sea you get used to this size, and if I do them any bigger I'll get too much in!'

The marine artist, then, uses cameras, sketches, or any other aids available to record material on the spot. But back in the studio he has to call on his artistic instinct, his batteries of experience and his inbuilt skills to visualise in his mind what he wants to place on the canvas. As one successful painter said to me 'When I close my eyes I can see the sea as it builds up, moves forward and tumbles. I can smell it and hear it, and even discern the structure of its component parts.' This surely is the facility which separates the real artist from the skilled copier of colour photographs.

COLOUR PLATE 19: PETER LEATH (b.1935)

'**J-class yachts** *Velsheda, Endeavour* **and** *Britannia*'. Oils, 20ins. x 30ins.

This painting shows J-class yachts racing off the Isle of Wight during the summer of 1935. The yachts are heading for the Nab Tower off the eastern extremity of the island; they 'round' this mark and return westwards up the Solent to Cowes.

The vessels shown are the famous yachts *Endeavour, Velsheda* and *Britannia*. The picture gives an excellent impression of the huge size of the J-class mainsails and their enormous booms which, even with their very large crews, must have been extremely difficult to handle in anything more than a gentle breeze.

Peter Leath is a self-taught artist who has had a lifetime of experience in small boats, including designing and building his own fishing trawler. He lives in the Isle of Wight and paints mainly in oils and acrylics.

Chapter 11.
Etchings and Prints

In some ways, etching and print-making are inseparable from 19th and 20th century marine painting, and the subject fully deserves a chapter to itself.

Many of the well known marine painters of the first part of the 20th century were also etchers. These included W.L. WYLLIE, NORMAN WILKINSON, FRANK MASON, ARTHUR BRISCOE, FRANK BRANGWYN, MUIRHEAD BONE and FRANK SHORT. There were a considerable number of other marine etchers, especially in the 1920s when etchings were popular. At that time the current decor, involving bare or sparsely decorated walls, was suited to the disciplined and rather striking medium of etching. Etchings were collected in folios as well as being used for wall decoration (collectors became quite fanatic and kept their folios in specially constructed cabinets) and the prices for both popular and rare examples reached heights which they have never since attained, relative to currency inflation today.

Etching is done by the artist himself, usually on a plate of soft metal such as copper. The picture is a mirror image, i.e., it is drawn by the artist in reverse on a thin surface of wax laid on the plate. The plate is then washed in a dilute acid which eats (etches) through the lines in the wax and thus into the metal. Black ink is wiped into the etched lines (the picture) and the artist takes one impression at a time on a sheet of special paper. This is a simplified description of the etching process, but from this it may be clear that two aspects are worthy of appreciation. First, the artist himself usually carries out the entire procedure and, therefore, each etching is an individually created work. Although, strictly speaking, an etching is a print, it is normally produced in far fewer numbers — probably not more than 100 from each plate and sometimes only ten or 20. (Prints of course may run into several thousand copies of each subject.) The artist signs each etching and often pencils in the number of copies taken from the plate, e.g., 2/10 will denote that the print bearing these digits is the second copy taken from the plate and that the total number was ten. After this total had been reached, the plate would be scored or otherwise destroyed. Thus, etchings also have a scarcity value as well as a large degree of originality.

The next point is that etching is not only a skilled but also a fairly complicated and messy procedure involving plates, waxes, acid baths, inks, presses and other paraphernalia. Today, few marine artists can be bothered with it — we live in a period when time is at a premium. It is a difficult art and it requires a great deal of practice to control the etching tool efficiently. Few artists seem to have the time for an exacting medium which requires mechanical preparation and execution. As one artist put it: 'There are also very few people pressing flowers in bibles nowadays.' A sign that the age of gracious living is long past.

There is yet another reason why etchings are not popular today: they are essentially black and white works of art, and everyone now demands colour. Colour photography and colour television have conditioned the human brain to a state in which it can no longer find visual fulfilment in less than colour. And this is a pity, because many of the early 20th century etchers were able to bring a special sense of light and sparkle into sea scenes; also, it is an eminently suitable medium for depicting the fine lines of ships, rigging and masts.

The study and collection of a few etchings is an excellent and inexpensive starting point for those who wish to possess some marine art. With a little patience and

tenacity, good and satisfying examples can still be found for comparatively modest prices. There are one or two basic points to look for: see that the etching is signed; avoid etchings with stains or foxing unless they are rare (foxing can often be removed, but it is a skilled job and costs money); try to avoid heavily inked or blurred specimens and go for the crisp, clean examples.

Other printing methods for reproducing marine art in colour are more popular today. Lithographic colour prints of marine paintings are available from many museums and art galleries. They are usually of excellent quality and quite inexpensive. On the whole, lithography is superior to letterpress as it gives a softer and more pleasing effect and the colours are usually truer to the original.

Some modern marine paintings are reproduced as limited edition prints made from original paintings specially commissioned for this purpose. These are often quite large, probably the same size as the painting, and usually beautifully printed. The limited edition may run to 500 or 1,000 copies of which perhaps the first 200 or so may be individually signed and numbered by the artist. (There are now instances where a so-called limited edition print will run into as many as 10,000 or 20,000 copies of a popular sea piece, but this is perhaps a slight stretching of the word 'limited'.)

There is nothing to be ashamed of in buying and hanging on your walls some of the superb prints of marine pictures now available. Of course an original painting will give you a feeling of greater satisfaction and will most probably increase in value whereas the print will not (unless it is a signed limited edition copy). But if you really cannot afford an original, why not start with the next best thing? There is in fact a potentially large market throughout the country for marine prints: the public, especially the younger generation, wants art of an understandable nature. The displays of questionable abstracts and other off-beat creations exhibited at the taxpayers' expense in museums and art galleries are patronised by a very small number of people in relation to the vast majority who heartily dislike the incomprehensible daubs which sometimes pass as advanced art.

What is missing from the later part of the 20th century are those marvellous steel engravings so superbly executed in the 19th. There is little nowadays which can hold a candle to GEORGE BRANNON's[16] coastal scenes around the Isle of Wight. The pinnacle of achievement in this field was undoubtedly J.M.W. TURNER's series of coastal and harbour views.[17] Turner himself selected the engravers for these little masterpieces and men like GEORGE COOKE (father of E.W. COOKE), W.B. COOKE (his uncle), J. COUSEN, E. GOODALL, R. BRANDARD, E. BRANDARD, W. MILLER, J.T. WILLMORE, J.C. ARMYTAGE, R. WALLIS, J.B. ALLEN and others of similar calibre engraved the plates from Turner's original paintings under the direct supervision of the master himself. (Until recently, these engravings were easily found at reasonable prices but now they have almost disappeared.)

The majority of these 19th century steel engravings have been coloured subsequently to satisfy the new desire for colour, but when this has been well done they are none the worse for it.

The uncoloured etchings of E.W. COOKE who started at the age of 17 to work on his superb series of 65 plates of shipping and craft (published in 1828 and 1829) are also

16. A wide variety of Isle of Wight coastal views were drawn and engraved between about 1825 and 1859 by the Brannon family, of whom George Brannon is the best remembered member. Many of these were published in large and rather lavish hard-covered 'guide books' such as *Vectis Scenery — Views on and near the coast of the Isle of Wight.*
17. *The Turner Gallery,* published in 1875, contains 60 large engravings including a number made from some of J.M.W. Turner's famous marine paintings. Another publication with the same name was in three volumes and contains 120 engravings. *Harbours of England* contains 12 plates engraved by Thomas Lupton, and the text was written by John Ruskin after Turner's death. Probably the finest of the engravings were those from his paintings which were specially commissioned and supervised by Turner himself.

little jewels which have no true counterparts today. There were also some fine coloured lithographs of shipping after paintings by THOMAS G. DUTTON (fl.1845-1879) and others which represent another aspect of this 'lost' art. And finally in the list, there were many beautiful aquatints made by a difficult and time-consuming process which seems to have almost disappeared.

With modern technology it should be possible to produce a far wider range of prints of all types for which marine artists have painted the originals and upon which they themselves work or directly supervise the process. The limited edition is not the whole answer to this suggestion; the field could go much wider, as it used to do, and I am sure the buying public would respond.

Meanwhile, my advice is to look for good quality etchings and some of the coloured marine lithographs and mezzotints from the earlier part of this century which are very attractive. There is still a field of discovery here awaiting the discerning collector of modest means.

COLOUR PLATE 20: BARRY MASON (b.1947)

'The brave *Guerrière*'. Oil on canvas, 36ins. x 48ins.

This painting shows a naval engagement during the American War of Independence. On 19th August, 1812, the British frigate *Guerrière* and the American frigate *Constitution* engaged in a long and hard-fought battle. The British broadsides made no impression on the *Constitution's* hull and it is believed that her nickname 'Old Ironsides' originated in this incident. The British ship was reduced to a mere hulk by the end of the battle and was holed many times below her waterline.

Barry Mason studied for three years at the Exeter College of Art. He specialises in painting deep sea sailing ships and historical naval subjects.

Photograph courtesy: The Omell Galleries, London.

COLOUR PLATE 21: CLAUDE MUNCASTER, PPRSMA, RWS, ROI, RBA, NRD (1903-1974)

'Camber Dock, Portsmouth, early morning'. Oils, 22ins. x 28ins. Painted in 1923.

Claude Muncaster was both prolific and versatile. He was a notable artist, and his talents not only embraced marine and landscape painting, but also illustrating, lecturing and writing. He exhibited at the Royal Academy as early as 1919 and was President of the R.S.M.A. from 1858 to 1973. As he was also a keen sailor, his marine paintings and harbour scenes bear the imprint of experience and authority.

Photograph courtesy: Martin Muncaster, Esq.

Chapter 12.
How to Choose a Marine Painting

Beauty is in the eye of the beholder and the best reason for buying a picture is because you like it and want to live with it. Buying a picture because it may appreciate in value has become an increasing habit in this materialistic age, but is not in itself a laudable way of enjoying art. Some people will admire a painting because it has a high monetary value or because the artist is famous; they often overlook the fact that famous artists sometimes painted awful pictures (everyone can make mistakes or have 'off' days) and that monetary values are usually geared to an artist's overall record rather than to one or two individual paintings.

Another disappointing fact of life is that most buyers prefer artists to be dead before they buy their work. Hence the popularity of 19th century painting. However, there is a strong case for urging people to look more carefully at the work of living artists, including some of the lesser known ones.

So far as the 20th century is concerned, there were many fine marine artists working in the earlier years and whose record is established. There are also many excellent artists painting today. May I therefore put in a plea for the buyer's judgement to be based on the actual merits of the painting rather than its potential as an investment. There are numerous 20th century pictures which can be bought quite reasonably at all ranges of expenditure according to your pocket. There are also strong ethical reasons why buyers should consider the work of living artists; the art of a nation reflects the degree of its civilisation, and I feel that there is some obligation upon private individuals to support the artistic products of their country. There is too widespread a

COLOUR PLATE 22: CHRIS MAYGER, RSMA (b.1918)

Gouache, painted for the book entitled: *The men that God forgot* by Richard Butler.
(Published by Hutchinsons of Australia.)

This painting shows a Brig built about 1833 in the infamous penal settlement of Sarah Island situated in Macquarie Harbour on the desolate south-west coast of Van Dieman's Land — now Tasmania. A new prison was built at Port Arthur and the last few prisoners and guards sailed in this Brig for the new settlement during which time the prisoners commandeered the vessel in a bid for freedom.

Chris Mayger paints in both gouache and oils. He has studied period naval and merchant ships from an early age and his pictures cover naval subjects from the 18th century onwards through World War II. Many of his paintings are used on the covers of books by well known authors.

COLOUR PLATE 23: MARK RICHARD MYERS, RSMA, ASMA (b.1945)

'Shipping on the river Dart, near Totnes, c.1630'. Acrylics on canvas, 24ins. x 36ins. Painted in 1978.

This painting shows a summer evening on the busy river Dart in the days of King Charles I. On the left is the ferryman's skiff, whilst towards the right-hand side is a square-rigged merchantman with her cargo of paper, wine and pottery from France. Mark Myers, who has had considerable seafaring experience, specialises in painting sailing ships and ports of the 17th, 18th and 19th centuries.

feeling nowadays that in a welfare state it is up to the government or some other organisation to hand out grants; however, it is more satisfactory in many cases for us to decide how and when we spend our own money, and the patronage of living art, even in a small way, can give great satisfaction to the buyer as well as encouragement to the artist. And encouragement from private buyers is a great deal more valuable to artists than state aid.

Whether you decide to buy early or present day 20th century marine pictures — or, ideally, a mixture of both if your budget will allow it — here are a few guidelines which may be helpful to you when making your choice.

First, look at pictures carefully and thoughtfully. This may sound extraordinarily obvious advice, but I can say from long experience that many potential buyers give only superficial attention to pictures when they are viewing them. Some buy quickly on impulse; others spend a long time agonising over a detail which may be irrelevant to the total composition.

View the painting at eye level — pictures which are placed above or below the eyes are not usually seen at their best. Generally speaking, it is best to look at small and medium sized paintings from a distance of about 6 feet (further away for large paintings). Many people look at pictures at too close a range; they may be interested in the brushwork, but they will almost certainly miss the overall impression that the artist intended. Furthermore, minute and meticulous brush strokes in themselves do not necessarily create a good picture; whilst there are excellent examples of realism executed in this manner (that is, excellent if they are not just a more expensive version of a colour photograph) there are also many beautiful sea pieces painted in freer style whose merits are apparent from a more distant view. This is often particularly true where the composition contains figures which, on close inspection, seem composed of only a few loose brush strokes, but which miraculously become alive, full-bodied and moving when you step further away.

Remember that artificial lighting makes some colours and tones invisible to the human eye. Gallery lighting is notoriously bad for viewing paintings; it is usually far too strong and much brighter than the light in a normal room. Filament lights tend to remove the blues and fluorescent lighting usually gives a cold and rather hard effect. The answer, therefore, is to carry the painting into or near daylight and switch off all but the most moderate of the nearby electric lights. You will see immediately that the picture you looked at in electric light has more tones and subtleties, and probably more blues, as soon as natural light falls upon it. It follows therefore, that you need to see your intended purchase in lighting conditions as near as possible to those it will have in your own home.

It would be ridiculous for me to try to indicate the types of composition to look for, because a work of art is not something which needs to conform to a precise formula (although some masters in the past have propounded various formulae). However, there are several important aspects which you may wish to bear in mind. For instance, the sky and sea should be in harmony, because one reflects the other. Bright blue seas are not harmonious with grey skies. In fact, bright blue seas are not always credible; they may look jolly at first glance but I suspect that they can pall on the taste. Even the remarkable blue seas one sometimes encounters in sunny climates have numerous other tones, textures and colours interwoven in them. The sea itself is a moving, dynamic force and the painting should show this; that there is nothing more difficult to paint than the sea is affirmed by all marine artists.

Ships should sit in and move through the sea and not on top of it. In some pictures of sailing vessels, the ship looks almost balanced on the surface, with her keel hardly biting the depths, whilst her masts lean at such an exaggerated angle that one fears she may capsize in the next squall.

In ship portraits, the buyer often (quite legitimately) looks for absolute accuracy. The spars and rigging, the ship's lines, her flags, the wind direction and many other

details must be just right. However, it is not always wise to apply such requirements of correctness to other types of marine painting. Some of the masterpieces of marine art are wide open to criticism by seamen who want to see accurate representation; nonetheless they are artistic masterpieces. For instance, Turner's freely painted marine pictures or those of the Impressionists have more to do with the real sea and ships than stereotyped compositions which have every rope, block and tackle and seam in the ship's side painstakingly drawn in.

Not long ago, I read an extraordinary criticism of a painting by MONET in which the writer sought to prove that the artist had the wind blowing on the wrong side of a sailing boat in relation to smoke emitted from the funnel of a railway engine on the distant shore. To substantiate this theory, it was suggested that the viewer should draw an imaginary line through the bow and stern of the boat and extend it to the background, and another imaginary line from the engine's smoke; it would then be seen that the lines diverged. This critic said that nearly half-a-million pounds seemed a great deal to pay for a technically inaccurate painting! Perhaps the comment was made tongue-in-cheek but, if not, the writer had made a common error in conceiving that all masterpieces need to be 'technically accurate'. They do not; many of EUGENE BOUDIN's boats, for example, might sink instantly if such rules were applied to them. Nevertheless, who cannot admire the beauty of a Boudin and acknowledge his genius?

The framing of a picture can do a great deal to enhance its beauty. It has always puzzled me that most artists frame their own pictures rather badly. When it comes to putting a frame on their *chef d'oeuvre* they often settle for a wooden surround that would look better around a bathroom mirror. Perhaps they begrudge the cost, because good hand-made frames are quite expensive. Yet a finely made frame, carefully chosen to complement the subject, will give your painting a considerable lift. My advice, therefore, is not to pass by a picture because its frame makes you shudder; try to eliminate the frame from your mind's eye and if the painting seizes you, buy it and then consult a good framer or art dealer.

Size is another obvious yet constantly overlooked factor. Small pictures over large mantlepieces usually look like a pea on a drum. On the other hand, large airy seascapes in small rooms can sometimes be a spectacular success — an expanse of sea and sky can create an additional window. So, do not necessarily rule out the possibility of buying a large marine painting because your house only has small rooms.

Lighting is of considerable importance. Some natural light is very desirable as already mentioned. An oil painting placed on a wall directly opposite a window may look dark or dead because the light bounces straight back from it, but placed on a wall at right angles to the source of light it may well look at its best. It is a matter of holding up the picture in different places in a room to discover where the light suits it most. Artificial light at night may be provided by a table lamp nearby, perhaps from below and to one side, or by a picture light (e.g., Linolite) attached to the back of the frame at the top. These lights give a soft overall illumination, generally far superior to a gallery spotlight. Sometimes it is possible and useful to hide a low powered spotlight (say 75 watts) behind a beam or in a corner where the fitting itself is not visible; but it must be at least 6 feet away from the picture, otherwise you will create a distractingly bright light in your room and you will see this rather than the painting.

Fortunately, we are living in a period when bare walls are no longer fashionable. It is thoroughly enjoyable to have original pictures on your walls and I see few reasons to limit the number except within the bounds of commonsense and your purse. However, pictures crowded too close together tend to fight one another and for this reason a decent space between them is advisable so that each one may be enjoyed individually. This overcrowding aspect is one reason why the painting you choose in a gallery usually looks far better when you get it home; a gallery of necessity has to use most of its available wall space.

Let me say how much pleasure you can get from small pictures and from well

executed freely painted pictures. (The larger pictures and the more meticulously painted ones can speak for themselves). A picture which perhaps is rather hazy or freely painted and leaves something to the imagination is sometimes more likely to give you lasting pleasure than the painting which tells you everything it has to say in the first glance.

Finally, may I remind you once again that when you are looking at an original painting you are not looking at a colour photograph — a fraction of a second frozen out of time. The painting is a living and continuing story (or it should be, if it is any good) which the artist created by seeing something which he or she considered memorable and beautiful. The artist's perception, vision and skill transmitted his feelings to canvas (or paper) and it is these feelings which are being communicated to you, in much the same way that music or writing communicates the feelings of the composer or author. A good painting, like a book or a symphony, must have been something of a love story and also a struggle between the artist and his media. It matters not whether the artist is famous or little known, he is trying to show you something which he saw in a certain way, in certain colours and shapes and light. If you will take the time and bear this in mind when you look at paintings, you will not go far wrong when you buy one.

COLOUR PLATE 24: CHARLES MURRAY PADDAY, RI, ROI (fl.1890-1940)

'The yacht race'. Oils, 18¼ins. x 26ins.

This very fine painting shows the elegance of yacht racing in Edwardian days. The composition is beautifully balanced between the two calm figures in the foreground and the other yachts ploughing through the water behind them. It was probably painted about 1908, as the artist was then living at Hayling Island and this address is inscribed on the reverse of the canvas. The scene is obviously in that area of the south coast. The picture is in the collection of Roger Hadlee, Esq.

Photograph courtesy: The Royal Exchange Art Gallery, London.

COLOUR PLATE 25: (GWENDOLENE FRANCES) JOY PARSONS, FRSA, SWLA, SGA (b.1913)

'From foreign shores'. Watercolour, 14ins. x 20ins. Exhibited at the Royal West of England Academy.

Joy Parsons specialises in painting marine still-life, flowers and wild-life. She has been exhibiting at the RSMA since 1954 as well as other leading centres. About this colourful and attractive picture she has this to say:
 'Attracted as usual by the glorious colours, shapes and textures of the shells, I arranged them and painted them on a very rough paper using pure watercolour with the addition of a little candle wax here and there to improve texture and also a little silver paint. The Starfish and the 'Mermaid's Purses' or Skates Eggs were added to give further variety of shape and weight at the bottom of the group.'

Chapter 13.
Money and Marine Painting

On the whole, artists are not outstandingly clever at handling the money-making process. Most of them dislike the commercial aspects of selling their paintings and hate any form of negotiation about price (which they tend to think of as 'bargaining' or 'haggling'). Their generally mild and non-aggressive natures are not normally in tune with the tougher aspects of business dealings and self-promotion. Nevertheless, there are not many starving marine artists nowadays; most of them have a reasonable standard of living, and in the last 20 years there have even been a handful who have been highly paid.

Whether the average good marine artist of today receives *enough* money for his or her work is another matter. The problem is that an artist often has to be dead for some years before his pictures are fully evaluated and appreciated. Apart from the few who have become famous whilst alive, it seems that there has to be a period of time, perhaps 20 years or more, during which the public stands back and waits for some signs that one particular artist had more merit than others. These signs may take the form of a major exhibition of the artist's work, inclusion of his or her name in reference books and dictionaries, praise in newspaper or magazine articles, and the like. The reputation of the dead artist must stand on his record and because he cannot produce any further pictures his output can be judged in its entirety. Also, if a demand for his work is created, scarcity value then enters the scene.

One sobering thought is that it is only in the last 15 years that we have learned to assess the true value of 19th century marine painting. Whilst appreciation of that period of art rose to its climax in the 1890s, it fell into a limbo between the two world wars when architects and other shapers of fashion decreed that bare or sparsely decorated walls were in good taste. Today, it is quite difficult to remember that it was as recently as the 1960s that the passion began once more for everything to do with the 19th century.

The appreciation of marine painting 100 years ago did not mean that all marine painters were highly regarded, and the same applies today. What is different is the recent situation in which even mediocre 19th century sea pictures have fetched high prices, due to the large-scale demand fostered by the big auction rooms, coupled with a trend towards using pictures as speculative investment commodities regardless of their merits as works of art. Now there are indications in the 1980s that poor 19th century marine pictures are dropping in value whilst excellent examples are continuing to rise — a proof to the speculators of the validity of the old dictum that it always pays to buy the best.

Agents and galleries

The role of agents or galleries in promoting a marine painter is the subject of controversy amongst the artists themselves. It seems that the majority do not have agents or agreements with galleries for selling their pictures. Sometimes the antipathy of artists towards agents arises from a bad experience (although one artist described his hate for galleries as 'a self-inflicted wound'). One painter had an agent who went broke owing him a great deal of money; other artists speak of excessive rates of commission and lack of understanding of art. The stories about inefficient or avaricious agents and

galleries probably gain in circulation and scare off some artists who might well benefit from a good representative.

There is no doubt that an efficient and well recognised gallery can promote both an artist's work and his name, sometimes with astonishing effect. Assuming that the paintings have considerable merit, it is possible that the gallery can get as much as double the price normally being asked by the artist when he sells direct. Galleries are quite shy about revealing the rate of commission which they charge, but 40 or 50 per cent of the gross selling price is not unusual today, and 70 per cent has been known. If the gallery is doing a good job in promoting and publicising the artist, in displaying his work, publishing catalogues, holding exhibitions and so on, these rates of commission are by no means exorbitant in relation to the overheads borne by the gallery. Overhead expenses — the hard bite of rent, rates, lighting, heating, electricity, staff salaries, printing, postage and taxes including V.A.T. at a swingeing 15 per cent, none of which can be avoided or minimised — are those costs which few buyers of pictures ever remember as being part of the profit margin on a painting. Fifty per cent always sounds like daylight robbery until one sees the substantial costs which have to be paid out of this margin.

A very successful marine artist told me that he sold his own pictures (a process he heartily disliked) but although he had work commissioned for two years ahead, he never seemed to make any money. He lived modestly and had not had a holiday for five years. He admitted that he would probably earn twice as much if he had an agent, yet he was reluctant to tie himself up.

Perhaps it is the psychological dislike of formal agreements which keeps some artists from making arrangements with galleries. If there is mutual trust between a gallery and an artist, a sensible representation arrangement must make the artist's life enormously more simple. All he then has to do is to paint, thus saving himself an immense amount of non-productive time and worry.

An example of a very happy arrangement is the one between LESLIE WILCOX, who has deservedly won international acclaim, and the Parker Gallery in London. This gallery has represented the artist since he took up full-time marine painting in 1945. It is evident that over a period of some 35 years a friendship has been established which has been both pleasant and beneficial to everyone concerned.

Since the art world of galleries and dealers cannot claim a greater degree of integrity than other professions, it must be noted that there have also been instances of the work of mediocre artists being successfully promoted. The excuse that 'the buyer gets what he deserves, for after all he has a free choice' is not good enough. Because a large number of people of all age groups and financial strata wish to own original pictures, there is a moral obligation for dealers and galleries to present their art honestly and with a responsibility that goes further than the Trade Descriptions and Fair Trading Acts. Buyers rely quite heavily on expert advice, and are swayed by skilful presentation. The abuse of this power is as damaging to artists generally as it is to the purse of the buyer.

Guiding the buying public

Art critics, especially those who write for national newspapers, must take their share of any blame attached to lack of practical guidance of the buying public. They are inclined to take little notice of the kind of art which most normal people want to know more about. Instead, they often fill their columns with esoteric language difficult for the uninitiated to comprehend (and of not much interest to those who can understand it). The objects of their reviews are frequently paintings or pieces of art which are usually unobtainable except by millionaires or museums, or so obscure that the average person is unlikely to encounter them. As one well-known artist remarked to me, many critics are not particularly concerned about painting as such, they are more concerned about airing their own knowledge in exotic and complicated phrases.

In most cases, collectors or other sensible potential buyers are better served with advice by reading the down-to-earth articles which appear in practical art and antique magazines. These are usually written by people who are in touch with day to day reality and who realise that their readers want straight commonsense talked to them.

Up to the end of the 19th and the beginning of the 20th century, buyers of paintings were relatively well advised. The dealers and critics made a definite attempt to set standards and develop the good taste of their patrons. Now, pictures are treated as another form of currency. Normal currency has been degraded and depreciated to the extent that people seek articles in which they think their money may be safer. The merchant banks have entered the business, auction networks have multi-million pound annual turnovers and profits to match, and the publicity given to saleroom prices has helped to turn many private collectors of only modest means into petty speculators. Hence, perfectly nice people have been brainwashed into looking at marine paintings primarily as investments rather than works of art which reflect the blood and soul of the artist.

Patronage and sponsorship

At one time collectors with limited budgets commissioned paintings in a small way purely for pleasure. The life of the artist was not made easier, but it was certainly more interesting. Now, the patronage of art has largely slipped from individuals and private hands into the province of industry — with much credit to those who have taken over this mantle. (In 1978, small firms contributed some £3½ millions to helping and promoting art.) Usually, an industrial concern is extraordinarily enlightened in commissioning painting. They often select a marine artist purely because they like his particular interpretation of a subject, and they generally let him have a free hand. They sometimes choose an artist who knows little of the technicalities of, say, tankers or oil rigs, so that the sheer impact of these vast pieces of marine machinery will find an original response.

COLOUR PLATE 26: ELLIOTT SEABROOKE (1886-1950)

'Heybridge basin'. Oils, 16ins. x 20ins.

Although probably best known for his landscapes, Elliott Seabrooke also painted many excellent harbour scenes and fully deserves to be described as a marine artist in this category. The picture illustrated here was painted during the artist's pointillist period. He studied art at the Slade, exhibited at the New English Art Club from 1909, and was elected President of the London Group in 1943.

Photograph courtesy: The Louise Whitford Gallery, London.

COLOUR PLATE 27: EDWARD BRIAN SEAGO, RWS, RBA (1910-1974)

'Fishing boats on the Golden Horn, Istanbul'. Oil on board, 15¾ ins. x 23¾ ins.

Edward Seago, a versatile and outstanding modern artist, painted landscapes, portraits, circus scenes and animals, town scenes and marine subjects. As a child he was bedridden for some years and taught himself to paint, although he had some professional tuition later. He became a Major in the Royal Engineers in World War II and served overseas in France and Italy between 1939 and 1944, during which time he still managed to paint (four of his pictures are in the Imperial War Museum, including a portrait of General Lord Gort, VC, dated 1940).

He travelled extensively and was also an enthusiastic yachtsman producing some very fine seascapes, coastal subjects and harbour scenes such as the picture illustrated here. His work has been much admired and acclaimed both in Britain and overseas.

Photograph courtesy: Sotheby Parke Bernet & Co.

What is needed in addition to industrial patronage is a far greater and more realistic feed-back into marine and other painting projects by some of those organisations who make so much money out of it — some of the auction houses and the big dealers backed by merchant banks, perhaps? Grants and scholarships for young artists, and meaningful awards carrying considerable kudos for established painters are obvious and well-proven methods of stimulating both artists and art buyers. More encouragement is needed to get people to realise the usefulness and pleasure in buying modern marine pictures, and in collecting the work of artists whose style they favour. This is the most practical and invigorating form of patronage, and it would be more widespread if artists were given at least a small part of the glory at present reserved for professional footballers and television actors.

There have been two outstanding examples of the enlightened patronage of marine painting in recent years. One of these is the major commission undertaken by DAVID COBB for the Royal Naval Museum at Portsmouth. The first part of this commission, completed in 1979, was a series of 17 oil paintings showing scenes from the Battle of the Atlantic, 1939-1945. The artist continued work in 1980 on two further series, also commissioned by the museum trustees, of pictures covering the Mediterranean and Pacific campaigns. Thus, a major painting record will be created of the largest-scale war in which the Royal Navy has ever been engaged. The whole series (described by the Museum Director as 'one of the most exciting projects in which the Royal Naval Museum has been involved since its foundation in 1972') will be permanently displayed in Portsmouth as a major contribution towards showing the whole history of the Royal Navy.

The other large-scale project of this nature is comprised in the 65 paintings of World War II naval actions painted by JOHN HAMILTON. This project was sponsored by a number of shipping and City of London livery companies, and through their generosity the pictures are now permanently exhibited, under the auspices of the Imperial War Museum, in a special gallery on board H.M.S. *Belfast,* the first warship since H.M.S. *Victory* to be preserved for Britain. Again, this large series was completed in 1979 — obviously a good year for enlightened patronage.

Following this, John Hamilton was working in 1980 on a further 89 paintings of the Pacific War, and it was expected that this series would be sponsored by one of the American foundations. The pictures of the Second World War at Sea took the artist three years of research and painting, and the Pacific project is expected to take a further four years.

It is obvious that sponsored projects of this sort can have great advantages where the end results are permanently on display in suitable locations and under excellent conditions, where many thousands of people can see them every year. However, other notable collections which were presented to museums earlier in this century have not fared so well; many excellent pictures now lie in the vaults and basements of museums where they are rarely seen and only half-remembered.

The American market

Some of the more successful British marine artists have found their best markets in the U.S.A. The Americans get certain tax concessions for buying original art — a practice which might well be helpful here. But, in addition, the Americans have realised (as, apparently, the British have not, as yet) that there is not enough outstanding 19th century marine painting to go around. They are therefore buying what they consider to be the best of British 20th century marine art and particularly that which depicts 19th century scenes and ships in U.S. settings.

Money and art

A disappointing aspect of art today is its constant equation with money by those engaged in trading in it. Unfortunately, this trend is not singular to art; today, everything is equated in terms of money. Our only hope is that there will one day be a large scale revulsion and revolt against this excess materialism. Perhaps the more that

money is made a reason for all activity the greater will be the chance of this absurdity becoming apparent. Possibly, one day, art will shake itself free of the monetary parasites and revert to a system of assessment by merit, criticism of a practical nature, patronage by collectors of modest means made possible by a fairer tax system, and a general atmosphere of sanity. The artists themselves who have remained generally innocent meanwhile — and that is the majority — will then be judged and rewarded in a just manner.

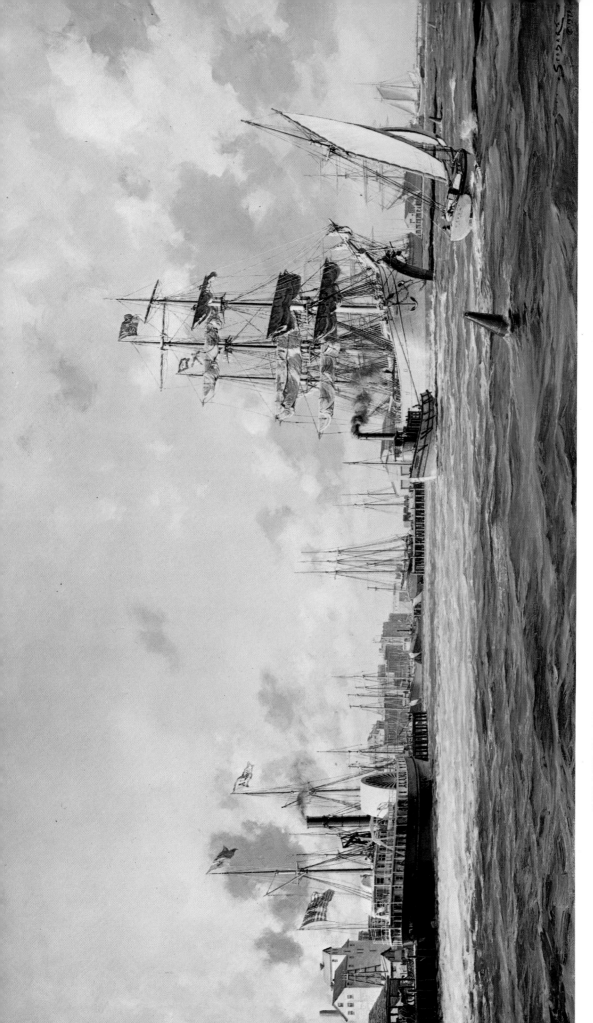

COLOUR PLATE 28: JOHN STOBART, RSMA, ASMA (b.1929) 'Galveston'. Oils, 28ins. x 48ins.

This picture shows the 19th century barque *Elissa* departing from Galveston in 1884. The *Elissa* has now been acquired by the Galveston Historical Foundation and will be permanently berthed beside the restored waterfront buildings as a fitting memorial to the bygone age of sail.

John Stobart studied at the Derby College of Art and the Royal Academy Schools. He now lives in America and paints historic narrative harbour scenes, inshore shipping and ships at sea. His seafaring experience includes 21 ocean crossings and a voyage around Africa. He has been a regular exhibitor at the RSMA and is Vice-President Emeritus of the ASMA. His work has won wide acclaim, particularly in the U.S.A.

Chapter 14.
The Royal Society of Marine Artists

During the four years immediately preceding the last world war, as the result of initiative by a group of marine artists which included ARTHUR BRISCOE, CHARLES PEARS, CECIL KING and NORMAN WILKINSON, a number of successful marine painting exhibitions were held under titles such as 'Ships and the Sea',[18] 'Our Navy in Peace and War'[19] and 'Sea Power'. The latter exhibition took place in the New Burlington Galleries, London, in June, 1937, under the patronage of King George VI and was opened by Winston Churchill. A final pre-war exhibition took place in Portsmouth[20] in December, 1938, and was opened by Admiral of the Fleet the Earl of Cork and Orrery who remarked that it was strange that a country which had such a long maritime history and depended so much on sea power had no organisation for its marine artists, and he advocated the formation of a society. From this suggestion and the interest aroused by all these exhibitions, there arose a correspondence in the *Daily Telegraph* which proposed that a society of marine artists be formed. Out of this a meeting took place from which the present Society was born in 1939 with the title of the Society of Marine Artists. Its first President was CHARLES PEARS.

The exhibitions in the years from 1937 to 1939 had been organised by the Art Exhibitions Bureau (the fore-runner of the Arts Council) of which the director was MAURICE BRADSHAW. It is to his intensive and diplomatic activities in dealing with so many diverse artists that much of the credit is due for the formation of the original society, of which he became and remained for many years its Secretary. (In 1978 he was made a Governor of the Federation of British Artists.)

The war curtailed all normal activities and although members' work was included in the United Artists' exhibitions at the Royal Academy during three of the war years, the inaugural exhibition of the Society could not take place until 1946. Since then and until 1980 it has held its annual exhibitions in the Guildhall Art Gallery, London, with conspicuous success.[21] (In recent years, there has also been a secondary annual exhibition at the International Boat Show in London.)

In 1966 the Queen granted the use of the word 'Royal' in the title.

Membership is rather exclusive and there are just under 50 elected artist members who are entitled to use the letters R.S.M.A. after their names. In addition, the Society has the support of some 500 lay members who are keenly interested in marine art. Membership of the R.S.M.A. is to some extent restricted by the amount of wall space available on which to hang pictures at the annual exhibition. There is a large waiting list of artists who have applied to become members, but no one was elected, for instance, in 1978. Another reason given for the slowness in electing new members is that it is difficult to find artists who are *regularly* producing hangable marine paintings, although it has also been said that there are some very successful marine painters who feel they do not need

18. Held at the Eastbourne Municipal Art Gallery in June, 1935, and thereafter shown at a number of other provincial centres.
19. Held in Portsmouth Dockyard during Navy week in August, 1936.
20. At the headquarters of the firm of Gieves.
21. From 1981 the venue has changed to the Mall Gallery, London, S.W.1. (Federation of British Artists) due to building works at the Guildhall.

the patronage of the R.S.M.A. and therefore do not apply for membership.

The nomination of candidates for election to membership may be made by individual members or by the Selection and Hanging Committees. The nominations are 'guided' by these committees and election to Membership takes place by majority vote at the Annual General Meeting.

The Annual Exhibition is open to the work of non-members as well as members and a description of the way in which the Selection Committee works is given at Appendix A. Every member is entitled to hang up to four paintings each year, and the total exhibition usually consists of 200 to 300 pictures, both oils and watercolours, the numbers of which are fairly evenly divided between members' and non-members' work.

There exists a degree of amicable difference of opinion amongst the members about the admissible range of marine subject matter in the qualifying work of potential members and also about the content of the exhibitions. These differences centre on the same question, and this is whether the Society should devote itself more firmly and narrowly to ships and the sea or whether marine painting should embrace the widest possible vistas from beach scenes to harbours and the flora and fauna of marine life. At present, the latter view appears to be dominant, although it is said that there are some excellent marine painters who are not members simply because they do not paint ships. The type of member changes, as does all else with the passage of time. In 1948 about half the members had direct experience of seafaring in some form or another, but this proportion had dropped to about 25 per cent by 1980.

In past years, the prices of the pictures at the R.S.M.A. exhibitions have been modest and this factor, coupled with the popularity of the subject, may account for the high sales rate. In October, 1979, it was still possible to purchase an oil for less than £100 from a choice of nearly 30 available below that figure. There were also nearly 50 watercolours for sale at under £100. There were over 40 oils and watercolours priced between £100 and £200, and over 30 oils and watercolours in the £200 to £500 range. Thus, out of just over 200 pictures exhibited in that year, well over half were available for less than £500. This is the sort of price structure[22] to which buyers at these exhibitions have become acclimatised, and it might be difficult to suddenly increase the prices in spite of inflation and soaring costs. It seems evident that many of these paintings have been very good value for money, and this point is reinforced when one sees the prices which have been obtained at auction for some quite mediocre 19th century sea pieces.

At the other end of the 1979 price scale there were 12 oil paintings marked at between £3,000 and £10,000, whereas in the previous year the highest single price was £2,350, with the majority of the paintings priced below £500. The up-grading of the price structure at the top level reflects more than the national inflation rate; it means that some of the more distinguished artists have realised that their pictures have been much undervalued in past years.

The R.S.M.A. exhibition at the International Boat Show, whilst secondary to the Annual Exhibition, attracts many buyers who would not normally darken the doorway of a picture gallery. These are the people who go to look at boats and suddenly find themselves in a certain area surrounded by sea pictures. They find that they like them and the prices seem reasonable in comparison to the high cost of a boat or piece of boat equipment. Thus, the number of sales is usually very high.

When one views these exhibitions, it is apparent that the majority of the work is competent and pleasing to a high standard rather than brilliant and outstanding. The same is true of most 19th century marine painting available on the market today. From that period, the best work of artists like E.W. COOKE, WILLIAM JOY, CLARKSON STANFIELD, THOMAS WHITCOMBE or JOHN WARD of Hull is not seen very much nowadays (when it is, it is prohibitively expensive) and in the 20th century it is probably still too early to say who bears comparison with such artists in terms of sheer achievement. There is the fundamental phenomenon consisting of the necessity to stand back from art in order to perceive its virtues, and perhaps in another 20 or 30 years' time some of the 20th century names mentioned in this book will have become household words in the homes of marine painting collectors. There are nevertheless a handful of artists capable of producing brilliant work and, naturally, it is these who already command the higher prices.

One of the senior officers of the R.S.M.A. told me that he found it difficult to understand why the prices of the pictures remained so reasonable. He thought some blame must be attached to the art critics who tend to take little notice of the exhibition because the painting is too orthodox (I recently read an article by a Sunday newspaper art critic who was complaining that a certain group of painters was too competent!). It is certainly a pity that more notice is not taken of the R.S.M.A. exhibitions by art magazines and the art editors of newspapers. Marine painting is an important facet of British art and a matter of interest to the public, and the exhibitions are well representative of modern marine painting. The Selection Committee is careful to maintain high standards and rejects about four out of five submissions. Thus, as I have said before, the exhibitions provide probably the best annual cross-section of British marine painting today, and I would have thought they would warrant a good deal more publicity than they receive.

22. An analysis of the November, 1980, exhibition showed that the price structure for a larger number of 269 exhibits had not changed significantly in one year.

Artists who have served on the R.S.M.A. selection committee speak of 'the incredible amount of sheer rubbish' amongst the 800 or so pictures submitted by non-members each year. (The same remark applies to the Royal Academy where the annual submissions run into thousands of pictures.) More disturbing than the rejected 'rubbish' (which, after all, may often be an honest attempt at art by a striving if untalented painter) is the annual crop of facsimile copies of work which was originally painted by popular artists such as MONTAGUE DAWSON or JACK SPURLING. They are mainly direct cribs, submitted as original work, and the selection committee prides itself on being able to spot and reject them very quickly. There is also a proportion of paintings copied directly from colour photographs, sometimes reversed from left to right in the hope that they will look less identifiable. However, here again, the flatness of the technique is such that they are immediately recognised by the committee and promptly rejected.

To ensure that a cross section of good 20th century marine painting will be handed down to posterity, a Diploma Collection was started in 1964. In this system, the rule is that each newly-elected member must within two years of election submit a painting which is truly representative of his work. This he donates to the R.S.M.A. if it gains the approval of the Council. The custody of the Diploma Collection is in the hands of the National Maritime Museum at Greenwich.

COLOUR PLATE 29: TERENCE LIONEL STOREY, RSMA (b.1923)

'The Royal Progress'. Oils, 30ins. x 48ins.

This painting shows H.M.S. *Britannia* in the Pool of London between London Bridge and Tower Bridge, during the River Thames Silver Jubilee celebrations on 9th June, 1977. H.M.S. *Belfast* is on the left (upstream). The Queen was in the Port of London Authority's barge *Nore* seen between the *Belfast* and the *Britannia*. The escorting craft belong to the River Police, Customs and Excise, Pilots, etc.

Terence Storey paints a wide variety of marine subjects as well as portraits, landscapes, industrial scenes and aircraft. He has been exhibiting at the RSMA since 1970 and at many other leading centres.

COLOUR PLATE 30: JOHN SUTTON (b.1935)

'Thames barges off Northey Island, Essex'. Oils, 20ins. x 26ins.

John Sutton paints a wide range of marine subjects in oils, watercolours and gouache. He spends a lot of time travelling and collecting material in his sketch books, also researching in museums.

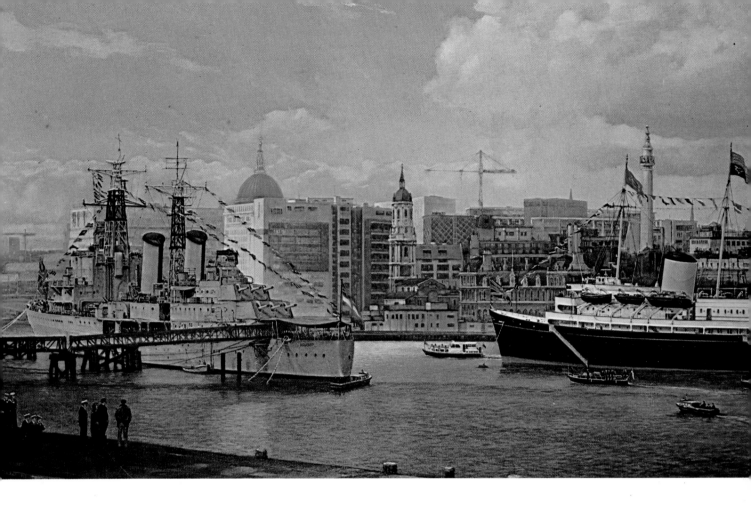

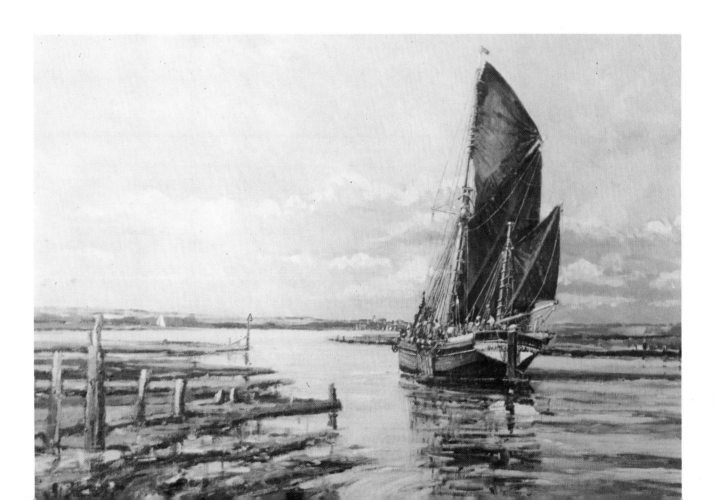

Chapter 15.
The Artist is Human...

The pleasantest part of writing this book was the considerable time I spent in meeting and talking to a large number of professional marine artists. Without exception, they were kind and helpful and they dealt with the numerous questions I asked thoughtfully and with patience. They are all busy people, whether at the beginning of a successful career or nearing the end of one and reaping the acclaim their work deserves. They are busy because painting is their *raison d'être*, their life, and yet they appear to have avoided many of the pressures and they certainly lack the aggressiveness which commerce and industry generate. Most have their studios at their homes, which means that they live in a more relaxed atmosphere in spite of the strains and disciplines of artistic effort.

A large proportion of the comments they made to me about art and artists and artistic organisations have been woven into the text of this book. Some other comments they made off the record, because artists are as capable of passionate opinions as most people, and these are not recorded here. But our talks were all enriched with touches of humour or reminiscence, and I thought it would be interesting to repeat verbatim a small selection of anecdotes and comments.

Communication

Painting is a common language, which has the problem of trying to see how one can use it to communicate the things which really interest you.

ROWLAND HILDER

The importance of the sky

After my years in the Navy I find that I can paint the sea mainly from my experience of it. I've never succeeded in painting it from a boat and I admire anyone in a seaway who can. I study the sky much more than the sea. The sea takes its colour and tone from what is above. So many marine painters neglect the sky — it is just as important in a marine painting as the sea and should be studied accordingly.

DEREK GARDNER

Terrick Williams said to me 'Now look here, if you paint a sky every morning and every evening for a year, at the end of that year you'll be able to paint a sky'. And that's what I did. Every morning, I'd put a little bit of landscape in at the bottom, just to get the tone and colour against the sky, because it always varies, and it is amazing what one learns by doing that.

W. ERIC THORP

Art as a full-time occupation

Some years ago, I painted a portrait of a man's wife and when it was nearly finished they both came over for a drink to discuss it. As the man came into my studio he glanced around at the various paintings and then said 'Is this all you do all day long?'

A friend of mine who was the leading horn player in a symphony orchestra had a similar experience. He was playing in a concert in South America and afterwards there was a drinks party at one of the embassies. The ambassador came up to this horn player and asked 'And what do you do during the day?'

JOHN WORSLEY

Learning when to leave out detail

Here is a drawing of a tree by my old friend TOM MONNINGTON which he did when he was 18. It is dated 1919. He tried to draw the tree leaf by leaf. As you can see, he had to give it up. He exhausted himself. But because he left it unfinished, it is a very beautiful composition.

RODNEY J. BURN

The sea

Pure sea is one of the most difficult things to paint. It took me a long time to discover that most people don't like it — perhaps it frightens them. Fear of the sea is one of the things which keeps one perpetually interested in it. It is not the fear of drowning, but an awesome respect for its enormous and terrifying force. If you've seen it really with the lid off, it is not easily forgotten.

DAVID COBB

Chance and reputation

New artists often get their reputations enhanced when the public finds it cannot buy the work of the well known ones any more. Then the best of the 'new' artists are found to be as good as the so-called first raters, and they become established names.

ROY CROSS

At the scene of action

I once painted a picture of Francis Chichester rounding Cape Horn. Of course I'd never been near Cape Horn and I painted the sea out of my head, but the man who bought the picture had been round many times. He telephoned me and said 'I can see you've also been round the Horn more than once. Couldn't we get together and talk about our experiences?' I had to put him off.

W. ERIC THORP

Colour No. 9

My normal palette consists of eight colours. In the English light every colour you use needs to be slightly reduced. In fact, I have an additional colour for this country: colour No. 9 — filth. The stuff that collects on the corner of your watercolour palette. A little bit of filth with your brown or blue will give you your English scene.

EDWARD WESSON

The hazards of London

I taught for 20 years at Camberwell and although I found it terribly interesting being involved with teachers and students, I found that the teachers, who were supposed to be painters, were always on each other's doorsteps wondering what the other one was doing. And their wives were always giving parties and keeping up certain kinds of appearance. Their wives also demanded: 'Oh darling, would you go to the bank this morning', and that kind of thing — and so the day was gone, when they should have been painting. That's how it went on, and I was glad I didn't live long in London after my student days. Well, I lived there in basements and garrrets for three or four years, which was very good for me. Having very little money when young is a useful discipline.

RICHARD EURICH

The ability to paint

Talking generally about painting, I believe masses of people could do it. Many years ago, my wife and I were asked to run a village art class. One woman who came along asked 'Well, what do I need?' I said 'You don't need to spend much money — three tubes of paint and a couple of brushes, wrap it all in newspaper and bring it along.' She turned out to be a marvellous artist. She had not painted anything since she left school, but she had a wonderful dexterity with the brush, and easy flow, no inhibitions, beautiful drawing — the lot. Great artistic assets. But she was a busy housewife and soon gave it up.

LESLIE WILCOX

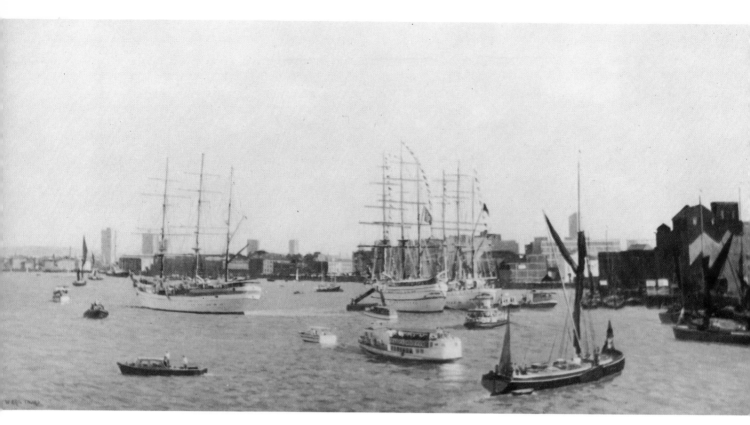

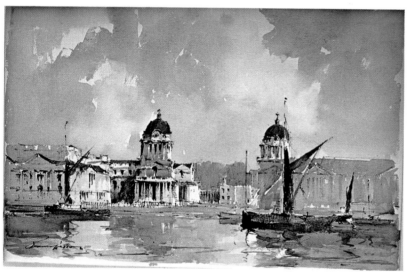

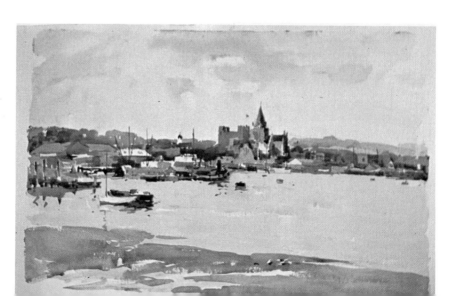

The benefit of exhibiting nationally

The advantage of exhibiting with good societies such as the R.O.I., R.B.A., R.S.M.A., etc., is that this gives you a national assessment of your work. It also helps to sell pictures and get specific commissions. On the other hand some local exhibitions may have 300 places and only 240 submissions, which means that everything will probably get in and there is no weeding out.

TERENCE STOREY

The arctic regions

If you try to analyse why these places are so beautiful I think the answer is that everything you look at is in its natural form. It is the only place on earth where the landscape bordering the sea is moulded by the elements and the earth itself. There is no geometry in it and nothing altered or landscaped by man — no shapes of fields, buildings or roads to catch your eye. Just an upheaval of rock or an avalanche or glacier or free flow of ice. It is a great spell-binding gorgeous abstract.

KEITH SHACKLETON

Turner: Britain's greatest painter

People forget that Turner was not appreciated in the first part of this century. When I went to the Slade in 1925, Turner's name was a dirty word. I was terribly enthusiastic about his work, but found that people gave me sidelong glances. The teachers said that Turner had nothing to offer any modern student, and that sort of rubbish.

RICHARD EURICH

Following the Master...

I was asked to do a commissioned painting for the Royal Dartmouth Yacht Club's centenary. When I got down there, I found that Turner had painted the first commission. I thought it rather a tall order to follow.

W. ERIC THORP

COLOUR PLATE 31: WILLIAM ERIC THORP, PS, RSMA (b.1901)

'Tall ships in the Lower Pool, River Thames, as seen from Tower Bridge, London'.

The artist was a founder member of the Wapping Group of Artists, devoted to painting Thames scenes, and was the President for five years. This picture shows a wide panorama in the late afternoon, with cool sunshine on the ships, and lighting reminiscent of a Canaletto.

COLOUR PLATE 32: EDWARD WESSON, RI, RBA, RSMA (b.1910)

'View of the Royal Naval College, Greenwich'. Pen and wash.

This picture was drawn from notes made by the artist some 40 years ago. His family lived near this scene from 1925 to 1937 and during that period Edward Wesson worked a lot along the foreshore and over on the Isle of Dogs from where this subject is seen. He says that the barges often lay loaded with timber, etc., and always made a foil to the industrial shapes along the banks of Blackwall Reach and the two lovely domes of the Wren buildings.

COLOUR PLATE 33: EDWARD WESSON, RI, RBA, RSMA (b.1910)

'On the Medway'. Watercolour.

This watercolour was painted by Edward Wesson whilst he was working on a commission for the Royal Engineers at Brompton Barracks. It shows a scene on the river Medway at Upnor near the place where the *Arethusa* training ship was then moored. The Thames and the Medway at Chatham and Rochester have a great fascination for the artist. In this picture, instead of the domes of Greenwich and St. Paul's, we have Rochester Castle and the Cathedral. Although the Cathedral is only a small one, it has an atmosphere of history about it which seems to linger right up to this day.

Time changes everything

The Impressionists were not admired in my days at the Slade. I remember that we used to have a monthly sketch club with a competition. One of my sketches was hung and old Tonk's comment was 'This student has been influenced by painters who have not been dead long enough!'

RICHARD EURICH

The lack of drawing

My great belief is that today we are short of pure drawing. The word drawing *means, to me, really classical drawing as Leonardo and Rembrandt drew. Nowadays, there is a tendency to sheer away from this, because it's considered old-fashioned.*

JOHN WORSLEY

Flash-back

On one occasion I was painting some moored boats on the River Blyth and was very much put in mind of a Monet painting, when a boat passed upstream with a gentleman in a high stiff collar and tall bowler hat at the helm. It seemed like a dream and I was still puzzling over it as I drove home past the village green. And there I saw a crowd of women in bustles, and soldiers in red coats. It transpired that a Hardy novel was being filmed — Suffolk rather than Dorset was the location, as there were fewer TV aerials.

HUGH KNOLLYS

The contents of marine paintings

I like to put figures into my pictures to give life and interest. You will notice that many marine paintings seem devoid of human life — some ships look as if they have been abandoned and are sailing themselves!

Years ago when I started marine painting, an old printer told me never to introduce death or ships going away — no corpses in the foreground and no ships sailing away. So my ships are always sailing towards you and there is nothing in the foreground to upset anybody!

LESLIE WILCOX

The Impressionists

It was the Impressionists who showed the way into a new concept of painting and, ever since, marine artists have been would-be Impressionists.

RODNEY J. BURN

The tidal Thames and its bad teeth

As an artist I am particularly saddened by the dramatic changes taking place to this river of ours. Its banks have grown a set of bad teeth in the shape of high-rise buildings and this continues apace, slowly blotting out and overshadowing unique views which at one time provided many a scene well worth any artist's attention. These views are becoming more difficult to find, and dodging bad teeth — almost impossible!

JACK POUNTNEY

How to paint sea

As a child, I remember watching John Singer Sargent painting a portrait of a woman with long brown hair. He said to me: 'Paint hair and the sea in the same way, with a full brush of wet creamy paint. Splash it on and never overpaint your first strokes. It's a bit of a hit or miss affair, and if you miss, tear it up and start again!' Needless to say, he seldom missed.

FRANCES PHILLIPS

A knowledge of colour

In the art schools they still teach a little painting, and there is a great tendency for the students to suppose that they can paint from nature with the primary colours. Although it might be possible scientifically to get every shade from the colours of the prism, a true painter does not think that way, he thinks of what he can get from certain tubes. Wilson Steer, who taught me painting, believed in having a great number of different tubes (especially for his watercolours, but also for his oils). You need to get to know many different browns. The harsh effect in so many modern paintings may be caused by students having been taught that all they need to use are the primary colours.

RODNEY J. BURN

Modern trends

There are probably not as many talented painters today as there were in the 19th century, but there are more artists who are just interested in painting rather than in learning the craft, which is a mistake. There are too many 'Sunday painters' who slapdash the paint around and call themselves artists. Also, it seems easier to sell rubbish nowadays. One sees so much mediocre stuff which sells, but it is too expensive even if the price is low. You may see a poor painting priced at £40, which seems cheap, yet in reality it may not be worth 40p.

TERENCE STOREY

Self-criticism

When you are your own hardest taskmaster — which a good artist should be — it does not satisfy you to be told that one of your pictures is marvellous if you yourself know that you could have done it better. You live on top of this situation, and you see other people's work and realise that they have the same problems.

KEITH SHACKLETON

Honest self-appraisal

The day I had a painting accepted by the Royal Academy, I realised I knew nothing whatsoever about painting!

(Name withheld)

Chapter 16.
The Future

W hat routes will marine painting take in the years up to 2000 A.D.? Who but a Turner or a Constable could have foretold and preceded the advent of the Impressionists? In spite of, or perhaps because of, their solid roots in both traditional 19th century painting and impressionism, today's artists seem to be steering safe courses, charted largely by what the public wants and accepts and often motivated by the desire to avoid having a difficult life. When I asked one distinguished artist whether his work was influenced by any particular factor, he replied with one word: 'Money!' Even granted the fact that, having a good sense of humour, he said this with a smile, there is a valid case for the artist receiving enough money to enable him to reject unsuitable commissions and to plan his destiny. The danger point arrives when the artist with a successful formula begins to earn an income which provides him with such a satisfying life that he has no further motivation for experimenting. Indeed, he may fear to diverge too far from his successful formula in case his standard of living and those who are dependant on it are threatened.

Fashions and tastes change. Who now remembers the period between the two wars, when our parents or grand-parents gave their Victorian paintings to the vicar for his jumble sale or to the gardener to burn on the bonfire? Such recollections voiced in the plush halls of the London auction houses would turn many a face pale, because a large part of their vast turnover and profits has been amassed from creating an international demand for paintings and *objets d'art* produced in the last 150 years.

Some artists say they cannot find any romance in a tanker, hovercraft or hydrofoil. Yet the cult of the vintage car, for example, shows that what was commonplace only 60 years ago has an aura of romance about it today.

It is not *what* you do but how you do it that in the end conveys new ideas and originality. Nor is it necessarily the prerogative of young men to lead. Some of the older successful artists at the end of their careers are turning towards new experiments in their painting.

The Impressionists appeared to break entirely new ground (and indeed they did) and turn away from the conventional style of Victorian art as it was then practised. The interesting thing today is that almost all the successful marine painters who are using the realistic traditional style, as well as those who are not, claim that their work has been influenced by the Impressionists. The impact on all styles of modern painting by the Impressionists has been great. Their theory of the juxtaposition of two colours to give a third colour, and the special use of underpainting to give life and light, heat haze or atmosphere — these techniques are now used more widely than is realised.

The future of marine painting therefore probably lies not so much in its ability to use new subject matter as in its treatment of today's subjects. The fact that we eulogise about the Impressionists and Post-Impressionists does not mean that we exclude from our appreciation the work of the Dutch old masters, the Van de Veldes and the Monamys. On the contrary, the true appreciation of art recognises the contribution of all artists in all periods of time and the continuity of knowledge which has passed from one generation to the next.

If one asks, what will the present generation of artists pass on to the next, and what will come from this legacy, such questions of necessity remain unanswered in definite terms because humanity cannot, fortunately, forsee the future. However, one might hazard a guess that advancing techniques and technology will provide new tools for the artist who, with them, will give us new forms of marine art. At the same time, I personally see little possibility that the best of the sea pieces produced in the past 200 years will go out of favour — and 'the best' encompasses a truly enormous number.

Appendix A

The Selection of Paintings for the R.S.M.A. Annual Exhibitions

Contributed by MARK MYERS, Hon. Secretary, R.S.M.A.

The task of choosing the best of the paintings, drawings and sculptures submitted by non-members to each open exhibition is, of course, the lot of the Selection Committee. The worthies who make up this group are not really the blind, horned and tailed creatures imagined by some of the artists whose work they have rejected, but rather are mere members, chosen by ballot from and by the membership. They total 13, nine being the highest scorers in a special ballot, and the remainder, the four officers. This ominous number 13 is reduced in the Hanging Committee, which despite its macabre title, gets along with about nine members and deals with screws and nails rather than nooses.

The job of selection usually begins on the morning after the works for a show are handed in. When the group assembles at about 10.30 a.m., many a wary glance is cast at the long ranks of pictures carefully stacked up, facing the wall. These are the works to be judged, some 600 to 800 in an average year, and from them will come the 200-odd pictures and sculptures to be accepted. In another corner stand the members' works, rather smugly awaiting hanging. These carry a sort of diplomatic immunity to the selection process, and may total somewhere around a hundred items. The number of paintings which can be accepted depends on three limiting factors — the physical size of the gallery which will be used, the number of members' works, and the amount of high quality work from among all that submitted.

The Selection Committee, once seated, operates in the following time-honoured manner: as each artist's work is taken out of the stacks and placed upon a long table, the members react in their individual ways to the work before them. Some crane their necks forward, ready to swoop like a hawk upon rigging gone wrong or a sea out of true, while others arch back and peer through lowered eyelids at the success or failure of the artistic effect. Each picture carries a number which is read out by the Secretary. Then comes the vote, a raised hand signifying 'it is a good picture — let's include it in the show' or an awful stillness meaning the reverse.

Perhaps 'stillness' is an inappropriate word to choose for this part of the proceedings, as members are free to comment in praise or protest on any aspect of any painting. Sometimes, the group will defer to the opinion of a specialist in one of the arcane fields of research which seem to abound in the R.S.M.A., although it is not unknown for two such specialists to emulate their medical brethren and strongly disagree. Some artists will be generally good natured and vote for most works of more than modest accomplishment, and others, perfectionists themselves, will vote for only the best by their own standards. With such diversity of points of view, it is a rare picture which all can agree on, yet a simple majority is fortunately enough to pass a work through the committee and secure its acceptance.

Appendix B

The American Society of Marine Artists

The Americans have a very fine seafaring history and have built and sailed many superb ships. In the last decade they have become more conscious of their maritime heritage, and collectors and others who have long admired British art have begun to take a keener interest in the work of their own marine painters.

One of the results of this new awareness of their considerable fund of artistic talent has been the formation of the American Society of Marine Artists. The Society was chartered as a non-profit making organisation in March, 1978, under the auspices of the National Maritime Historical Society. One of its main aims is 'to encourage public awareness of our maritime heritage and the value of ships, the seas, and the inland waterways as a rich and demanding theme for artistic expression'.

Membership of the A.S.M.A. is open to any interested persons. There are three categories: Members, who are not artists but have an interest in marine art; Artist Members, who create art dealing with marine themes; and Fellows, who are those few artists who represent the highest standards of excellence in marine art and a high degree of maritime knowledge and experience. All members are entitled to submit entries for the annual national exhibition.

The first annual exhibition of the A.S.M.A. took place at the World Trade Centre, New York, in November and December, 1978. Some 83 paintings of a high standard were on show. There was a good selection of clipper ship subjects, historic sailing vessels and events, and some modern ships and yachts (a range not dissimilar to that which one sees in the R.S.M.A. exhibitions in London).

An indication of the prices being asked for pictures in this inaugural exhibition is as follows. A few pictures were quoted as low as $150.00 for 'Cape Horner *E.B. Sutton*' by JAMES M. KELLY; $175.00 for 'Miniature Naval Hero Portraits' by GEORGE CAMPBELL; $225.00 for 'End of Patrol' by CHARLES L. LOCK; and $300.00 for 'Swell' by BILL KROWL. About 30 pictures were in the price range $1,000.00 to $3,000.00 including, for example, 'Brigantine coming into harbour' ($1,200.00) by FRANK W. HANDLEN; 'Lady in Waiting' ($1,500.00) by JOSEPH R. CORISH; '*Passat* below Auckland' ($2,000.00) by THOMAS W. WELLS; and 'Whaling Bark *Alice Knowles*' ($3,000.00) by ROBERT STICKER. Some 13 paintings were priced at over $3,000.00 including 'Steaming up the Potomac' ($3,200.00) by PAUL McGEHEE; 'The start of the 1972 Bermuda Race' ($4,500.00) by CHARLES J. LUNDGREN; 'Sea Ghost' ($8,000.00) by MARSHALL W. JOYCE; and 'Seaward' ($18,000.00) by KIPP SOLDWEDEL.

The Society's second annual exhibition, held in December, 1979, was also a considerable success. Some 39 artists exhibited 69 pictures, of which 33 were sold for a total of $60,000.00.

The first President (1978) of the A.S.M.A. was CHARLES J. LUNDGREN who at the time of his election to office had been a marine painter for 48 years. He has had a lifetime of marine experience from sailing small boats to ocean racing and has engaged in extensive research work. He spent his youth around Long Island Sound and has written '. . . tacking among the yachts of the mighty gave me a sense of those special moments that only happen on the water, and taught me the care that men lavish on their vessels'.

The Vice-President in 1978 was JOHN STOBART, who was born at Leicester in

England, studied at the Derby College of Art and Royal Academy Schools, and now lives and works in the U.S.A. He is a Member of, and exhibitor at, the R.S.M.A. and thus represents one of several happy personal connections between the two Societies. A further personal connection is formed by MARK MYERS, an American now living in Cornwall, England, who is a Fellow and is on the Advisory Board of the A.S.M.A. and is also Hon. Secretary of the R.S.M.A. Mark Myers painted American shipping subjects before he moved to the U.K. in 1971, and since then he has devoted much of his work to British ships.

Another distinguished American artist member who lives in Somerville, Massachusetts, is JOSEPH RYAN CORISH (born 1909) who has been a regular exhibitor at the R.S.M.A. in recent years. His paintings have been exhibited in countries throughout the world and are in many permanent collections, including several in the U.K.

No doubt, as art is international, further links and interchanges will grow up between the two Societies through the activities of individual members. This can only be helpful to the furtherance of marine painting and its appreciation by an even larger section of the public.

By the beginning of 1980, the Society had 75 members, 68 Artist Members and 14 Fellows. The President was PETER W. ROGERS; Vice-President and Treasurer, CHARLES E. ROBINSON; and Secretary, ANN ROGERS. Charles J. Lundgren had been created President Emeritus and John Stobart was Vice-President Emeritus.

COLOUR PLATE 34: LESLIE ARTHUR WILCOX, RI, RSMA (b.1904)

'Homeward bound — Picking up a tug off Dover'. Oil on canvas, 27ins. x 40ins. Exhibited at the RSMA, Guildhall, 1979.

This coastal barquentine, the *Waterwitch,* is rounding Dover on her way home to the Thames. She would be carrying a cargo such as china clay and needed the tug for the last leg of her voyage around the forelands to the estuary.

Leslie Wilcox, a self-taught artist, turned to full-time marine painting after 1945. His work is now much in demand and paintings by him are in the possession of H.M. the Queen and H.R.H. Prince Philip. For many years he has been represented by the Parker Gallery, London, where his pictures are shown.

Photograph courtesy: The artist and the Parker Gallery, London.

COLOUR PLATE 35: LESLIE ARTHUR WILCOX, RI, RSMA (b.1904)

'Jeanette — Battle of Trafalgar, 1805'. Exhibited at the RSMA, Guildhall, in 1970. Oil on canvas, 40ins. x 60ins.

This painting shows a young French girl, Jeanette, about to be rescued from the sea during the battle of Trafalgar by a boat's crew from H.M.S. *Pickle.* The girl was a stowaway in the French ship *Achille* in which her husband was serving. Towards the end of the battle the *Achille* was set ablaze and finally blew up, and Jeanette was one of the many survivors saved by the British.

Leslie Wilcox likes to introduce figures into many of his marine paintings, as he justly feels that this gives additional life and interest. The expressions of amazement and disbelief on the faces of the British sailors in the boat's crew are a study in themselves. The story had a happy ending for Jeanette, as she eventually re-joined her husband.

Photograph courtesy: The artist and the Parker Gallery, London.

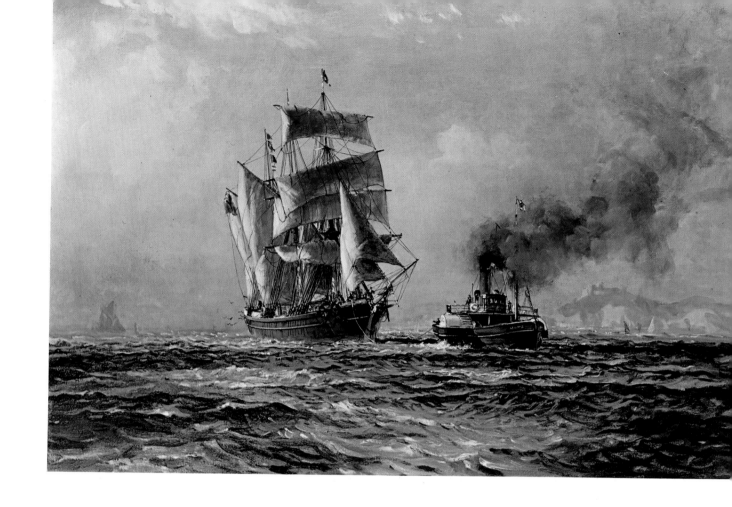

Appendix C

The Wapping Group

This group is limited to 25 artists who paint scenes on the tidal Thames. Applicants submit suitable pictures and, if selected, they become candidates for one year. At the end of that year, if they are considered to be up to the required standards, they are elected as full members.

The group was born in 1947. In that year, four or five members of the Langham Sketching Club[23] went sketching down the river Thames to the Prospect of Whitby and thereabouts. They were approached by the Chairman of the Port of London Authority, Sir John Anderson (who later became Lord Waverley), who said he would like to hold an exhibition of pictures of the London River. The Wapping Group was formed and provided pictures for the first exhibition in 1949, which was a great success. The first few exhibitions were held at the P.L.A. headquarters, and Sir John Anderson provided everything including encouragement plus the premises and tea. The sales at the first exhibition amounted to about £470, and by 1980 they were well over £6,000.

This is an active, enthusiastic group. Because they are linked to a specific subject of allegiance they tend to produce exciting work and visitors to their exhibitions come from as far away as China and Japan.

Appendix D

The Preparation of Wood Panels for Oil Painting

JOHN HAMILTON invariably paints in oils on wood panels. I am indebted to him for supplying the following notes on the preparation of these panels:

Cut the full width of a sheet of marine or exterior quality plywood, at least 9mm. thick (I usually cut 30 x 48 ins. or 36 x 48 ins.). Cover with 'polyfilla' and allow to dry. Sand off so as to leave a smooth grainless board.

Apply five coats of grey cellulose filler. This is the undercoat used in the motor trade, reduced by thinning. Use a wide flat brush and work fast. Do not go over the work a second time. It dries in 40-60 minutes.

Apply five coats of white cellulose filler. Rub down with wet and dry paper, first medium and then fine grain, until the whole surface is absolutely smooth. By preparing the surface in two colours you will know when you have rubbed half way through the paint, as the grey will begin to show. Never allow the rubbing to uncover the wood.

Cut the panels with a fine tenon saw to the size required. It is always easier to prepare a large surface and cut it up than to paint and rub down small pieces of board.

23. Founded in 1830. Now the Artists Society.

Appendix E

The East Anglian Group of Marine Artists

Contributed by G.A. Jones, Hon. Secretary.

The Group is a loosely-knit band of professional and semi-professional marine artists who regularly paint in the area from the Wash to the Thames. First proposed in 1979 by a few painting friends who often work together on coastal subjects in the region, the Group was constituted in April 1980 with John Davies, OBE, RSMA as its first President. Membership is limited to 21 and members plan to paint together several times a year and to use the 'Butt & Oyster' at Pin Mill as their meeting place.

It is anticipated that one or two exhibitions will be held annually at such places as Norwich, Ipswich, Colchester, Cambridge and later on in London. There may also be smaller displays at other East Anglian centres.

East Anglia has always had a tremendous influence on painters, greater, perhaps, than any other region in the British Isles, producing such masters as Gainsborough, Constable, Henry Bright, the Cotmans and the Cromes. Those who were more influenced by marine subjects in Norfolk, Suffolk and Essex are, in some instances, scarcely less notable, portraying the shipping of their day, the local craft, harbours and waterways with great observation, skill and charm. Here are some names which come to mind: Arthur Briscoe, George Burrows, Thomas Churchyard, Miles Cotman, E.W. Cooke, Charles Dixon, Edward Duncan, Nora Davison, George Frost, Martin Hardie, Alfred Herbert, the Joy Brothers, Thomas Lound, Henry Moses, John Moore, C.M. Maskell, Bertram Priestman, George Race, Edward Seago, Leonard Squirrell, Joseph and Alfred Stannard, Colijn Thomson, Alker Tripp, George Vincent, Charles and William Lionel Wyllie, Barlow Wood — and a dozen others.

This is the tradition the East Anglian Group of Marine Artists takes up, depicting the marvellous skies of the region, the muddy seas, sandbanks, mudflats and empty beaches, local fishing and work-boats, as well as Thames barges, yachts, coasters and shipping. The range of subjects is very great, with the many estuaries and creeks, the busy docks and disused barge wharves, as well as the navigable inland waterways such as the Broads and Fenland rivers.

COLOUR PLATE 36: TERRICK JOHN WILLIAMS, RA, RI, ROI (1860-1936)

'Brixham harbour'. Oils, 20ins. x 30ins.

The work of Terrick Williams has become more widely acclaimed in recent years. Whilst his painting shows the influence of the Impressionists, his style is original and distinctive. His exhibition record in the early part of the 20th century is impressive (including 142 pictures at the Royal Academy and 111 at the ROI) and his work is now sought after by discerning collectors. He painted both marine and landscape pictures, many of them being harbour scenes. He studied in Antwerp and Paris and was at one time President of the RI and Vice-President of the ROI.

Photograph courtesy: The Louise Whitford Gallery, London.

COLOUR PLATE 37: JOHN WORSLEY, VPRSMA (b.1919)

'Chinese New Year, Aberdeen, Hong Kong'. Oils, 38ins. x 60ins. Painted in January, 1979.
Exhibited at the RSMA, Guildhall, in October 1979.

John Worsley is noted for his wide-ranging talents as a marine artist, portrait painter, illustrator and sculptor. He has these interesting comments to make about the large and impressive picture illustrated here:

'Having been a marine artist for many years I have tended to get disenchanted with modern ships — enormous tin boxes with no romance — and this regrettably has diluted my enthusiasm to a point where I seldom ever get excited by a subject as I once did.

'It was for this reason that I thought I must jolt myself out of this state of mind, and a trip to Hong Kong, where there still might be some junks left, could be a cure. Sadly, I found that there are few sailing junks remaining; in fact I saw only one from red China passing through. However, the fishing town of Aberdeen gave me a rare excitement and I regained all the old enthusiasm, at any rate for this occasion. The result was this picture.

'I was fortunate in having hospitable friends with whom to stay, and I spent all of a month in and around this floating town. The view is taken from the roof of a floating restaurant, on which I sat for two days doing watercolours and taking photographs. The remainder of the time was spent in sampans and fishing boats making friends in spite of the formidable language barrier, drawing, photographing and studying the various craft and the fascinating floating population with their ever fluttering washing, dogs, chickens, pigs, drying fish and delightful children.'

ILLUSTRATIONS

In selecting pictures from the many hundreds available, the chief endeavour has been to make the range as wide as possible. The work of well known artists is therefore seen alongside and can be compared with that of lesser known painters. There is an abundance of talent and it is clear that a number of artists deserve wider recognition. **As the photographs are arranged in the alphabetical order of the artists' surnames, their sequence does not denote any preferment of artistic merit.**

The illustrations which follow are divided into two sections:

PLATES 1 to 212

First, there is a short sequence of photographs which are intended to show the general development of styles through the 19th century leading to the 20th. This is immediately followed by the main section consisting of illustrations of oils, watercolours and drawings by British marine artists from 1900 onwards.

PLATES 213 to 254

This section consists of the marine pictures of a number of war artists from both World Wars. As will be seen, the atmosphere and feeling which these artists produced in their pictures could not have been achieved by photography. Most of these artists were professional painters who continued their work in civilian life.

Plates 1 to 13 show the general development of styles bridging the 19th and 20th centuries.

PLATE 1: DUTCH SCHOOL (c.1650)

This Dutch marine oil sketch was painted *en grisaille* on a mahogany panel (20ins. x 24ins.) about 1650. It shows the orderly way in which the Dutch artists generally drew ships and the formalised treatment of the sea with its waves in regular and somewhat stylised rows.

Photograph courtesy: Christie's.

PLATE 2: ROBERT SALMON (c.1775-1840)

'Shipping off Greenock, Scotland'

This picture shows the continuance of the Dutch influence in British marine painting at the end of the 18th and beginning of the 19th centuries. It is interesting to compare both the formalised treatment of the sea and the composition of the ships with the same features in PLATE 3.

PLATE 3: MILES AND SAMUEL WALTERS (c.1830)

'The sailing ship *John Taylor* **off Liverpool'.**

Oil on canvas, 28ins. x 46ins., painted jointly by MILES WALTERS (1774-1849)
and his son SAMUEL WALTERS (1811-1882).

This magnificent picture is another good example of the Dutch influence in British marine painting originated by the
VAN DE VELDES. Again, the formalised sea and elegant attitude of the ship (two views of the same vessel) are clearly
part of the long-standing 'classical' tradition in marine art.

PLATE 4: JOSEPH MALLORD WILLIAM TURNER, RA (1775-1851)

'Life-boat and Manby apparatus going off to a stranded vessel' (A vessel in distress off Yarmouth).
Oil on canvas, 36ins. x 48ins. Exhibited in the Royal Academy in 1831.

The genius of J.M.W. Turner as a marine artist has never been equalled, but his work has inspired and influenced hundreds of other painters to this day.

His treatment of sky and sea shows a remarkable depth of feeling for the power and structure of those vast forces of nature. Note also his clever placing of the figures on the beach in the foreground (compare this with a similar composition by John Constable, PLATE 7).

PLATE 5: JOSEPH MALLORD WILLIAM TURNER, RA (1775-1851)

'Yacht racing in the Solent'. (Sketch for 'East Cowes Castle — The Regatta beating to windward' No.3).
Painted c.1827. Oil on canvas, 18¼ ins. x 28½ ins.

Turner's sure touch and deft handling of light and air are well illustrated in this oil sketch of yachts racing. A forerunner of impressionism and other 'modern' techniques, J.M.W. Turner would be just as much at ease if he were painting scenes of Cowes Regatta today, over 150 years later.

PLATE 6: JOHN CONSTABLE, RA (1776-1837)

'Brighton beach with Colliers'. Painted in 1824. Oil on paper, 5⅞ ins. x 9¾ ins.

This beautiful small picture, painted in oils on paper, demonstrates Constable's mastery of the 'impressionist' coastal scene long before the advent of the French Impressionists.

PLATE 7: JOHN CONSTABLE, RA (1776-1837)

'Coast scene with shipping in the distance' ('Hove Beach'). Painted c.1824. Oil on paper, 12½ ins. x 19½ ins.

Here is a superb example of marine painting by John Constable, sometimes incorrectly thought of as a landscape artist only. He painted many fine coastal and sea pieces, including one of H.M.S. *Victory* at the battle of Trafalgar. This picture illustrates Constable's marvellous understanding of the relationship between sea and sky in marine work and his genius as an impressionist. Note also the solitary figure on the beach, which gives a total completion to the whole composition.

PLATE 8: C.M. POWELL (fl.1807-1821)

'A revenue cutter going out to an armed merchantman near Dover'. Oil on canvas 24ins. x 36ins.

This shows a classical presentation of the vessels with a representational and dramatic treatment of the sea. It is a picture in the 'old master' style before the era of Victorian romantic attitudes.

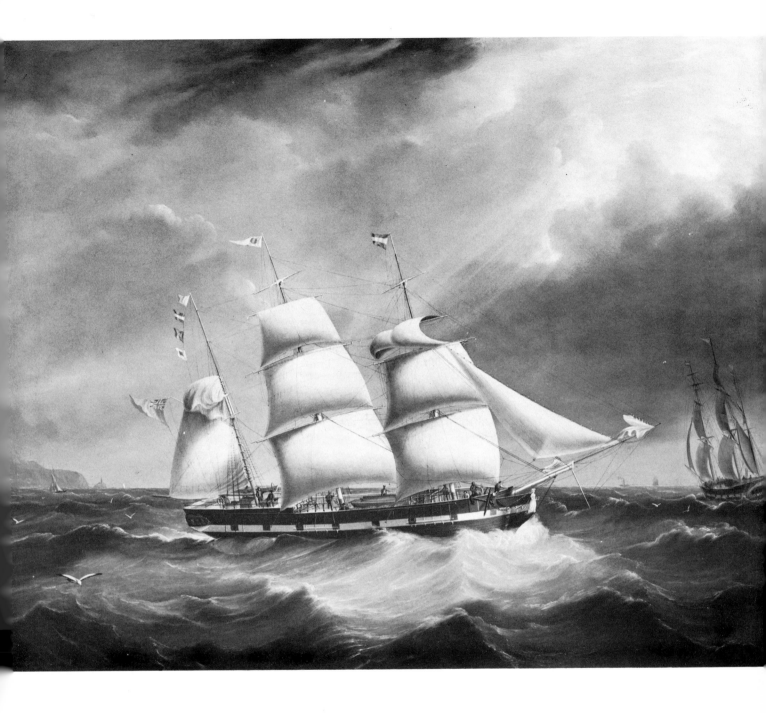

PLATE 9: JOSEPH HEARD (fl.1839-1856)

'**The sailing ship** *Mary Ray* **under sail off the coast**'. Oil on canvas 28ins. x 36ins.

This painting shows the beginning of a more fluid approach to the portrayal of sea. The sea is still powerful and dramatic, but the shapes and formation of the waves are closer to nature than to the former tradition of classical design.

PLATE 10: THOMAS ROSE MILES (fl. 1869-1888)

'Rye fishing boats coming ashore near Hastings after a stormy night'. Oil on canvas 28ins. x 40ins.

Here is a typical Victorian treatment of subject and sea — realistic and with a story to tell. This type of style and feeling have been carried through into many 20th century paintings.

PLATE 11: JOHN MOORE OF IPSWICH (1820-1902)

'Sailing vessels off a harbour entrance'. Oil on canvas 22ins. x 30ins.

This fine picture was painted in 1872 and has a mellow, Gainsborough-like quality. The sea and the sailing vessels are treated in a less rigid style than earlier in the century, and there is a tendency towards the freer techniques of painting which grew in the last part of the 19th century.

PLATE 12: HENRY MOORE, RA (1831-1895)

'**A short cut to the Krossec Rocks, Wimeraux**'. Watercolour, 22ins. x 31ins.

One of the really great painters of pure sea, Henry Moore was influenced initially by the Pre-Raphaelites but later turned to his famous style as illustrated here: a free, impressionistic technique, giving the impression of vast seas and skies acting in harmony. This picture is dated 1887 and shows how far British marine artists had developed their own ideas, free from rigid classical formulae, by the end of the 19th century.

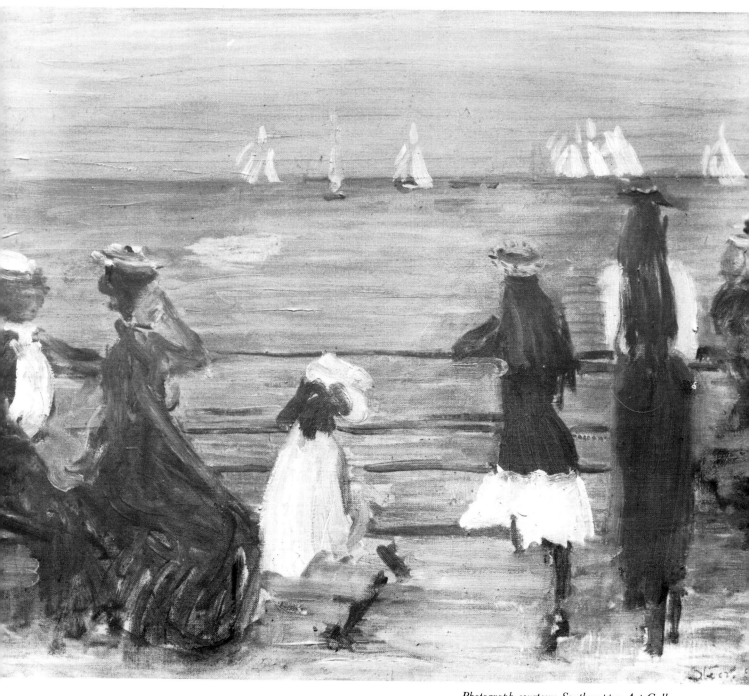

Photograph courtesy: Southampton Art Gallery.

PLATE 13: PHILIP WILSON STEER (1860-1942)

'Watching Cowes Regatta', Oils, 20ins. x 24ins.

This beautiful picture was painted in 1892 and illustrates almost the ultimate in free style by a British artist at the end of the 19th century. Following some criticism of his drawing, Wilson Steer later tightened up his draughtsmanship (see PLATE 248) perhaps to the detriment of the splendid freedom shown in his early work. The picture shows the considerable influence of the French Impresssionists, which travelled side by side with Victorian traditional representation into 20th century Britain.

20th Century Marine Paintings.

The illustrations are arranged in the alphabetical order of the artists' surnames.

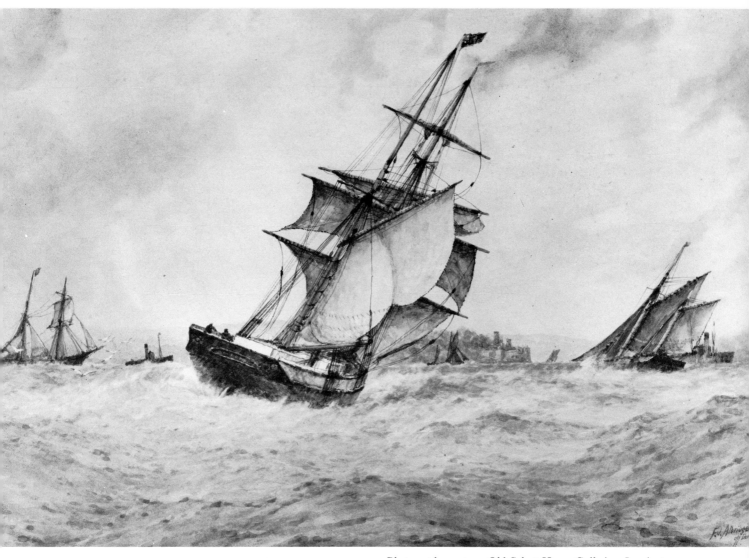

PLATE 14: FREDERICK JAMES ALDRIDGE (1850-1933)

'**Off Dartmouth**'. Watercolour, 19ins. x 29ins.

This artist lived in Worthing for some 83 years and for 50 years he was a regular visitor to Cowes week. His watercolours are distinctive, usually colourful, and becoming increasingly appreciated. His sailing vessels, as shown in this picture, are often exceptionally well painted. He carried the 19th century traditions very effectively into the 20th, and the steam vessels in the background of this painting give a hint of things to come.

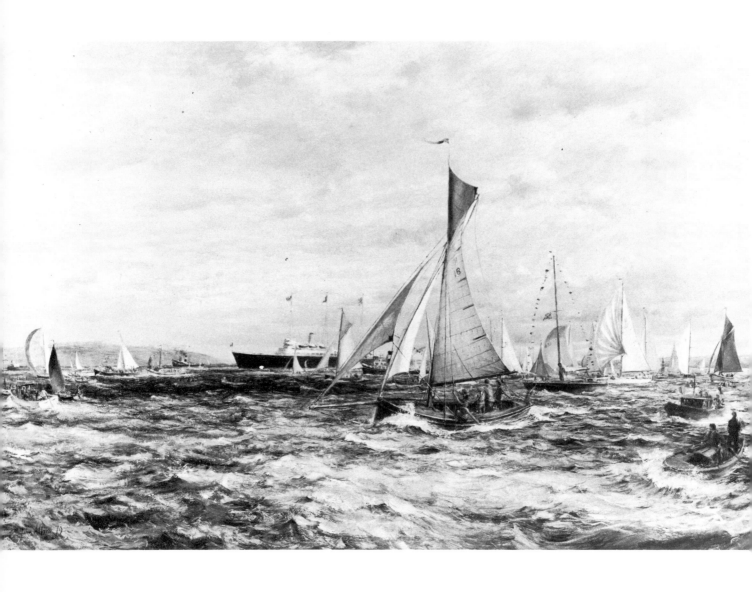

PLATE 15: JOHN ALFORD, RBA, NEAC, NDD (b.1929)

'The *Britannia* at Falmouth'. Oil on board, 31ins. x 48ins.

A lively, interesting picture, full of action. The artist was on one of the many yachts that sailed out to meet the *Britannia* when the Queen visited Falmouth as part of her Jubilee Tour in 1977. The vessel in the foreground is a Falmouth Quay Punt — a local class that was originally used for shuttling cargoes to and from ships at anchor in the roads. It was on a quay punt, owned by Howard Spring, that the artist first sailed in the 1950s.

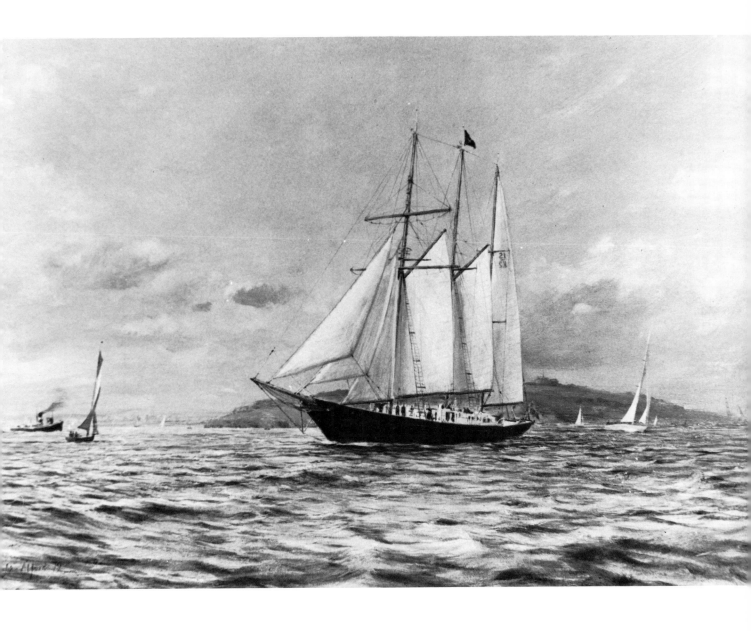

PLATE 16: JOHN ALFORD, RBA, NEAC, NDD (b.1929)

'The *Malcolm Miller* **leaving Falmouth'.** Oil on board, 20ins. x 30ins.

John Alford was sailing at Plymouth at a time when the *Malcolm Miller* called at that port, and was able to capture this scene.

 The sister ships *Malcolm Miller* and *Sir Winston Churchill* are owned by the Sail Training Association. They are three-masted topsail schooners with gaff and topsails on the fore and main and a Bermudian mizzen, and square sails on the foremast. Their Thames measurement is 300 tons, length 153 feet, beam 25 feet, and draft 16 feet. The top of the main mast is 112 feet above the waterline. Both ships cruise in the English Channel and North Sea throughout the year, taking young people on cruises of about two weeks duration. There are cruises for boys, girls and mixed adult cruises. The ships also take part in the Tall Ships Race.

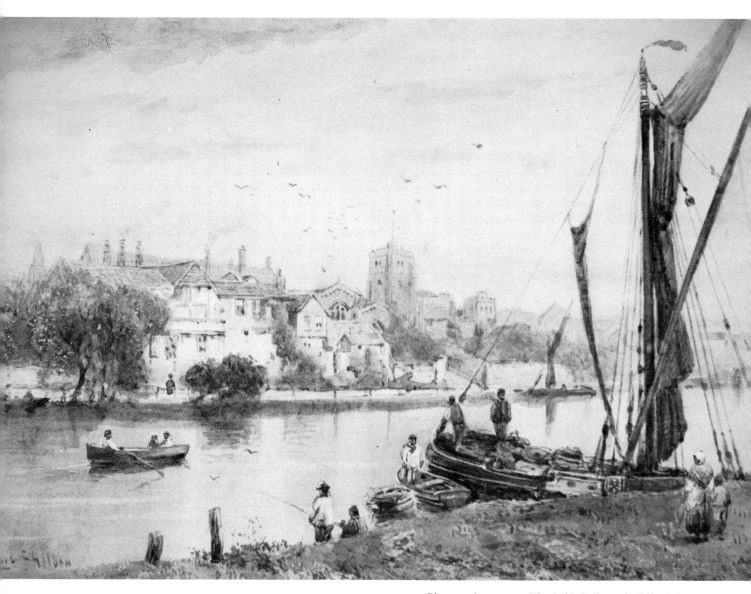

Photograph courtesy: The Reid Gallery, Guildford, Surrey.

PLATE 17: CHARLES FREDERICK ALLBON, ARE (1856-1926)

'Sailing barges in an estuary'. Watercolour, 4¾ins. x 7ins.

Charles Allbon painted mainly in watercolours, and was also an illustrator and etcher. He exhibited quite considerably at the Royal Society of Painter-Etchers and Engravers, also at the Royal Academy. This small watercolour shows his skilful handling of figures as well as barges at rest.

PLATE 18: CHRISTOPHER NICHOLAS ANDERSON (b.1926)

'**The sailing ship** *Cimba*'. Oil on canvas, 28ins. x 36ins.

The artist has been associated with the sea all his life, from small boats to large ships, and has been painting marine subjects for some 30 years. The painting is in the possession of J.M. Fimister Esq., whose grandfather owned the *Cimba*.

PLATE 19: CHRISTOPHER DAVID ARNOLD (b.1955)

'Thames barges at Greenwich'. Watercolour, 12ins. x 18ins.

This picture was painted after the artist saw the Thames Barge Race of 1979. He has been exhibiting at the RSMA from 1978.

PLATE 20: ROBERT TRENAMAN BACK, DA(Edin.) (b.1922)

'*Dreadnought* **parts with her pilot off Sandy Hook, New York'.** Oil on canvas, 24ins. x 34ins.

Dreadnought was built in 1853 at Newbury port, Massachusetts. She was 1,417 tons and belonged to the Red Cross Line. This renowned packet ship gained a reputation as the finest passenger liner of the great days of sail. With a long list of record passages to her credit, she became known as 'the wild boat of the Atlantic'.

The artist, Robert Back, lives and paints in England, but is well known in the U.S.A. for his pictures of 19th century American ships and maritime events.

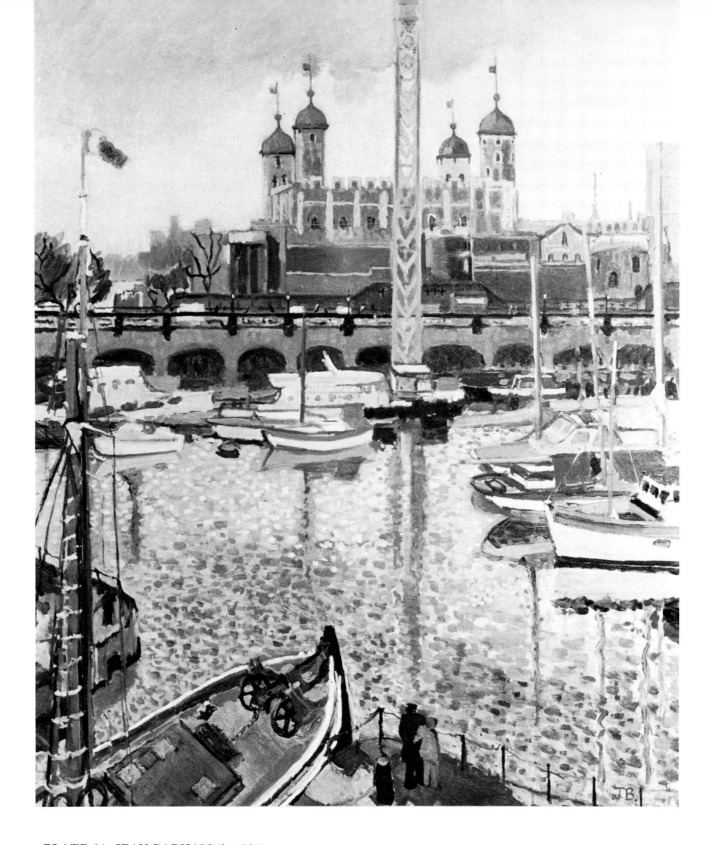

PLATE 21: JEAN BARHAM (b.1924)

'The Tower from St. Katharine's Dock'. Oils, 50ins. x 48ins.
Award winner in 'Spirit of London' competition, Royal Festival Hall, 1979.

This large painting shows a view of the Tower of London which has now been cut off by the construction of a new building.

PLATE 22: STUART BECK, RSMA (b.1903)

'Atlantic weather ships transferring mail'. Oils, 20ins. x 30ins. Exhibited at the RSMA, Guildhall, 1979.

In 1979, Stuart Beck spent three weeks on board a weather ship in the Atlantic ocean, making sketches and painting oils and watercolours. One of the resulting pictures is shown above and the artist has described the scene as follows:
 'The Atlantic Weather Station *Lima* (57°N.20°W.) is manned by two ships which relieve one another every three weeks. The relieving ship drops the mail container overboard, attached to floats (and in this case lights, as it is dark). It is picked up by the other ship, with a heaving-line and grapnel. By this procedure the crew of the vessel going off station get their mail and newspapers sooner than they would otherwise, because she is still about three days steaming from Greenock, her home port.'
 Stuart Beck has had a lifetime's experience of the sea and marine painting. His first attempt at oils (belonging to his mother, as it happened) was painted on a piece of shoe box when at the age of seven he was somewhere off Cape Horn in a cargo ship.

PLATE 23: STUART BECK, RSMA (b.1903)

'The long, slow haul'. Oils, 16ins. x 30ins.

The artist has painted his impression of the wearisome monotony of a long ocean tow at very slow speed. Towing oil rigs is a skilful and hazardous task, and this picture captures the scale of such operations.

Stuart Beck has been a regular exhibitor at the RSMA since the inaugural exhibition in 1946. He is well known for his marine watercolours, but is equally at home in using oils.

PLATE 24: VYVYAN BENNETT, ATD (b.1928)

'The Ferry Boat Inn, Salcombe, Devon'. Watercolour, pen and ink, 10ins. x 14ins.

The artist is particularly interested in skies and light over water and land. He is a keen deep water sailor and makes a watercolour, pen and ink record of the places he visits.

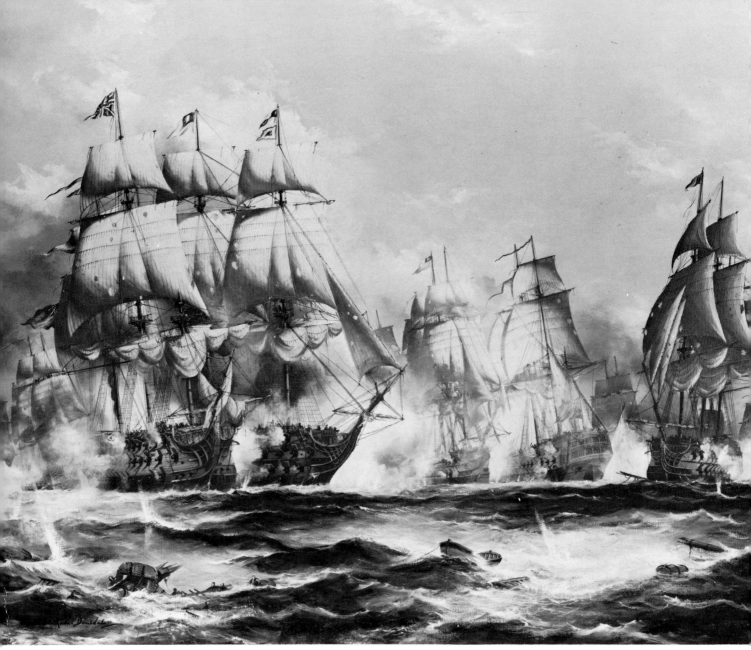

PLATE 25: JOHN BENTHAM-DINSDALE (b.1927)

'The Glorious First of June'. Oil on canvas 40ins. x 50ins.

John Bentham-Dinsdale has painted marine subjects for many years and has become well known for his pictures of deep sea sailing ships and naval engagements.

This large and impressive painting shows the naval engagement on 1st June, 1794, between the British and French fleets in the North Atlantic some 400 miles off Ushant. The picture shows Admiral Lord Howe's flagship the *Queen Charlotte* (which has just lost her fore topmast) and the French flagship *Montagne* commanded by Admiral Villaret de Joyeuse. The *Montagne* eventually arrived back in Brest with 230 holes in her hull and some 300 dead and wounded.

This was the first major sea battle in the war between Britain and Revolutionary Napoleonic France. Lord Howe took six prize ships and sank a seventh with no loss of his own forces. He was acclaimed as a hero on his return to England. On the other hand, the French also considered they had won a victory, as a vital grain convoy from America, which their fleet was supposed to protect, managed to slip through and reach France. Some historians feel that Lord Howe could have captured the convoy if he had pressed home his victory, but he was 68 years old and had become exhausted after four days of fighting. Furthermore, he had been at sea since the 2nd May. Whatever the theories of later commentators may be, Howe was a great and experienced Admiral and his achievements in this battle were considerable.

134

PLATE 26: ROY BERRY, PS (b.1916)

'**Waiting for the tide, Porthleven'.** Oil on canvas, 24ins. x 36ins.

Roy Berry always paints directly from life and practises traditional methods. His marine work is mainly concerned with coastal scenes, harbours, and boatyards.

PLATE 27: WILLIAM MINSHALL BIRCHALL (1884-c.1930s)

'Running into heavy weather'. Watercolour, 10ins. x 13¾ins. Dated 1922.

The artist painted chiefly in watercolours and produced many fine pictures of deep sea sailing ships, such as the one illustrated here. He was born in Iowa, U.S.A., but worked for many years in England and well into the 1930s. His marine subjects usually cover the Thames estuary and English Channel, but he also went as far south as Gibraltar. Examples of his work are in the Walker Art Gallery, Liverpool, permanent collection.

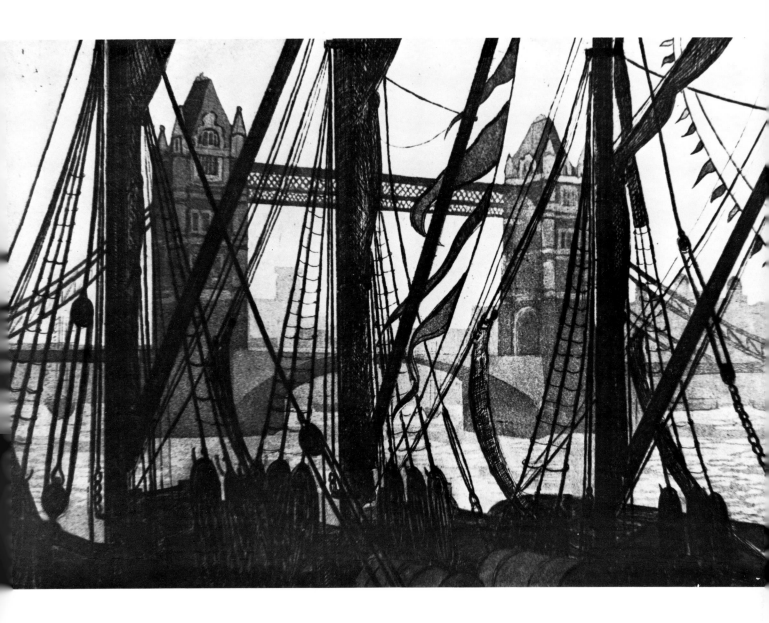

PLATE 28: MAUREEN BLACK (b.1926)

'After the barge race, Clipper Week 75'. Etching and aquatint, 10¾ ins. x 15¾ ins.
Exhibited at the RSMA, Guildhall, 1977.

This etching was done as a result of going to see the moored-up barges at Hay's Wharf, London, at the end of the Barge Race during 'Clipper Week 75'. Maureen Black says she found the shapes of masts, spars and rigging silhouetted against Tower Bridge particularly beautiful. She is a member of the Thames Barge Sailing Club.
 The plate with the rigging, spars and masts is mainly etching and the colour used is dark brown-red. The second plate of the water and Tower Bridge is mainly aquatint, and the colour used is blue-grey.

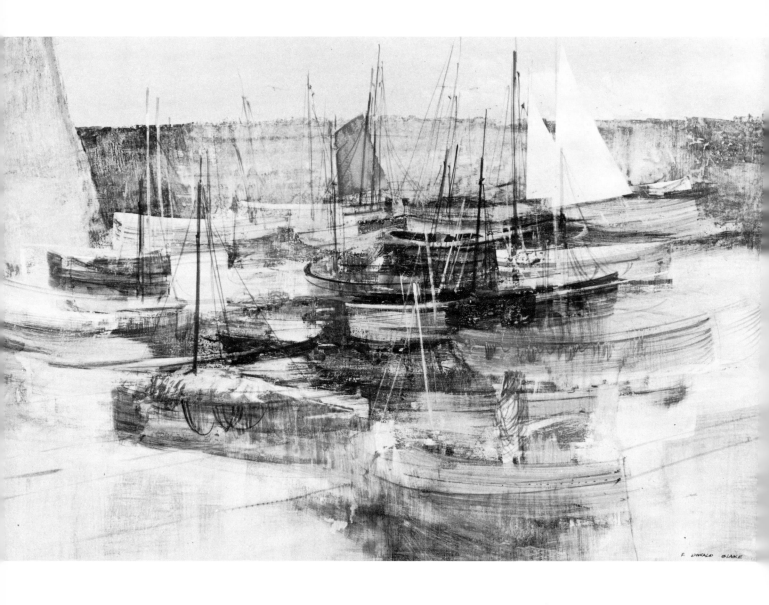

PLATE 29: FREDERICK DONALD BLAKE, RI, RMSA (b.1908)

'**In harbour'.** Watercolour, 17 ½ ins. x 27 ½ ins. Exhibited at the RSMA, Guildhall, 1979.

A very unusual and imaginative picture in which the artist is giving a special interpretation of the subject as he sees it. Basically, he is concerned with the fact that when clustered together, boats lose their individual identities and become a sort of totality — a kind of fussy, busy mess with certain internal rhythms and repetitions. The harbour is no particular place but an essence of many similar harbours, with all the fussiness being enclosed by the firm line of the harbour wall. The white sail provides a strong focal point.

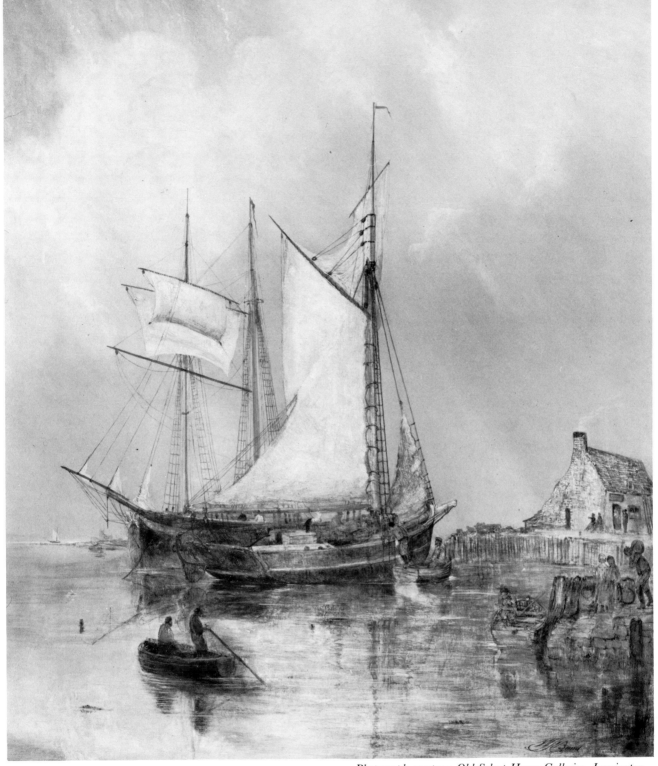

Photograph courtesy: Old Solent House Galleries, Lymington.

PLATE 30: WILLIAM JOSEPH J.C. BOND (1833-1926)

'Sailing vessels by a harbour wall'. Oil on canvas, 29½ ins. x 23½ ins.

This artist was affectionately known as 'Alphabet Bond' on account of his numerous initials. He painted a considerable number of pictures in the 19th century, but continued well into the 20th. He had a passion for ships and the sea and remained a courageous sailor until he was well over 70 years old. W.J.J.C. Bond was a Liverpool painter who started out in the Pre-Raphaelite manner and became converted to impressionism. His pictures show great talent and often some genius. The painting illustrated here is dated 1901.

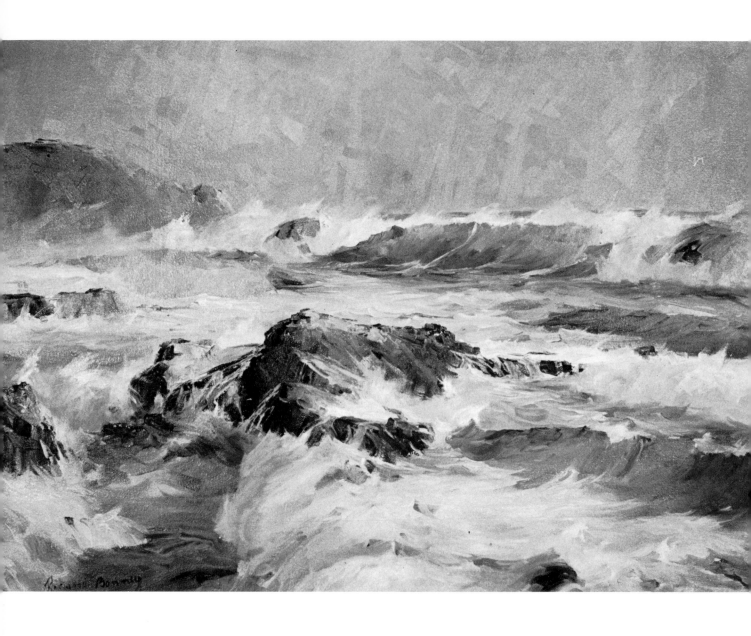

PLATE 31: RICHARD OLIVER BONNEY (b.1902)

'Spindrift'. Oil on canvas, 22ins. x 32ins.

Richard Bonney has lived for most of his life in Cornwall and his sea pieces are particularly concerned with the coast there. He is President of the Newquay Society of Artists (1980) and has exhibited at the RSMA from 1970.

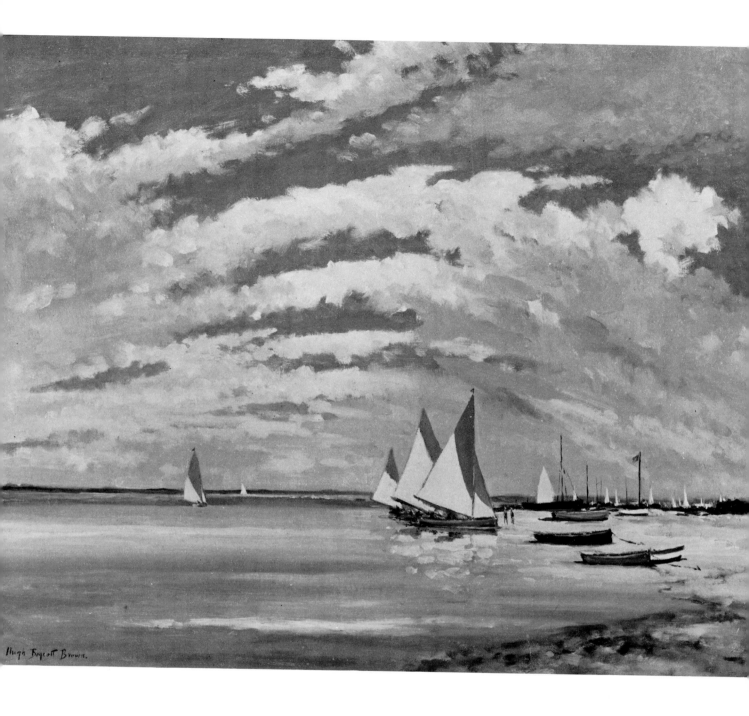

PLATE 32: HUGH BOYCOTT-BROWN, RSMA (b.1909)

'**Before the start**'. Oil on canvas 23½ ins. x 29½ ins. Exhibited at the RSMA, Guildhall, 1977.

This painting is a view of the 'cut' from the end of the quay at Blakeney in Norfolk. It shows the yachts ready to go to the start of the handicap race in the harbour. For many years after the war, the artist had a cottage at Blakeney where he used to both paint and sail. The artist says that 'in pre-war years I had great help from Sir Arnesby Brown, RA, and in addition there was my admiration for Boudin and the Impressionists — therefore Blakeney was a wonderful and ideal place to begin to study the sky, the clouds, and the magic light of East Anglia. The lessons I learnt there have never been forgotten in my work — with the sky and the light always forming the dominant element in all my paintings'.

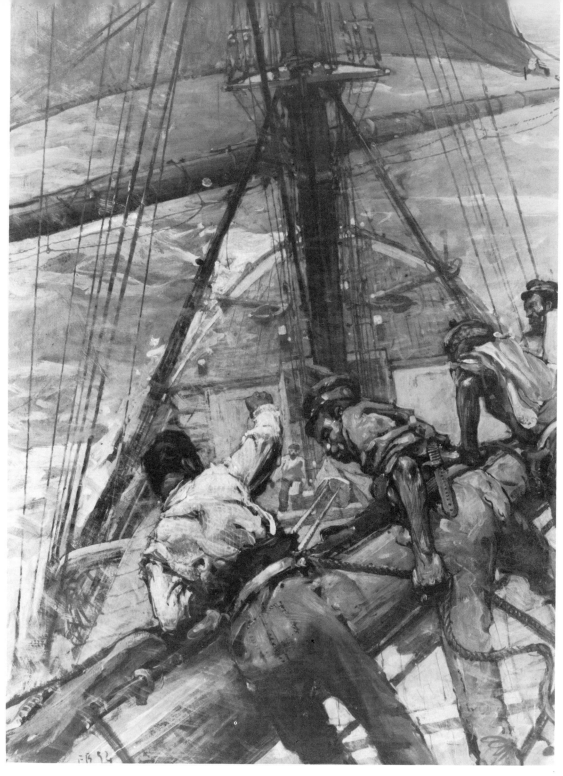

PLATE 33: SIR FRANK BRANGWYN, RA, RWS (1867-1956)

'Heavy weather in the Channel: Stowing a mainsail'. Oils, 30ins. x 22ins.

Frank Brangwyn had an enduring love of the sea. He worked and travelled on ships from an early age and understood the vessels and the seamen. His marine work, which includes oils, watercolours and etchings, has been much admired by many other artists. The range of his painting, etching and lithography extended widely to other subjects including figures, architecture and murals, and his pictures are in numerous public collections.

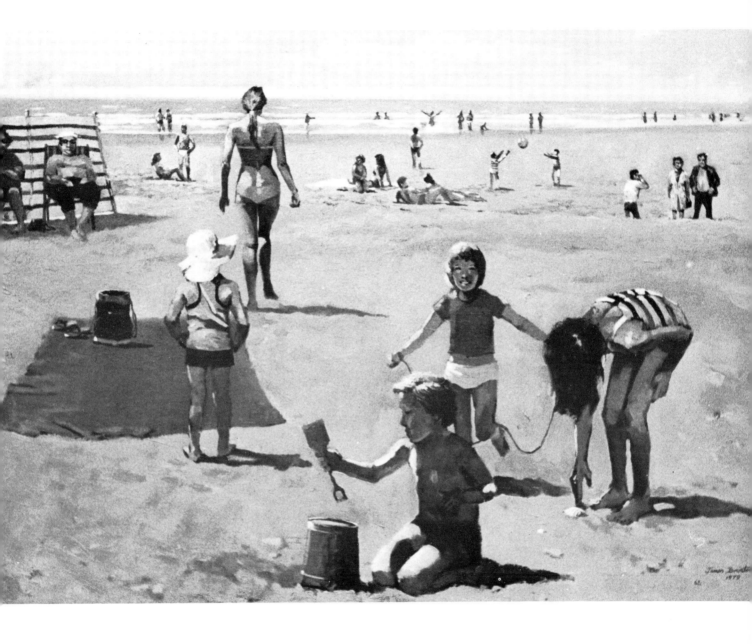

PLATE 34: JAMES JOSEPH BRERETON (b.1954)

'**Beach scene**'. Oil on canvas, 24ins. x 36ins. Painted in 1979.

This painting is a composite and is no beach in particular. The figures are taken from holiday memories and the couple being photographed in the top right-hand corner are the artist's parents. The artist was trying to capture the feeling known to so many: a day by the sea. For some children it is their first glimpse of it, and an exciting adventure.

There is a lot of jollity and atmosphere in this picture to remind us that the sea can be enjoyed by thousands of land-based people who just like looking at it and putting their toes in the salt water.

PLATE 35: ARTHUR JAMES WETHERALL BURGESS, RI, ROI, RBC, RSMA (1879-1957)

'The Brotherhood of Seamen' *(The Glengyle).* Oils, 41¼ ins. x 65ins.

The artist was at one time an illustrator for well known periodicals and his excellent sense of draughtsmanship may be judged by the ship in this picture. He exhibited at the RSMA from the inaugural exhibition in 1946 onwards, and was a founder member and Vice-President of that Society. His marine work is highly regarded.

The painting illustrated here shows an imaginary incident in which survivors are being rescued. The *Glengyle*, however, was real enough. She was a cargo liner belonging to the Glen Line and has some claim to fame as she was used as Field Marshall Montgomery's headquarters for the invasion of Sicily.

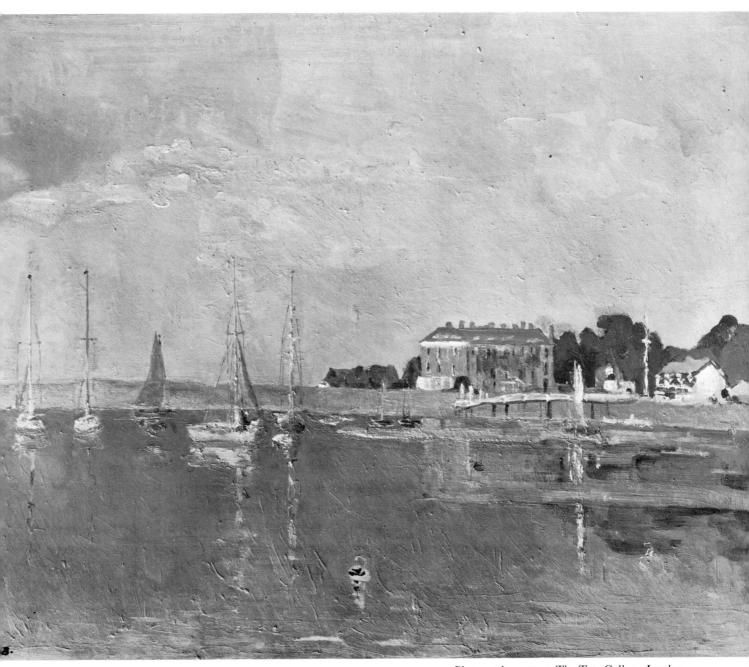

PLATE 36: RODNEY JOSEPH BURN, RA, NEAC, Hon.RSMA (b.1899)

'Bembridge'. Oil on canvas 32ins. x 40ins. Painted in 1952. (Chantrey Bequest from the artist, 1953).

The alluring impressionism of this painting demonstrates how the touch of professional genius can achieve a wholly satisfying effect which hundreds of lesser painters strive after for years without gaining the same result.

This picture, now in The Tate Gallery, shows Bembridge harbour in the Isle of Wight and was reproduced as a limited edition colour print in 1979.

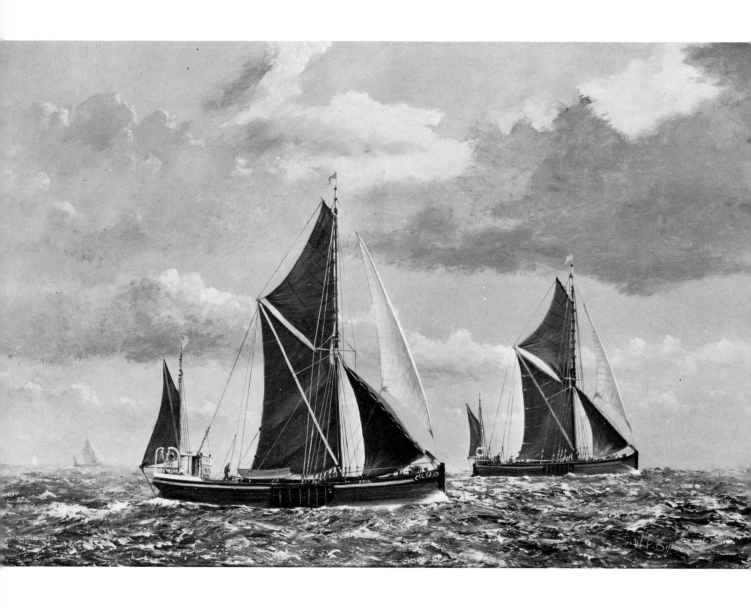

PLATE 37: WILLIAM FRANCIS BURTON (b.1907)

'Ethel **and** *Reminder'*. Oil on board, 16ins. x 24ins. Exhibited at the RSMA, Guildhall, 1977.

Two of the few remaining coastal barges, which have been converted into pleasure craft as their trading life has ceased. The graceful lines and dignity of these craft appeal to many artists. William Burton's paintings of coastal craft have enjoyed wide popularity primarily because of his meticulous attention to detail.

PLATE 38: DONALD EVERARD (DON) BUTLIN (b.1929)

'**Men of Dunwich'.** Oils, 20ins. x 32ins. Exhibited at the RSMA, Guildhall, 1978.

A strong painting which makes a good contribution to the records of present day coastal fishing and the men who are engaged therein. The artist has lived near the sea in Essex and Suffolk for over 20 years and so gains his material from direct observation and experience.

PLATE 39: ASHTON CANNELL, RSMA, ATD, UA (b.1927)

'**After rain on the Thames**'. Watercolour, 20ins. x 29ins.

The picture was painted in the artist's studio from a smaller one (half Imperial) done on location a couple of weeks previously. The original sketch had somewhat less dramatic lighting and in fact was abandoned because 'rain stopped play'. In this larger painting Ashton Cannell wanted to capture the effect of sunlight filtering through cloud after rain and being reflected in the river and mud.

 Although some liberties have been taken with the distant bank, the painting is a fairly literal copy of the original drawing which depicts a stretch of the Thames known as Bugsby's Reach which lies between Greenwich and Woolwich just down-river from the Blackwall Tunnel.

Photograph courtesy: Pyms Gallery, London.

PLATE 40: JOSEPH W. CAREY (fl. 1915-1935)

'A schooner in Caribbean waters'. 9¾ins. x 7ins. Dated 1916.

Joseph Carey, a native of Belfast, was principally a watercolour artist. He exhibited 25 pictures in the Royal Hibernian Academy and was elected an Academician of the Ulster Academy of Arts on its foundation in 1930.

PLATE 41: SANDRA LORRAINE CARLIN (b.1956)

'*Adda* — **Castletown harbour, Isle of Man'.** Watercolour. Exhibited at the RSMA, Guildhall, 1978.

Painted on the spot in the winter of 1977-78. The artist lives only a few yards from this scene. Castletown is her home town and her favourite harbour in the Isle of Man.

PLATE 42: PETER J. CARTER, RSMA (1920-1979)

'**London barge**'. Oil on canvas 23½ ins. x 36½ ins. Exhibited at the RSMA, Guildhall, 1977.

The artist was a very disciplined and hard-working painter and the Thames barge was dear to his heart and a favourite subject. He had a great respect for working boats, such as the trawlers at Brixham in Devon, but especially for the barge which he felt was both beautiful and practical. This painting shows a deep feeling for the subject.

PLATE 43: TREVOR CHAMBERLAIN, ROI, RSMA, NS (b.1933)

'**Martello tower and boat**'. Oils, 9½ ins. x 13½ ins. Exhibited at RSMA, Guildhall, 1977.

A nicely balanced composition. The artist set out to portray a bright morning with a slight breeze, and with the subject matter bathed in an almost silvery light. The nearly unique features of the Kent coastline coupled with the characteristics of the local craft make a most interesting combination.

PLATE 44: JAMES CHAMBURY (b.1927)

'Aldeburgh, very early morning, fishing boats going out'. Oil on canvas, 18ins. x 38ins.

This picture was painted from sketches made at four o'clock in the morning during one week of the summer of 1978 and was one of a series of six paintings made from these sketches. At that time of day the light changes rapidly and it is only possible to make sketches and take colour notes.

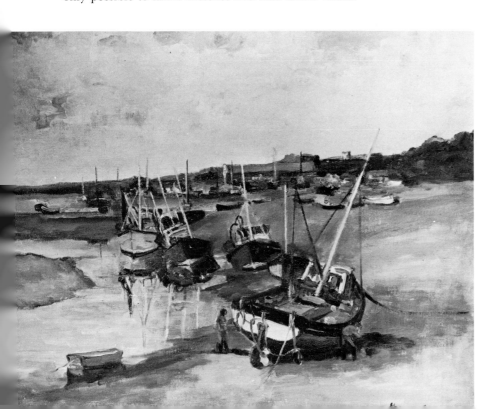

PLATE 45:
MARION COKER (b.1911)

'Bawleys of Old Leigh'.
Oil on canvas board, 16ins. x 20ins.

The artist lives at Leigh-on-Sea, Essex, and likes to paint the local fishing vessels and other craft. She has exhibited at the RSMA since 1964.

153

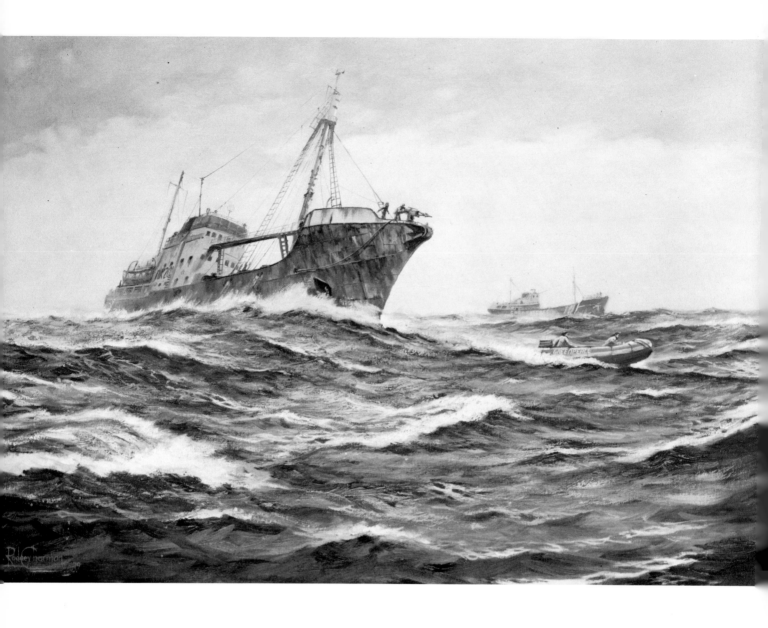

PLATE 46: RODNEY JOHN KEITH CHARMAN (b.1944)

'To save the whales'. Oil on canvas, 20ins. x 30ins.

A vigorous picture of special present day interest, it shows two members of the *Greenpeace* crew positioning their rubber inflatable boat between a Russian whaler and fleeing whales. This is a good example of art being used as an effective communication on behalf of a cause close to the artist's heart.

PLATE 47: HUGH CHEGWIDDEN
(b.1913)

'Nets and floats'.
Oil on canvas, 24ins. x 30ins.

The artist specialises in marine still-life and *trompe l'œil*. In this picture he wanted to record the glass floats in particular as they are becoming extinct, being replaced by plastic floats. It used to be something of a find to pick up a glass float washed up on the beach, and many were displayed on window ledges with exotic sea shells, or were hung alongside cottage doors. It is left to the viewer's imagination as to what the old stone jar might contain, but the red handkerchief with white spots is part of the traditional gear of fishermen, often worn around the neck to this day.

PLATE 48:
ALBERT JOHN HENRY
CLIFFORD
(b.1934)

'Great Yarmouth harbour (Darbys Hard)'.
Oils, 30ins. x 40ins.

An American tug breaks away briefly from her work in the North Sea oil and gas fields to act as anchor for a roll-on-roll-off ferry heading down river stern first carrying articulated trailers bound for Holland. In the foreground, men prepare a shrimper that represents the dwindling fleet of small longshore fishing boats still using Great Yarmouth, which was once the world's leading herring port.

This oil by an artist specialising in Norfolk Broads and harbour scenes captures the three aspects of this port.

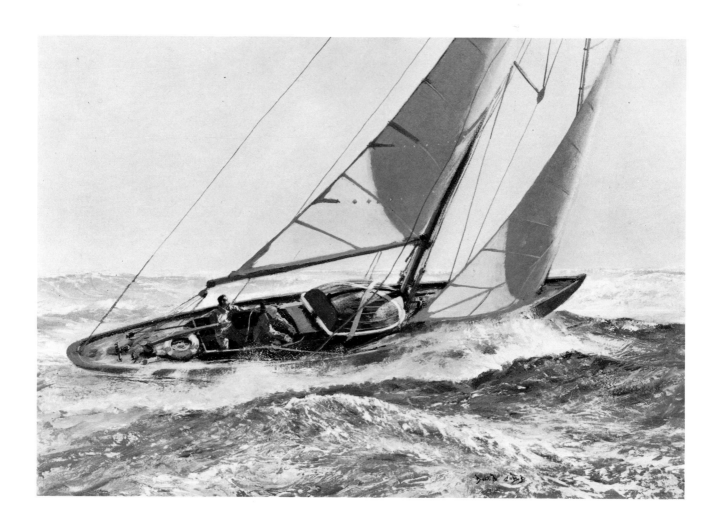

PLATE 49: DAVID COBB, PRSMA, ROI (b.1921)

'**Blow the wind Southerly**'. Oils, 18ins. x 26ins. Exhibited at the RSMA, Guildhall, 1977.

This painting shows the ex-8-metre *Alpenrose* owned by the artist, 1956-62. A classic type of racing yacht, it sailed superbly well, but was a very wet craft. The irregular run of the sea and hazy sky were typical of the Brittany coast, which *Alpenrose* often visited.

David Cobb is a keen yachtsman and a dedicated marine painter. His whole life has been focussed on and around sea-experience and a study of the sea, and his knowledge of the way it works is put to expert use in his pictures.

PLATE 49/A: DAVID COBB, PRSMA, ROI (b.1921)

'1,000-guinea Wager Race, 1st September, 1834'. Oils, 24ins. x 30ins.
(Now in a private collection in Canada)

Two Royal Yacht Squadron craft, the *Waterwitch* (a brig of 331 tons) and the *Galatea* (a schooner of 179 tons) raced from the Nab lightship round the Eddystone and back. They reached the Eddystone together, but on the return run up-Channel, *Waterwitch* drew very slowly ahead to win by 20 minutes. Such wager races were common at that time.

The artist, David Cobb, says that he paints in oils 'everything of any period that floats'. He served in the Royal Navy in the last World War and started painting professionally in 1946 at Newlyn. He now lives in the New Forest, Hampshire, and is President of the Royal Society of Marine Artists.

PLATE 49/B: DAVID COBB, PRSMA, ROI (b.1921)

'Lower Hamstead, Newtown, Isle of Wight'. Oils, 20ins. x 24ins.

The left-hand yacht in the foreground is the 8-ton cutter *Laura* built to A.E. Payne's design in 1900 at Woolston and still cruising in 1980. Newtown is a famous beauty spot and nature reserve, much beloved by yachtsmen as a peaceful summer anchorage.

Photograph courtesy: The Omell Galleries, London.

PLATE 50: SALVATORE COLACICCO (b.1935)

'**The paddle-steamer** *Cambria*'. Oil on panel, 10ins. x 14ins.

Salvatore Colacicco was born in Italy in 1935. He studied art at the Brera Academy, Milan, and made a special study of the paddle-steamers used on the Italian lakes before coming to England where he now lives and paints.

PLATE 51: PETER RICHARD COOK (b.1944)

'**Halcyon days**'. Watercolour, 17ins. x 21ins. Exhibited at the RSMA, Guildhall, 1977.

The ship was a cross-Channel ferry named *Alma* and she is seen entering St. Peter Port, Guernsey, whilst operating on the Southampton-Channel Islands service during the early years of this century.

This ship sailed during the period which many people now consider was the golden age of steam ships, and the intention of this painting is to recreate the gentle charm and tranquillity of a bygone age, rather than just a historical curio.

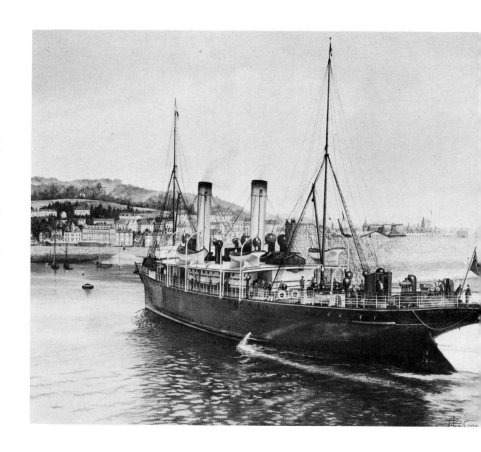

PLATE 52: JOHN COOPER (b.1942)

'**The trawler** *Sunningdale*'. Watercolour and bodycolour, 18ins. x 28ins. Exhibited at the RSMA, Guildhall, in 1979.

The *Sunningdale* is a Dutch built steel 'beam' trawler which was first used for river-estuary work. She came to England from Holland in 1962 and was first berthed at Grimsby. She then went to Scarborough and subsequently to Bridlington in 1973. Her dimensions are: 55ft. length overall, 13ft. 6ins. beam, 6ft. draft. She is powered by a 270 h.p. Volvo engine and is owned and skippered by Mr. Charles Newby with a crew of two.

The picture shows *Sunningdale* heading for home after a day's fishing. John Cooper paints a wide range of marine subjects, but is particularly interested in trawlers, in which he specialises.

PLATE 53: JOSEPHINE MARY (JO) COOPER, SGA, VA, ARMS (b.1932)

'Evening light at Pin Mill'. Watercolour, 21ins. x 27ins. Exhibited at the RSMA, Guildhall, 1978.

Jo Cooper paints boats of all descriptions, ports, harbour scenes and landscapes, in oils and watercolours. She has had numerous exhibitions, and is a Rowland Prize winner (1977) and a Silver Medallist, Paris Salon (1974).

PLATE 54: JANE CORSELLIS, NEAC, ARBA, NDD

'Fishing off Newport Sands, Dyfed'. Watercolour, 12ins. x 22ins. Exhibited at the RSMA, Guildhall, 1979.

This picture was painted in the Autumn of 1978. Jane Corsellis is particularly interested in beaches in the autumn and winter when they are almost deserted and the cool light brings out tones of blue and grey seldom seen in the summer.

PLATE 55: GRENVILLE GEORGE COTTINGHAM (b.1943)

'The supertanker *British Argosy* homeward bound'. Oils, 24ins. x 36ins.

This picture was painted in 1968 when the artist was serving with the Seafarers Education Service as their first seagoing artist-tutor, a scheme started in 1966 to encourage an interest in the creative arts on board British merchant ships. The painting shows the *British Argosy* on her return voyage from the Middle East after loading oil. She was then the largest British built tanker afloat at 112,000 tons dwt.

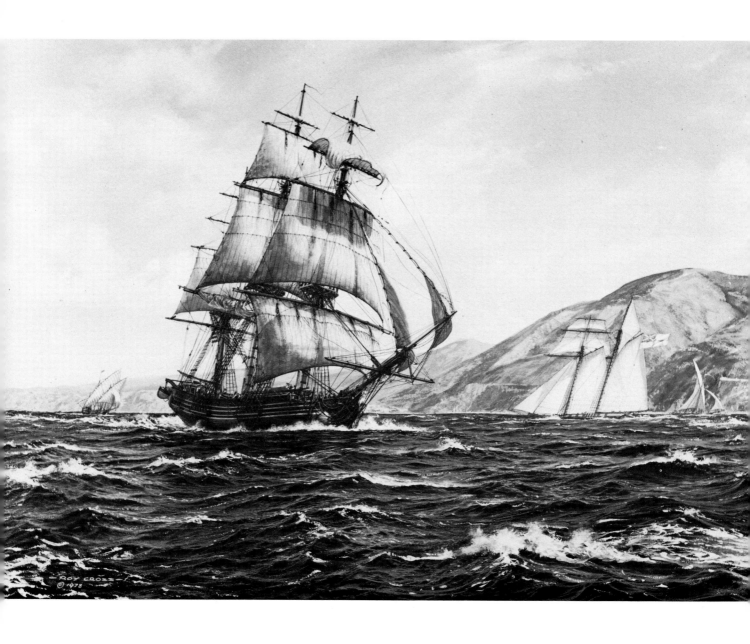

PLATE 56: ROY CROSS, RSMA, SAvA (b.1924)

'**The Mediterranean Trade**'. Gouache, 20ins. x 30ins.

This painting shows the trader *Lovely Matilda* off the Italian coast near the straits of Messina, with a Royal Navy schooner and local craft in the background. Built in Philadelphia in 1805 with a burthen of 231 tons, she was typical of the vessels which carried the bulk of trade into the inland sea from Northern Europe and North America.

PLATE 57: ROY CROSS, RSMA, SAvA (b.1924)

'The privateer *Lynx* off the Maine Coast, U.S.A.' Oils, 21ins. x 29ins. Exhibited at the RSMA, Guildhall, in 1977.

Roy Cross specialises in painting famous sailing ships, sea battles and historic marine events in harbour and at sea. He travels extensively for research purposes and his work has received international recognition, particularly in the U.S.A.

Photograph courtesy: National Maritime Museum, London.

PLATE 58: ALMA CLAUDE BURLTON CULL (1880-1931)

'*King Edward* **class battleships at sea'.** Oils, 30ins. x 66ins. Dated 1912.

Because his pictures are rarely seen today, the name of A.B. Cull is now little known. Nevertheless, he was a very fine marine painter, working in the early years of the 20th century, and his ability may be clearly seen in the work illustrated here. He exhibited at the Royal Academy and other leading galleries and was commissioned by King Edward VII to paint ships.

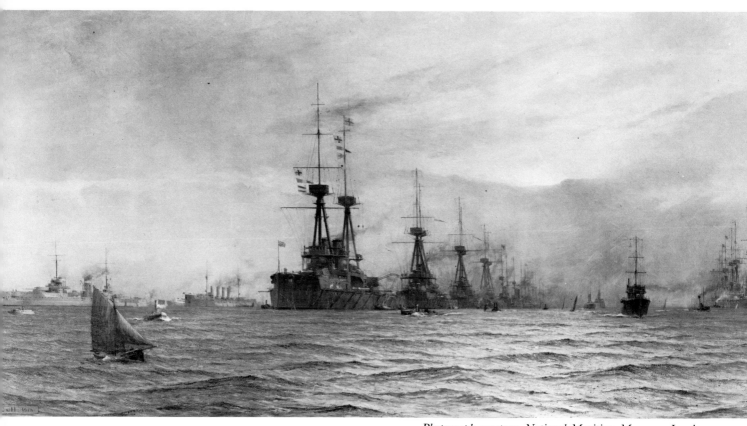

PLATE 59: ALMA CLAUDE BURLTON CULL (1880-1931)

'The eve of Coronation Review, 27 June, 1911'. Oils, 38ins. x 74ins. Dated 1912.

The quality of this painting and its excellent atmosphere bring to mind similar work by the famous W.L. Wyllie.

 Pictures of this type point up the important role of marine artists in recording ships and events which pass into history. The artist achieves effects and feeling that can never be replaced by photography.

Photograph courtesy: The Bourne Gallery, Reigate, Surrey.

PLATE 60: ERNEST DADE, NEAC (1865-1935)

'Early morning, Scarborough'. Watercolour, 13ins. x 20ins.

Although Ernest Dade was born in London and studied art in France, he lived for many years in Scarborough and is often thought of as a Yorkshire artist. His work is very talented but not often seen. The picture illustrated here was in fact painted at the end of the 19th century, but he continued in this idiom well into the 20th, painting the sea and coast in the area of Scarborough, Whitby, etc. He was a true marine artist and also an excellent ship modeller.

PLATE 61: DAVID DAVIES, ROI (1864-c.1924)

'The harbour, Dieppe'. Watercolour, 8½ ins. x 10¼ ins.

An Australian who spent most of his life in England, David Davies painted many fine seascapes and landscapes in Cornwall and France, where he made Dieppe his base as he was fond of painting the harbour there.

Photograph courtesy: Sotheby Parke Bernet & Co.

PLATE 62: MONTAGUE DAWSON, RSMA (1895-1973)

'The Lady and the tramp'. Oils, 19 ½ ins. x 29 ½ ins.

Montague Dawson became internationally known for his pictures of clipper ships, but he also painted many other marine subjects including yachts, steamships and some coastal scenes and historic naval subjects. This interesting painting shows that his repertoire was by no means confined to sailing ships.

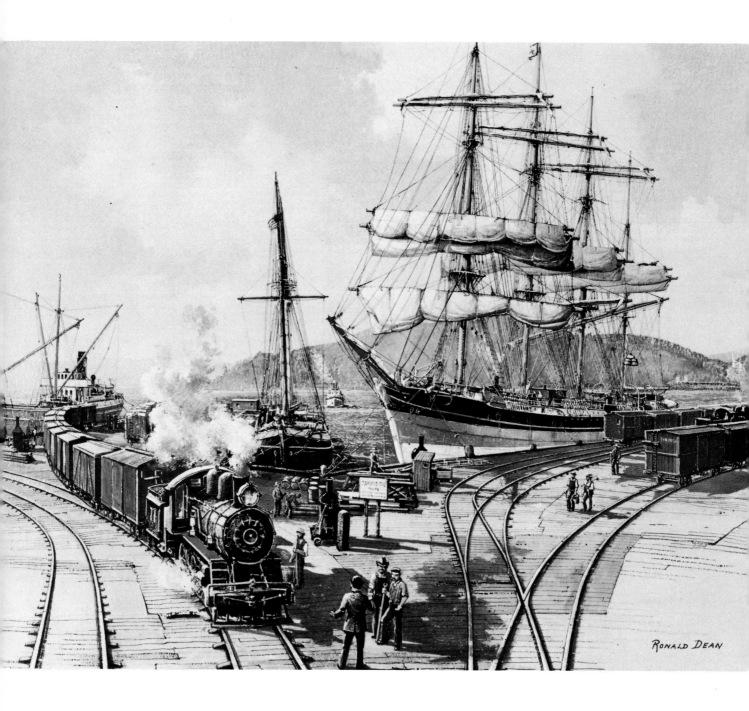

PLATE 63: RONALD DEAN, RSMA (b.1929)

'Loading grain at Oakland, California, c.1905'. Gouache, 18ins. x 24ins.

This picture was inspired by an old photograph in the San Francisco Maritime Museum. Ronald Dean said that on seeing the photograph he immediately thought that a judicious simplification of the railway sidings and a little more curve on the lines would give a splendid composition. To avoid any suggestion of copying, he altered the square-rigger and based her on the *Lyderhorn*, a four-masted barque which carried home cargoes of grain from San Francisco at about the time the photograph was taken. The artist also visited the harbour and got as near as it is now possible to get to the actual spot from which this view was painted.

170

PLATE 64: KENNETH DENTON, RSMA, FBID (b.1932)

'The Silver Light, River Blackwater'. Oils, 23ins. x 35½ins. Exhibited at the RSMA, Guildhall, 1977.

The painting depicts the Blackwater Barge Race in 1975. The time is about 8.30 a.m. and the viewer is looking into the sun which is beginning to penetrate the rising river mist. The subtlety of these circumstances offers a great challenge to the painter. Kenneth Denton says that such a situation reflects his conception of marine and landscape painting, based on the many aspects of light as it is conditioned by the prevailing weather into its infinite variety of atmospheric effects.

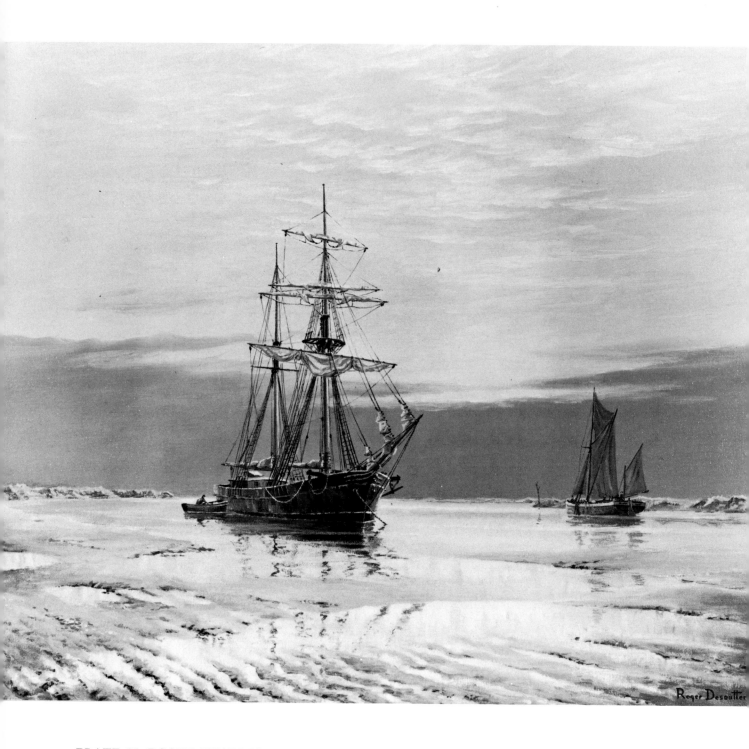

Roger Desoutter

PLATE 65: ROGER CHARLES DESOUTTER, FRSA (b.1923)

'**The Scandinavian Brigantine**'. Oils, 20ins. x 24ins. Painted in 1979.

This is a scene from the days of coastal sailing craft on the East coast of England, where the estuaries and rivers still provide a wide variety of subjects for the artist.

Roger Desoutter has been painting for most of his life, combining this ability with a successful career as an engineer, first with Sir Frank Whittle on jet engines and later as the head of his family firm. He started exhibiting with the Society of Aviation Artists in 1955 and more recently with the RSMA.

PLATE 66: JOHN STEVEN DEWS (b.1949)

'*Salamis* **outward bound**'. Oil on canvas, 30ins. x 40ins.

Salamis was a wool clipper, built in 1875 by Hood of Aberdeen. She was 1,130 tons gross, and her length was 212 feet. The picture symbolises the sailing conditions this artist most enjoys: wind force 4 to 5 with sunlight dancing on a boisterous sea. A fine sailing ship is probably seen to her best artistic advantages in these circumstances.

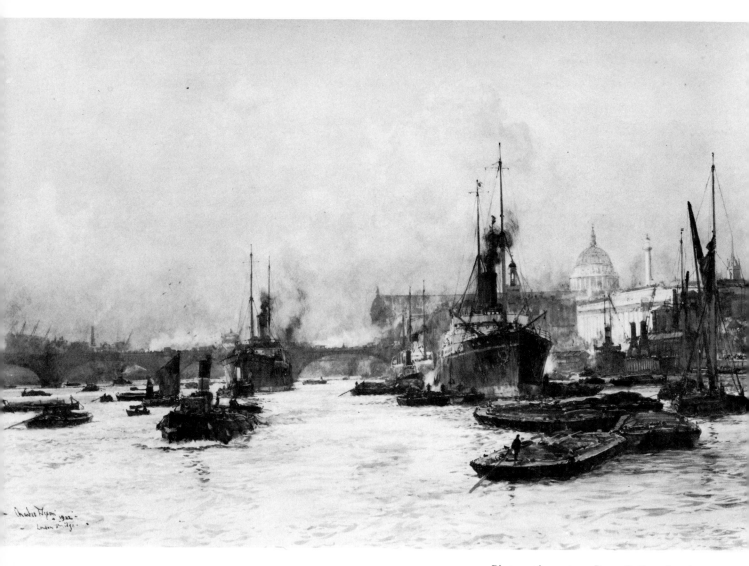

PLATE 67: CHARLES DIXON, RI (1872-1934)

'London Bridge'. Watercolour, 20ins. x 30ins. Dated 1922.

Charles Dixon's tidal Thames scenes with cargo steamers and sailing barges are now greatly admired and sought after by collectors. The picture illustrated here shows a nostalgic view of the Thames that will never be repeated, with the disappearance of the ships and their attendant smoke. This was a time when many artists felt that the London River was at its most romantic, and they say that today it has lost much of its appeal for painters.

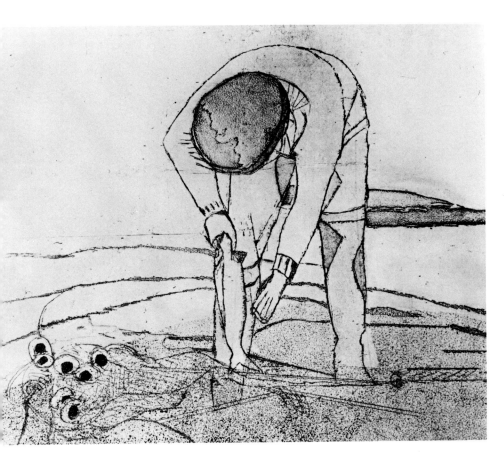

PLATE 68:
HONOR DOBBS (b.1903)

'John Duffy'.
Etching, 10ins. x 13ins.
Exhibited at the RSMA,
Guildhall, 1979.

John Duffy has the salmon
fishing rights at Cushendun, Co.
Antrim, Northern Ireland. The
artist paints a wide range of
subjects in oils and watercolours,
and she is also an accomplished
etcher.

PLATE 69:
ALEXANDER BRIAN
RODERICK
DOW (b.1918)

'Porthguarnon 1979'.
Acrylics, 14½ ins. x 21½ ins.

This scene is based on rocks at
Porthguarnon in Cornwall, but
reconstructed and incorporating a
theoretical lighting and impossible
calm sea situation to produce a
dreamlike surrealist effect.
 The artist is a regular exhibitor
at the Royal West of England
Academy, and paints in oils, water-
colours and acrylics.

PLATE 70: VICTOR (VIC) ELLIS, DSM, RSMA (b.1921)

'Trading days: in the Jenkin Swatch'. Oil on canvas, 20ins. x 30ins. Exhibited at the RSMA, Guildhall, 1978.

This painting tells of trading days in the earlier part of the 20th century, as the buoyage indicates. The 'Jenkin Swatch' (now known as the 'Nore Swatch') is the channel between the Nore Sand and the Kent shore. The barge *Hawk,* in the foreground, was one of five of that name all operating at the same time. She was owned by the Bowman family of Southend-on-Sea and is shown here in a stiff northerly blow together with other barges bound from London to the river Medway.

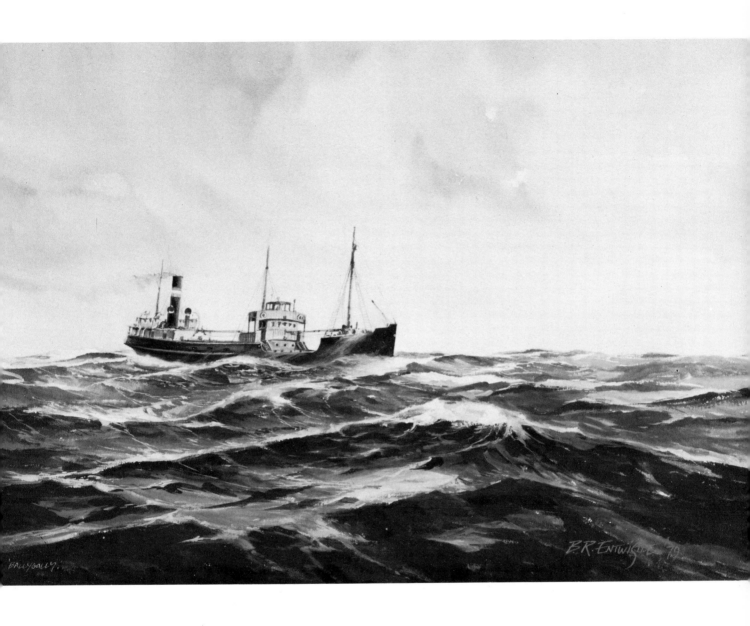

PLATE 71: BRIAN RICHARD ENTWHISTLE (b.1939)

'**Coaster** *Ballygally*'. Watercolour, 11ins. x 16½ins. Exhibited at the RSMA, Guildhall, 1979.

This picture gives a good impression of the lonely slog of small vessels around our shores in all weathers. The artist feels that not enough marine painters devote their time to the post-war shipping scene with its multitude of small working craft such as coasters and trawlers.

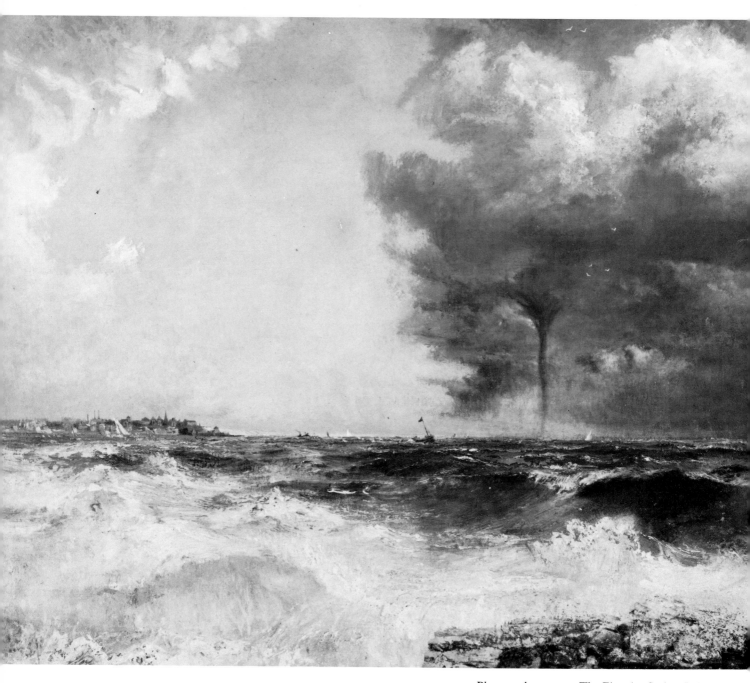

Photograph courtesy: The Fine Art Society Ltd.

PLATE 72: RICHARD EURICH, RA, Hon. RSMA, Hon. NEAC (b.1903)

'Waterspout on the Solent'. Oil on canvas, 20ins. x 24ins. Painted in 1954.
(Exhibited at the Royal Academy in 1955).

This picture demonstrates the artist's complete command of sea painting, and shows how the work of many of the great 19th century marine painters can still be rivalled today. The dramatic sky reflected in the sea, the powerful movement of water, the distant vessels and shoreline — all are beautifully observed and balanced in a masterly composition.

Air currents over the Solent produce heavy clouds over the mainland, which result in very heavy showers and other natural phenomena over the water. The artist witnessed this particular scene much as it is presented in the painting.

PLATE 73: RICHARD EURICH, RA, Hon. RSMA, Hon. NEAC (b.1903)

'**The Great Tanker**'. Oil on canvas, 30¾ins. x 40ins. Painted in 1969.

Not very far from the artist's home is that area of the Solent between Southampton Water and Cowes where super-tankers anchor whilst awaiting their turn to discharge their cargoes at the nearby Fawley oil refinery.

Richard Eurich has painted a number of pictures embodying these giant vessels (in which, he says, the scale presents an interesting problem). A straightforward picture of a supertanker is rarely prepossessing, but by using the vessel as part of the human scene and related to surrounding sea activities, the artist has produced a picture of considerable fascination.

PLATE 74: JOHN EVERETT (1876-1949)

'Yachting: A small gunter-rigged cutter towing a dinghy'. Oil on paper, 10ins. x 14ins.

There is a collection of some 1,700 oil paintings and an even larger number of drawings and engravings by John Everett in the National Maritime Museum. This collection very nearly represents the artist's entire output of marine pictures as he never sold his paintings, having a sufficient private income. He studied at the Slade and at Julian's in Paris. From 1898 onwards he made many sea voyages, sometimes as an ordinary seaman, and accumulated hundreds of his talented paintings and sketches made from first-hand experience. At one time he also owned a 9-ton cutter called the *Walrus,* in which he cruised. A memorial exhibition of his work was held in 1964 at the National Maritime Museum.

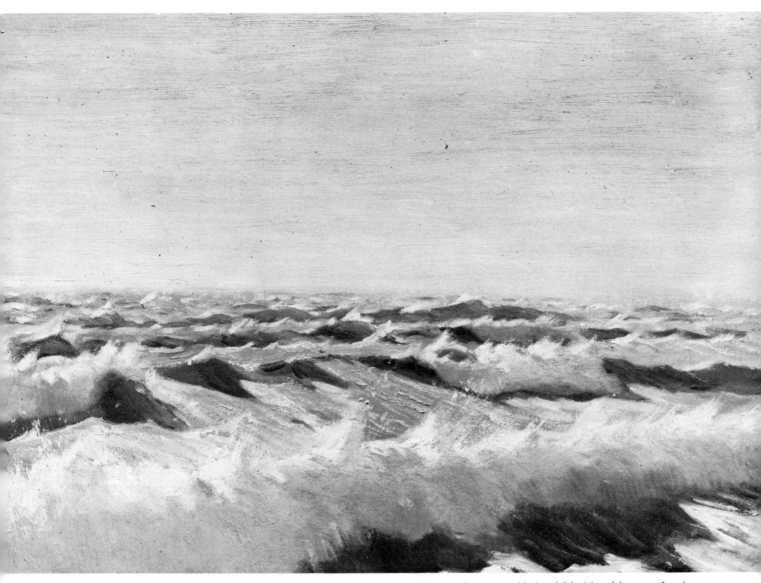

PLATE 75: JOHN EVERETT (1876-1949)

'Seascape'. Oils, 14½ ins. x 20ins.

This relatively little-known artist had a deep love of the sea and a considerable talent for painting it, as may be seen here. His work is rarely seen at auction or in picture galleries, as the major part of his output is held in the National Maritime Museum.

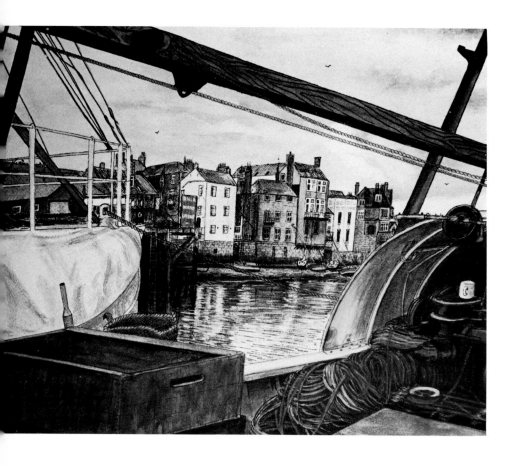

Photograph courtesy: Colin Pells of Bradford.

PLATE 76:
DAVID FELL (b.1927)

'Buildings and boats, Whitby, 1975'.
Waterline painting, 12ins. x 18ins.
Exhibited at the RSMA, Guildhall, 1979.

This view of Whitby is at low tide with part of the old town in the background. The artist specialises in harbour scenes and old buildings, and has developed a style which he describes as 'waterline'.

PLATE 77: STANLEY
FINKILL, FSAI (b.1929)

'The MV *Leadsman* **at Stanlow'.**
Exhibited at the RSMA, Guildhall, 1978.
Indian ink on Whatman hot press paper, 13ins. x 19ins.

The picture shows the vessel discharging fuel oil at Stanlow on the Manchester Ship Canal. The subject and the medium are unusual in modern marine art; they bring their own kind of beauty to the viewer and, also, these records of today have great value for the future.

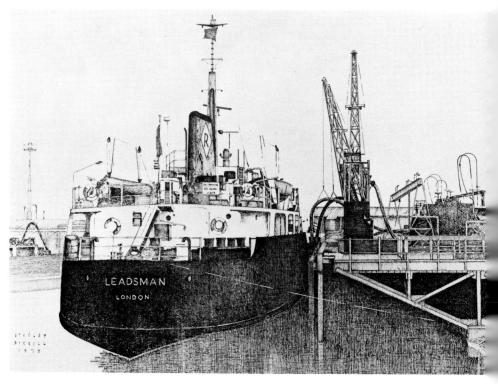

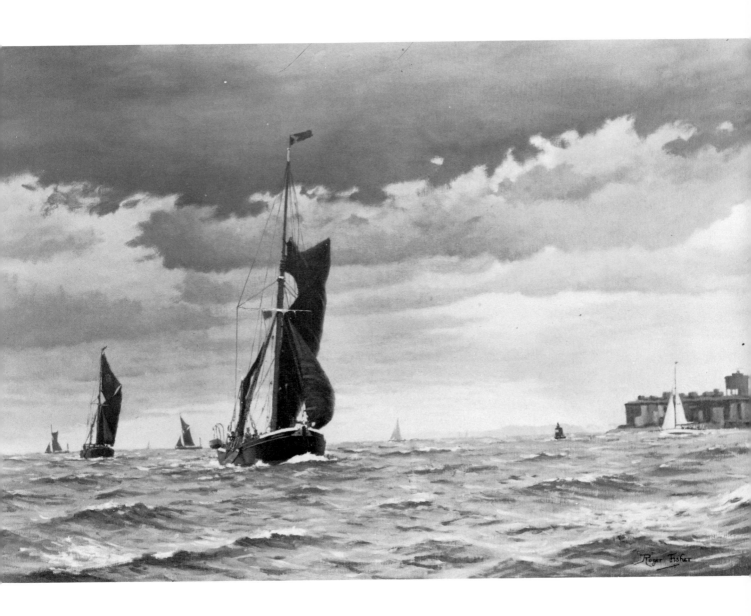

PLATE 78: CAPTAIN ROGER ROWLAND SUTTON FISHER, CBE, DSC, FRSA, RN (Retd.) (b.1919) (ROGER FISHER).

'Thames sailing barges entering the Medway in a stiff following breeze'.
Oil on hardboard (covered with sized muslin and primed) 24ins. x 36ins.

The barges are under reduced sail. The leading barge has lowered the head of her topsail, keeping the clewline taut, thus reducing the area of that sail exposed to the wind. Her mizzen is furled. The fort is Garrison Point, Sheerness, with the coast of Sheppey beyond.

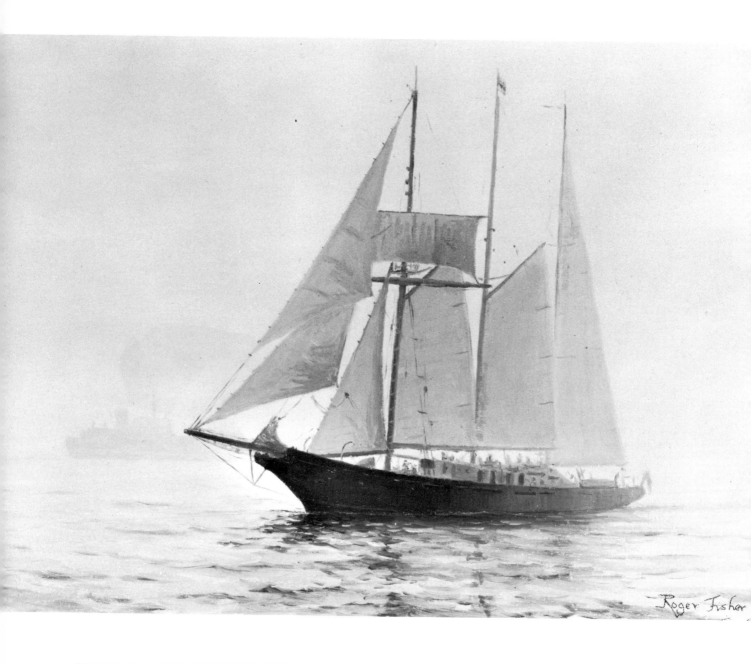

PLATE 79: CAPTAIN ROGER ROWLAND SUTTON FISHER, CBE, DSC, FRSA, RN (Retd.) (b.1919)

'**STS** *Sir Winston Churchill* — **becalmed**'. Oils, 15½ ins. x 23½ ins. Exhibited at the RSMA, Guildhall, in 1977.

The artist served for 37 years in the Royal Navy and has continued to go to sea in many different types of ships since retiring. He has acted as a Watch Officer on the *Sir Winston Churchill* on four cruises, and is a regular exhibitor at the RSMA exhibitions.

This is an unusual view of the *Sir Winston Churchill,* becalmed in a mist, with soft lighting and little movement. It is a peaceful treatment of a ship which is often sailing in the Channel or North Sea in Force 8 gales and upwards.

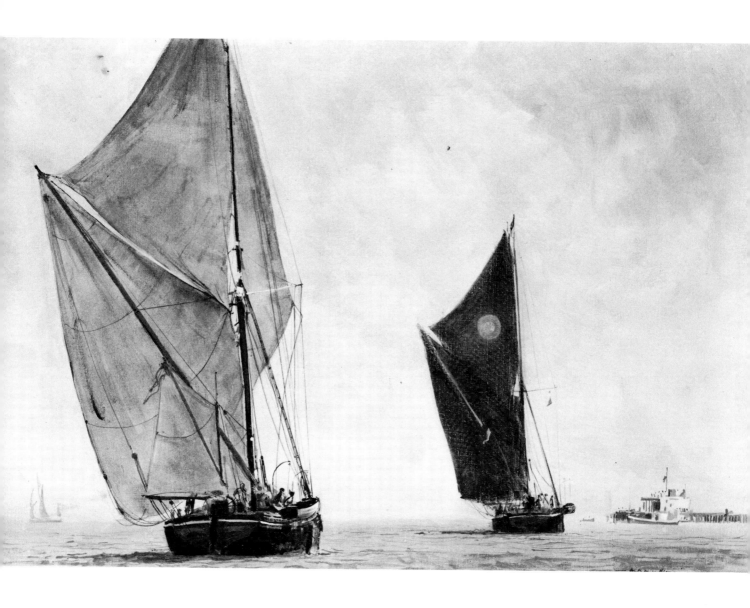

PLATE 80: ANTHONY FLEMMING (b.1936)

'**Thames barges: Southend barge match**'. Oils, 20ins. x 30ins. Exhibited at the RSMA, Guildhall, 1979.

The artist has been sailing since the age of eight, and has cruised extensively, sailed in the Fastnet Race, and has also sailed frequently in Thames barges.

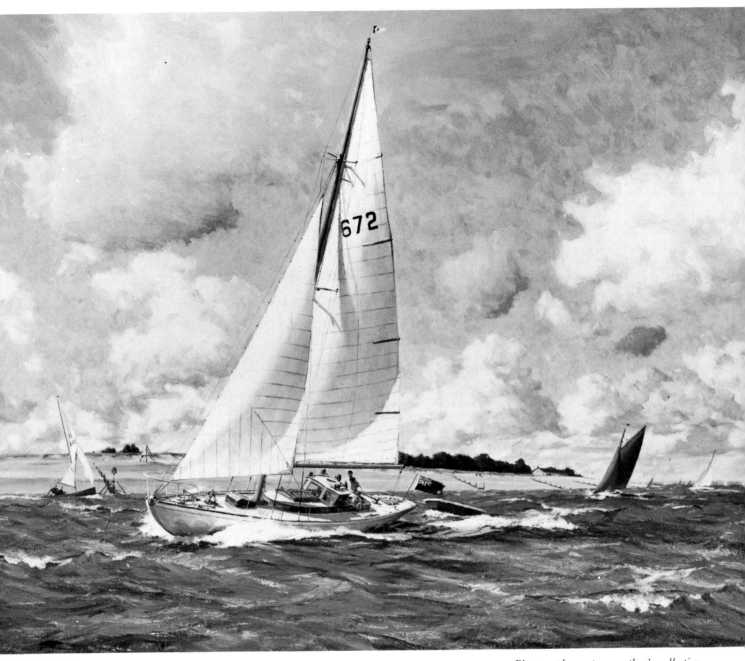

Photograph courtesy: author's collection.

PLATE 81: DERYCK FOSTER, RSMA (b.1924)

'The yacht *Corinne* **leaving Chichester Harbour'.** Oils, 32ins. x 40ins.

This painting, commissioned from Deryck Foster in 1958, shows the ocean-racing yacht *Corinne*, owned by the author at that time. She was a wooden vessel, some 33 feet overall, built in Scotland in 1896 as a gaff cutter. Her original sail plan embodied a long bowsprit and a main boom which overlapped the stern by about 10 feet. She was modernised in the Isle of Wight in the 1950s and proved an exceptionally sound and seaworthy yacht in spite of her advancing years. The picture shows the exit from Chichester Harbour off Hayling Island, still little changed today.

At one time, Deryck Foster specialised in painting yachts, but he now devotes most of his time to painting historical sailing vessels and events.

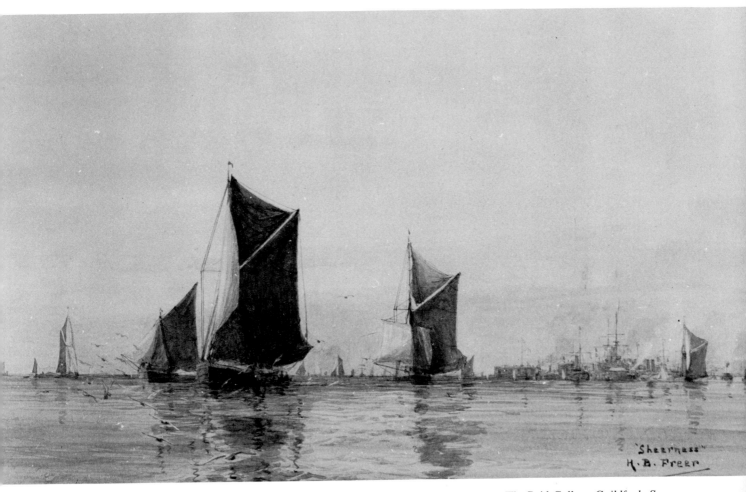

Photograph courtesy: The Reid Gallery, Guildford, Surrey.

PLATE 82: H. BRANSTON FREER (fl.1905-1915)

'**Sheerness**'. Watercolour, 7ins. x 12ins.

Work by this artist is not seen very often but it shows considerable atmosphere and professionalism. In some ways his style is reminiscent of the great W.L. Wyllie. The picture illustrated here demonstrates his delicate but firm handling of sea, sky and ships. He lived in the areas of Rochester, Gravesend, and Blackheath — next to the tidal Thames — and exhibited at the Royal Academy, RBSA, and Liverpool.

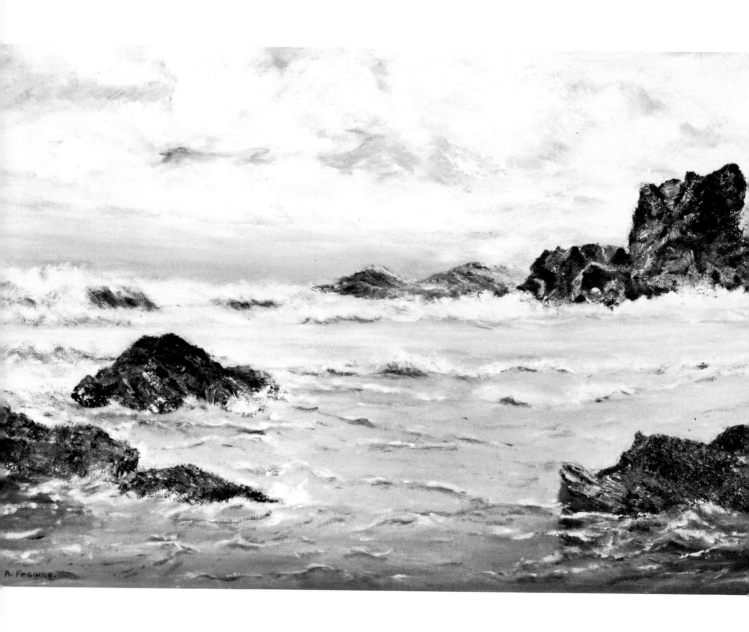

PLATE 83: DAPHNE ALMA FROOME

'**Rough seas, Porthcothan Bay**'. Oil on canvas, 20ins. x 30ins. Painted in 1978.

The artist lives for part of her time at Porthcothan Bay on the North Cornish coast and specialises in painting coastal views there and particularly rock studies.

PLATE 84: DR. PETER KENNETH DAVY FROOME (b.1949)

'**Anchored**'. Oils on panel, 14ins. x 18ins.

Ship's cats, like the men who sail ships, are all too rarely shown in paintings — which is a pity, because they add life and atmosphere to sea pictures. This artist has a special interest in trading schooners and ketches, and as he also paints animals — particularly cats — he sometimes combines the two fields, as here, with happy results.

PLATE 85: GERALD HENRY (GERRY) FRUIN (b.1931)

'Hovercraft off the Isle of Wight'. Watercolour, 11ins. x 19ins. Painted in December, 1978.

The hovercraft, seen here through a pattern of yacht's masts, is a familiar sight to those who live in the Solent area near Cowes or Southampton, between which it plys as a passenger ferry.

 This artist prefers to paint present day scenes such as this, rather than old sailing ships, and feels that painters should reflect the present and not the past. In years to come no doubt the hovercraft will look quaint and romantic to our grandchildren. Now, it has a certain power and drama as portrayed in this setting.

PLATE 86: FRANK JOSEPH HENRY GARDINER (b.1942)

'**Reflections — Maldon**'. Exhibited at the RSMA, Guildhall, in 1979.

Painted on a late summer afternoon, this peaceful scene gives the interesting feeling that the viewer might well be sitting at water level in a small boat looking towards the shore.

Frank Gardiner is a professional illustrator and has exhibited at the RSMA since 1971.

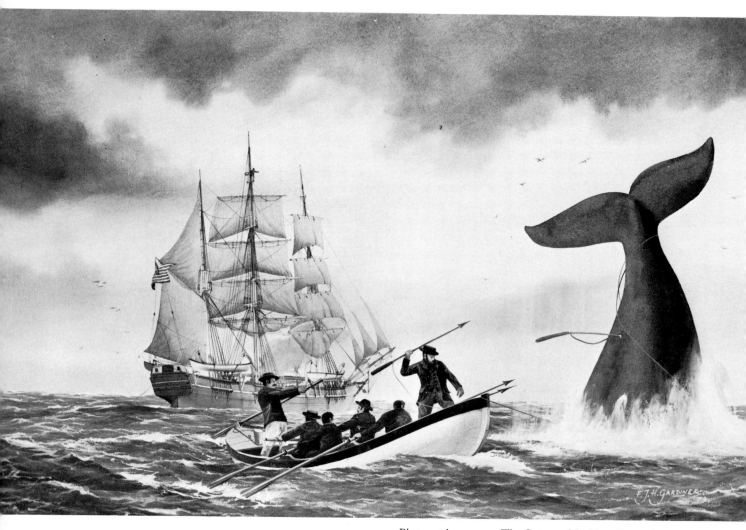

PLATE 87: FRANK JOSEPH HENRY GARDINER (b.1942)

'Harpooned'. Watercolour, 15ins. x 25ins.

Painted for the jacket of a book by Bill Spence entitled *'Harpooned'*, this picture shows the American whaler *Charles W. Morgan* around the turn of the century, hunting the sperm whale.
 The artist paints ship portraits, sailing ships and harbour scenes, mostly historical, in both oils and watercolours.

PLATE 88: DEREK GEORGE MONTAGUE GARDNER, VRD, RSMA (b.1914)

'*Enterprise* **and** *Boxer,* **5th September, 1813'**. Oil on canvas, 24ins. x 36ins.

This painting shows the short and decisive action off the New England coast near Portland, U.S.A., on 5th September, 1813, between the American ship *Enterprise* and the British brig *Boxer.* After manoeuvering in fluky winds during the morning, the ships were able to close to 70 yards and both opened fire at 3.15 p.m. The *Boxer's* captain was killed immediately and the captain of the *Enterprise* was mortally wounded. By 3.30 p.m. the *Boxer* had lost her maintopmast and foretopsail-yard; after further heavy damage and casualties were inflicted on her she was forced to surrender at 3.45 p.m.

Derek Gardner specialises in painting historic sailing ships and naval actions and carries out considerable research in order to achieve accuracy. The picture illustrated here, and also those shown at colour plates 14 and 15, were in a major exhibition of the artist's work presented by the Polak Gallery, London, and Mandell's Gallery, Norwich, in June, 1979.

Photograph courtesy: Mr. and Mrs. Cullen.

PLATE 89: WILLIAM JASPER GELLER, SGA (b.1930)

'Barges at Maldon, Essex'. Pen and sepia ink. Drawn 1975.

The clean-cut, accurate and economical drawing of this artist puts one in mind of the fine early work of E.W. Cooke (1811-1880) whose 65 drawings and etchings of shipping and craft were published so successfully in 1828 and 1829. Good drawing is a most desirable quality in art today.

Photograph courtesy: Mrs. Olive Geller.

PLATE 90: WILLIAM JASPER GELLER, SGA (b.1930)

'*Concord* **at Clovelly'.** Pen and sepia ink, 14ins. x 18ins. Drawn in 1975.

The majority of this artist's marine pictures are concerned with boats at rest. The technique used is pen and sepia ink, carefully built up by overdrawing until a glaze effect is achieved. This allows the detail of hull construction and rigging to be clearly seen, whilst giving freedom to the requirements of modelling the form of the subject. The completed drawing is usually quite large by pen and ink standards, providing the opportunity for a high degree of technical accuracy, which the artist says he considers important in the portrayal of marine subjects.

194

PLATE 91: SYBIL MULLEN GLOVER, RI, RWA, RSMA

'**A winter theme**'. Watercolour, 12ins. x 22ins.

This watercolour, with its delicate tones, is intended to convey the early morning atmosphere of the Barbican at Plymouth, which the artist always finds fascinating.

PLATE 92: SIDNEY GOODWIN (1867-1944)

'Portsmouth from Gosport'. Watercolour, 13½ ins. x 21ins.

Sidney Goodwin was a prolific watercolour painter of coastal scenes, and many of them are of very high quality. He lived in Southampton from 1912 and Dublin from 1917 and exhibited in the RHA. He was a nephew of Albert Goodwin whose work is highly rated.

PLATE 93: KENNETH GRANT (b.1934)

'**The Australian wool clipper** *Derwent* **picking up the pilot in the English Channel**'. Oil on canvas, 20ins. x 30ins.

The *Derwent* was built in 1884 by Macmillan and Company of Dunbarton for Devitt and Moore. This picture is a good example of a sea painting by one of the many self-taught and talented marine artists working today.

PLATE 94: STUART GRAY, NS, UA (b.1925)

'**The Swale at low tide**'. Watercolour, 12 ¾ ins. x 20 ½ ins. Painted in September, 1979.

The artist has captured the atmosphere of a typical English day at low tide near the Thames estuary. The sky and the wet mud flats reflect and balance each other well.

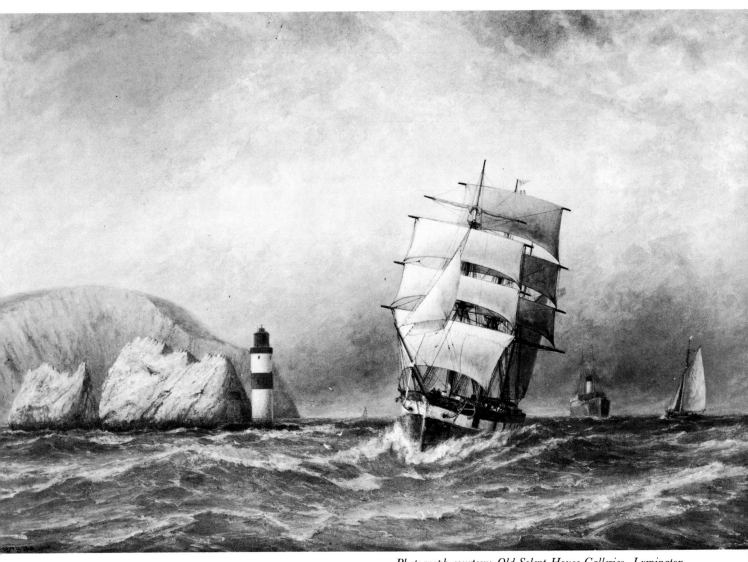

Photograph courtesy: Old Solent House Galleries, Lymington.

PLATE 95: GEORGE GREGORY (1849-1938)

'Sailing ship coming in past the Needles, Isle of Wight'. Oil on canvas, 20ins. x 30ins. Dated 1918.

George Gregory was a prolific and versatile painter in both oils and watercolours. Although a great deal of his work was done towards the end of the 19th century, he continued up to about 1931 and was therefore a real bridge-builder between the two centuries. He lived and painted all his life in and around the Isle of Wight, but sometimes travelled to Germany, Belgium, Holland and northern France. His style is distinctive and talented and although he never bothered to exhibit or strive for academic recognition his pictures are now sought by many collectors.

PLATE 96: GEORGE GREGORY (1849-1938)

'A Royal Naval Review'. Oil on canvas, 20ins. x 37ins.

George Gregory is usually thought of as a 19th century artist. In fact, he lived until 1938 and continued painting well into the 1930s. Many of his subjects were sailing vessels off the south coast of England, towards the end of the last century, but he sometimes painted battleships and steam vessels of a later date. The picture illustrated here is dated 1907.

PLATE 97: DONALD GREIG, RSMA, FRSA (b. 1916)

'**Children at the pool**'. Oils, 20ins. x 24ins. Exhibited at the RSMA, Guildhall, 1977.

One of a series of paintings whose subjects were based on groups of children and fishermen on the beach at St. Ives, Cornwall.

This particular study was an attempt to capture the perennial fascination for children of a sandy pool in summer-time.

PLATE 98: JOHN MICHAEL GROVES, RSMA (b.1937)

'**Blowing hard**'. Oils, 12ins. x 18ins. Painted in 1978.

This painting has an interesting treatment of two vessels running parallel in a strong blow. The misty shape of the larger ship in the background gives emphasis to the men grappling with the headsail of the vessel in the foreground.
 Michael Groves has been keenly interested in sailing vessels from his childhood and paints a wide variety of marine subjects from square riggers to historic naval battles and trawlers.

PLATE 99: CAPTAIN PHILLIP GUNN, DSM, RN (Retd.)

'The rope's end'. Oils on canvas/board.

Captain Gunn joined the Royal Navy as a boy seaman in 1911, served through both world wars, and retired aged 55 after 35 years service. After he retired he taught himself to paint and has subsequently contributed to many exhibitions. In 1979 33 paintings by this artist, illustrating his early life in the Royal Navy, were purchased and exhibited by the Royal Naval Museum, Portsmouth. One of these paintings is illustrated here and a description of the scene is as follows:

'In the Naval Training ship in 1911 everything was done at the rush. When the bugle call demanded the sailor boys to parade on deck it meant mad rushes up the ladders, etc.

'To encourage them to go at their fastest, a Seaman Petty Officer stood at the bottom of the ladder with a rope's end which the last boy up the ladder received across his seat.

'It hurt, of course, but in those days they accepted this as a perfectly normal form of encouragement, and the boys didn't look upon it as cruel or unfair. Just determined not to be last one up next time!'

PLATE 100: GORDON HALES (b.1916)

'**Steam coasters of the twenties**'. Oils on gesso panel, 18ins. x 25ins. Exhibited at the RSMA, Guildhall, 1979.

This painting owes its origin to the artist recalling in later years a vision familiar in his youth. It shows coasters and colliers that have steamed up the estuary to discharge their cargoes and take on new ones or, sadly, ballast.

It is a time when coal and steam have superseded sail and when coal in its turn is being superseded by oil; a time when old sailors still chewed tobacco and served their time on these short or long raised quarter deckers with their boilers (aft or amidships) gusting great volumes of black smoke from the tall, elegant funnels — a time when ships still looked like ships and the last of the great square-riggers could still be seen trading about the world.

PLATE 101: RICHARD HALFPENNY (b.1932)

'Culley's Camel'. Oils, 10ins. x 16ins. Painted in 1979.

This painting shows Lt. Culley, R.N.A.S., taking off from a converted barge in 1918 to shoot down a German Zeppelin. The artist specialises in historic steamships and naval aviation scenes.

PLATE 102: JOHN ALAN HAMILTON, MC (b.1919)

'**Atlantic storm**'. Oils, 19½ins. x 31½ins. Exhibited at the RSMA, Guildhall, 1977.

John Hamilton, a self-taught artist, has been painting the sea and ships for many years. Pure sea paintings such as the one illustrated here are as comparatively rare in the 20th century as they were in the 19th. The artist himself points out that one of the most difficult aspects of painting sea is to capture movement: 'the great upward thrust of a swell as well as the tops of the waves being blown off by a gale.' He says 'I think it is this unending power which seems so effortless, but which will lift at will anything man can make, and then develop into a fiendish force, bent on destroying objects small enough or weak enough to succumb to its grey impersonal cruelty. The fascination of the sea is that it can be both cruel and also gentle.'

PLATE 103: DENNIS JOHN HANCERI, RSMA (b.1928)

'**Thames sailing barge off Dungeness**'. Watercolour, 8ins. x 13ins.

This artist paints mainly in watercolour and bodycolour. He has exhibited at the R.S.M.A. since 1969 and is a member of the Wapping Group of artists.

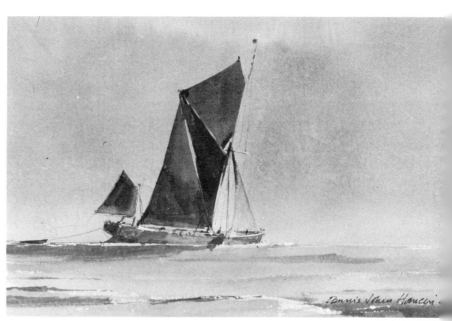

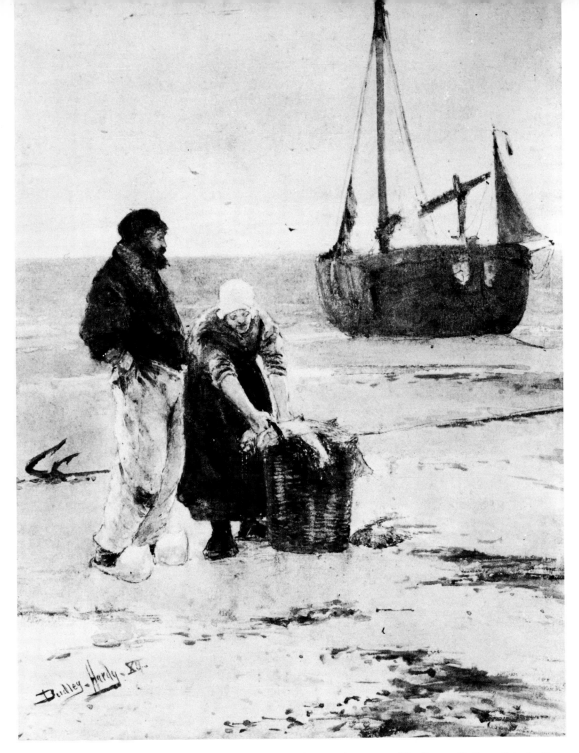

Photograph courtesy: The Bourne Gallery, Reigate, Surrey.

PLATE 104: DUDLEY HARDY, RI, ROI, RBA, RMS, PS (1867-1922)

'Landing the catch — Dutch fisherfolk on the sea shore'. Watercolour, 10¾ ins. x 8¼ ins.

Dudley Hardy was the son of Thomas Bush Hardy, the well known 19th century marine artist who is best remembered for his numerous watercolours of fishing vessels on the coast or entering or leaving harbour. Dudley Hardy had a somewhat freer style than his father (under whom he studied at one time) and his ability with figures is shown in this picture. He also painted landscapes, subject pictures and portraits, and was an illustrator.

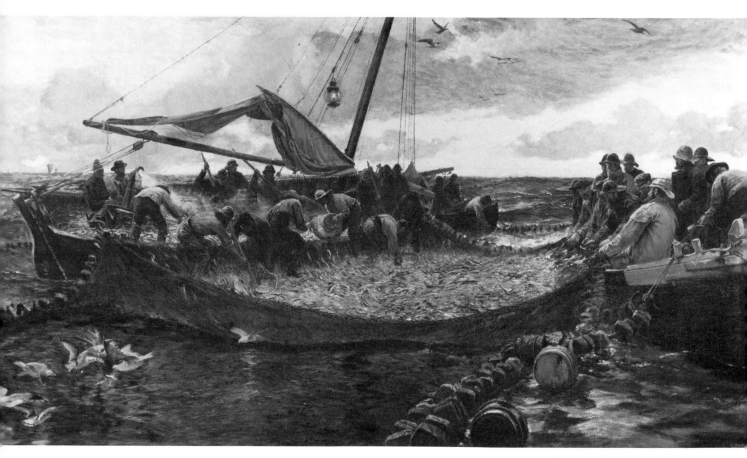

PLATE 105: CHARLES NAPIER HEMY, RA, RI, ROI, RWS (1841-1917)

'Pilchards'. Oil on canvas, 44½ ins. x 83½ ins.

Painted at the end of the 19th century (1897) this picture is representative of the type of powerful romantic painting which was continued into the first quarter of the present century. Charles Napier Hemy was one of the outstanding marine painters of the last part of the 19th century and the early years of the 20th. His handling of sea and figures, mostly fishermen, was strong and masterly. From 1883 he lived in Falmouth, where he had a yacht, and was thus always near the sea and the seafarers. His work is said to have influenced a number of 20th century marine artists, including his pupil Montague Dawson.

PLATE 106: ROWLAND HILDER, PRI, RSMA (b.1905)

'Iron grain ship'.
8ins. x 10½ins.

This drawing was sketched from the embankment in front of the Royal Naval College, Greenwich, in the summer of 1926. It is indicative of Rowland Hilder's very fine draughtsmanship, one of the qualities for which he is notable.

PLATE 107: DENNIS ROY HODDS (b.1933)

'Hunstanton beach'. Oils, 18ins. x 24ins. Painted in April, 1979.

This scene combines the painter's favourite subjects. It is taken from his watercolour sketch of July, 1966. The pier has recently been destroyed by gales and the combined atmosphere of sky, beach, sea and children — though common to many other resorts — has stirred a special memory for the artist.

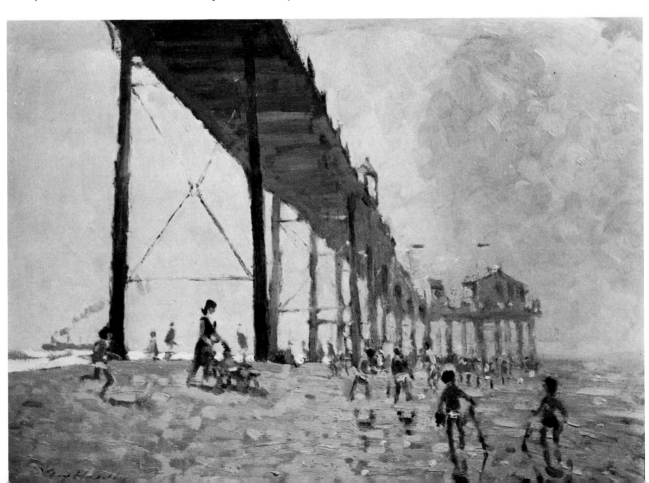

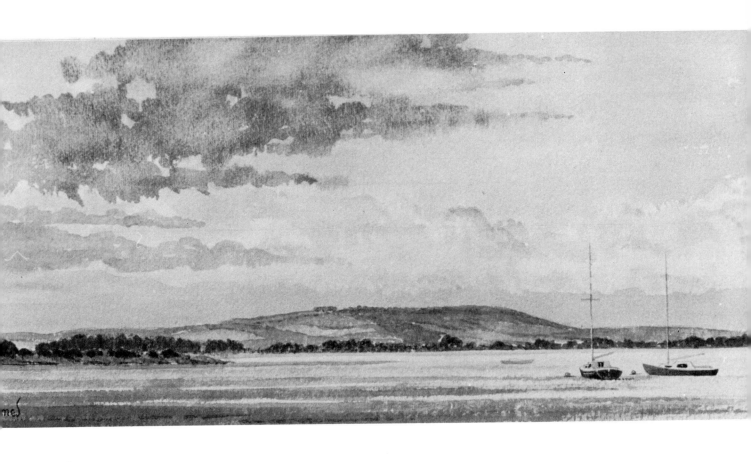

PLATE 108: DAVID HOLMES, FSAE, FRSA (b.1927)

'**The Downs, from Hayling Island**'. Watercolour, 15ins. x 22ins. Exhibited at the RSMA, Guildhall, in 1978.

This watercolour is painted on coarse toothed paper. The artist's intention has been to create a well balanced, tranquil composition. He has emphasised the texture, tone and delicate colours of the clouds, land mass and sea. The boats on the right counter-balance the clouds on the left.

Some 1,200 of David Holmes' paintings are in collections throughout the world.

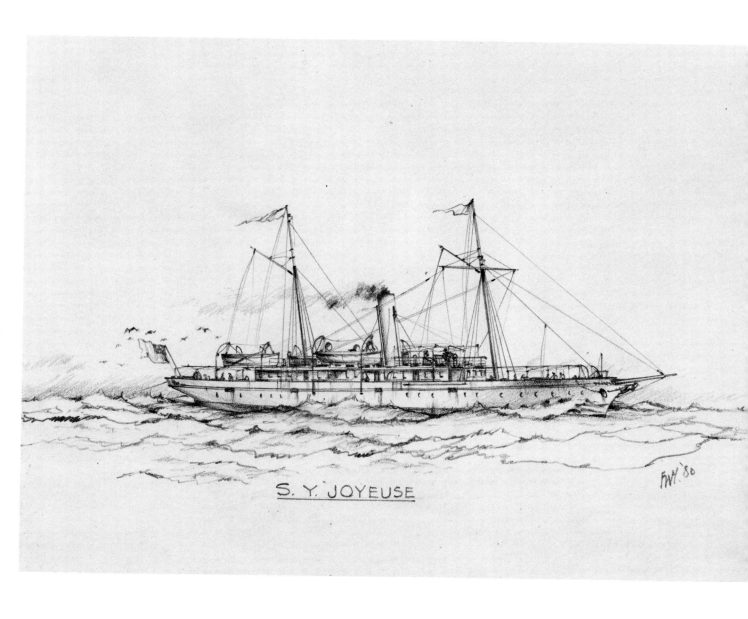

S. Y. JOYEUSE

PLATE 109: FREDERICK WILLIAM HOPPER, MBE (b.1891)

'The steam yacht *Joyeuse*'. Pencil, 7½ ins. x 10½ ins. Drawn in 1980.

For 38 years, Frederick Hopper was General Manager and Director of a shipyard in Sunderland. During this time he designed every vessel built there and made a painting or drawing of every ship launched from his yard.

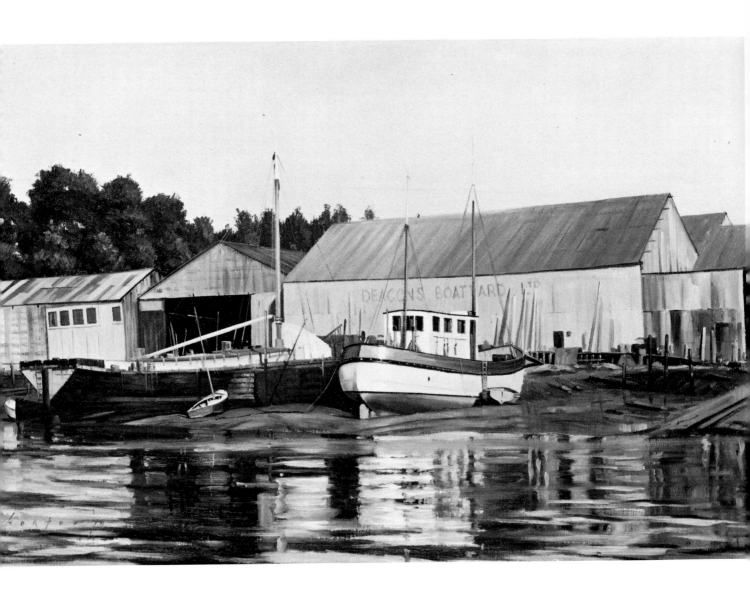

PLATE 110: JOHN MALCOLM HORTON (b.1935)

'Deacon's Yard'. Oils, 20ins. x 30ins. Exhibited at the RSMA, Guildhall, 1979.

This painting was started at 6.30 in the morning, from the artist's dinghy, as the light came up. The yard, at the top of the Hamble river at Bursledon, dates back many years and was once run by perhaps the only woman yard owner of those times, Mrs. Deacon. The buildings were due for demolition in 1980, and so this sort of record has added value from the viewpoint of local history.

Photograph courtesy: Abbey Antiques and Arts, Hemel Hempstead, and the artist.

PLATE 111: ROBERT L. HOWEY (b.1900)

'Landing the catch'. Watercolour and gouache, 15ins. x 18ins.

Robert Howey uses a mixture of watercolour and gouache with great effectiveness to capture the feeling of the north-east coast. His lighting often presents a dramatic effect, as shown here. He has exhibited widely, particularly in the North of England.

PLATE 112: GEOFFREY WILLIAM HUNT, AOI (b.1948)

'H.M.S. *Excellent* **entering Portoferraio, Elba'.** Oil on canvas, 22ins. x 30ins.

The artist made the first sketch for this painting while he was sailing in that area. He had on board his sloop Captain Denham's *Tyrrhenian Sea Pilot* and he says that the author's frequent references to Nelsonic feats of navigation made those line-of-battle ships seem very close at times.

Geoffrey Hunt specialises in painting ships of Nelson's period, ironclad warships, and modern warships and yachts. At one time he was art editor of the *Navy International* and *Warship* magazines.

PLATE 113: WILLIAM HENRY INNES, PS, UA (b.1905)

'Shadows on the Channel'.
Pastels, 18ins. x 22ins.
Exhibited at the Pastel Society Exhibition, 1978.

This picture was executed from the beach at Eastbourne on a late September day at about 11 a.m. to 12 noon. William Innes often likes to obtain the effect of working against the light and on this occasion was particularly interested in the cloud shadows thrown across the sea. He has been a member of the Council of the Pastel Society for many years. He also paints in oils and has exhibited widely.

PLATE 114: EILEEN JAMES (b.1939)

'Bringing in the catch'. Oil on board, 18ins. x 24ins. Painted in 1978.

Eileen James, a self-taught artist, painted this picture after watching the fishermen hauling their boats up on to the shingle at Dungeness. Miss James has exhibited at the RSMA since 1977.

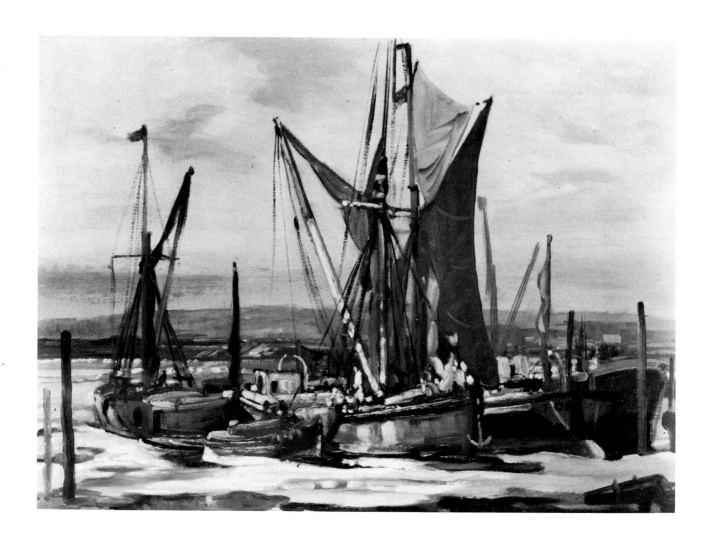

PLATE 115: PATRICK ARTHUR JOBSON, RSMA (b.1919)

'**Medway race barges**'. Oils, 15ins. x 20ins. Painted in 1976.

This artist was a founder member of the RSMA. He is a past President of the Artists Society and was President of the Wapping Group in 1980. He believes in painting from life and feels that the recent tendency has been too much towards illustration.

PLATE 116: ROBERT JOHNSTON, RI, ROI, RSMA (b.1906)

'On the beach in Brittany'.
Oils, 24ins. x 31ins.

This scene was painted first of all in watercolour and then re-arranged in oils. The artist's intention is towards the abstract. The picture went on tour throughout the U.S.A. in 1975 in an exhibition arranged by the RBA.

PLATE 117: RICHARD RAYLTON JOICEY, RSMA (b.1925)

'Maintenance at low tide'. Watercolour, 7ins. x 12ins. Exhibited at the RI, 1980.

The artist says that the hues of the mud and the interesting figure postures inspired him to capture this study. The sparkle on the wet mud and the rings in the shallow water particularly caught his attention. It is worth noting the successful effects which can be obtained with a minimum of brushwork and the use of the paper showing through the transparent watercolours.

PLATE 118: RICHARD RAYLTON JOICEY, RSMA (b.1925)

'Brent Geese on the marshes'. Watercolour, 16ins. x 26ins. Exhibited at the RI, 1980.

This is a study in pinks, browns and black made one evening by the artist on the mud flats at Langstone harbour near Portsmouth. These birds come to our shores every winter from Siberia and make a delightful subject. Richard Joicey is often attracted to painting these geese in different attitudes and groupings. He has exhibited at the RSMA since 1967.

PLATE 119: HELEN PATRICIA (PAT) KEEL-DIFFEY (b.1926)

'Breakwater'. Etching and aquatint.

Pat Keel-Diffey has been involved in print making since 1975, especially subjects relating to the sea shore, waves and water. She is interested in contrasts of scale, texture and tone, as may be seen in this illustration.

218

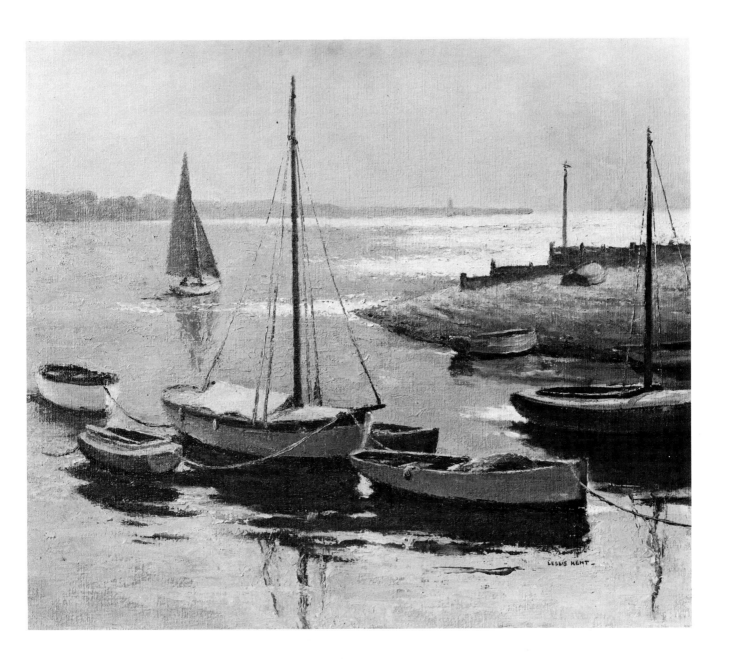

PLATE 120: LESLIE KENT, RBA, RSMA (1890-1980)

'Titchfield Haven, Hampshire'. Oils, 20ins. x 24ins.

The artist, who had many years of experience sailing in small boats, specialised in painting sailing vessels in harbours, estuaries and off the coast.

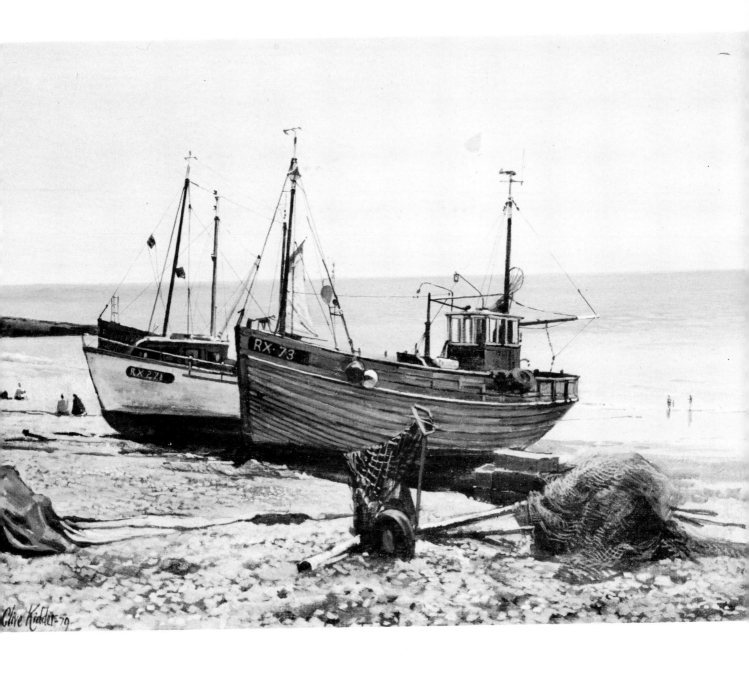

PLATE 121: CLIVE KIDDER, NS (b.1930)

'**Beached trawlers — Hastings**'. Acrylics on canvas, 18ins. x 24ins. Exhibited at the RSMA, Guildhall, 1979.

About this painting Clive Kidder says that he was trying to describe the vastness and emptiness of the sea on a hot summer day. He used the silhouettes of the trawlers to emphasise the smallness of man in relation to the great space of the sea; also he feels that the trawlers symbolise the craftsmanship and the courage of man.

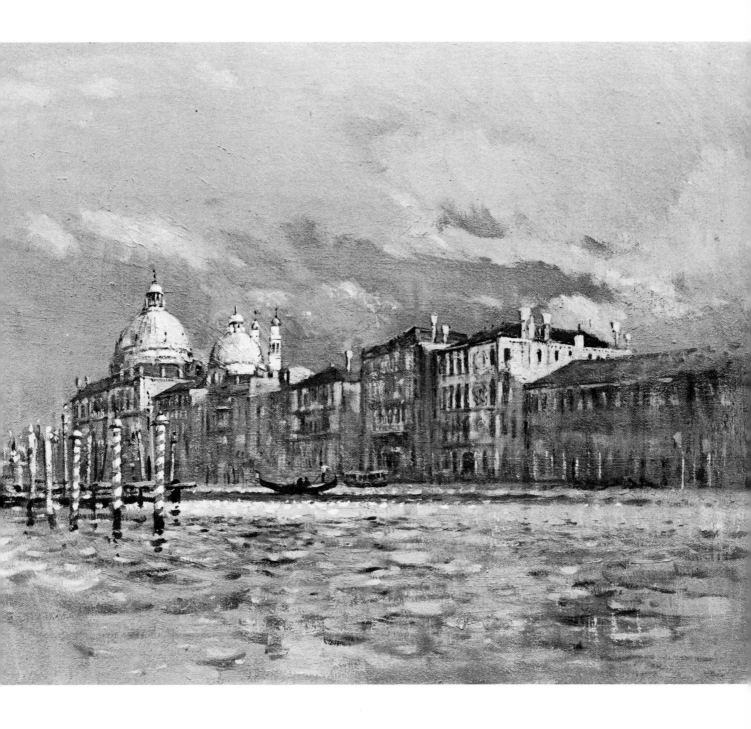

PLATE 122: ROBERT KING, RI (b.1936)

'**Grand canal, Venice**'. Oil on canvas, 18ins. x 22ins.

This painting was taken from a colour sketch made whilst Robert King was on a working holiday in Venice during October, 1975. The late afternoon autumn sunlight was falling on the distant Santa Maria della Salute, leaving the far side of the Canal bathed in shadow whilst the water and the red and white poles in the foreground sparkled. The artist says that he found this light irresistible.

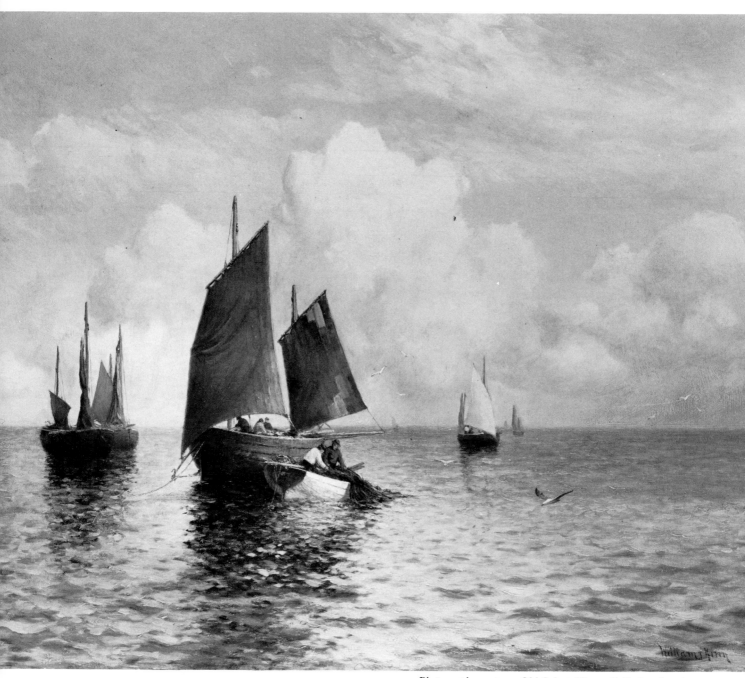

Photograph courtesy: Old Solent House Galleries, Lymington.

PLATE 123: WILLIAM J. KING (fl.1885-1943)

'Hauling in the nets'. Oil on canvas, 22ins. x 27ins.

This picture is fairly typical of early 20th century paintings of fishing vessels off the coast on a calm sunny day. The colours have become fresher and the sky rather bluer than similar paintings of the mid-19th century.

William J. King was a Birmingham artist who worked in both oils and watercolours. He painted marine and landscape pictures and between 1885 and 1943 exhibited no less than 457 paintings at the Royal Birmingham Society of Artists.

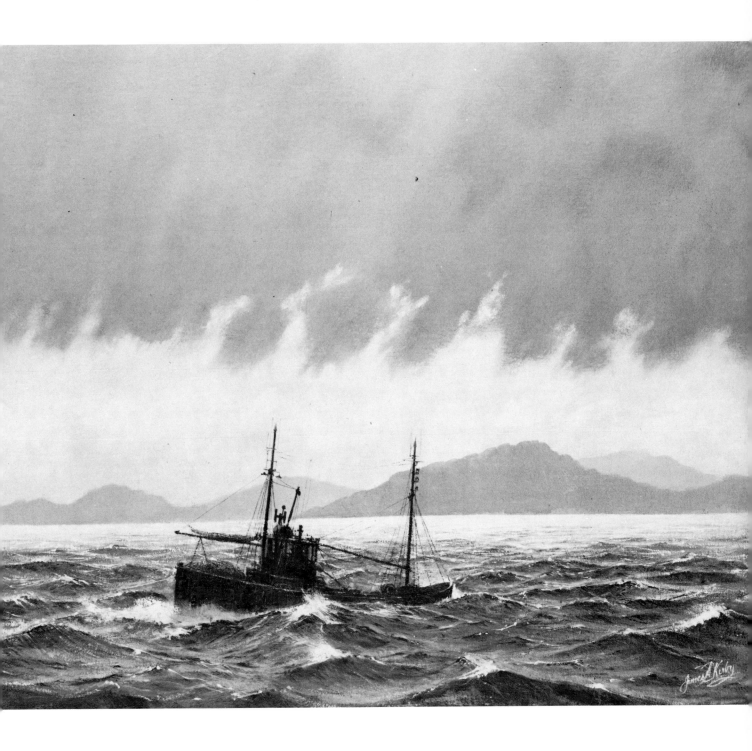

PLATE 124: JAMES ALFRED KIRBY (b.1917)

'**Dying storm, Galway coast**'. Oils, 25ins. x 30ins. Exhibited at the RSMA, Guildhall, 1979.

As well as serving in the Royal Navy from 1939 to 1945, James Kirby has spent a lifetime in the fishing industry and therefore brings to his paintings a deep and first-hand experience of the sea.

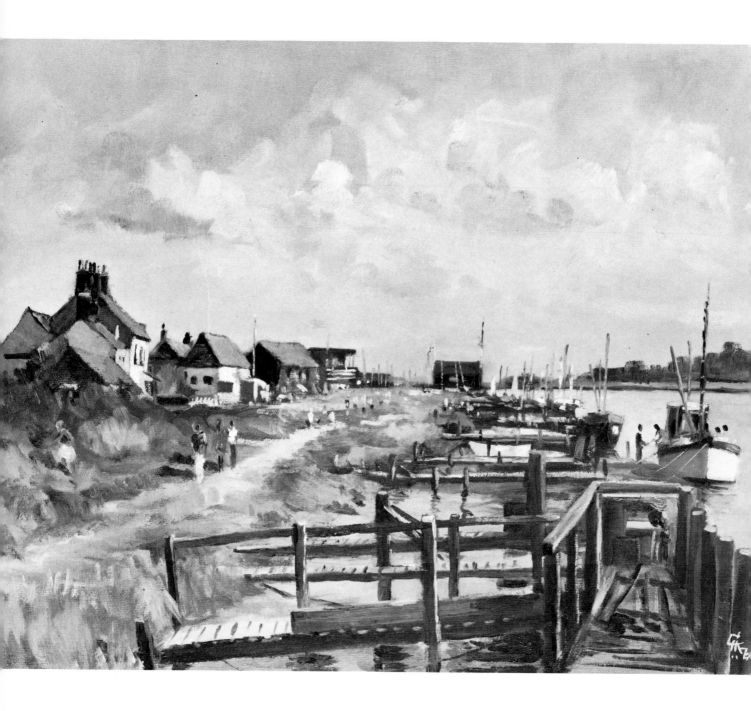

PLATE 125: HUGH KNOLLYS (b.1918)

'Riverside, Southwold'. Oils, 16ins. x 20ins. Exhibited at the RSMA, Guildhall, 1979.

This picture was painted in about four hours in the summer of 1979. Painting on the spot has many advantages, but the artist mentions some typical hazards when he recalls one very windy Sunday, with the sailing boats scudding up and down the river. He started to paint a dinghy and when he looked up, it had disappeared — capsized. Next moment, his palette blew into the water and he had to recover it 20 yards downstream!

PLATE 126: CECIL PETER KNOX

'*Tactician* **rounding the Cape of Good Hope, 1970'**. Oils, 36ins. x 28ins.

The painting dates from the artist's seafaring days with the College of the Sea (he was an artist-tutor from 1968 to 1971) and shows the Harrison cargo ship *Tactician* pitching and rolling coming around the Cape of Good Hope. Peter Knox has for very many years been interested in the living ship, i.e., working, eroding, changing and absolutely itinerant.

PLATE 127: HELMUTH JOHANN LACKNER (b.1929)

'**Drying sails — Ragusa 1870'**. Oils on canvas, 36ins. x 48ins.

Ragusa (now Dubrovnik harbour) was a very popular port for International Fleets during the latter half of the 19th century and until the outbreak of the 1914 war.

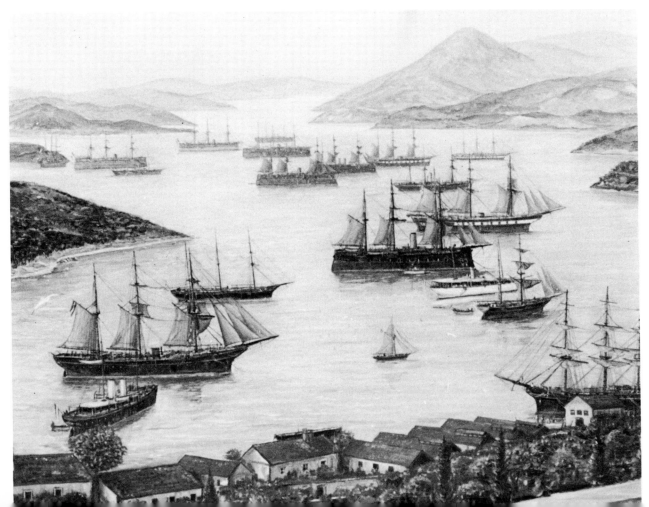

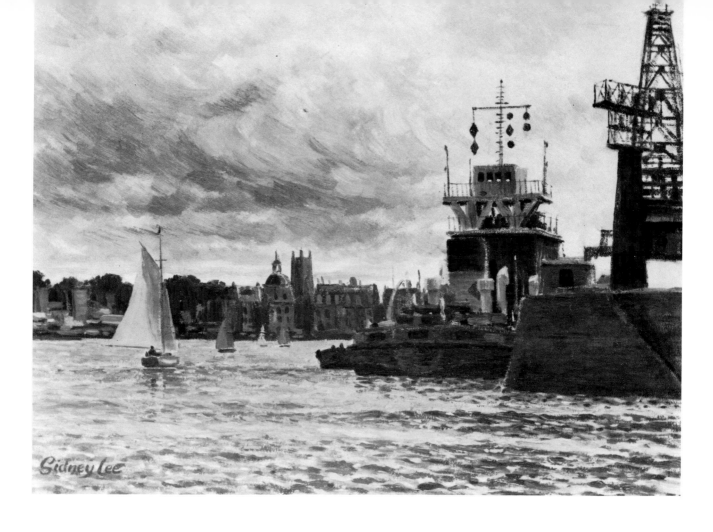

PLATE 128: SIDNEY EDWARD LEE (b.1925)

'**Dieppe harbour**'. Oils, 12ins. x 16ins. Exhibited at the RSMA, Guildhall, 1979.

Sidney Lee paints what he describes as 'everyday subjects seen while sailing on the English coast and the north coast of France'. He spent a large part of his career as a graphic designer before taking up marine painting a few years ago.

PLATE 129: ROXANE LOBANOW-ROSTOVSKY (b.1932)

'**Dead seagull and Shoreham sea defences**'. Watercolour.

When the artist found a dead sea-gull by the Shoreham sea defences she was struck by the pathetic vulnerability of life in contrast to the harsh, almost cruel, gigantic man-made concrete blocks. The mixture of strength and weakness proved irresistible as subject matter, and this picture was the result.

Mrs. Lobanow-Rostovsky paints still-life marine subjects, seascapes, etc., and is also a sculptress.

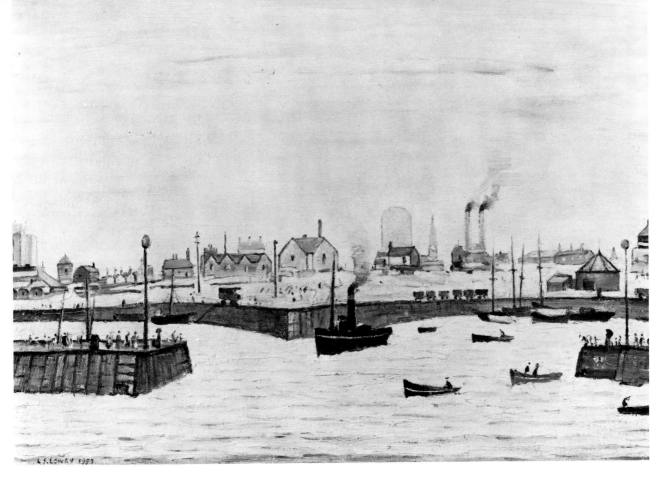

PLATE 130: LAURENCE STEPHEN LOWRY, RA, RBA (1887-1976)

'The harbour, Maryport, 1957'. Oil on canvas, 16ins. x 22ins.

This Lancashire artist became famous for his evocative and distinctive paintings of scenes in the industrial Midlands and North of England. He also painted harbours, boats and seascapes — a fact which is sometimes overlooked. His familiar 'industrial' idiom and small lonely figures have found their way into the harbour scene illustrated here.

PLATE 131: LAURENCE STEPHEN LOWRY, RA, RBA (1887-1976)

'Yachts at Lytham, 1965'. Oil on panel, 17¼ ins. x 11¼ ins.

This impressionist and spacious painting has a soft, hazy quality which might not be immediately connected with the usual work of L.S. Lowry, so well known for his town scenes drawn in a distinctively clear technique and naïve form. The effect is altogether successful as a seascape, and recalls atmospheres of a similar nature created by Whistler and Wilson Steer.

PLATE 132: JOHN EDMUND MACE, RBA (fl.1916-1948)

'West Solent One Design yachts in harbour'. Watercolour, 12½ ins. x 18½ ins.

John Mace painted marine subjects in oils and watercolours, and also some landscapes and flower pictures. His style shows delicacy combined with excellent draughtsmanship. He exhibited quite extensively including the RA, RBA and ROI, and his work is in several public collections. He lived in London and Torquay, and the latter place may well be the location of the picture illustrated here.

PLATE 133: FORTUNINO MATANIA, RI (1881-1963)

'**Bognor, 1939**'. Watercolour, 5ins. x 7ins.

A breaking wave is a subject which has fascinated and tested the abilities of many artists. In this example, Fortunino Matania has succeeded admirably in creating a feeling of great space and movement on a peaceful summer's day.

The artist was principally an illustrator and painter of historical pictures, but also produced some talented seascapes such as the one illustrated here.

Photograph courtesy: The Haida *Preservation Society of Canada.*

PLATE 134: CHRIS MAYGER, RSMA (b.1918)

'H.M.C.S. *Haida,* June, 1944'.

This illustration shows a painting which Chris Mayger did for the *Haida* Preservation Society, Ontario Place, Toronto, Canada. It is one of a pair portraying two of *Haida's* actions with the 10th Destroyer Flotilla in the English Channel, operating out of Plymouth — a mixed unit of Canadian and British Tribal Class Destroyers.

This painting shows H.M.C.S. *Haida* and H.M.C.S. *Huron* retiring after driving a German destroyer, Narvik Class Z-32, on to the rocks of the Ile de Bas, in the cold grey dawn of 9th June, 1944.

The 10th Destroyer Flotilla was patrolling the French Coast on 9th June. After making contact with four large enemy destroyers, there was a chase through mine fields followed by gun and torpedo action in which the enemy Destroyer Z-32, after receiving damage, made for the coast and ran aground to avoid sinking. The enemy vessel was then raked with salvo after salvo until she was destroyed by fire and explosions right there on the rocks.

H.M.C.S. *Haida* went on to serve in the Korean War. When decommissioned in 1963 she was bought by a group of her former crew and other interested Canadians as a memorial to those in Canada's Naval War. This painting was commissioned to give added background interest.

PLATE 135: JOHN HARDY MEADOWS (b.1912)

'The Boat People — South China Sea'. Watercolours, 18ins. x 25ins. Painted October/November, 1979.

An impression of the high-seas rescue of Vietnamese refugees by a passing freighter. Much of the atmospheric quality of the painting is provided by the element of colour. An oily swell, a threatening sky and the steamer with no more than steerage way on her; these factors have set the scene for the drama of the rescue.

This artist specialises in painting steamships at sea, war-time convoys, and dock and tidal river scenes.

PLATE 136: JOHN HANSON MELLOR (b.1909)

'Slack water at Lympstone, Devon'. Watercolour, half Imperial size.

High reflections are shown on the estuary, with the river Exe in the distance.

PLATE 137: COLIN JAMES MOORE (b.1924)

'**The barque** *C.J.S.* **off Coin de Mire, Mauritius**'. Oil on canvas, 16ins. x 24ins. Painted in 1978.

The barque was owned by Charles Jacobs and Sons and traded between Australia and Port Louis, Mauritius.
 The artist is self-taught and specialises in painting square-rigged ships and working coastal sailing craft of all types, as well as steam.

PLATE 138: PHYLLIS MAY MORGANS, RGI

'**Gathering clouds, Cros de Cagnes, Cote d'Azur**'. Oils, 16ins. x 20ins.
Executed mainly with the painting knife, 1979.

This painting uses the brilliant colours of the south of France, with white buildings, red Provençal roofs, white and green boats reflected in an aquamarine sea, with the clouds gathering over the Alpes Maritime. The artist favours sketching on the spot to capture the atmosphere.

Photograph courtesy: Martin Muncaster, Esq.

PLATE 139: NOEL MORROW (b.1915)

'Storm astern'. Watercolour.

This picture shows a 470-class racing dinghy running before a strong breeze, with thunder-grey storm clouds forming the background. There are surprisingly few paintings of dinghies sailing, although it is an exhilarating sport enjoyed by thousands of people of all ages.

PLATE 140: CLAUDE MUNCASTER, PPRSMA, RWS, ROI, RBA, NRD (1903-1974)

'A South Pacific Blow'. Oils, 30ins. x 20ins.

In 1932, Claude Muncaster sailed round Cape Horn as a deck-hand in the clipper *Olivebank* to gain first-hand experience for his work as a marine artist. He painted on the passage and his purpose in going to sea was 'to learn to paint ships and the sea with greater authority'. During a long and distinguished career he painted some 5,000 pictures, and exhibited at the Royal Academy from the very early age of 16. The picture shown here was used a a cover illustration for the book about the artist's life by his son Martin Muncaster (*The Wind in the Oak* published by Robin Garton, 1978).

PLATE 141: MARK RICHARD MYERS, RSMA, ASMA (b.1945)

'**The loss of the** *Peter and Sarah,* **Ilfracombe, 1st November 1859**'. Acrylics on canvas, 24ins. x 30ins.

The *Peter and Sarah* was 50 years old when she sailed with 70 tons of coal from Newport for Newquay. Soon after dawn on 1st November, 1859, she was seen off Ilfracombe with her mainsail blown to ribbons in the gale. A gig rescued two crew members, but the Captain dived below to save the ship's papers and the rescue boat was blown to leeward. The Captain managed to brace round the ship's topsail and head for the open sea, but the little vessel was overwhelmed by giant waves and lost.

PLATE 142:
EDWARD ALAN NORMAN
(b.1930)

'Boats on the mud, Dell Quay,
Chichester harbour'.
Watercolour, 10½ins. x 15ins.
Painted in May, 1979.

This picture is painted against the
light, which gives an interesting
and dramatic shadow effect.

Photograph courtesy: The Priory Gallery,
Bishops Cleeve, Cheltenham.

PLATE 143: WILLIAM
EDWARD NORTON (1843-1916)

'A Dutch beach scene'.
Watercolour, 17ins. x 23½ins.

Although American by birth,
William Edward Norton lived in
London and exhibited in many
leading British galleries including the
Royal Academy. His handling of
figures, beach and sea in this water-
colour is skilful and evocative. The
effect of space and distance beyond
the figures to the horizon is very
cleverly created.

237

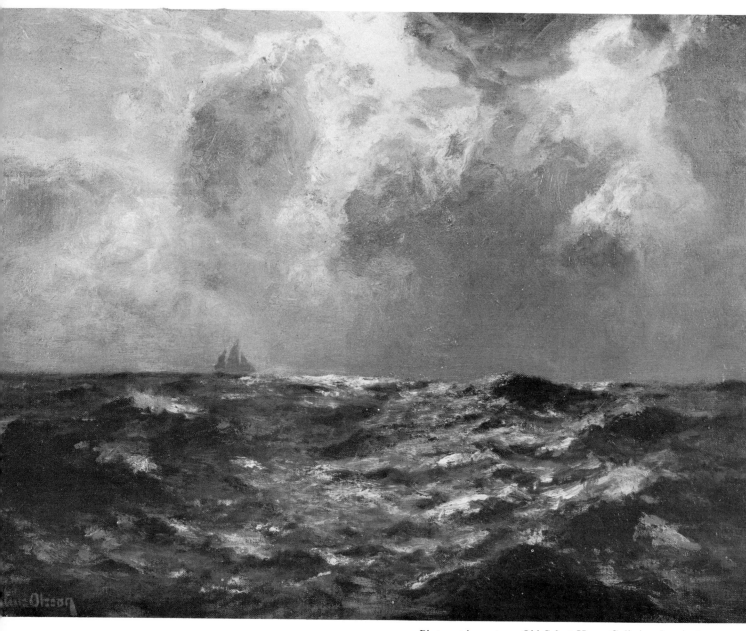

Photograph courtesy: Old Solent House Galleries, Lymington.

PLATE 144: JULIUS OLSSON, RA, PROI, RBA, RWA, NEAC (1864-1942)

'Seascape with distant sailing yacht'. Oil on canvas, 18ins. x 24ins.

Julius Olsson was one of the great turn-of-the-century painters of the sea. His work is much admired by many distinguished marine artists, but still surprisingly undervalued by the public. He achieved marvellous effects of light and movement with very free brushwork, as may be seen here.

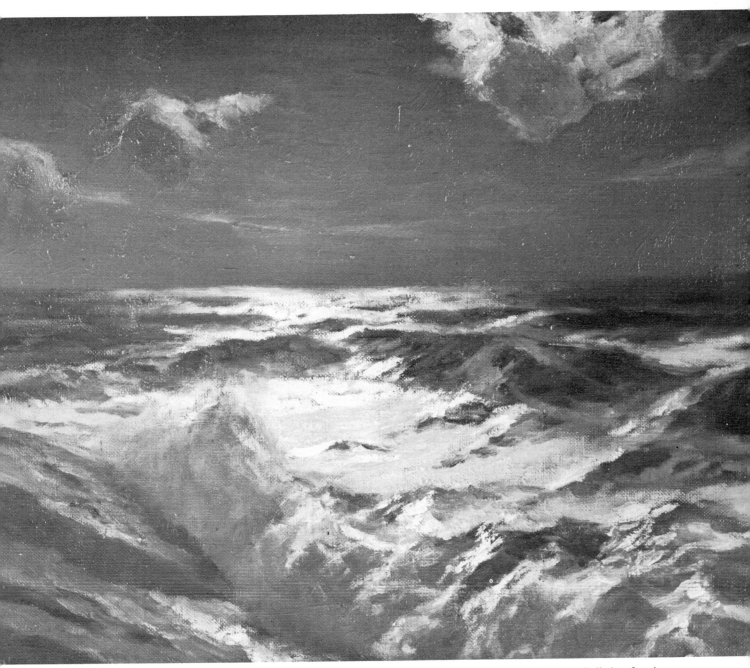

Photograph courtesy: Old Solent House Galleries, Lymington.

PLATE 145: JULIUS OLSSON, RA, PROI, RBA, RWA, NEAC (1864-1942)

'**A moonlit seascape**'. Oil on canvas, 14ins. x 18ins.

Once described at a Royal Academy banquet as 'the great Julius Olsson' this fine artist's seascapes are now undeservedly neglected except by discerning collectors and connoisseurs. The moonlit seascape illustrated here has enormous atmosphere and power, achieved with very little brushwork and a free style. Work by him was purchased by the Chantrey Bequest, and he exhibited widely in major London and provincial galleries, including the RA where he showed 175 paintings.

PLATE 146: LEONARD JOHN PEARCE, MSIA (b.1932)

'*Vasa*, **1628**'. Oils, 18ins. x 27ins. Painted in 1978.

The *Vasa* was a 64-gun wooden warship built at Stockholm by command of Gustavus Adolphus of Sweden. She capsized and sank just as she was about to start on her maiden voyage on 10th August, 1628. Her wreck was located in 1956, lying in just over 100 feet of water, and she was finally raised in 1961. Some 16,000 objects were recovered from the hull, which is now preserved in a special *Vasa* Museum in Stockholm.

 The artist went to Stockholm specially to study this ship at the museum where the vessel is being restored. He also researched the harbour, buildings, small craft, etc., of the 1600s. In order to achieve a high degree of accuracy, he sat in a small boat at the exact spot where the ship capsized, and made *aide memoire* photographs of the surroundings. This painting shows *Vasa* in a moment of glory, just before her tragic end.

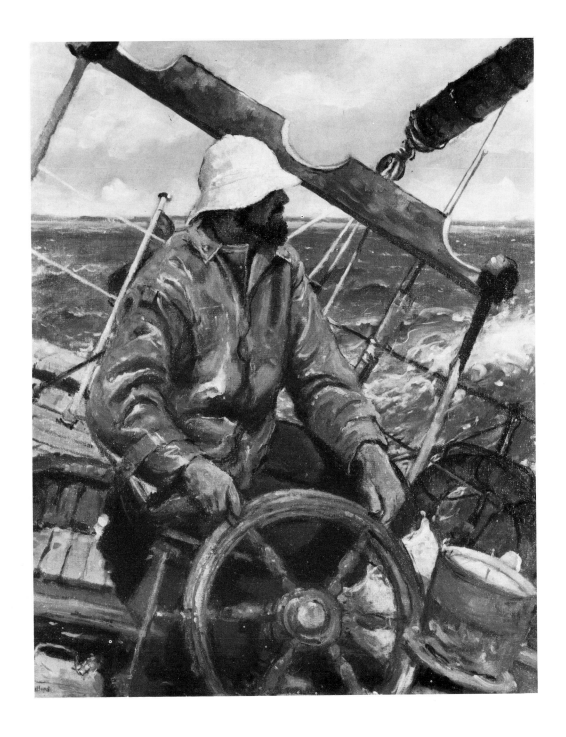

PLATE 147: FRANCES PHILLIPS (b.1903)

'**The Solent straight**'. Oils, 20ins. x 16ins. Exhibited at the RSMA, Guildhall, 1979.

An evocative painting which will strike an immediate chord in those who sail or have sailed in coastal waters. The artist was taught how to mix paint by John Singer Sargent, who also gave this advice: 'When you paint sea, treat it the same way as painting hair — with a free, full brush and never paint over it. It's a hit and miss method. If you miss, throw it away and start again!'

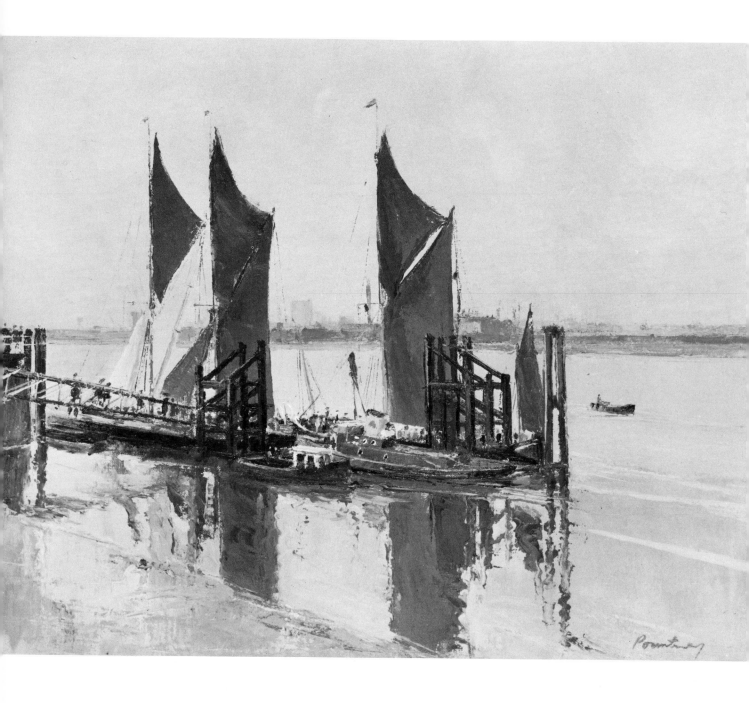

PLATE 148: JACK DENNIS POUNTNEY, FRSA (b.1921)

'**Thames barges — Greenwich Pier**'. Oils, 15½ ins. x 19½ ins. Exhibited at the RSMA, Guildhall, 1977.

This picture was painted after the annual open weekend of the Thames Sailing Barge Club, where the public can enjoy a close-up view of the few remaining grand old ladies of the London River. The impact of this painting lies in the graceful sail shapes and the reflections in the foreshore at low tide, and also the hint of activity on the craft.

The artist paints mainly in oils and uses the painting knife in preference to brushes in order to broaden technique and suggest rather than introduce detail. He is fascinated by the effects of light and atmosphere, and marine subjects provide a whole spectrum of these qualities. Although in watercolours he works on the spot, for oils he makes sketches and colour notes plus a short descriptive story of the scene he has chosen.

PLATE 149: MARK RANDALL (b.1921)

'**North Sea rig**'. Watercolour, 12ins. x 16ins. Painted in 1977.

Mark Randall's marine painting is largely devoted to docks, industrial marine subjects, wharves, oil rigs, etc. He is also a demonstrator and art critic to numerous art societies.

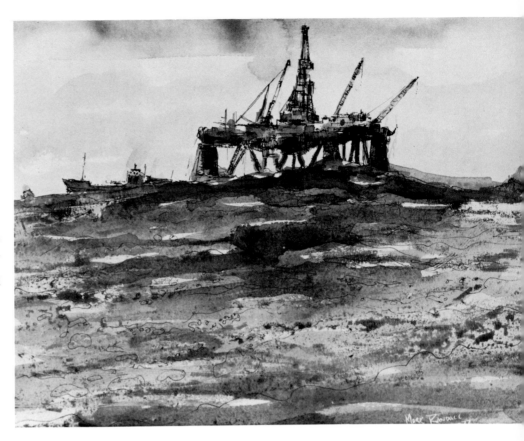

PLATE 150: PETER AUGUSTAVE RASMUSSEN, ARWA, PS (b.1927)

'**Safe anchorage — Juan les Pins**'. Oils, 19ins. x 27½ins. Exhibited at the RSMA, Guildhall, 1977.

Peter Rasmussen has been increasingly occupied in the last seven years with marine subjects between St. Tropez and Monaco. He describes the light in that area as 'incredible' and the arrival by sea at places like Monaco as 'breathtaking'.

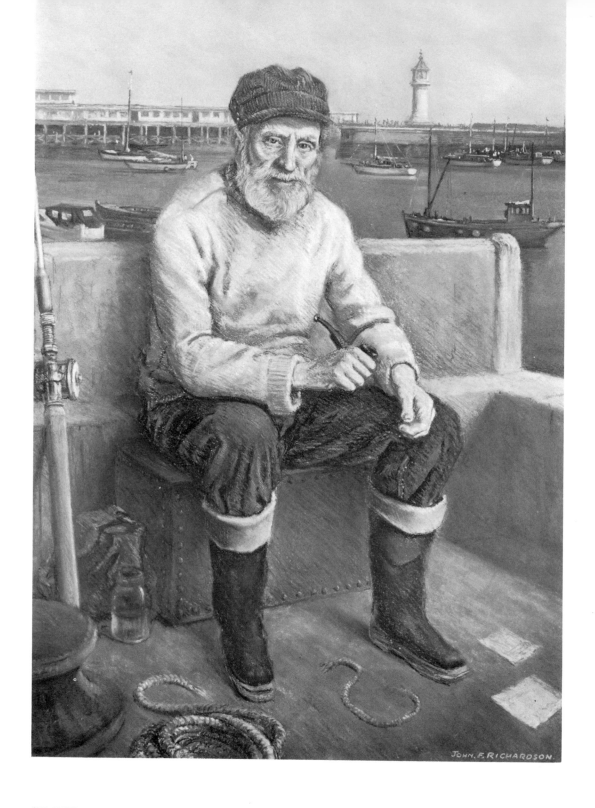

PLATE 151: JOHN FREDERICK RICHARDSON, ATD, SGA, UA, FSAI, FRSA (b.1912)

'The Fisherman's Tale'. Pastel drawing. Exhibited at the RSMA, Guildhall, 1975.

John F. Richardson was a professional teacher of art for many years and his advice to young artists includes the admonition: 'learn to draw, draw, draw!' He is in the habit of working on the spot and making direct sketches or finished watercolours from which, if necessary, he composes more elaborate works in his studio.

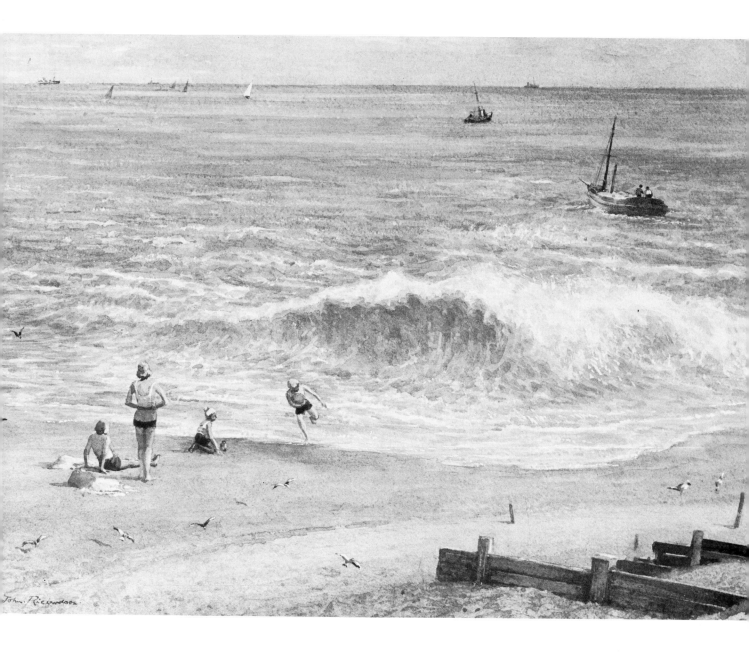

PLATE 152: JOHN FREDERICK RICHARDSON, ATD, SGA, UA, FSAI, FRSA (b.1912)

'**The Wave**'. Watercolour. Exhibited at the RSMA, Guildhall, in 1978.

This watercolour was designed and painted from sketch book studies. The figures in the left-hand foreground provide scale and movement — without them, the picture would lose a great deal of its impact. The eye is drawn automatically by these figures to the breaking wave. Beyond the wave the sea is calm and the vessels on it are unaffected by the surge of water on the shore.

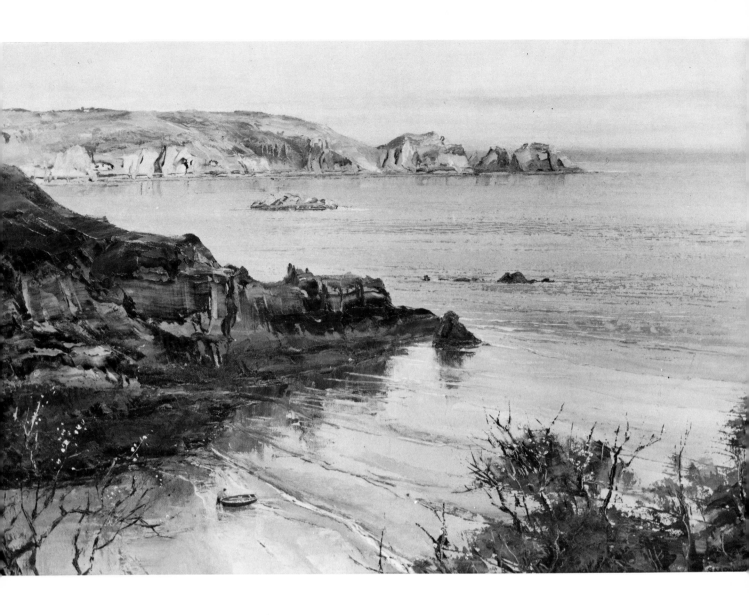

PLATE 153: SHEILA MacLEOD ROBERTSON, RSMA (b.1927)

'Early Spring, Saint's Bay, Guernsey'. Oils, 19½ ins. x 29½ ins. Exhibited at the RSMA, Guildhall, 1977.

This picture embodies low-angle spring sun which lights the distant headland, in contrast to the nearer cliffs which remain in shade. The first blossoms are showing on the wind-blown thorn scrub in the foreground.

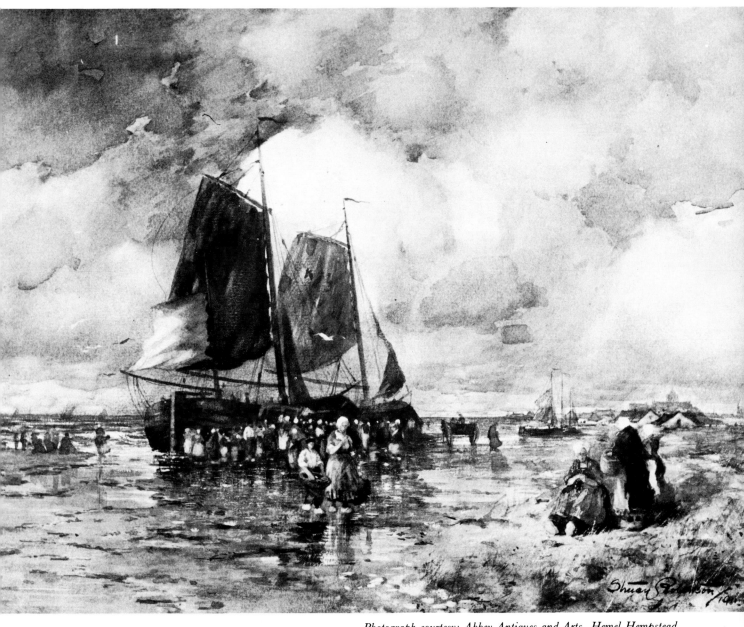

PLATE 154: STRUAN ROBERTSON (fl.1903-1918)

'Dutch pinks on a foreshore with fisherfolk'. Watercolour, 11¾ins. x 15½ins. Dated 1911.

This Scottish artist has a very attractive style which might be said to fall within the Post-Impressionist idiom. Pictures of this type from the first half of the 20th century are most desirable but not easy to find. The artist lived in and near Glasgow and exhibited at the Glasgow Institute of Fine Arts.

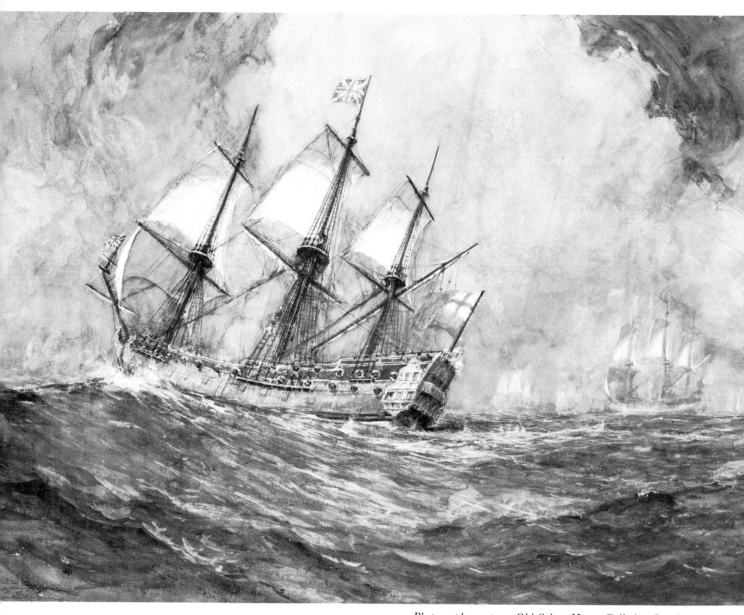

PLATE 155: GREGORY ROBINSON (fl.1907-1934)

'The Commander-in-Chief bound for the Mediterranean, c.1685'.
Watercolour and bodycolour, 21½ ins. x 29½ ins. Painted in 1915.

Gregory Robinson studied at the Royal Academy Schools and later served at sea in World War I. He painted many historical sea pieces. The picture illustrated here is a good example of the effective use of bodycolour to add substance and impact to the texture of the subject; in this instance, the final result falls somewhere in appearance between pure watercolour and oils.

PLATE 156: SONIA ROBINSON, RSMA (b.1927)

'Two boats, Falmouth'.
Oils, 16ins. x 22ins.

This picture shows a pair of well-used fishing boats huddled together in Falmouth old harbour. The artist says that she could not imagine them apart and that the two of them made a splendid almost geometric pattern against the oblongs of granite harbour wall.

Sonia Robinson particularly likes to paint boats at anchor and boats at rest, and she is enthusiastic about the structure and design of old harbours, wharves and the jumbled buildings around them. She has exhibited widely, including the RA and RSMA, and lives at Mousehole in Cornwall.

PLATE 157: HARRY HUDSON RODMELL, RI, RSMA (b.1896)

'The S.S. *Vesteralen*'. Oils.

This painting was carried out from a sketch made by the artist on the spot when he was in Norway a few years ago. The vessel *Vestaralen* ran on a regular service, coastwise, to the North Cape. Mr. Rodmell was a founder member of the RSMA. He is a Hull artist and has been exhibiting since the early 1930s.

**PLATE 158: MALCOLM
ROBERT ROGERS (b.1915)**

'**The spirit of London Docks**'.
Watercolour, 12ins. x 16ins.
Exhibited in 'Spirit of London'
Exhibition, 1978.

This picture shows a cargo fire
in a ship's hold. It was painted
on some sympathetic French
handmade paper, still being
made today as it was in the
year 1326 at an old mill in the
Auvergne. The artist worked
'wet into wet' with some final
dry brush treatment.

**PLATE 159: JOHN LINCOLN ROWE
(b.1951)**

'**MV** *Donga*: **derrick, number 5 hatch, and
midships accommodation**'.
Pastels, 25ins. x 38ins.

The MV *Donga,* a cargo liner, was built in
1960 for the Elder Dempster Line (now
amalgamated with Ocean Fleet). This pic-
ture was completed whilst steaming off the
West African coast, the vessel's traditional
run from the U.K. (Liverpool, West
Africa, Dublin).

PLATE 160: SYDNEY JAMES ROWE (b.1911)

'**At Keyhaven, Hampshire**'. Watercolour, 14ins. x 20ins. Exhibited at the RSMA, Guildhall, 1977.

This picture was painted on the site and slight adjustments made in the artist's studio. In the middle ground is Hurst Castle and the old lighthouse, and beyond this the Solent and the high ground of the Isle of Wight.

Photograph courtesy: The Priory Gallery, Bishops Cleeve, Cheltenham.

PLATE 161: FRANK W. SCARBOROUGH (fl.1890-1939)

'Unloading: Pool of London'. Watercolour, 14ins. x 21ins.

Frank Scarborough painted many excellent watercolours of the tidal Thames with shipping, as illustrated here, and also coastal scenes. His work has been somewhat neglected and undervalued until recent years, but is now quite widely admired and collected. He succeeded in capturing the atmosphere of the smokey Thames in his own distinctive style and warm colours.

Photograph courtesy: Abbey Antiques and Arts, Hemel Hempstead.

PLATE 162: FRANK W. SCARBOROUGH (fl.1890-1939)

'Wapping Reach, London'. Watercolour, 6½ ins. x 9¾ ins.

This is another example of the excellent handling of tidal Thames scenes by Frank Scarborough whose work is now becoming more widely admired.

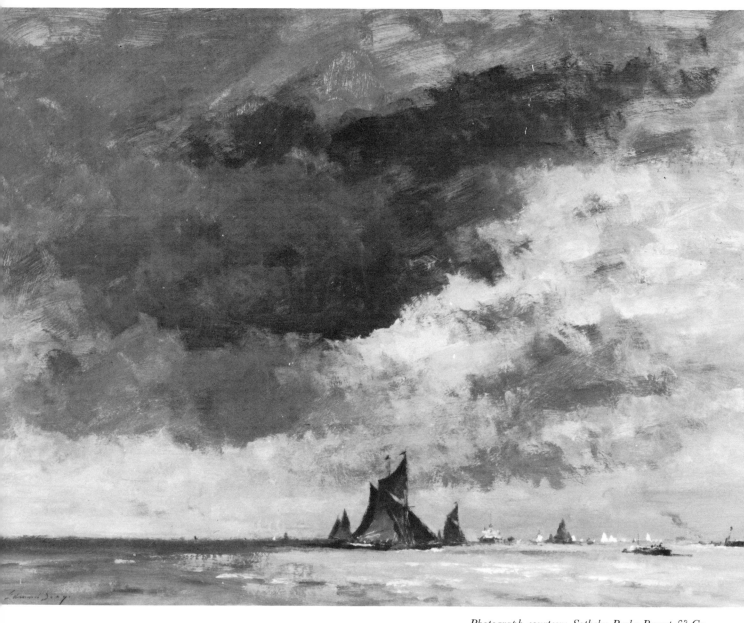

PLATE 163: EDWARD BRIAN SEAGO, RWS, RBA (1910-1974)

'Barges racing in the Harwich approaches'. Oil on board, 26ins. x 36ins.

The artist's mastery of sky and sea are well shown in this fine painting. Although he travelled widely abroad, he lived in Norfolk when in England and therefore knew intimately the unique lighting effects on landscape and coast in those parts of the country. Edward Seago's work is internationally admired. He covered many subjects, including landscapes and portraits and he was also a marine artist of considerable ability.

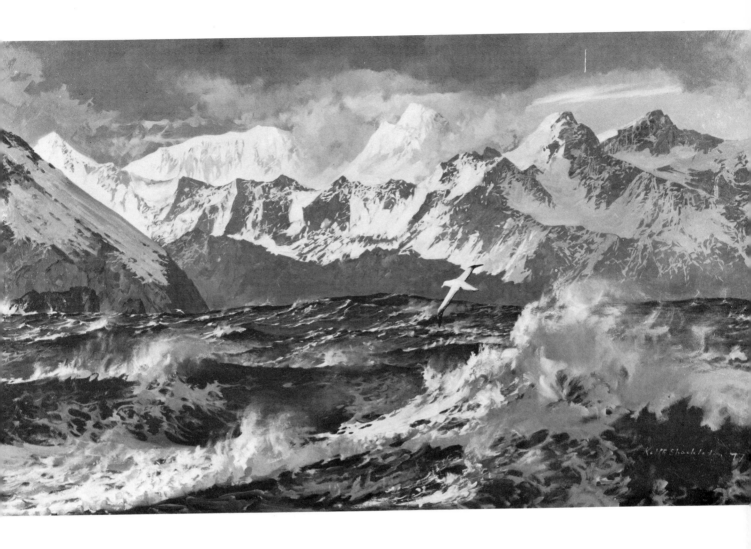

PLATE 164: KEITH SHACKLETON, PPRSMA, SWLA (b.1923)

'South Georgia'. Oils, 20ins. x 46½ins. Exhibited at the RSMA, Guildhall, 1977.

A dramatic and powerful painting, the circumstances of which are described by the artist as follows:

'South Polar waters meet the more temperate seas of latitudes further north along the Antarctic Convergence, a ring around Antarctica at around 55° South.

'The line of this ring is vague and variable but near the meridian of 30° West it takes a special swing to embrace South Georgia. The significance of this grip is made manifest in the whole appearance of the island.

'South Georgia is a rugged, elemental place with an aspect more akin to the mainland of Antarctica than its latitude would suggest. To a naturalist it is a paradise. Enormous colonies of albatross and petrels, penguins and seals breed here. To an artist it offers the unsullied shapes of rock, snow-field, glacier and moraine.

'This picture is a layer-cake of the essential elements of the island — cloud, mountain and sea in equal proportions. The wind is traditional and the wandering albatross is always on hand.

PLATE 165: FAITH TRESIDDER SHEPPARD, RGI (b.1920)

'Caernarvon Castle and harbour'. Oil on canvas, 20ins. x 35ins. Exhibited at the RSMA, Guildhall, 1977.

The artist owned a cottage near Caernarvon in the early 1970s and painted a number of views of the castle and harbour. She studied at the Royal Academy Schools and has exhibited widely in the U.K. and overseas. As well as harbour scenes, Faith Sheppard also paints seascapes, sailing ships and landscapes.

PLATE 166: ALAN JOHN SIMPSON, RSMA (b.1941)

'**Entering Plymouth**'. Oils, 22ins. x 30ins. Exhibited at the RSMA, Guildhall, 1979.

This artist specialises in coastal subjects, ports and harbours along the south, west and East Anglian coasts, with a particular interest in coastal sailing craft.

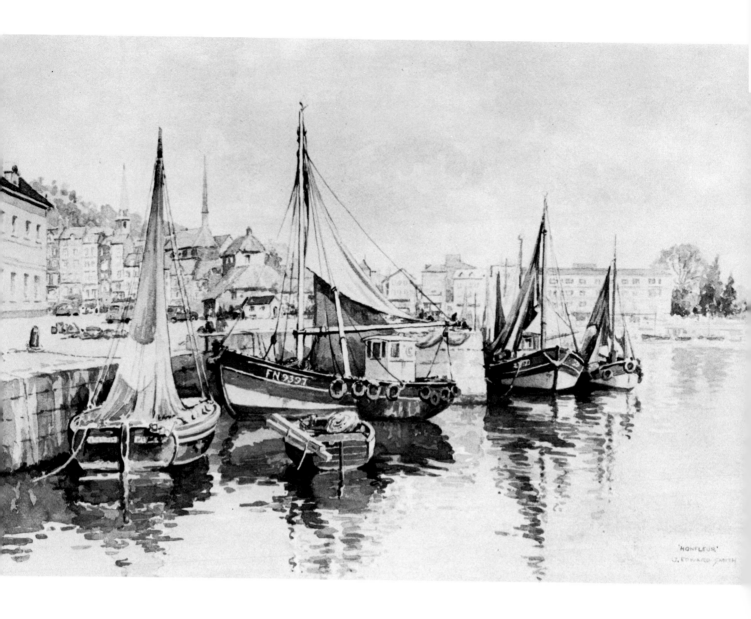

PLATE 167: J. EDWARD SMITH (b.1905)

'**Honfleur**'. Watercolour, 18ins. x 27ins.

The small harbour of Honfleur on the Normandy coast opposite to Le Havre has been a favourite haunt of artists since the 19th century. This painting effectively captures the peaceful atmosphere of the port, and shows a firm but delicate handling of detail.

Edward Smith paints harbours, ships, landscapes and portraits. He has exhibited at the RSMA, the Royal Society of Portrait Painters and the Welsh Academy.

Photograph courtesy: K. Scharf Ltd., London.

PLATE 168: JOHN SNELLING, FRSA (b.1924)

'Boulogne harbour, France'. Oil on canvas, 16ins. x 20ins.

This view is painted from the road bridge to the Ferry Terminal in Boulogne. The artist specialises in coastal scenes and has had numerous one-man shows.

PLATE 169: THOMAS JAQUES SOMERSCALES (1842-1927)

'A barque running before a gale'. Oils, 16ins. x 22ins. Dated 1910.

Thomas Somerscales, a Hull artist, painted many fine pictures of deep ocean sailing ships. He lived in Chile from 1865 to 1892, but later returned to Hull where he died in 1927. His British exhibits included 25 pictures in the Royal Academy and his well known painting *'Off Valparaiso'* was purchased by the Chantrey Bequest. Whilst he is often thought of as a 19th century artist, in fact he stepped firmly into the early 20th century with his work.

PLATE 170: PHILIP WILSON STEER, OM, NEAC (1860-1942)

'**The White Yacht**'. Oil on canvas, 24ins. x 36¼ ins. Painted in 1912.

This picture shows a scene in Porchester harbour, Hampshire, where Steer spent the summer of 1912. At this time he was still painting in the free unhibited style which he admired so much in Whistler and the French Impressionists.

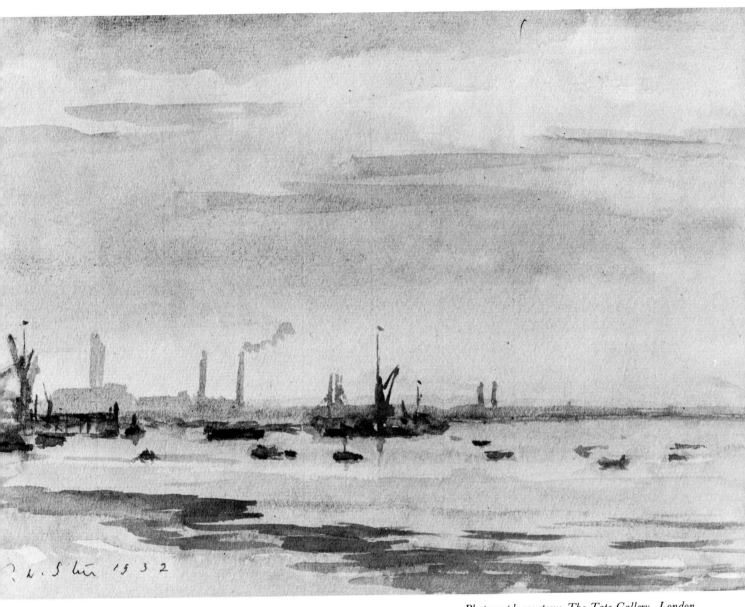

PLATE 171: PHILIP WILSON STEER, OM, NEAC (1860-1942)

'Low tide, Greenhithe'. Watercolour, 8¾ ins. x 12ins.

The delicate execution of this watercolour, painted in 1932, does not hide the fact that in his later career Steer took greater pains with his draughtsmanship and perhaps leaned more towards the 'English' school of painting.

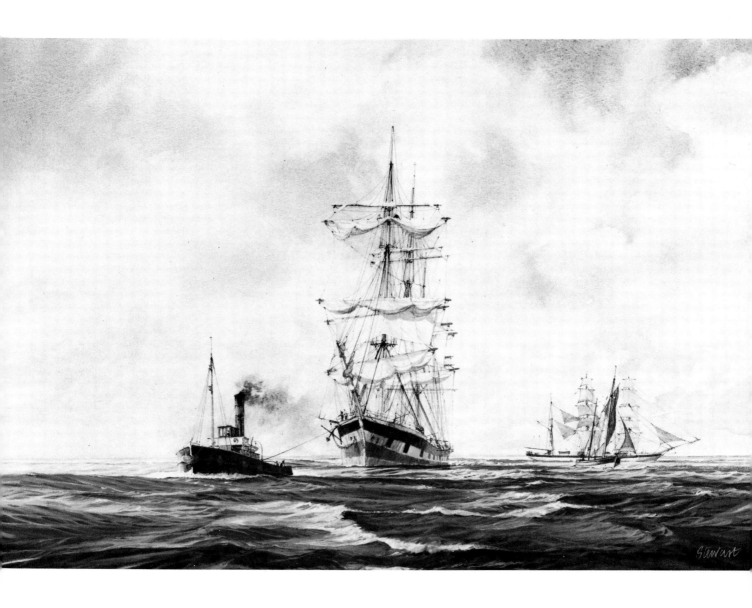

PLATE 172: ALAN JOHN STEWART (b.1933)

'Largiemore'. Watercolour, 13ins. x 20ins. Exhibited at the RSMA, Guildhall, 1979.

The *Largiemore* was of 1,938 tons and owned by Thompson, Dickies. This painting shows her hove-to off a Channel port and picking up the pilot. The artist was inspired by a sailor-made model, which he owns, of this ship.

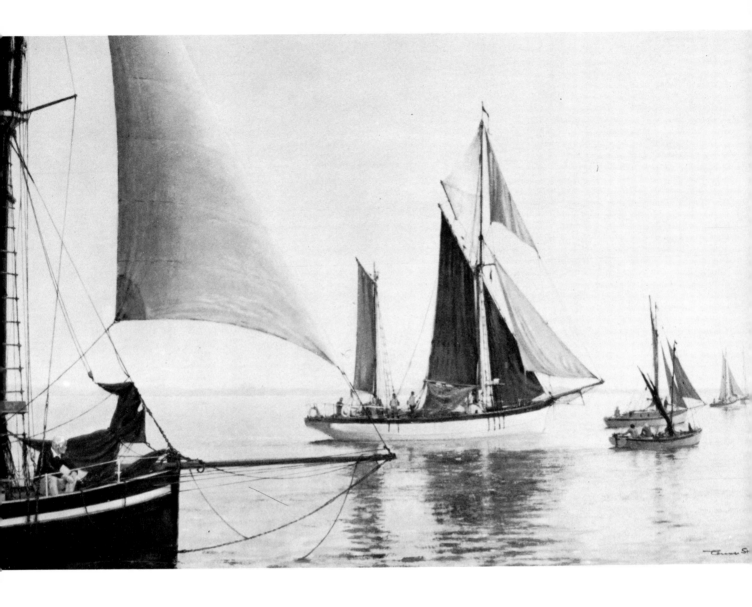

PLATE 173: TERENCE LIONEL STOREY, RSMA (b.1923)

'**Old Gaffers**'. Oils, 24ins. x 36ins. Exhibited at the RSMA, Guildhall, in 1979.

The artist made sketches of a number of boats and composed this imaginary scene from them. The figures on these vessels give life and credibility to the subject; in some marine pictures, the lack of figures on ships makes them appear to have been abandoned.

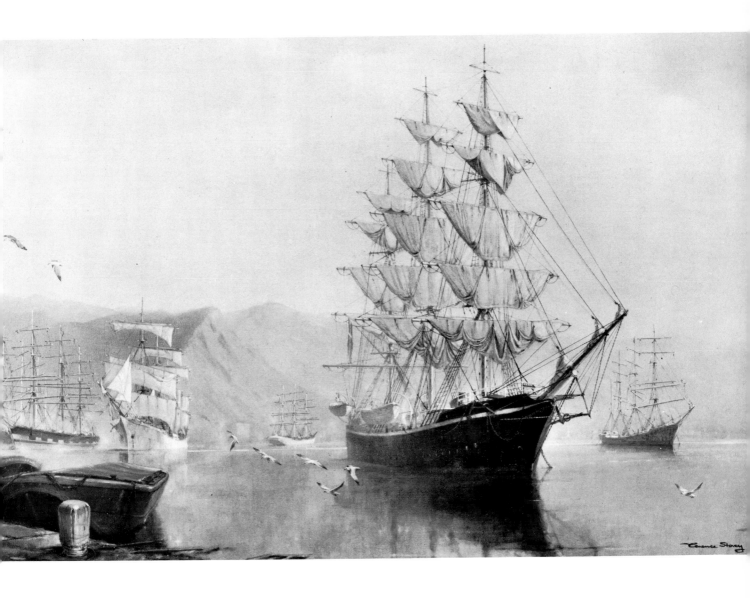

PLATE 174: TERENCE LIONEL STOREY, RSMA (b.1923)

'The *Georg Stage II* in Santa Cruz bay, Tenerife'.
Oil on canvas, 24ins. x 36ins. Exhibited at the RSMA, Guildhall, in 1977.

In 1882 the Danish shipowner Carl Frederik Stage set up a Foundation which he called 'Georg Stage's Minde' and presented to it the fully-equipped full-rigged ship *Georg Stage*. The ship and the Foundation were named after his only son who had died shortly before. In 1935 that ship was replaced by the new present-day *Georg Stage II*. (The old *Georg Stage* still exists as the *Joseph Conrad*).

The *Georg Stage II* was built of steel at Frederikshavn's Vaerft & Flydedok, A/S, Frederikshavn, in 1934/35 and commissioned in April, 1935. Her home port is Copenhagen and her main details are as follows. Tonnage: 298 gross. Length: 134 feet. Breadth: 27 ft. Mainmast 98 ft. above the waterline. Sail area: 9,260 sq. ft. Engine: 122 h.p. diesel.

Her complement is 92, including approximately 80 boys under training. By tradition, each summer the *Georg Stage II* visits Sweden, Norway and Scotland. In the winter she is laid up in the Royal Danish Naval Yard, Copenhagen. She sailed in the Tall Ships Race in 1956, 1960, 1966 and 1974.

Terence Storey made the reference drawings for this painting in September 1975 when the *Georg Stage II* was moored just above Tower Bridge, London. The cadets furled and unfurled the sails each day for public entertainment. The largest of the two white ships in this picture is the *Lawhill*.

265

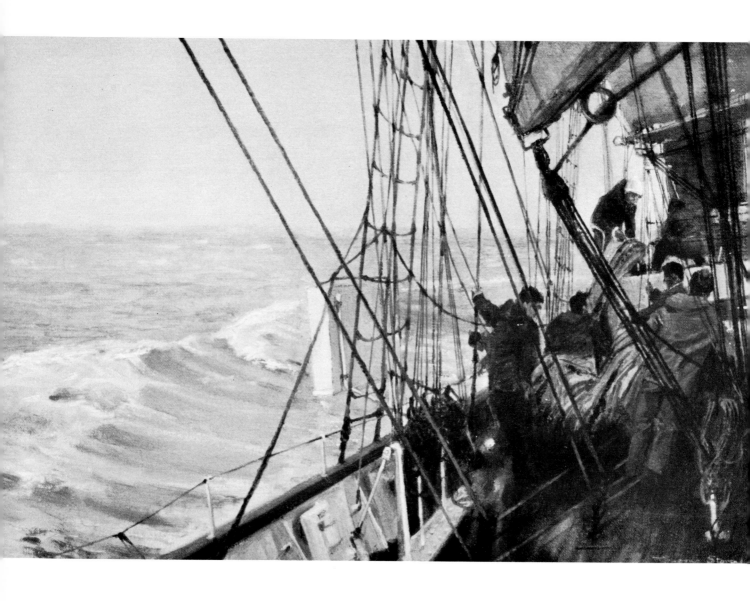

PLATE 175: TERENCE LIONEL STOREY, RSMA (b.1923)

'**On board the** *Sir Winston Churchill*'. Oil on canvas, 12ins. x 18ins.

The sail training schooner *Sir Winston Churchill* together with her sister ship the *Malcolm Miller* are owned and run by the Sail Training Association, a non-profit making charitable organisation whose object is 'to provide young people with an outlet for their spirit of adventure and an opportunity to develop a sense of responsibility, self-discipline, and above all, an ability to work as one of a team, all of which will help them throughout their lives'.

Terence Storey painted this picture from sketches made on board the ship.

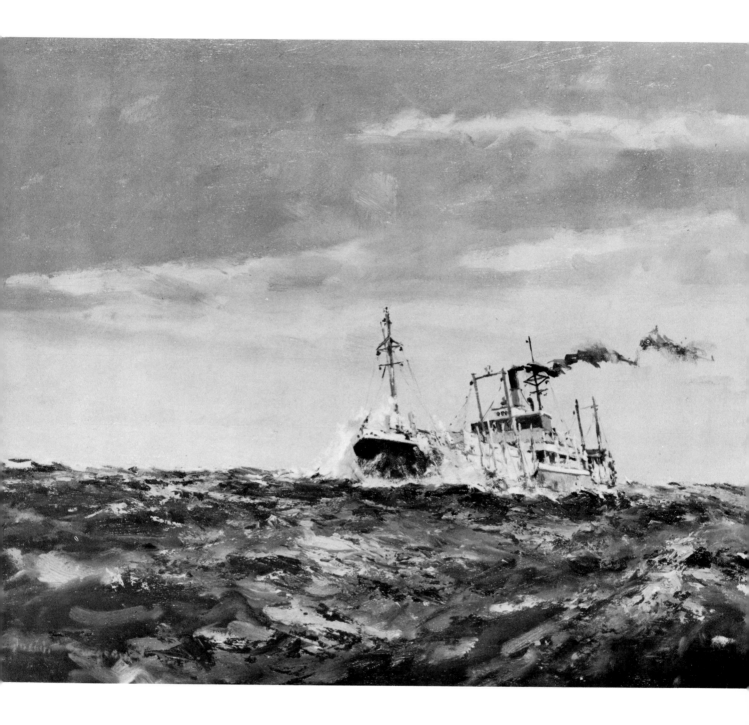

PLATE 176: JOSIAH JOHN STURGEON, RSMA, RI, FRIBA (b.1919)

'The *Atle Jarl* — **Yarmouth bound'**. Oils, 16ins. x 20ins. Exhibited at the RSMA, Guildhall, in 1979.

The *Atle Jarl* was one of many Scandinavian ships trading with Yarmouth and other east coast ports. She often arrived with a heavy list after the deck cargo received a drenching on a rough crossing and would be met by the port tug *Richard Lee Barbour* (c.1950) and towed across the treacherous bar at Gorleston. She would then proceed up-river to discharge her timber cargo below Haven Bridge.

Josiah Sturgeon grew up in a nautical family environment and within the sight and sound of ships and shipping. He spent many of his early years afloat and has known the North and South Atlantic oceans in summer and winter in peace and war. He has been a regular exhibitor at the RSMA and other major London exhibitions for many years.

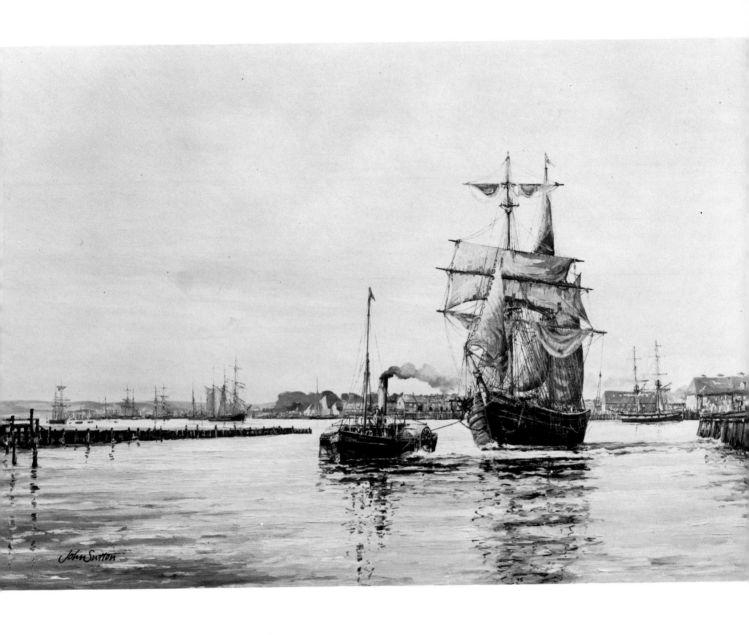

PLATE 177: JOHN SUTTON (b.1935)

'The paddle tug *Jumma* **towing the brig** *Blue Belle* **out to sea in the Edwardian era'.** Oils, 24ins. x 36ins.

John Sutton paints a variety of marine subjects in oils, watercolour and gouache. He prefers the traditional methods of British marine painting, and his work has been exhibited widely in London and the provinces. He spends a great deal of time collecting material and researching in order to achieve accuracy and the right atmosphere for his sailing ships, steam vessels and harbour and estuary scenes.

PLATE 178: MAURICE TAYLOR (b.1917)

'**The tug** *Formby* **at Southampton**'. Oils, 20ins. x 30ins. Painted in 1977.

The tug *Formby* belonged to the Alexandra Towing Company in 1967. Maurice Taylor taught himself to paint in order to use up some inherited materials (he says). He specialises in ships, especially tugs, and harbour scenes.

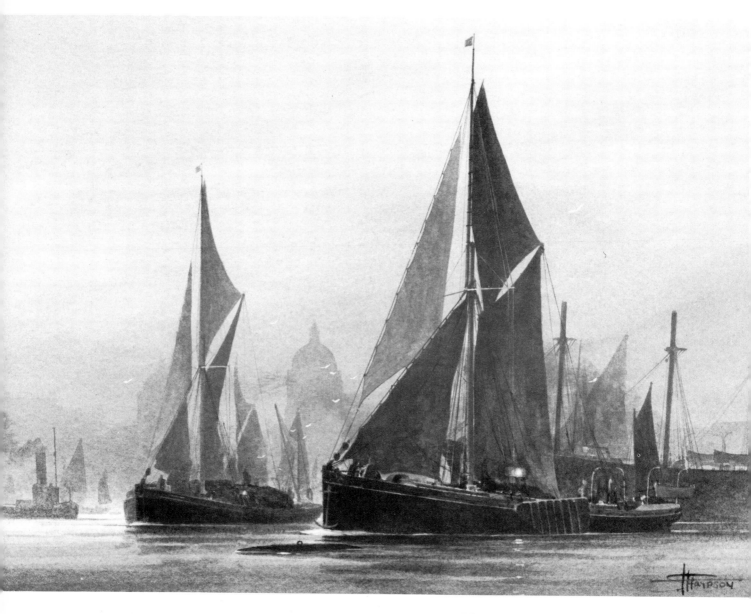

Photograph courtesy: The Omell Galleries, London.

PLATE 179: STEPHEN FREDERICK THOMPSON (b.1948)

'Dusk on the River Thames'. Watercolour, 10ins. x 14ins.

A scene which recalls the days of the London River earlier in the 20th century when there were still plenty of sailing barges about and the smoke from tugs and chimneys hung low over the water.

Stephen Thompson travels widely in England, sketching and painting on the spot. He studied at the Exeter College of Art.

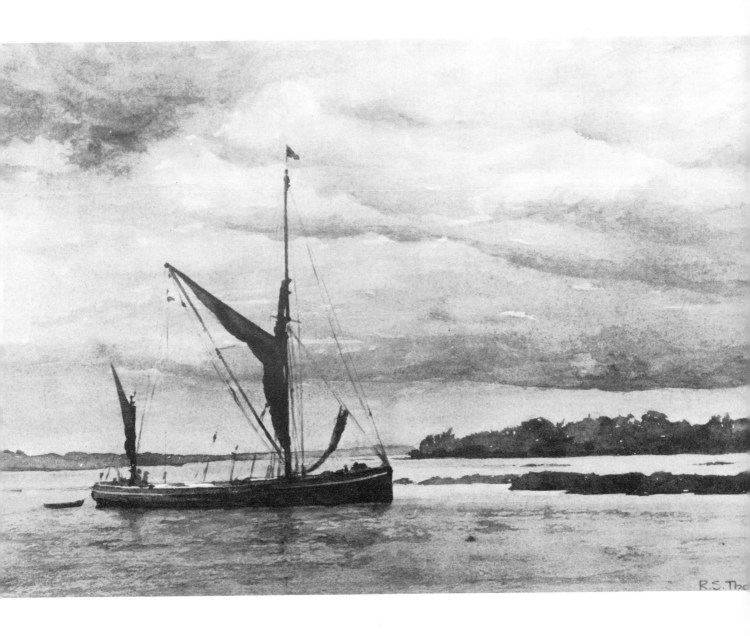

PLATE 180: RAYMOND STANLEY THORN (b.1917)

'On the evening tide'. Watercolour, 9½ins. x 14ins. Painted in 1977.

The picture shows an ex-barley trade barge which is now used for educational and recreational purposes out of Snape Maltings, Suffolk. It was painted at Iken near Aldeburgh.

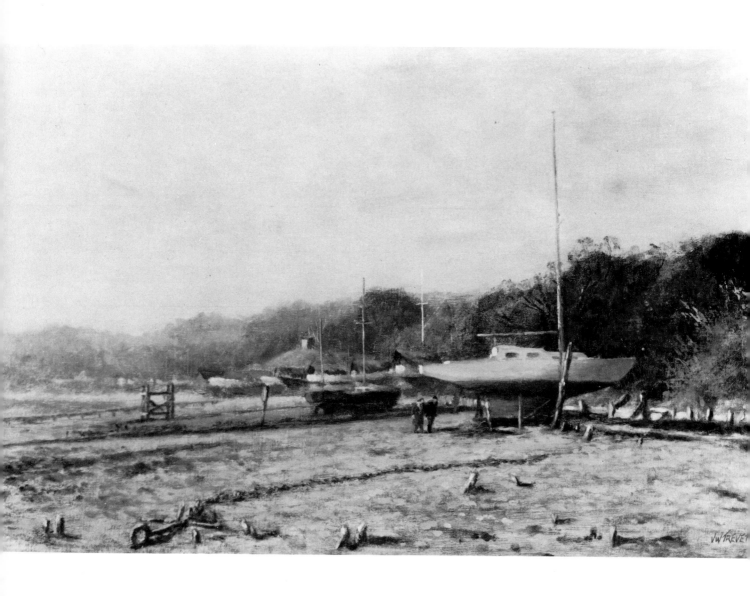

PLATE 181: VICTOR WILLIAM TREVETT (b.1930)

'Winter sunshine, Cockham beach'. Oils, 16ins. x 24ins. Painted early in 1979.

This part of Cockham beach adjoins the Medway Yacht Club hard which can be seen in the middle ground. Like many present day marine artists, Victor Trevett is a great admirer of Boudin.

PLATE 182:
GERALD EDWIN
TUCKER (b.1932)

'Barge race'.
Watercolour, 12ins. x
16ins.

The artist has first-hand
experience of these craft as
he once owned a Thames
sailing barge at Pin Mill in
Suffolk.

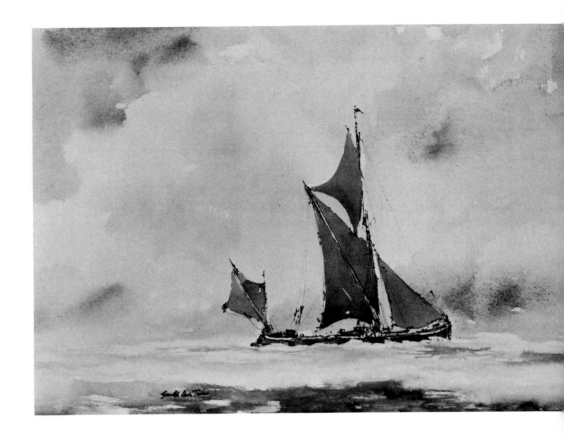

PLATE 183:
Cdr. ERIC ERSKINE
CAMPBELL TUFNELL
(1888-1978)

'Light coastal forces:
21st MTB Flotilla'.
Watercolour, 10ins. x 14ins.

Commander Tufnell served
in the Royal Navy in both
World Wars. He painted, in
watercolours, a large number
of pictures of naval vessels and
incidents and 10ins. x 14ins.
was his invariable size. His
paintings became particularly
popular over the years with
those who served in the R.N.
or R.N.V.R.

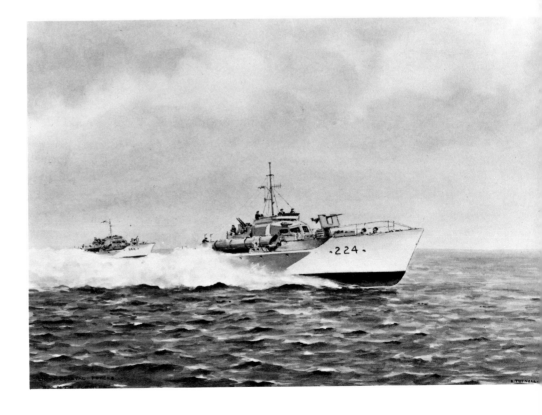

273

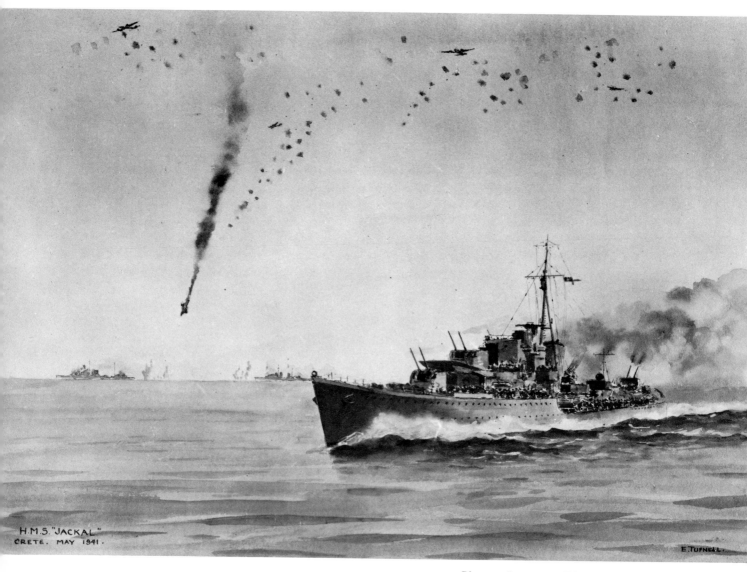

H.M.S. "JACKAL"
CRETE. MAY 1941.

E.TUFNELL

PLATE 184: COMMANDER ERIC ERSKINE CAMPBELL TUFNELL (1888-1978)

'H.M.S. *Jackal,* **Crete, May, 1941'.** Watercolour, 10ins. x 14ins.

Commander Tufnell served in the Royal Navy in a variety of active roles in different parts of the world from 1903, when he entered as a cadet, until 1946 when he retired from a post in the Naval Information Services. He was a self-taught artist with an accurate eye and a deep understanding of ships from first-hand experience. His output was considerable and the majority of his work over many years was handled by the Parker Gallery, London.

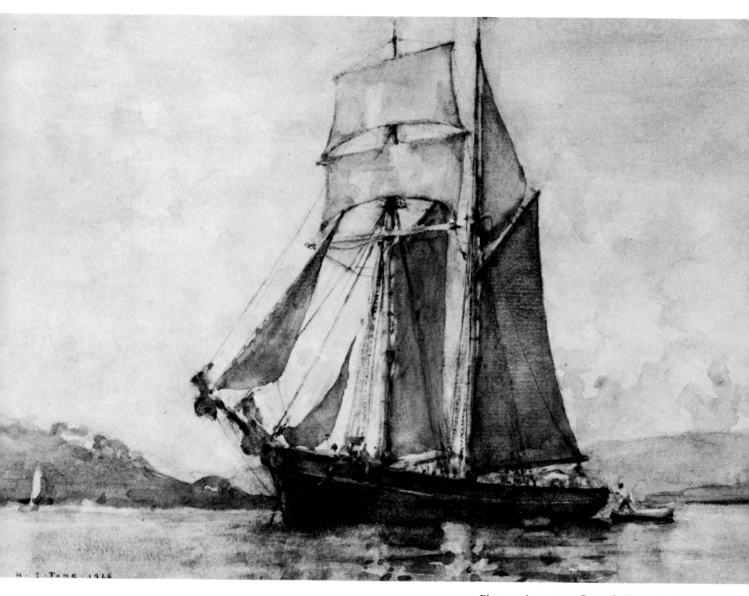

Photograph courtesy: Pyms Gallery, London.

PLATE 185: HENRY SCOTT TUKE, RA, RBA, RWS, NEAC (1858-1929)

'Schooner in Falmouth harbour'. Watercolour, 7ins. x 10ins. Dated 1928.

Henry Scott Tuke, a prominent associate of the Newlyn School in its heyday, underwent several phases in his work. One phase included his powerful marine oils (see PLATE 186) and another was his preoccupation with painting boys bathing, for which he is often most remembered. He also produced some beautiful and delicate watercolours of ships, such as the one illustrated here. This picture was exhibited in the Royal Academy Winter Exhibition in 1933 and shows the artist's complete understanding of sailing vessels.

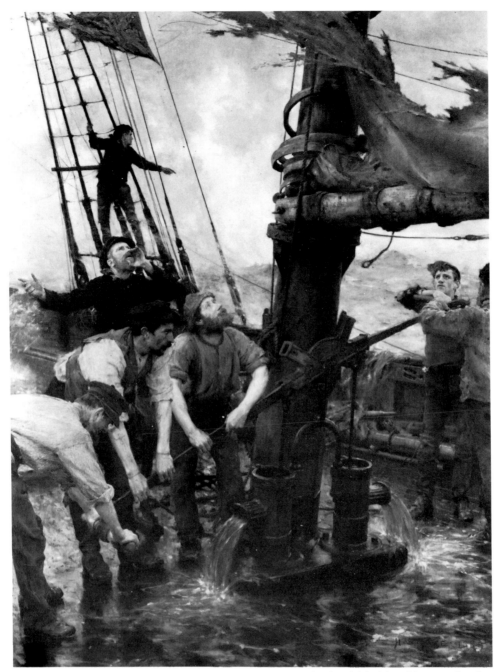

Photograph courtesy: National Maritime Museum, London.

PLATE 186: HENRY SCOTT TUKE, RA, RBA, RWS, NEAC (1858-1929)

'All hands to the pump'. Oils, 73ins. x 56ins.

The artist's very considerable talent with figure painting is well displayed in this large and powerful seapiece. Tuke is now categorised as a member of the Newlyn School, but when he was living in Falmouth from 1895 he considered himself somewhat apart from that group although he had close associations with its members. He was a keen amateur sailor and yacht owner and much of his important work was done at the turn of the 19th century. Nowadays, his name is most often thought of in connection with his paintings of nude boys bathing and on the beach, but his claims on posterity rest wider, as both his delicate water-colours of ships and his robust marine paintings show.

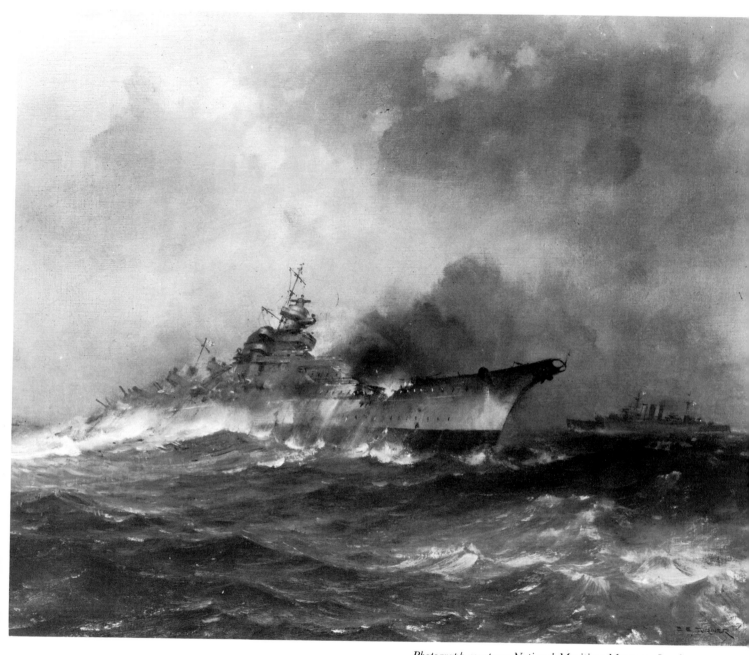

PLATE 187: CHARLES E. TURNER (1883-1965)

'Sinking of the *Bismarck*, 27 May, 1941'. Oils, 25ins. x 30ins.

Charles Turner was a Captain in the R.A.F. in World War I and contributed two paintings to the Imperial War Museum including 'Clearing the seas: a 'P' boat exploding a mine' (see PLATE 249). It is interesting to compare this early picture with the one illustrated here which shows a much later and perhaps more sophisticated development in his style.

The artist was also an illustrator and made numerous drawings of marine subjects for the *Illustrated London News*.

PLATE 188: ROWELL TYSON, RBA, ARCA (b.1926)

'**Cliffs near Broadstairs**'. Oil on board, 11 ½ ins. x 18ins.

The artist lives about three minutes from the sea and is constantly confronted by cliffs and the shore line, at high and low tides and at all times of the day. He says that cliffs have a certain presence for him, and his paintings evolve from confrontations which result from particular relationships between sea, sky and cliffs. This picture was painted from drawings made by Rowell Tyson.

PLATE 189: COLIN VERITY, RIBA, RSMA (b.1924)

'**Picking up the pilot**'. Oils, 10½ins. x 14ins. Exhibited at the RSMA, Guildhall, in 1977.

This painting shows a tramp steamer in the early 1900s picking up a pilot offshore from a pilot cutter prior to entering estuary waters. It is an incident invented by the artist with no particular location in mind, but typical of hundreds of places around the British Isles and in European waters.

Colin Verity believes that marine painting should not be undertaken without careful thought and analysis. He feels that it is essential to have the ability to observe and draw, because ships are particularly unforgiving to the indifferent draughtsman and no amount of 'arty verbosity' can disguise this fact.

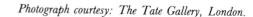
Photograph courtesy: The Tate Gallery, London.

PLATE 190: EDWARD ALEXANDER WADSWORTH, ARA, NEAC (1889-1949)

'The beached Margin'.
Tempera on linen laid on panel.
28ins. x 40ins. Painted in 1937.

Edward Wadsworth liked to paint in tempera, although he also used other media. His marine still-life and nautical subjects have a stylised formality blended with a dream-like atmosphere. He exhibited widely and his works are in many well known public collections.

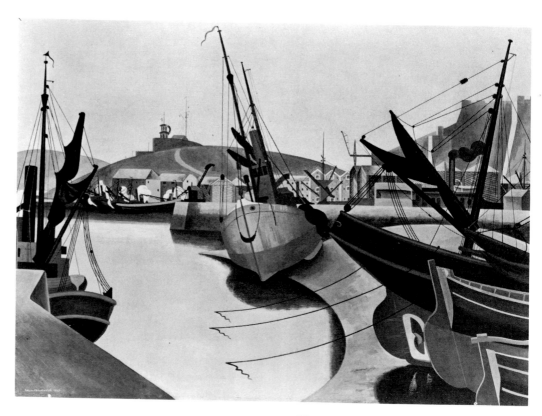

Photograph courtesy: The Tate Gallery, London.

PLATE 191: EDWARD ALEXANDER WADSWORTH, ARA, NEAC (1889-1949)

'A Seaport'. Tempera on linen laid on plywood, 25ins. x 35ins. Painted in 1923.

This painting, in the Tate Gallery, is a Chantrey bequest from the artist's daughter. There is a note in the records to the effect that the scene probably shows La Rochelle; however, as may be seen, the trawler in the centre of the picture has a Lowestoft registration number. Wherever the location may be, the artistic achievement is clean-cut and powerful. The absence of figures does perhaps give this painting a strangely deserted and brooding atmosphere.

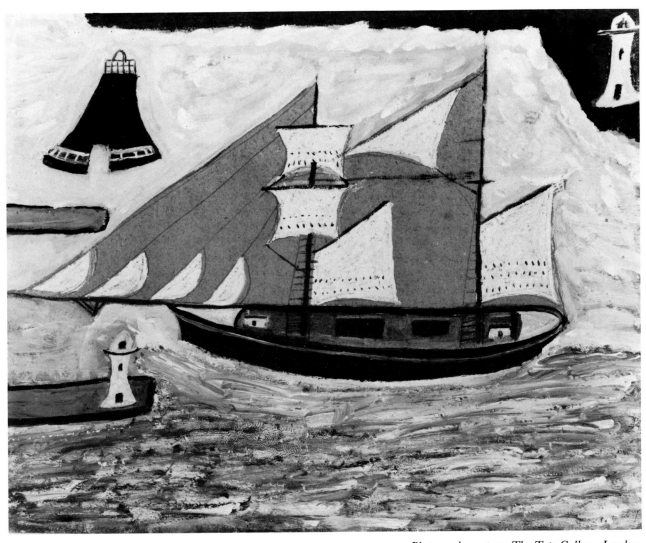

PLATE 192: ALFRED WALLIS (1855-1942)

'The Blue Ship'. Ship's oil paint on cardboard mounted on plywood, 17¼ins. x 22ins. Believed painted c.1934.

Every 50 years or so, there emerges from the many amateur and 'primitive' painters one whose work fires the imagination and gives fresh impetus to at least part of the spectrum of marine art. At the beginning of the 20th century, France 'discovered' Henri Rousseau (1844-1910) who took up painting on retirement from his job as a minor Customs official. His naïve work is now widely acclaimed. Similarly, Alfred Wallis, a simple sailor who went to sea when he was nine years old, began painting about 1925 for his own amusement. His primitive pictures were painted on scraps of card, paper or wood and he hung them in his cottage at St. Ives, Cornwall. Christopher Wood and Ben Nicholson saw his work and noted the same spark of genius which illuminated the paintings of Henri Rousseau. Alfred Wallis died in a Penzance workhouse, but his work is represented in the Tate Gallery, London, just as Rousseau's is displayed in the Louvre in Paris.

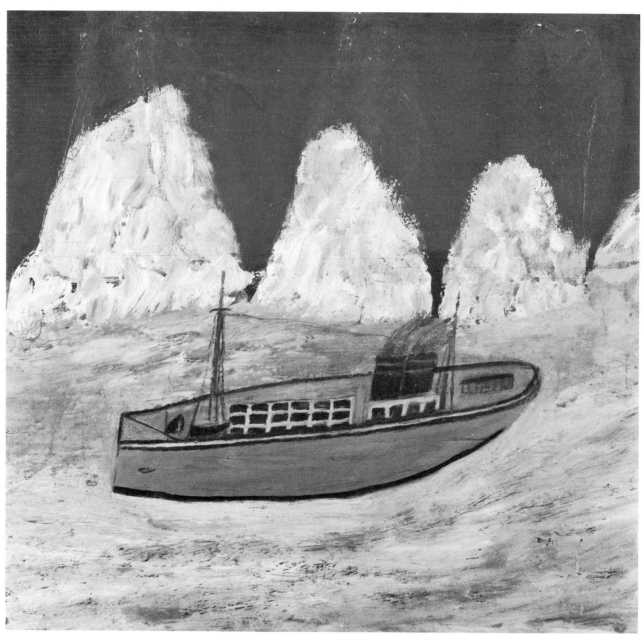

PLATE 193: ALFRED WALLIS (1855-1942)

'Voyage to Labrador'. Ship's oil paint on plywood, 14½ ins. x 15½ ins. Believed painted c.1935-1936.

Alfred Wallis recorded what he saw, in direct and simple terms. Childish pictures to some, but the work of untutored genius to many professional artists and art critics. Scenes such as 'Voyage to Labrador' would have come from his own hard seafaring experiences as a sailor in the Atlantic. He later became a Cornish fisherman.

PLATE 194: FRANK WASLEY (fl.1880-1914)

'Fishing craft off Staithes'. Watercolour, 21ins. x 29ins.

The work of Frank Wasley deserves wider recognition and this fact has become recognised by some collectors in recent years. His impressionistic handling of marine subjects is most attractive and skilful, as may be seen in the excellent example illustrated here.

Photograph courtesy: Old Solent House Galleries, Lymington.

PLATE 195: FRANK WASLEY (fl.1880-1914)

'**Below London Bridge**'. Oil on canvas, 17ins. x 24ins.

A dramatic evening picture by an early 20th century artist whose work is still under-rated. Frank Wasley, a British Post-Impressionist, died about 1930. His work is highly talented but not often seen. As shown in this illustration, his style was free but powerful.

PLATE 196: LESLIE JOSEPH WATSON, MBE, ARCA, RSMA (b.1906)

'Folkestone harbour'. Oil on canvas, 28ins. x 36ins. Exhibited in the Royal Academy, 1945.

In the mid-1930s Leslie Watson sailed out of Ramsgate in a 30ft. Bermudian sloop. His paintings of this period, particularly those concerned with the Folkestone area, enabled him to have a one-man exhibition at Portsmouth before the last war, and this exhibition in turn led to him becoming a founder member of the RSMA.

PLATE 197: ROY KINGSLEY ETTWELL WEAVER (b.1916)

'Pulpit Rock, Portland Bill'. Oil on canvas board, 16ins. x 20ins.

This strong picture was painted on site in stormy winter sunshine in November, 1977. It shows the Pulpit Rock (so named due to its shape) at Portland Bill, looking south-eastwards. The great mass of the rock seems to be peering towards the horizon, rather like a ship's figurehead. On the horizon, on the right-hand side, is a far distant ship. There is a great deal of movement in this painting, both in the composition and posture of the massive rocks and in the flow of water surging around their base.

Roy Weaver lives at Weymouth, not far from this scene and paints harbour and coast pictures, mainly in Dorset, in both oils and watercolours. He has been exhibiting at the RSMA since 1977.

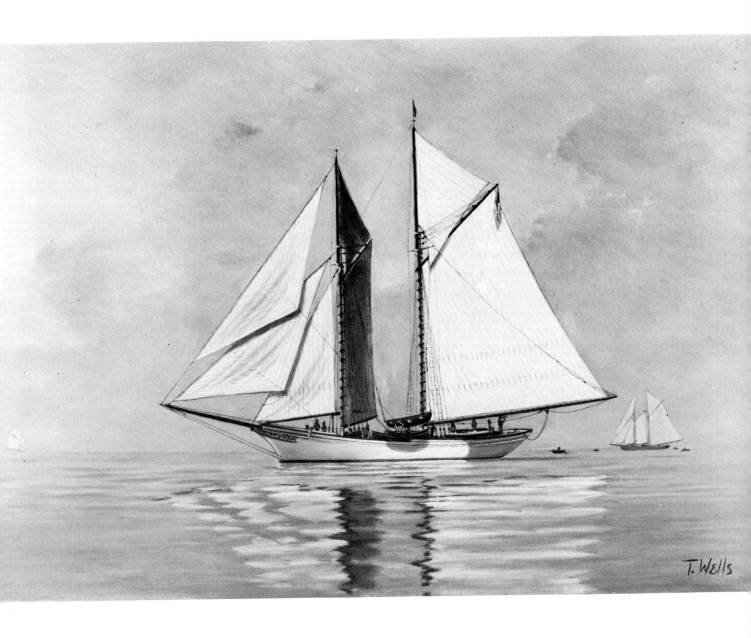

PLATE 198: TIMOTHY WAITE WELLS (b.1942)

'**The Grand Banks fishing schooner** *Lottie S. Haskins*'. Oils, 20ins. x 30ins. Painted in 1980.

Although the artist paints a wide range of marine subjects, the type of vessel illustrated here has become one of his favourite subjects. He has had considerable sailing experience and has exhibited his pictures extensively in the U.S.A. as well as the U.K.

PLATE 199: EDWARD WESSON, RI, RBA, RSMA (b.1910)

'**Holiday beach**'. Oils, 8ins. x 14½ins. Exhibited at the RSMA, Guildhall, 1977.

Edward Wesson is a great admirer of the work of Boudin. His view is that Boudin's light is a continuation of Turner and Constable — a lovely quality of silvery light on his foreshore and river subjects. Mr. Wesson's choice of subjects is often similar to that of Boudin by whom he says he has been influenced more than any other artist.

PLATE 200: LESLIE ARTHUR WILCOX, RI, RSMA (b.1904)

'The *Oxford* **Black Ball packet leaving Liverpool, 1836**'. Oils.

Leslie Wilcox feels that figures are frequently a notable omission from marine paintings. As he says, one often sees pictures which seem devoid of human life, and some ships look as if they have been abandoned and are sailing themselves. He is enthusiastic about including people in his own paintings, and as he also paints portraits and subject pictures he is well qualified as a figure painter, as may be seen here.

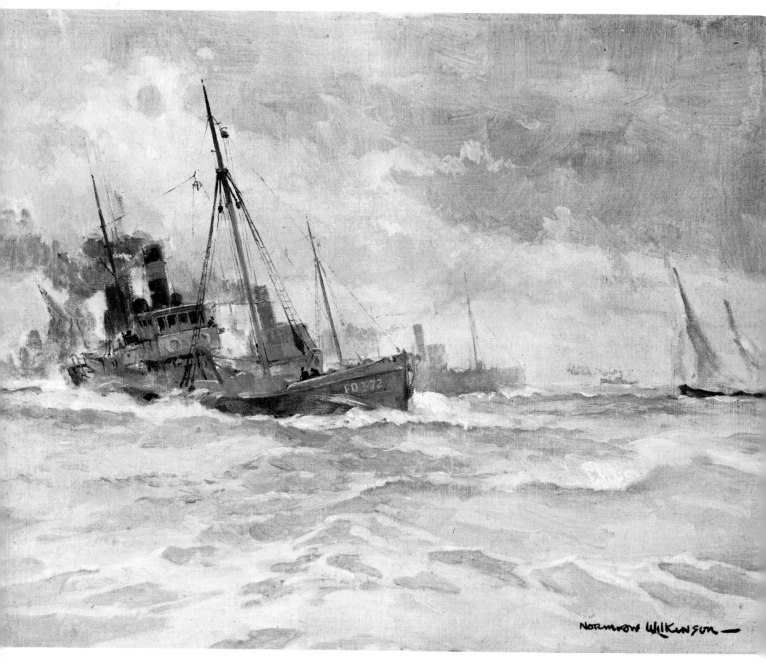

Photograph courtesy: Old Solent House Galleries, Lymington.

PLATE 201: NORMAN WILKINSON, CBE, PRI, ROI, RSMA, HRWS (1878-1971)

'Fleetwood trawlers at sea'. Oils, 12ins. x 14½ins.

Norman Wilkinson was capable of achieving a totally effective picture with the minimum of fussiness and detail, as may be seen here. He was a prolific artist and ranks amongst the foremost of 20th century marine painters. He was a founder member of the RSMA and exhibited widely in major galleries, including the RA, where he showed 55 pictures.

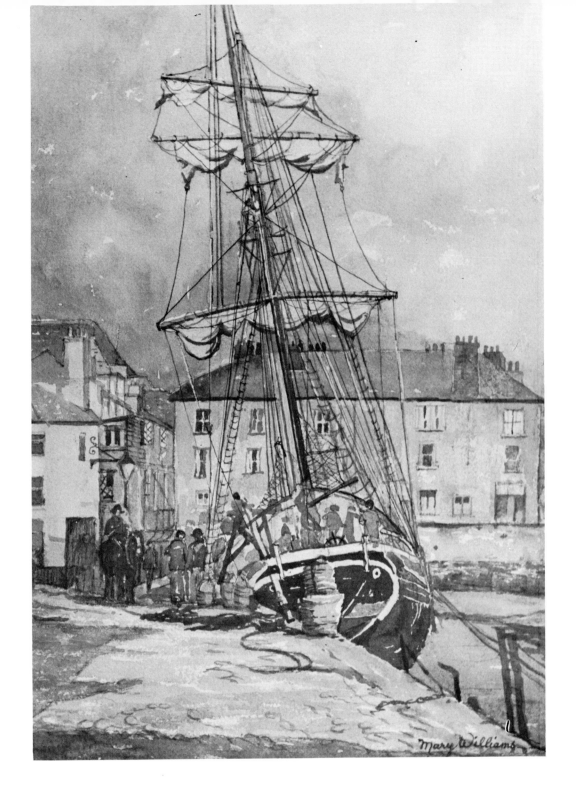

PLATE 202: MARY WILLIAMS, RWA, SWA

'*Elsa* **at Bayards Cove, Dartmouth'.** Painted in October, 1971.
Watercolour, 14¾ins. x 11ins. Exhibited in the RWA 1975, and the SWA 1977.

This picture was painted during the filming of *The Onedin Line* by the BBC in 1971. Mary Williams, who was a pupil of Claude Muncaster, has been painting harbour scenes and a wide range of other subjects since 1928.

PLATE 203: DAVID INNES SANDEMAN WOOD (b.1933)

'**Collecting bait — Harwich**'. Watercolour, 7ins. x 9½ins. Painted in 1979.

David Wood favours the Harwich area for painting as it is possible to paint the movement of ships against a wonderful backdrop of cloud effects. He is also interested in figures on beaches and wherever possible he puts people into his pictures.

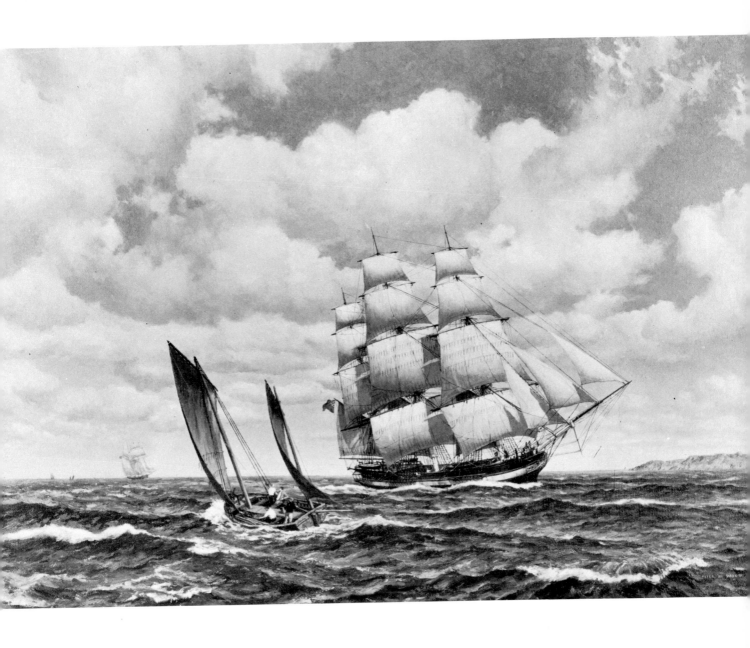

PLATE 204: PETER MacDONAGH WOOD, RSMA (b.1914)

'The West Indiaman *Thetis* **off Bolt Head'.**
Oil on canvas, 27½ins. x 40ins. Exhibited at the RSMA, Guildhall, 1977.

The artist has had practical seafaring experience from an early age and is a specialist in square-riggers — facts which show clearly in this painting. Of this picture, he says:

'This shows an early 19th century merchant vessel, of a type which I find very attractive, reaching up Channel with just about as much wind as she wants for full sail. I have hoped to convey in the action of the Indiaman and foreground lugger some of the pleasurable excitement of sailing on a fresh, lively day.

'The West Indiamen were, of course, much smaller than the warship-like big East Indiamen, but were impressively lofty and heavily sparred and canvassed.'

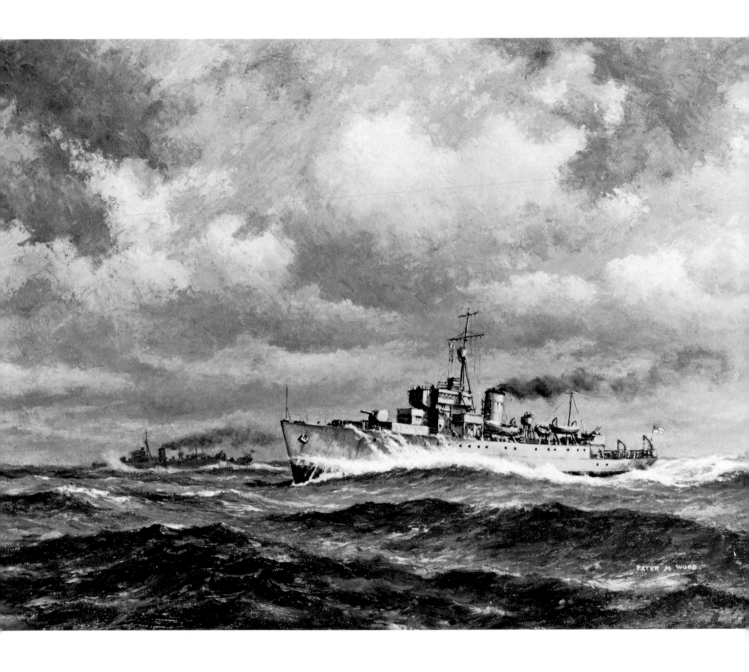

PLATE 205: PETER MacDONAGH WOOD, RSMA (b.1914)

'**Minesweepers**'. Oil on canvas, 17ins. x 23½ins. Exhibited at the RSMA, Guildhall, 1977.

Of this painting, the artist says:
'I tried to express the hard slog of routine work in uncomfortable home service weather conditions. The ships are *Algerine* class minesweepers which I considered to be quite handsome and staunch-looking small warships, although lacking fashion pieces and refinements. They measured 235ft. x 35.8ft., 1309 tons, and 86 were built between 1941 and 1946, many in Canada.'

PLATE 206: JOHN WORSLEY, VPRSMA (b.1919)

'Dubai Creek'. Oils, 29½ ins. x 39½ ins. Exhibited at the RSMA, Guildhall, 1977.

John Worsley says that he likes to paint commissioned work because it gives him a deadline which he can then go flat out to achieve. But every now and then he feels impelled to paint a scene or event which particularly impresses him, like this Dubai picture. He happened to be flying over on a commission, saw this view and thought 'That is absolutely superb. I must do that'. So he obtained the use of a helicopter and kept it hovering overhead for long enough to get the necessary notes and references.

He has had a long and distinguished career as an artist, as well as having been a naval officer and yachtsman. Two of his pictures were in the RSMA inaugural exhibition in 1946 and he has exhibited there regularly since then, as well as at other leading centres.

PLATE 207: BERT WRIGHT, RSMA, MBIM, FRSA (b.1930)

'**The Thames at Galleons Reach**'. Watercolours, 20ins. x 25ins.

This picture depicts a rain squall in the late evening during September, with the river Thames at low tide.
 Bert Wright is a member of the Wapping Group of Artists. He uses both oils and watercolours and prefers the traditional methods of painting marine subjects.

PLATE 208: JOSEPH FRANKLIN WRIGHT, ISA, SMP, VANS (b.1924)

'**Saltbankers racing off Halifax** — *Bluenose* **and** *Columbia*'.
Oils, 26¼ ins. x 35½ ins. Exhibited at the RSMA, Guildhall, 1977.

Joseph Franklin Wright lives at Port Hawkesbury, Nova Scotia, and therefore has first-hand experience of the vessels sailing in those waters. He also builds models of fishing schooners, tern schooners and square riggers.

PLATE 209: PAUL ANTHONY JOHN WRIGHT (b.1947)

'**Convoy**'. Watercolour and bodycolour, 15ins. x 18ins. Exhibited at the RSMA, Guildhall, 1979.

Paul Wright says that he has a passion for ships, especially iron and steel ships and warships spanning the last 120 years. This dates from a visit he made to H.M.S. *Vanguard* when he was ten years old. He paints many pictures for use as book jackets and the scene illustrated here was done for this purpose. It shows a convoy assembling and getting under way.

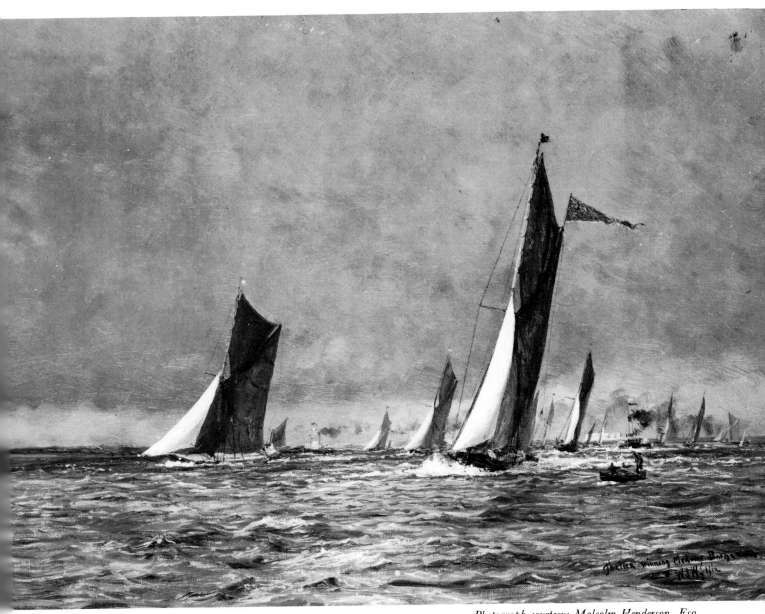

PLATE 210: WILLIAM LIONEL WYLLIE, RA, ROI (1851-1931)

'*Thelma* **winning the Medway barge match**'.

W.L. Wyllie was one of the most outstanding of the early 20th century marine painters. His work was greatly admired during his life but became somewhat neglected between 1945 and 1970 when many of his paintings and particularly his etchings could be bought well below their true value. In 1972, Malcolm Henderson held a major exhibition in London of the artist's work, and this was the start of the re-establishment of Wyllie's high reputation which is now widely acknowledged once more. He was very versatile in oils, watercolours and etching. His complete mastery of marine subjects is well shown in this finely lit picture.

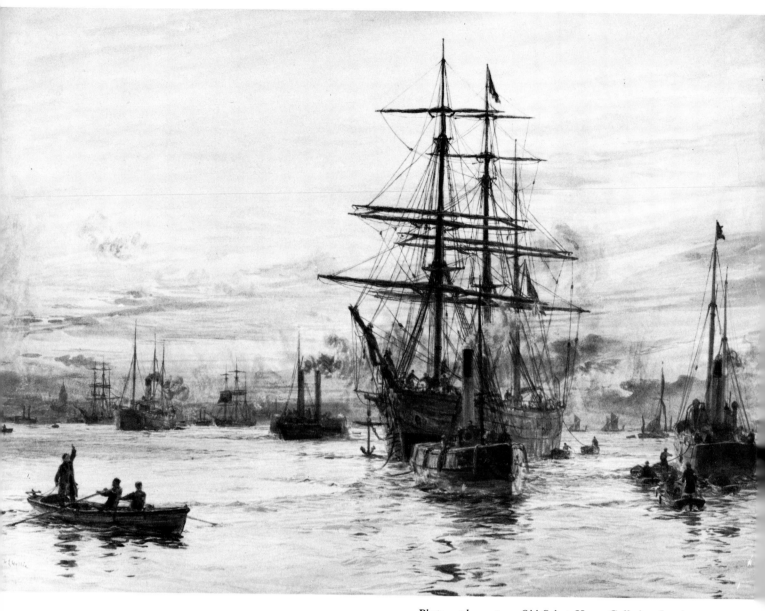

Photograph courtesy: Old Solent House Galleries, Lymington.

PLATE 211: WILLIAM LIONEL WYLLIE, RA, ROI (1851-1931)

'**A busy port, sunset**'. Watercolour heightened with bodycolour, 17½ ins. x 23½ ins.

This notable artist bridged the 19th and 20th centuries with his work and is considered by some people to have been one of the most talented marine artists of his time. The picture illustrated here shows steam and sail in a busy and romantic conglomeration, with enough smoke to give the right atmosphere. This evocative mixture makes a most desirable painting.

300

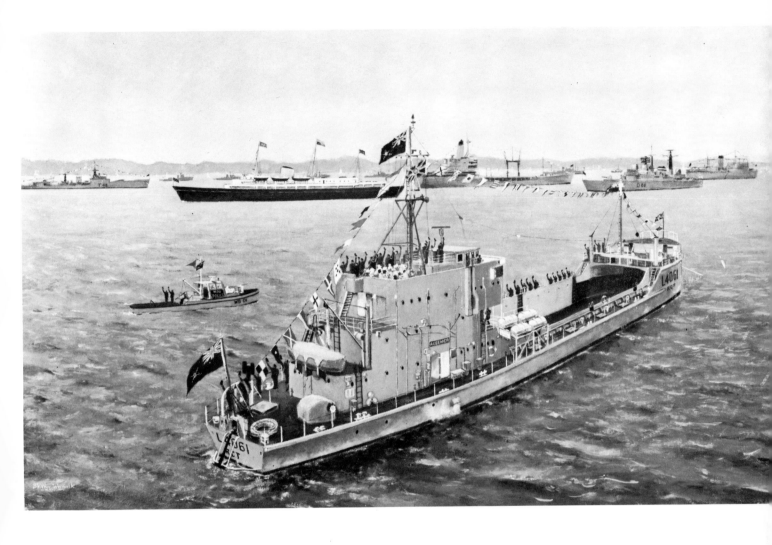

PLATE 212: Major BRYAN VANSITTART (BILL) WYNN-WERNINCK (b.1918)

'The crew of Her Majesty's Army Vessel *Audemer* cheering H.M. The Queen in the Silver Jubilee Fleet Review at Spithead, 28th June, 1977'. Oils, 26ins. x 42ins.

H.M.A.V. *Audemer* was one of several Landing Craft Tanks (MK 8), built for the invasion of Japan, which the Army took over from the Royal Navy in 1956 for operational purposes.

The painting shows an historic event, being the first time that a vessel, commanded by an Army officer and manned by soldiers, had been invited to take part in a Royal Naval Review. It was also the first time that the Army Ensign, designed in 1967, had been flown on such an occasion. Several Senior Officers, as guests, can be seen on the flag deck manning the side. The flag flying from the starboard yard arm denotes that a General Officer commanding a district is aboard.

These ships are operated by the Royal Corps of Transport, who commissioned the painting which hangs in the Headquarters Officers' Mess, Buller Barracks, Aldershot.

The artist has had considerable sea-going experience, including the command of MLs and LCTs and also yacht sailing. He is now a full time marine artist painting in oils and watercolours.

The War Artists of World Wars I and II

Unless otherwise stated, all the photographs in this section are reproduced by kind permission of the Imperial War Museum, London.

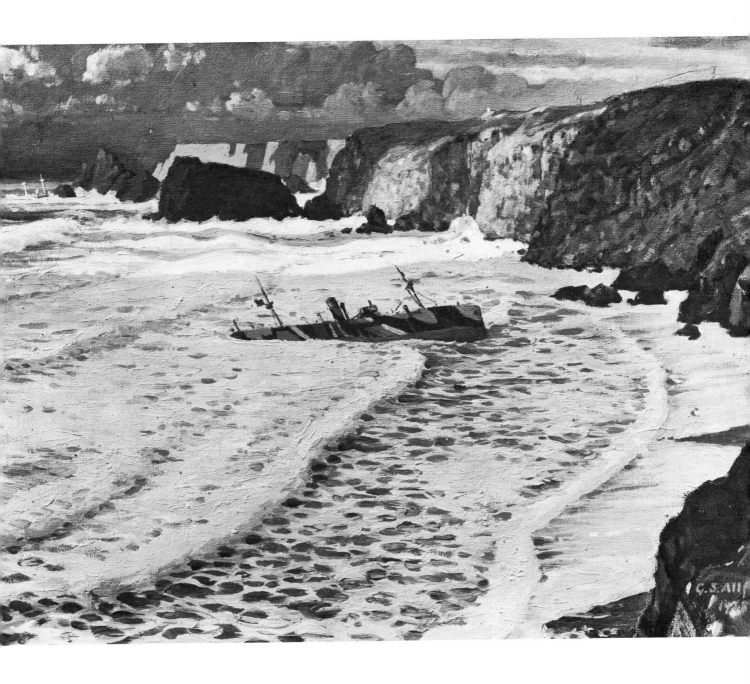

PLATE 213: GEOFFREY S. ALLFREE (fl.1911-1918)

'A torpedoed tramp steamer off the Longships, Cornwall'. Painted in 1918.

In World War I, Geoffrey Allfree was a Lieutenant in the R.N.V.R. and subsequently an official war artist. He was drowned on active service in 1918.
 This dramatic painting has a 'frothy' sea very reminiscent of many of the seas painted by Charles Pears.

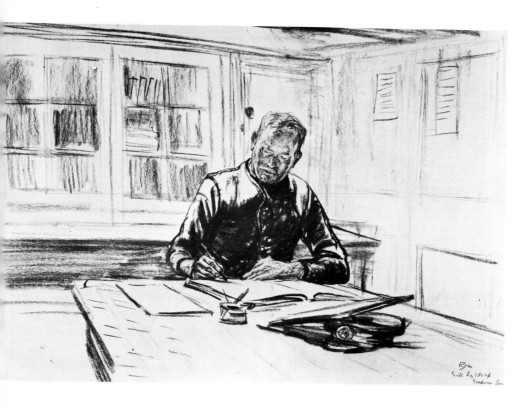

PLATE 214: SIR MUIRHEAD BONE, LL.D, D.Litt, NEAC (1876-1953)

'The Master of the Gull Lightship writing the Log'. Charcoal, 16½ins. x 25ins.

Sir Muirhead Bone was an official artist in both World Wars, and was a member of the War Artists Advisory Committee and an Hon. Major, Royal Marines, from 1939 to 1945. A large number of his pictures are in the Imperial War Museum, many of them naval, and other marine subjects in chalk, charcoal, watercolour and pencil. His work is noted for the fine quality of his drawing.

PLATE 215: STEPHEN BONE, NEAC (1904-1958)

'H.M.S. *Mauritius* and H.M.S. *Roberts* bombarding targets near Caen, 18th July, 1944.'
Oils, 19⅜ins. x 23¼ins.
Painted in 1944.

This powerful picture shows the 'primitive' style adopted by this distinguished artist. He was the son of Sir Muirhead Bone and served as a war artist with the rank of Hon. Lieut., R.N.V.R. from 1942 to 1945. Some 200 of his pictures are in the Imperial War Museum, many of them illustrating a large variety of naval subjects such as 'Bathing from a Motor Launch', 'The conning tower of a Dutch submarine' and 'On board an Escort Carrier'. He studied at the Slade and was also an illustrator, wood engraver and author.

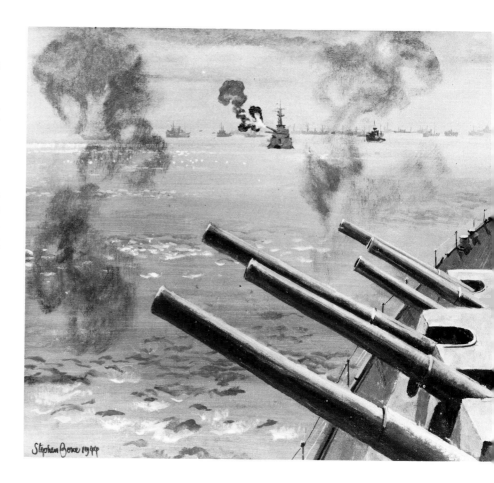

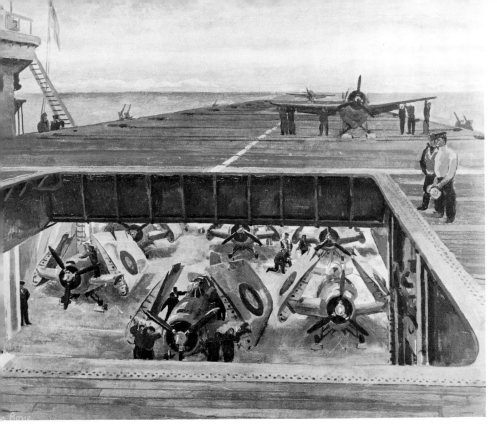

Photograph courtesy: National Maritime Museum, London.

PLATE 216: STEPHEN BONE, NEAC (1904-1958)

'Strike down aircraft after refuelling'. Oils, 25ins. x 30ins.

During his service as an official war artist with the Royal Navy from 1942 to 1945, Stephen Bone made a very large number of paintings and drawings of which some 200 are now in the Imperial War Museum.

The picture illustrated here has an unusual and interesting composition, showing activity on two levels of an aircraft carrier at sea.

Photograph courtesy: National Maritime Museum, London.

PLATE 217: HENRY MARVELL CARR, RA, RP, RBA (1894-1970)

'The sailor'. Oils, 30ins. x 25ins.

Henry Carr was a portrait and landscape artist. In the second World War he was an official war artist from 1941 to 1946 with the rank of Hon. Captain. He painted a large number of military subjects, and also this fine study of a sailor which is now in the National Maritime Museum at Greenwich.

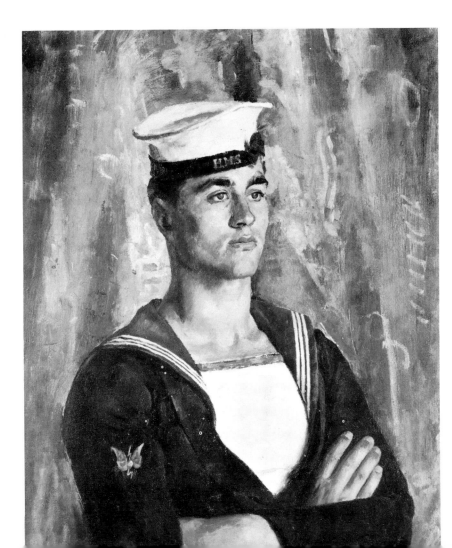

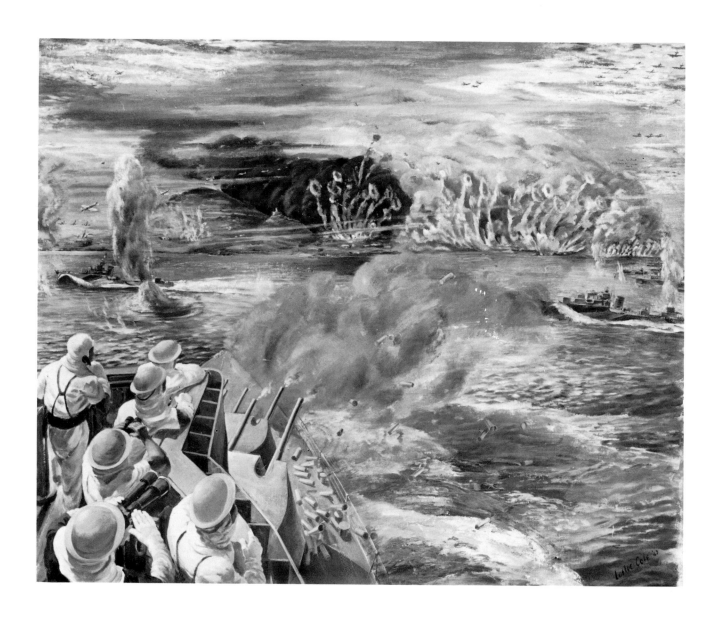

PLATE 218: LESLIE COLE, NEAC (b.1910)

'Admiral C.H.J. Harcourt's flagship H.M.S. *Newfoundland* in the attack on Pantelleria'.
Oils, 29½ ins. x 37¼ ins. Dated 1943.

As an official war artist with the rank of Hon. Captain, Royal Marines, Leslie Cole painted many naval scenes between 1941 and 1943, and thereafter the war on land and its aftermath until 1946. Some 95 of his wartime pictures, including lithographs and watercolours covering a wide variety of operations and people, are in the Imperial War Museum. In civilian life, he painted and drew marine subjects, landscapes and figures and exhibited widely including the Royal Academy, NEAC, etc.

It is interesting to compare his 'modern' style of painting with a similar picture by Stephen Bone (PLATE 215).

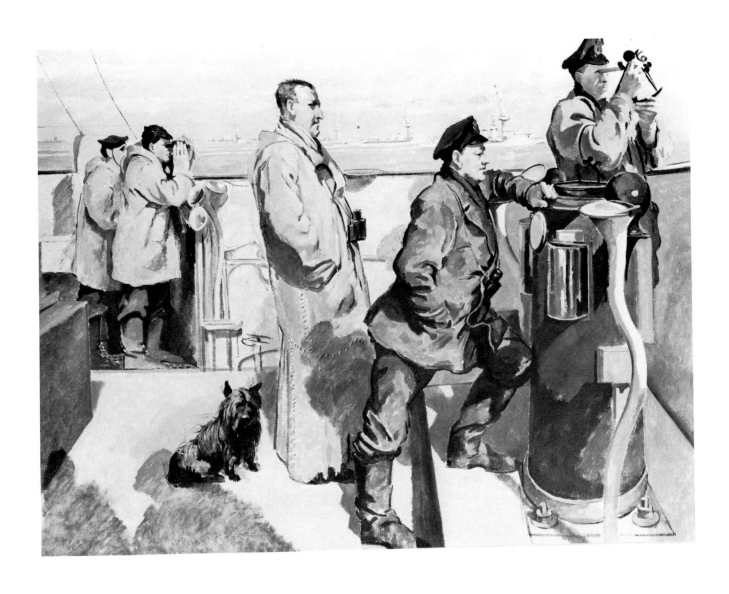

PLATE 219: PHILIP CONNARD, RA, RWS, NEAC (1875-1958)

'St. George's Day, 1918'. Oil on canvas, 30ins. x 40ins.

This painting shows personnel on the bridge of H.M.S. *Canterbury* whilst she was on patrol on the morning of 23rd April, 1918. This was St. George's Day and was the day on which the famous naval assault on Zeebrugge and Ostende took place. Many students of marine art and maritime history feel that there are too few visual records of sailors at sea and in action. This picture has a particular interest in showing us a little of the types of men who manned and fought the ships.

Philip Connard was an official war artist, R.N., in World War I. He later concentrated on landscape and portrait painting and exhibited extensively in London and provincial galleries.

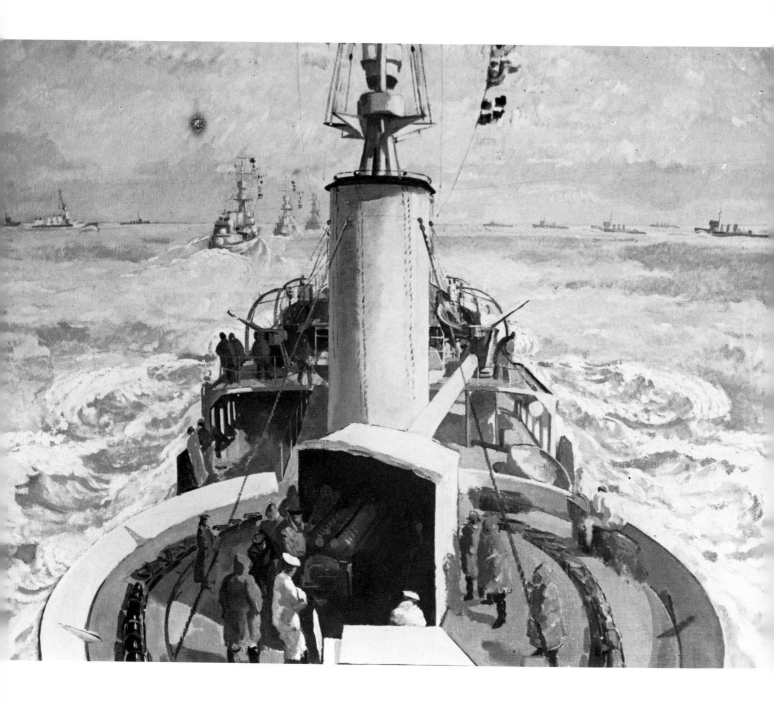

PLATE 220: PHILIP CONNARD, RA, RWS, NEAC (1875-1958)

'The Harwich Force at Sea'. Oil on canvas, 40ins. x 50ins.

This large canvas shows an unusually centralised view from an amidships position on the destroyer. There are some 80 World War I pictures by this artist in the Imperial War Museum and two which he submitted independently in the Second World War.

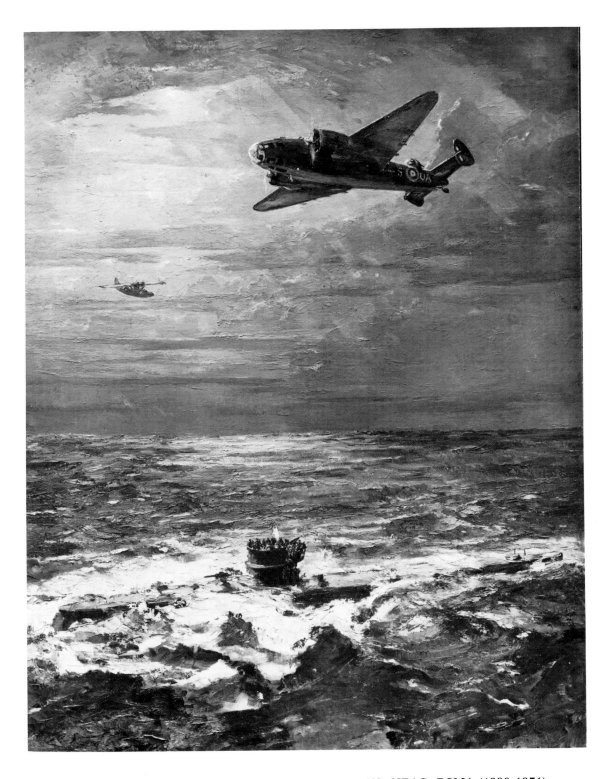

PLATE 221: CHARLES ERNEST CUNDALL, RA, RWS, RP, NS, NEAC, RSMA (1890-1971)

'**A U-boat surrenders to a Hudson aircraft**'. Oils, 44ins. x 34ins. Painted in 1941.

Charles Cundall served in the Army in the first World War and was an official war artist, with the rank of Hon. Captain Royal Marines, from 1940 to 1945. Although often classified as a portrait and landscape artist, he also painted many fine marine subjects and he was a member of and exhibited at the RSMA from the inaugural exhibition in 1946 until his death.

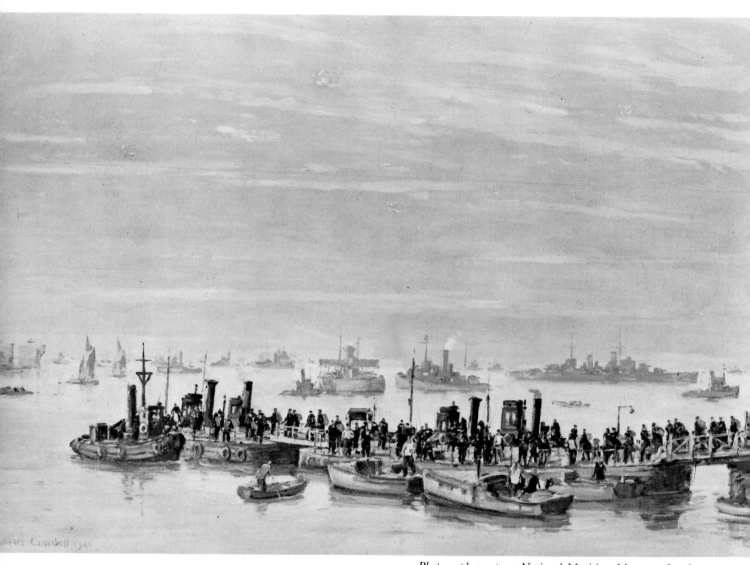

PLATE 222: CHARLES ERNEST CUNDALL, RA, RWS, RP, NS, NEAC, RSMA (1890-1971)

'Liberty boats at Sheerness'. Oils, 20ins. x 30ins.

Charles Cundall studied at Manchester, the Slade and in Paris, and became well known for his landscapes and portraits as well as his marine work. Twenty-one of his pictures are in the Imperial War Museum and four, including the one illustrated here, in the National Maritime Museum.

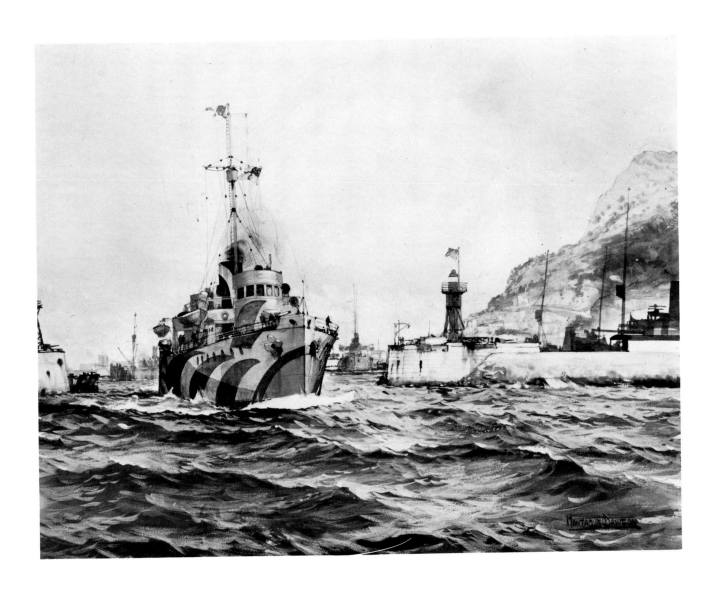

PLATE 223: MONTAGUE DAWSON, RSMA (1895-1973)

'**H.M.S.** *Donovan* **leaving Gibraltar'.** Watercolour, 18½ ins. x 23ins.

Montague Dawson served as a Lieutenant, R.N.V.R. in the first World War and contributed ten pictures to the Imperial War Museum. The excellent watercolour illustrated here seems a far cry from his large oil paintings of clipper ships for which he became famous later in his life.

PLATE 224: NELSON DAWSON, ARWS, RBA, RE, RWA (1859-1941)

'*Broke* and *Swift*'. Charcoal, with touches of white, on brown paper, 18¾ ins. x 28¾ ins.

In April, 1917, H.M.S. *Broke* rammed a German destroyer in the English Channel and hand-to-hand fighting ensued. Nelson Dawson, who recorded the event, was an official war artist at that time and 61 of his pictures are in the Imperial War Museum. He became well known for his marine and coastal pictures and metal artefacts, and exhibited widely.

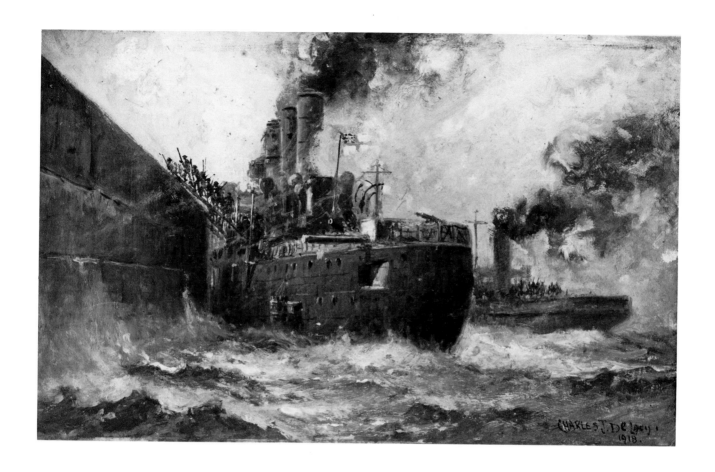

PLATE 225: CHARLES JOHN de LACEY (fl.1885-1920/30)

'The *Vindictive* at Zeebrugge: The storming of Zeebrugge Mole'. Oil on panel, 8½ ins. x 14½ ins.

Charles de Lacey was at one time a Press artist and special correspondent for the *Illustrated London News.* He was also an official artist to the Port of London Authority and he is probably now best known for his paintings of the tidal Thames. He was not an official war artist.

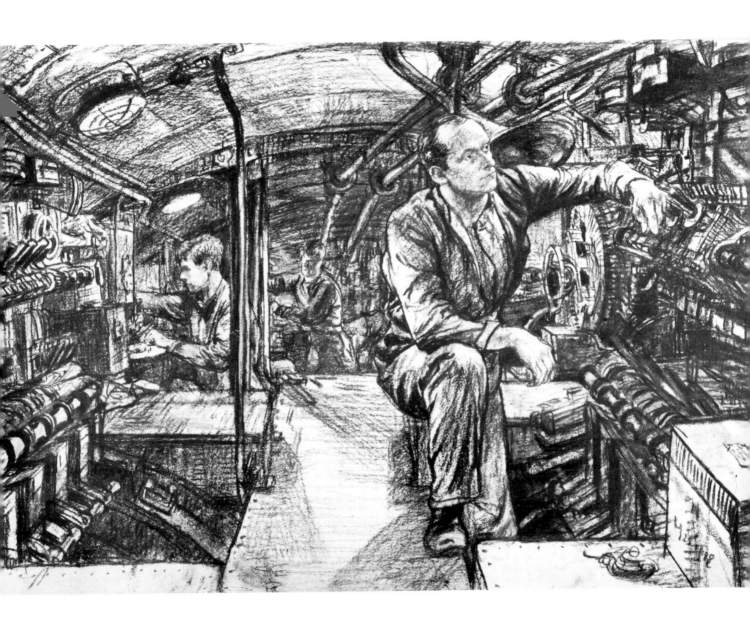

PLATE 226: FRANCIS DODD, RA, RWS, NEAC (1874-1949)

'Motor Room, H.M. Submarine'. Charcoal, 14ins. x 20¾ins. Drawn in 1918.

Francis Dodd was an official war artist in both World Wars. Nearly 200 of his pictures are in the Imperial War Museum and most of these are naval subjects from the first World War including a number of portraits of distinguished sailors. He was best known in his civilian career for his landscapes, portraits and narrative pictures.

The picture illustrated here has a note appended to it saying that the motor room '...is nearly always at 94 degrees F., and is used as a bathroom, dressing room, washing house and drying room by the crew during their 8 days patrol'. In the foreground, a Petty Officer is standing near the voice pipe and watching gauges. The sailor in the background is pumping bilges by hand, an essential and constant task.

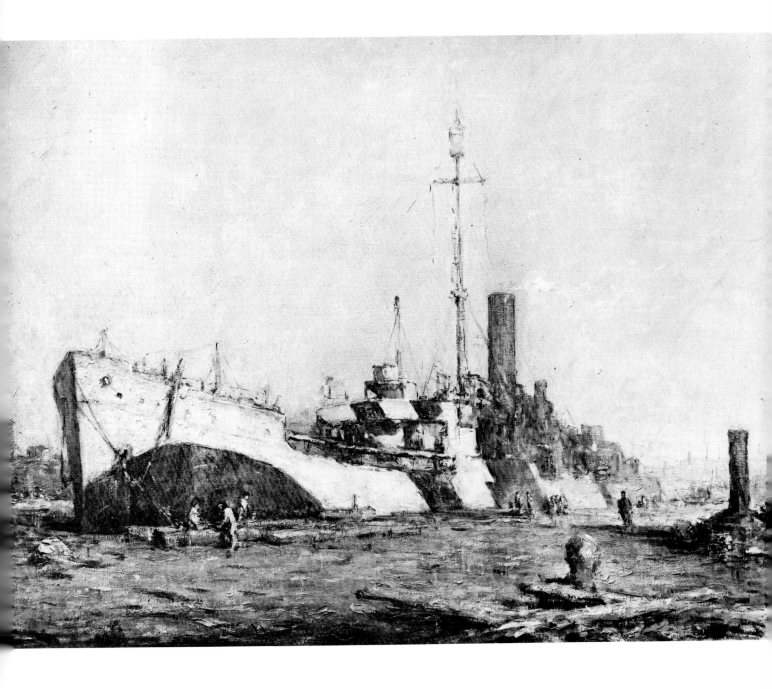

PLATE 227: SHOLTO JOHNSTONE DOUGLAS (1872-1958)

'The s.s. *Lackawanna*'. Oil on canvas, 34ins. x 44½ins.

Sholto J. Douglas was a Lieutenant, R.N.V.R., in World War I and became an official war artist. Of his 52 pictures in the Imperial War Museum, most have merchant navy ships as their subjects. The s.s. *Lackawanna* was a vessel which survived three torpedo attacks by German U-boats in 1918; her survival was almost certainly due to her zigzagging on course and her dazzle painting.

 In civilian life, the artist became known for his portrait painting. He exhibited at the Royal Academy, Royal Society of Portrait Painters and other leading galleries.

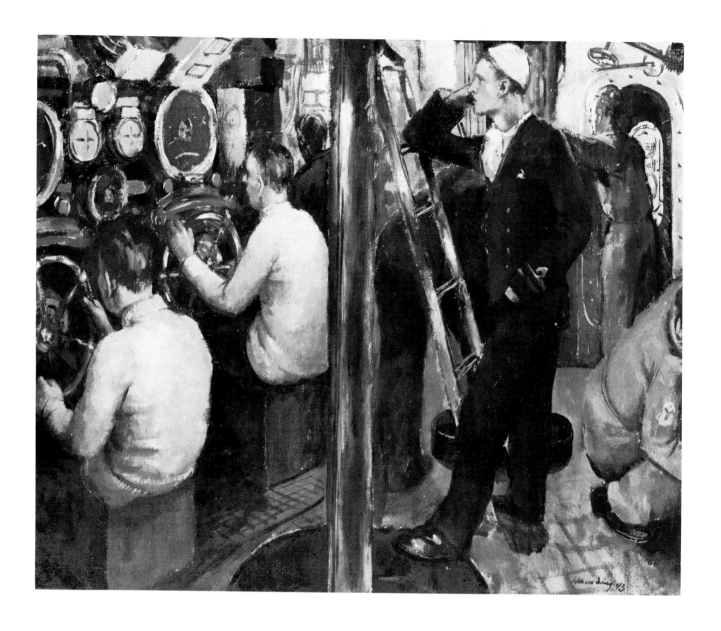

PLATE 228: WILLIAM DRING, RA, RWS, RP (b.1904)

'The control room of a submarine during an attack'. Oils, 20ins. x 24ins. Painted in 1943.

William Dring was an official war artist from 1941 to 1945, first with the Royal Navy and subsequently with the R.A.F. There are over 90 of his pictures in the Imperial War Museum, many of them portraits of sailors from Able Seamen to naval officers. He studied at the Slade, having won a scholarship, and became a landscape and portrait painter, also teaching at Southampton School of Art.

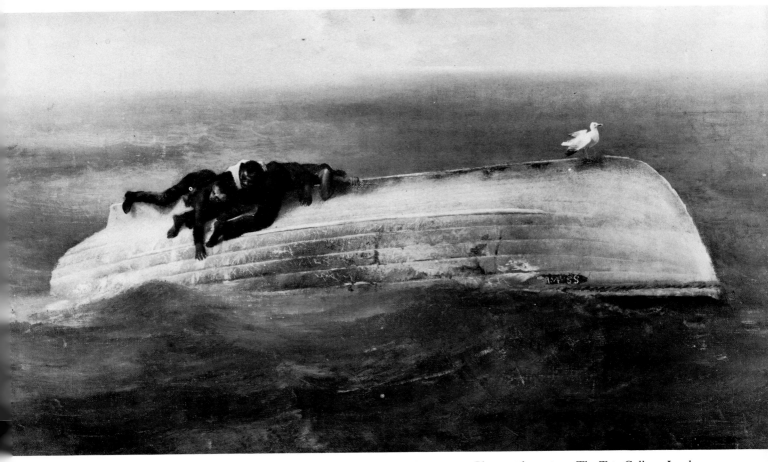

PLATE 229: RICHARD EURICH, RA, Hon. RSMA, Hon. NEAC (b.1903)

'Survivors from a Torpedoed Ship'. Oil on canvas, 14ins. x 24ins.

Richard Eurich was an Official War Artist to the Admiralty from 1939 to 1945, with the rank of Hon. Captain, Royal Marines. A number of his war paintings became famous including 'Withdrawal from Dunkirk' (now in the National Maritime Museum) and 'Air fight over Portland' (Imperial War Museum).

The picture illustrated here is both striking and poignant. The half-frozen men are held together by a negro clinging to an upturned ship's boat, which they dare not try to right. When first shown in 1943 it caused such a shock that it was withdrawn. Richard Eurich asked the Merchant Navy whether they objected to it, but they said 'far from it, we can't deal with the number of men who want to join, and this is just the sort of picture which is true and admirable'.

After the war, when the picture was put into the permanent collection at The Tate Gallery, Sir Winston Churchill considered it to be one of the best paintings to come out of the war.

PLATE 230: ROGER KEMBLE FURSE (b.1903)

'A sailor with his model yacht'.
Line and wash, 13ins. x 16½ ins.

Roger Furse was a Signaller in the Royal Navy when he submitted this excellent study to the War Artists Advisory Committee in 1941. This picture and his watercolour 'The Flag Deck, H.M.S. *Nigeria'* are now in the Imperial War Museum.

PLATE 231: CHARLES GINNER, ARA, RWS, NEAC (1878-1952)

'Building a battleship'.
Oils, 33ins. x 24ins.

This strong painting was one of those specially commissioned from the artist during the period 1941 to 1945 by the War Artists Advisory Committee. Charles Ginner was chiefly a landscape artist and engraver, but also painted some coastal scenes. He became what he described as a 'Neo-Realist' and is now generally classified as one of the British Post-Impressionists.

318

PLATE 232: PHYLLIS KEYES (fl.1908-1919)

'**W.R.N.S. sailmaking**'. Pencil and watercolour, 15ins. x 19½ins. Inscribed 1919.

There are six studies by this artist of W.R.N.S. at work, all in pencil and watercolour and dated 1919, in the Imperial War Museum. Phyllis Keyes was mainly a portrait painter and lithographer, and her ability with figure subjects is well shown in this picture.

PLATE 233: CECIL GEORGE CHARLES KING, RI, ROI, RBA, RSMA (1881-1942)

'Dazzled ships at Leith'.
Watercolour, 14½ ins. x 22ins

Cecil King was a Captain in the London Regiment in World War I and an official naval artist in 1918. He was at one time honorary official painter to the Royal Thames Yacht Club and was a Founder Member of the RSMA.

The dazzle painting of battleships is well shown in this picture. The system was intended to confuse the enemy as to the size, type, direction, speed and number of the ships thus decorated, and was immensely successful in practice when used with a zig-zag course, undoubtedly saving many vessels and lives.

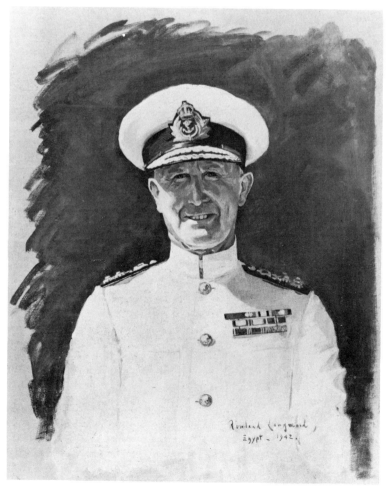

Photograph courtesy: National Maritime Museum, London.

PLATE 234: ROWLAND LANGMAID, RSMA (1897-1956)

'Admiral Cunningham'.
Oils, 23½ ins. x 16ins.
Painted in 1942.

In World War II, Rowland Langmaid was a Lieutenant Commander in the Royal Navy and was appointed a 'local' war artist by the C. in C. Mediterranean. There are about 20 of his war-time pictures in the National Maritime Museum. He was a pupil of W.L. Wyllie and his etchings, with which his name is most connected, often closely resemble the work of that artist.

This effective portrait of Admiral Cunningham was painted in Egypt in 1942.

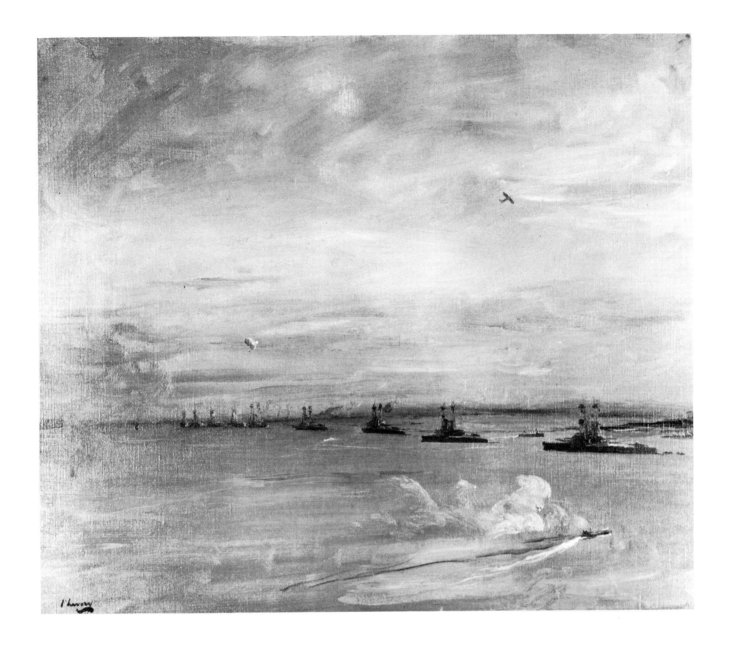

PLATE 235: SIR JOHN LAVERY, RA, RSA, RHA, PRP (1856-1941)

'**The American Battle Squadron in the Firth of Forth, 1918**'. Oil on canvas, 25ins. x 30ins.

The ships were the *New York, Texas, Florida, Wyoming,* and *Delaware.* They operated at their own request as a unit of the British Grand Fleet, and were known as the 6th Battle Squadron.

Sir John Lavery was specially employed as an official war artist in the first World War. There are 59 of his pictures in the Imperial War Museum illustrating a wide variety of subjects including, for example, a portrait of Admiral Sir Cecil Burney, 'The wounded at Dover, 1918' and 'The Guns of H.M.S. *Terror,* 1918'. He was best known for his portraits, figure subjects and landscapes and was elected RA in 1921. At the same time, his war artist naval pictures show a sensitive and impressionistic touch and fully deserve inclusion in any serious study of marine painting.

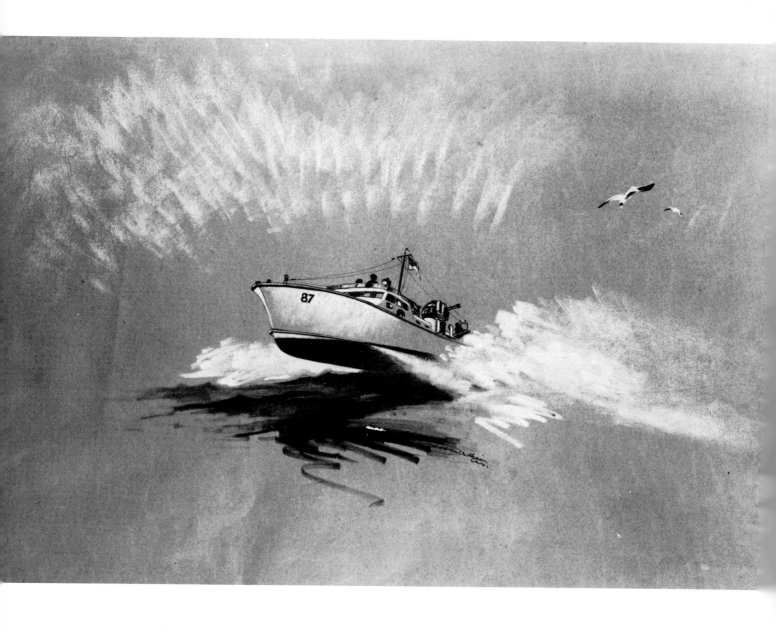

PLATE 236: HERBERT HASTINGS McWILLIAMS (b.1907)

'A motor gun-boat at speed'. Chalks, 20¾ins. x 30¾ins. Drawn in 1942.

As a Lieutenant, R.N.V.R., the artist submitted a number of black and white pictures of naval subjects between 1941 and 1942, of which 21 are now in the Imperial War Museum.

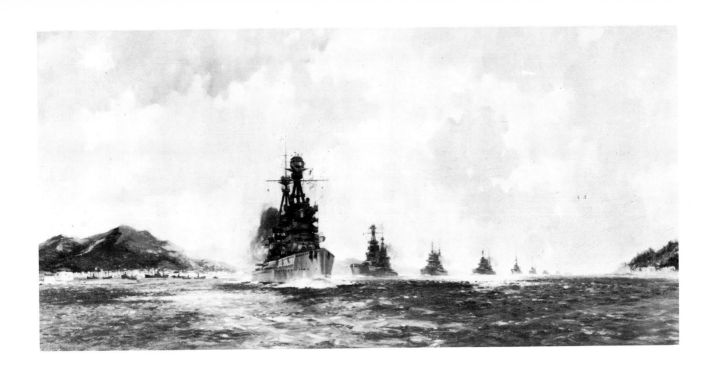

PLATE 237: FRANK H. MASON, RI, RBA, RSMA (1876-1965)

'**H.M.S.** *Superb*'. Oil on canvas, 35¾ ins. x 72ins.

This painting shows H.M.S. *Superb,* the flagship of the C. in C. Mediterranean, leading the British Fleet to Constantinople in November, 1918.

 Frank Mason is probably best known for his watercolours of English coastal scenes and an oil painting of this magnitude is unusual for him. He was a Lieutenant, R.N.V.R., in the first World War and became an official war artist. In World War II he served in the Directorate of Camouflage, Naval Division. He exhibited at the RSMA from 1961.

**PLATE 238:
JAMES MORRIS (b.1908)**

'**H.M.S.** *Argonaut*'.
Pen and wash, 15¼ ins. x 20¼ ins.

After the Japanese surrender in September, 1945, H.M.S. *Argonaut* was the first British ship to enter Shanghai harbour and a moment of this occasion is captured in this picture.

 James Morris was a Signalman R.N. in World War II and submitted drawings in 1943-44. He was made an official war artist with the rank of Hon. Lieutenant R.N.V.R. from 1945-46. There are 34 of his pictures in the Imperial War Museum, many of them showing Far Eastern subjects concerned with the end of the war in that area.

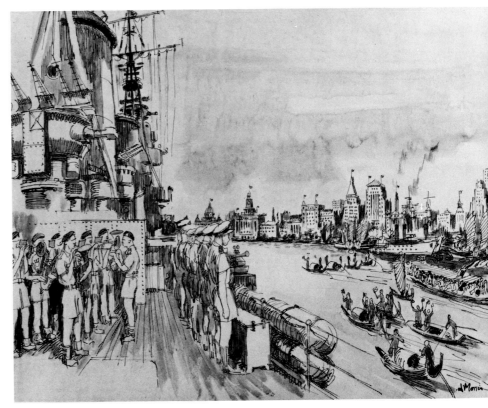

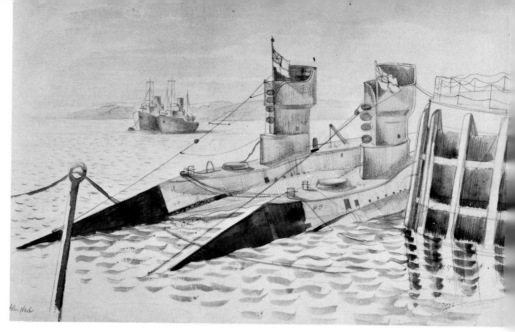

PLATE 239:
JOHN NORTHCOTE NASH, CBE, RA (b.1893)

'Two submarines by a jetty'.
Watercolour, 9¾ins. x 15¾ins.

John Nash was an official war artist in both World Wars. His 31 pictures from World War I in the Imperial War Museum are military subjects, but his three watercolours c.1940-41 in the Museum are naval scenes, plus a folio of 18 sketches. He is mainly known as a landscape artist, illustrator and wood engraver, and his work may be seen in many public collections.

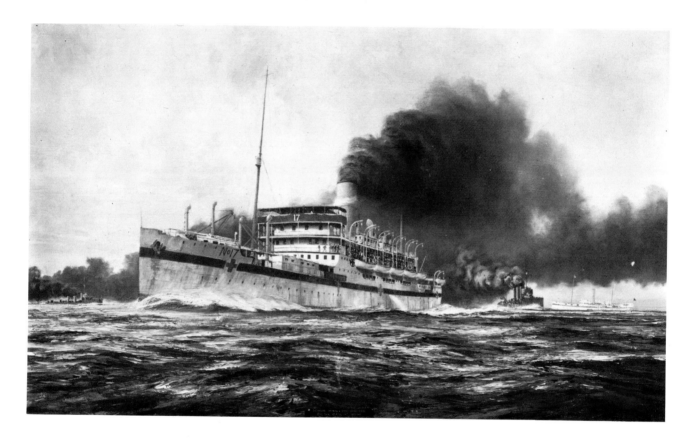

PLATE 240: OSCAR PARKES, OBE (1885-1958)

'The smoke screen'. Oil on canvas, 30ins. x 50½ins.

This painting shows the hospital ship *Karapara* making smoke and the escorting destroyers laying a smoke screen around her after another hospital ship, the *Dover Castle,* had been torpedoed.

The artist was a Surgeon Lieutenant in the Royal Navy. Seven of his works are in the Imperial War Museum, including another oil painting of similar size to that illustrated above, with the title 'R.N. Hospital ship *Somali* off Cape Helles, 1915 — Walking cases coming on board'. The remaining five pictures are in black and white wash and include scenes of the surrender of the German destroyer flotillas in 1918.

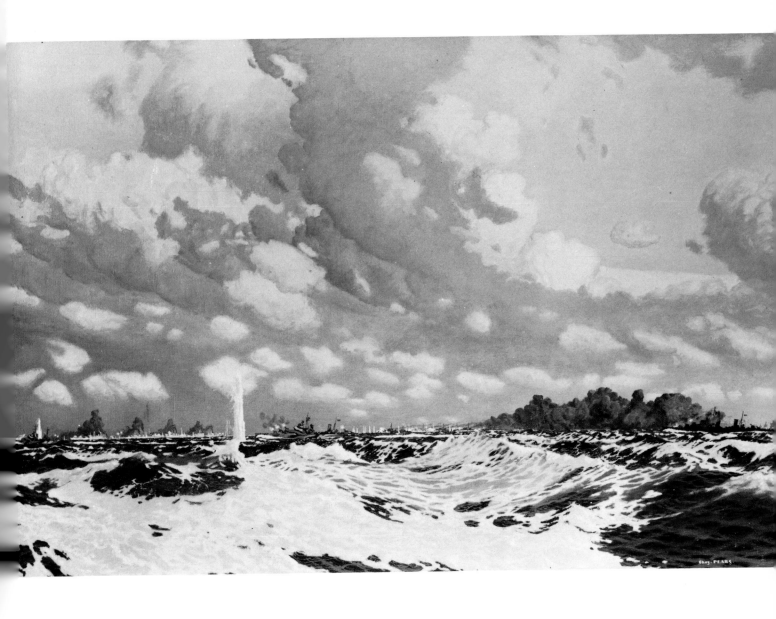

PLATE 241: CHARLES PEARS, ROI, PPRSMA (1873-1958)

'The convoy led by Admiral Vian fighting its way through to Malta, 1942'. Oil on canvas, 40ins. x 60ins.

This large picture is particularly interesting in its almost total dependence on sky and sea for overall impact. The frothy sea in the foreground is typical of this artist's treatment of that element and many of his marine paintings are instantly recognisable as his work by reason of this technique.

Charles Pears was a leading marine artist of the 20th century. He was a naval artist in both World Wars and the founder and first President of the RSMA in 1939.

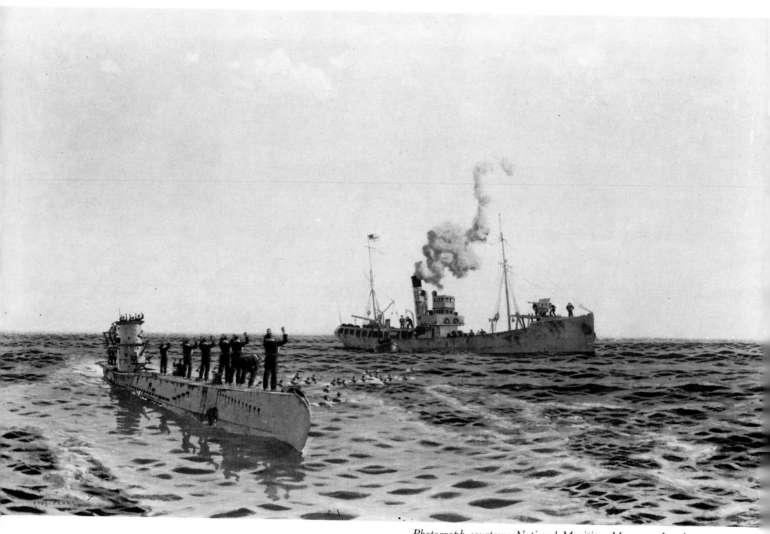

PLATE 242: CHARLES PEARS, RI, PPRSMA (1873-1958)

'Surrender of a U-boat to the trawler *Lady Shirley*'. Oils, 32ins. x 50ins.

This interesting picture shows the excellent draughtsmanship of Charles Pears who painted a large number of memorable events in both World Wars.

The U-111 was blown to the surface by the armed trawler *Lady Shirley* on 4th October, 1941. The U-boat's captain and crew surrendered and the submarine then sank.

**PLATE 243:
ROLAND VIVIAN
PITCHFORTH, RA, RWS
(b.1895)**

'A merchant ship leaving Bombay'.
Watercolour, 22ins. x 30ins.
Painted in 1945.

Roland Pitchforth was appointed an official war artist with the rank of Hon. Captain, Royal Marines, and served from 1940 to 1945. There are 90 of his pictures in the Imperial War Museum, 33 of which show naval and other marine subjects. His work as a landscape and architectural artist is well known and his pictures are in many public collections.

PLATE 244: JOHN EDGAR PLATT, RSMA (1886-1967)

'A convoy passing the Lizard, Cornwall'. Oils, 24ins. x 40ins. Painted in 1942.

John Edgar Platt was specially employed as a war artist between 1941 and 1945 and 13 of his oil paintings are in the Imperial War Museum. He had four pictures in the inaugural exhibition of the RSMA in 1946 and also exhibited in subsequent years. At one time he was Principal of the Leicester College of Art.

PLATE 245:
ERIC WILLIAM RAVILIOUS
(1903-1942)

'H.M.S. *Glorious* in the Arctic'.
Watercolour, 17¾ ins. x 22⅜ ins.

Eric Ravilious worked mainly in watercolours, but was also a talented engraver and mural painter. His distinctive modern style indicated a future career of great purpose, but he was killed at the age of 39 in an air patrol off Iceland in 1942. He had been specially commissioned as a war artist with the rank of Hon. Captain, Royal Marines, from 1939.

There are 27 of his pictures in the Imperial War Museum, mostly watercolours of naval scenes, but also a few R.A.F. subjects.

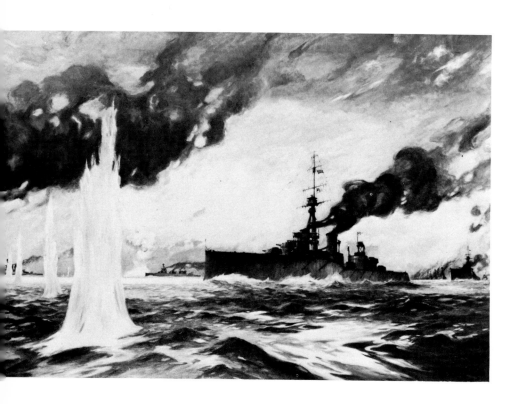

PLATE 246:
ROBERT HENRY SMITH
(fl.1906-1930)

'The battle of Jutland'.
Oil on canvas, 48ins. x 72ins.

Robert Smith was an Able Seaman in the first World War and was subsequently commissioned as a Lieutenant, R.N.V.R., for employment as a war artist. He was a Silver Medallist at the Lambeth School of Art and after the war he resumed his career as a marine artist, etcher and illustrator, exhibiting at the RA, RI and other galleries.

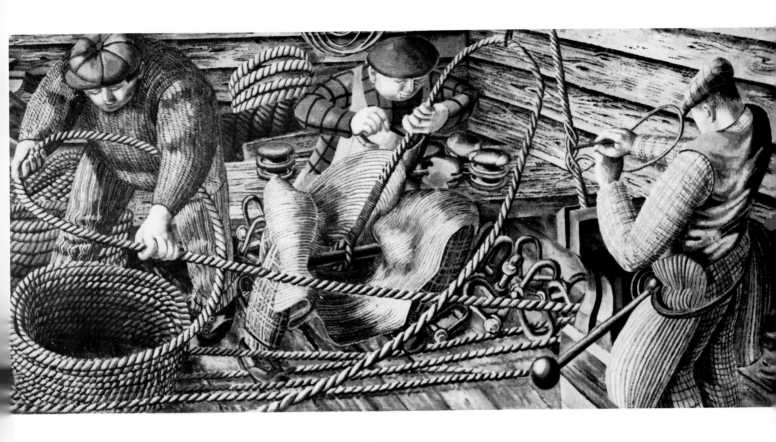

PLATE 247: SIR STANLEY SPENCER, CBE, RA (1891-1959)

'Shipbuilding on the Clyde. The Riggers'.

This illustration shows part of a large panel, painted in oils, the whole of which measures 20ins. x 194½ ins. The panel, together with 11 others all devoted to 'Shipbuilding on the Clyde', is in the Imperial War Museum. They were purchased for the Museum in 1960 by the National Art Collections Fund.

Stanley Spencer was a Post-Impressionist painter and is probably best remembered for his biblical scenes in modern dress. He was a private soldier in the Royal Berkshire Regiment in World War I and then specially employed as a war artist; he was also specially employed as a war artist from 1940-45.

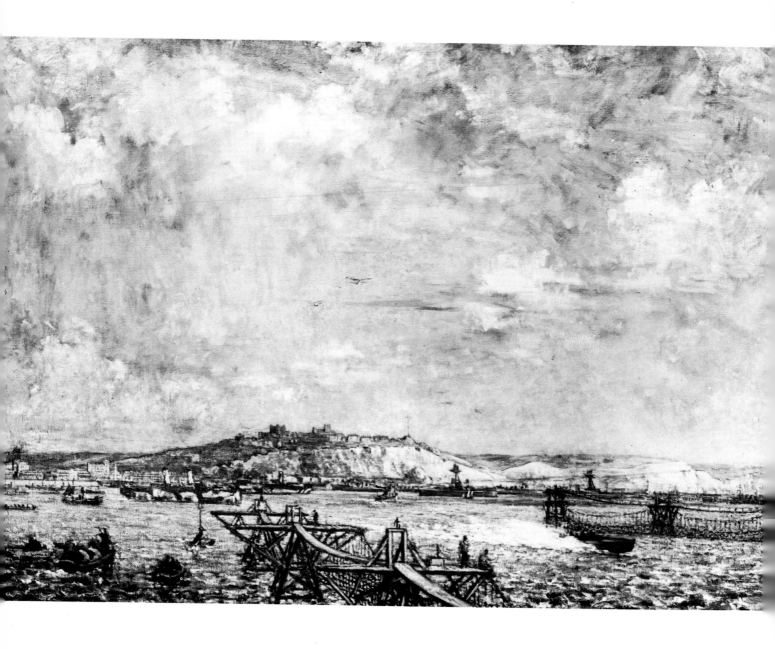

PLATE 248: PHILIP WILSON STEER, OM, NEAC (1860-1942)

'Dover harbour, 1918'. Oil on canvas, 42ins. x 60ins.

This large panoramic view of Dover harbour shows a tighter and more representational technique than the artist used in his earlier work which was much influenced by the French Impressionists and Whistler. Philip Wilson Steer was one of the important British Post-Impressionists and his work is increasingly admired. In the first World War he was specially commissioned by the Ministry of Information to produce a series of paintings, of which two oils (including that illustrated here) and four watercolours are in the Imperial War Museum; all of them have Dover as their subject.

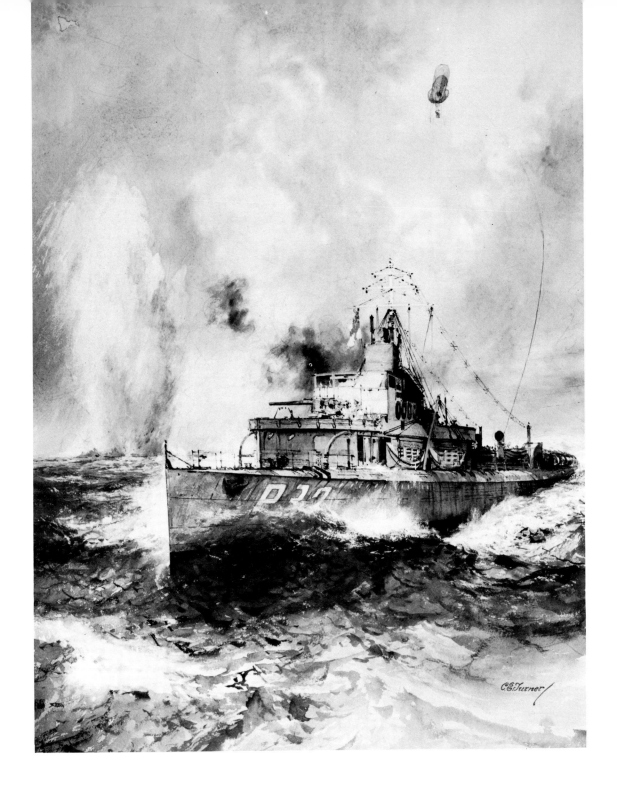

PLATE 249: CHARLES E. TURNER (fl.1912-1960)

'**Clearing the seas**'. Watercolour, 22¼ ins. x 16¾ ins.

This picture shows a 'P' boat in action in the first World War. It is towing a kite balloon from which the observer has sighted a mine which the 'P' boat has exploded.

Although there are eight paintings by this artist in the National Maritime Museum, there are few recorded details of his career. He lived in Lancashire in 1912 and died at Looe, Cornwall in 1965.

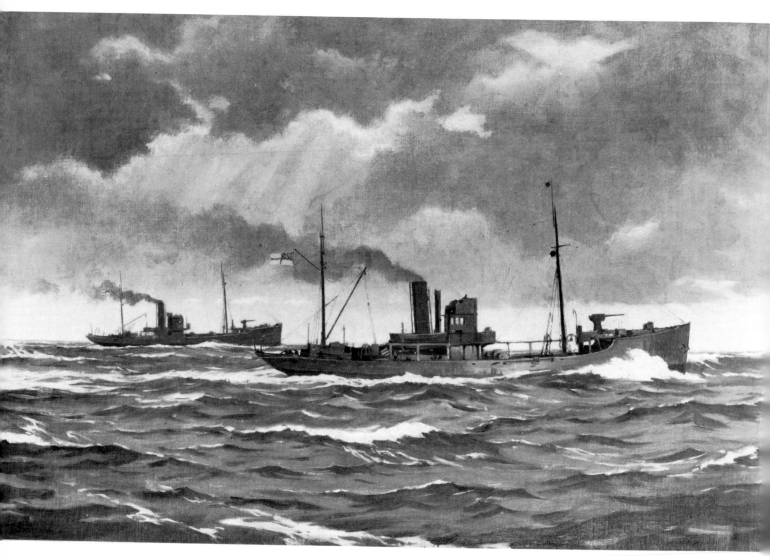

PLATE 250: DOUGLAS WALES-SMITH, RSMA (b.1888. fl.1929-1947)

'Minesweeping trawlers at work'. Oils, 25ins. x 40ins.

The artist painted marine subjects, landscapes and portraits. He exhibited four portraits of distinguished sailors in the 1946 inaugural exhibition of the RSMA. The picture illustrated here shows that he was also an accomplished painter of ships at sea.

PLATE 251: JOHN WHEATLEY, ARA, RWS, NEAC (1892-1955)

'**Divers at work repairing a torpedoed ship**'. Oil on canvas, 42ins. x 60ins.

This large painting is one of 55 works by John Wheatley in the Imperial War Museum. The pictures are nearly all of naval subjects and personnel. The artist became well known in his civilian career as a portrait and figure painter.

**PLATE 252:
JOHN WHEATLEY,
ARA, RWS, NEAC
(1892-1955)**

'A study of a British sailor'.
Pencil and watercolour,
14ins. x 8ins.

In World War I John Wheatley
was first of all a Sergeant in the
Artists Rifles and then became
an official war artist. Of his 55
pictures in the Imperial War
Museum, the majority are of
naval ships, events and people.
He studied art at the Slade and
also with Sickert and at Newlyn
with Stanhope Forbes. He
became well known for his por-
traits and figure studies. In 1925
he became Director of the
National Gallery of South
Africa, but returned to the U.K.
in 1937. He is another good
example of the ability of many
talented artists to paint and
draw in many fields, combining,
for instance, portraiture with
marine subjects.

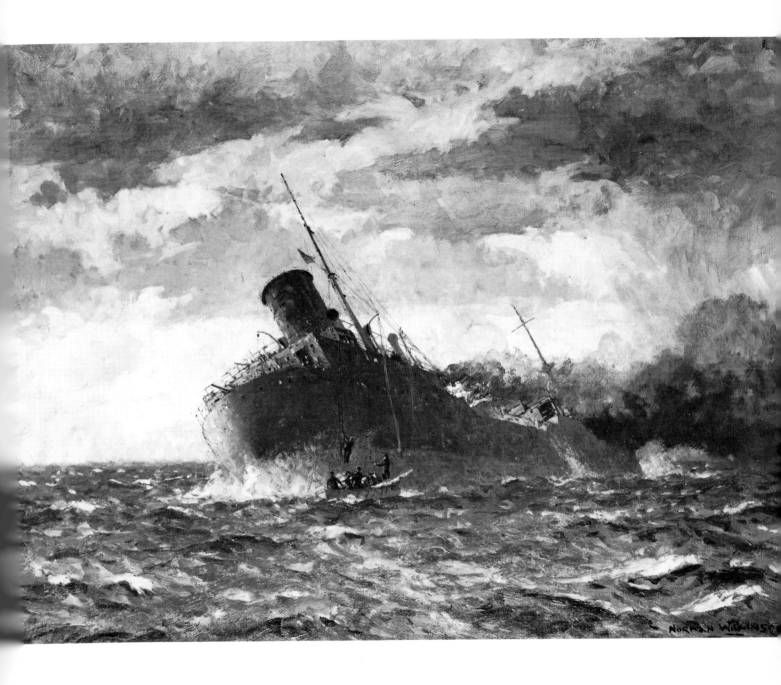

PLATE 253: NORMAN WILKINSON, CBE, PRI, ROI, RSMA, HRWS (1878-1971)

'The crew re-boarding the tanker *San Demetrio,* **7th November, 1940'.** Oils, 30ins. x 40ins.
(Presented to the Imperial War Museum by the Eagle Oil and Shipping Company, 1959).

The *San Demetrio* was an oil tanker of some 8,000 tons. On 5th November, 1940, she was carrying a full cargo of petrol in a convoy which was attacked by the German pocket-battleship *Admiral Scheer.* She was set on fire by shells and had to be abandoned by her crew, most of whom were rescued by a ship from another convoy. However, one lifeboat containing two officers and 12 seamen was not picked up, and next day this boat came across the *San Demetrio* still afloat. The boat's party re-boarded the burning ship at great risk and succeeded in quenching the fires. They then raised steam and reached Ireland eight days later, finally berthing in the Clyde on 19th November, 1940.

One of the best known of British 20th century marine artists, Norman Wilkinson's work is generally admired by other painters. He served as a Naval artist in both World Wars, and was at one time marine painter to the Royal Yacht Squadron.

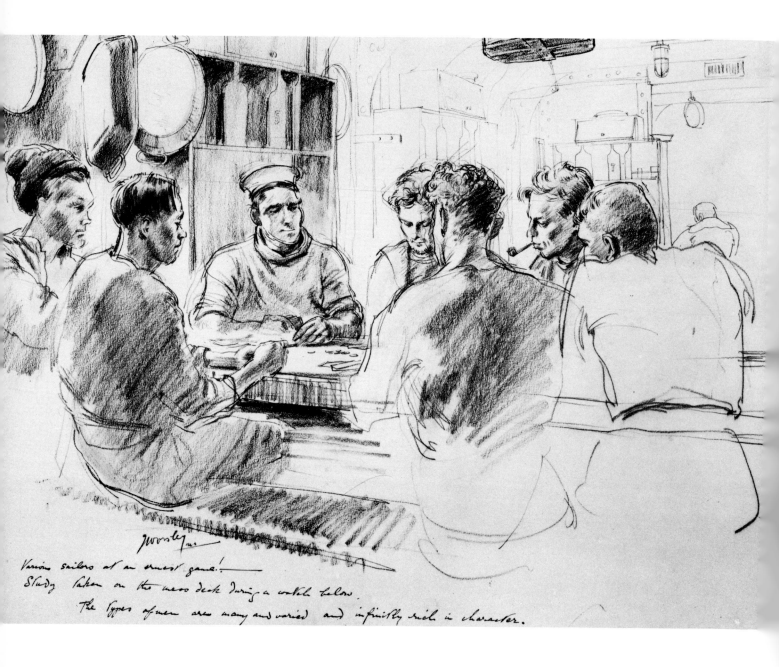

Various sailors at an earnest game! —
Study taken on the mess deck during a watch below.
The types of men are many and varied and infinitely rich in character.

PLATE 254: JOHN WORSLEY, VPRSMA (b.1919)

'An earnest game of cards'. Pencil, 14½ ins. x 20ins. Dated 1940.

John Worsley served in the R.N.V.R. from 1939 in destroyers and cruisers and in 1942 was made an official war artist on the staff of the C. in C. Mediterranean. He was subsequently captured on partisan operations but continued his drawing and painting in a prison camp, concealing his work in Red Cross milk tins.

Over 60 of this artist's pictures are in the Imperial War Museum. The drawing illustrated here is inscribed: 'Various sailors at an earnest game. Study taken on the mess deck during a watch below. The types of men are many and varied and infinitely rich in character.'

336

A Guide to 20th Century Marine Artists

The following alphabetical guide contains the names and brief details of some 600 artists who painted marine subjects, including coastal and harbour scenes, between about 1900 and 1980. This information has been compiled chiefly by examining several thousand entries and other information contained in the catalogues of exhibitions held during the period covered and, in the case of modern living artists, utilizing the material from questionnaires which they kindly completed for this purpose. A large amount of information was made available to me from the R.S.M.A. library and records, for which I am most grateful, and my wife has helped me over a considerable period in analysing this mass of material.

In order that the reader may make the best use of this guide, the following points are offered:

1. The work of the members of the R.S.M.A. and their annual exhibitions, also open to pictures by non-members, has most certainly formed the hard core of British marine painting in the last 30 or 40 years. Thus, all R.S.M.A. members past and present are included here, and also the vast majority of other exhibitors at the Society's annual shows from the inaugural exhibition in 1946 onwards. The letters R.S.M.A. after a painter's name denote that he or she was elected a member of the Royal Society of Marine Artists at some time, and for simplicity I have used this indication throughout, even though before 1966 the abbreviation was 'S.M.A.'

2. As my aim has been to compile details of artists who regularly painted marine subjects, I have generally omitted painters who exhibited at the R.S.M.A. only for one or two years in the past, although many new names of exhibitors have been included from 1978 onwards on the premise that they are likely to exhibit in future years. Where the artist's last recorded exhibition date is, for example, 1977 or 1978, it does not mean that he or she will not exhibit again.

3. Two pre-war marine painting exhibitions were held in Portsmouth in 1936 and 1938, helping to lead to the formation of the R.S.M.A. in 1939. Many of the exhibits in those two pre-war exhibitions have been noted against the names of the artists concerned, as have entries in the R.S.M.A. inaugural exhibition in 1946.

4. The titles of exhibits are quoted quite frequently throughout the guide, as this helps to give an impression of the artist's range of work.

 Many artists who have painted both marine and landscape scenes, and sometimes portraits or other subjects, have been included. Some modern artists who are not full-time professionals but who nevertheless paint and exhibit regularly also have their names recorded here. Experience has shown that the reader of reference books usually wants a wide range of information in a concise form, and to confine this guide to those who have only painted purely marine scenes would present far too narrow a view of the whole panorama.

5. The length of each entry does not necessarily denote the importance and achievements of the marine painter concerned. On the whole, I have tried to give as many relevant details as possible about the full-time professional marine artists who have been actively practising in the last decade. In addition, I have included many lesser known but nevertheless talented marine painters whose names have not yet appeared in a reference book. If I have overlooked anyone, I apologise to the artists concerned and hope they will get in touch with me via the publishers.

6. Famous artists of the earlier part of this century are not dealt with in great detail because there is already ample information available in other reference works. For example, I have included a basic entry for Sir Frank Brangwyn which indicates his importance, but a complete entry would occupy several pages and repeat already published material.

7. Marine painters who lived and worked mainly in the 19th century but also continued into the first few years of the 20th have not been included. (Details of these artists may be found in my companion book *British 19th Century Marine Painting*.)

Whilst every care has been taken in compiling and checking the information given here, neither the author nor the publishers can accept any responsibility for omissions or errors. The author will be pleased to hear at any time from readers who wish to supply additional information or corrections.

Guide to Marine Artists c.1900—1980

AGOUST, Loes (b.1940)
Mixed media. Beach scenes, coastal scenes, landscapes. Flemish descent. Studied in Paris; has worked and lived in France, Greece and Turkey. Exhib. in galleries in England, Wales and Scotland. Also author and illustrator. Lives in Bury St. Edmunds, Suffolk.

AITKEN, John Ernest, RSW, RCA (1881-1957)
Watercolours. Coast subjects and landscapes. Son of marine artist James Aitken (who exhib. mainly in 19th century). Exhib. RA, RCA, RI, RSW, RSA, RBSA, GI, Liverpool, Manchester, etc. Lived in Isle of Man from 1911.

AKERBLADH, Alexander (1886-1958)
Oils and watercolours. Coastal scenes and figure subjects (also landscapes and portraits). Born in Sweden, studied and lived in Britain. Exhib. from 1916 at RA, RI, ROI, RP, NEAC and Paris Salon. Exhib. at RSMA between 1946 and 1958. One-man exhibition Fine Art Society 1929.

ALDRIDGE, Frederick James (1850-1933)
Oils and watercolours. Marine subjects, coastal and estuary scenes, mainly in watercolours (which are generally superior to his oils). Often included amongst 19th century artists. Exhib. RA, RBA, RHA, RI, ROI. Lived Worthing, Sussex.
......................................See PLATE 14

ALDRIDGE, Winton
Watercolours. Marine subjects. Exhib. RSMA from 1967 (3 watercolours incl. 'Felixstowe Ferry') to 1976 (2 watercolours incl. 'Woodbridge').

ALFORD, John, RBA, NEAC, NDD (b.1929)
Oils and watercolours. Marine subjects, especially the sea; also landscapes with water. Studied Camberwell School of Art 1949-53. Sails in dinghies and cruising yachts, and cruises on both sides of the English Channel and in N. Wales. Director of Art, Shrewsbury School. Exhib. RSMA, also RBA and NEAC. Lives at Shrewsbury, Shropshire, and near Penzance, Cornwall.
......................................See PLATES 15 & 16

ALLAN, Robert Weir, RWS, RSW (1852-1942)
Oils and watercolours. Coastal subjects and landscapes. Chiefly known for watercolours, but exhibited 44 oils in the RA between 1875 and 1904 incl. many marines. Also exhib. RBA, RHA, RI, ROI, RSA, RSW, RWS, NEAC, etc. Bridged 19th and 20th centuries with his work.

ALLARD, R.B.
Watercolours. Coast and estuary subjects. Exhib. RSMA 1968, 1970 and 1971.

ALLBON, Charles Frederick, ARE (1856-1926)
Watercolours, black and white artist and etcher. Coastal and harbour subjects, also landscapes. Member of Langham Sketching Club. Exhib. RA and RE. Lived in Essex and London..............................See PLATE 17

ALLFREE, Geoffrey S., RBA (drowned on active service 1918)
Oil and watercolours. Marine subjects. Artist World War I. Some 50 examples of his work are in the Imperial War Museum, London, ranging from 'A convoy in the Channel' to 'A torpedoed Tramp Steamer off the Longships, Cornwall'. Exhib. 1911-18, RBA, NEAC, London Salon, etc.
......................................See PLATE 213

ANDERSON, Christopher Nicholas (b.1926)
Oils, watercolours, gouache, and egg tempera. Marine subjects (also landscapes, portraits, etc.). Studied at Byam Shaw School of Art. Served R.N.V.R. 1944-48. Cunard Steamship Co. 1950-70, latterly as President, N. America. Exhib. RSMA since 1951. Also exhib. RA, NEAC, etc. Engraves glass and this work is in many private collections including H.M. the Queen, Princess Anne, etc. Lives at Old Bursledon, near Southampton.
......................................See PLATE 18

ANDREWS, Leonard Gordon (1885-1960)
Watercolours. Coastal scenes and landscapes. Exhib. RSMA from 1951 to 1959 (1959 exhib. 'Trawlers in Brixham Harbour'). Also exhib. RA, RBA, etc.

ANNISON, Edward S., RSMA (fl.1910-1948)
Oils. Marine subjects. Exhibitor in inaugural RSMA Exhibition 1946: 'A Ship went sailing' and 'Outward Bound'; also 'A Fair Wind' (1947); 'Red Sails' (1948). Exhib. RA and Walker Art Gallery, Liverpool.

ANSON, Peter Frederick, RSMA (1889-1975)
Watercolours. Marine subjects (also landscapes) and author. A Founder Member of the RSMA (1939) where he exhibited for many years after the war. Also exhib. RA, RSA, RHA, NEAC, etc. Collection of his drawings at Nat. Maritime Museum. Became a monk and lived at St. Augustine's Abbey, Ramsgate, Kent (1958) and later in Scotland. (RSMA 1975 posthumous exhib. 'Duchess D'Aosta mid-Atlantic 1926' from the Society's Diploma Collection.)

ARBUTHNOT, Malcolm (1874-1967)
Oils and watercolours (also sculptor). Marine subjects, landscapes, etc. Exhib. RA, RBA, RCA, RHA, NEAC, RI, ROI, RSA, RSW. Lived in London, Jersey and Cornwall.

ARNOLD, Christopher David (b.1955)
Watercolours. A wide range of marine subjects and landscapes with rivers, barges, etc. Studied: West Surrey College of Art and Design 1972-76, graduating B.A. (Hons.) Fine Art. Exhib. RSMA from 1978 (4 watercolours) also RI, Laing Competition, and Britain in Watercolour, 1979. Lives at Guildford, Surrey.
......................................See PLATE 19

ASHFORD, Colin James
Watercolours. Naval and other marine subjects. Exhib. RSMA from 1970 ('Eyes of the Fleet, 1916' and 'Early catapult trials, 1918') to 1976 ('Woolwich Free Ferry').

ASHTON, Sir John William, ROI (1881-1963)
Oils. Marine subjects and landscapes. Pupil at one time of Julius Olsson. Exhib. RA, RBA, ROI, etc. Work is well known in Australia where he worked and died.

AYLING, George, RSMA (1887-1960)
Oils and watercolours. Marine subjects, also landscapes. Studied Putney School of Art 1912. Exhib. RA, ROI, RI and provinces, also Paris Salon. RSMA exhibitor from inaugural exhibition 1946 (4 pictures) until 1960.

BACK, Robert Trenaman, DA (Edin.) (b.1922)
Born 4th October, 1922, in Adelaide, South Australia. Oils. Coastal scenes, harbour scenes, sailing vessels and seascapes with sail. Studied: Edinburgh College of Art (Andrew Grant drawing and painting scholarship). Royal Drawing Society's Gold Medallist. Seafaring experience in the Merchant Navy (Union Castle and Royal Mail lines) and Royal Navy (war service); also yachtsman, ocean racing. Specialises in 19th century American sea events for which he is well known in the U.S.A. Exhib. RSMA from 1957. Lives at Seaford, Sussex.
.................... See COLOUR PLATE 1 and PLATE 20

BADHAM, Edward Leslie, RI, ROI, RBA (1873-1944)
Oils and watercolours. Marine subjects and landscapes. Exhib. RA, RBA, NEAC, RCA, RHA, RI, ROI, RSA. Lived and worked in Sussex.

BAGLEY, G.S. (fl.1923-1949)
Watercolours. Nottingham artist. Coast and harbour subjects. Exhib. RSMA 1949 'Dockyard Wharf'. Also exhib. Nottingham Museum and Art Gallery.

BAKER, Richard Edward
Oils and watercolours. Marine subjects. Exhib. RSMA from 1958 (watercolour 'Whale Catchers') and 1960 ('Auckland Yacht Harbour') to 1972 ('The *Oil Prospector* approaching a rig in the North Sea')

BALDWIN, F.W., RSMA (b.1899)
Watercolours. Coastal scenes. Exhibitor RSMA from 1954 (3 watercolours incl. 'Ebb tide, Southwold') until 1961 ('Fishing boats, Aldeburgh, Suffolk'). Also exhib. RA, RBA. Lived near Beccles, Suffolk.

BALL, Tom (1888-c.1930)
Watercolours. Marine subjects and landscapes. Lived at Budleigh Salterton, Devon, 1922-30. Exhib. RBSA and RWA.

BALL, Wilfred Williams, RE (1853-1917)
Watercolours and etching. Marine and coastal subjects and landscapes. Exhib. RA, RBA, RE, RI, etc. Worked chiefly in the 19th century but also into the early 20th. Lived at Lymington, Hampshire, in 1911. Died Khartoum.

BANNISTER, Mrs. Margery Frances
Watercolours. Marine and coastal subjects. Exhib. RSMA from 1958 (2 watercolours incl. 'The Porthole') and until 1962.

BARDILL, Ralph William (1876-1935)
Oils and watercolours. Coastal scenes and landscapes. Exhib. RA, RCA, RI. Lived in Lancashire and N. Wales.

BARHAM, Jean (b.1924)
Oils. Maritime subjects, chiefly the tidal Thames with boats in the area of St. Katherine's Dock and Greenwich. Studied at Camberwell School of Art 1947-50. Served in the W.R.N.S. in the 2nd World War as Boats Crew WRN, also Bowman on Captain's Yacht at Felixstowe MTB base. One-woman exhibitions: World Trade Centre, London 1973, and *Cutty Sark* Greenwich, 1979. Mural at Greenwich: 'The barge race'. Lives at Greenwich, London..................... See PLATE 21

BARNARD, Miss C.A. Lily (b.1902)
Oils and watercolours. The sea in all its aspects, especially its power and violence; ships and boats; also flowers and some landscapes. Studied drawing in Paris, under Habert Dys, and oil painting at the Emile Renard Studio. Private exhib. Paris 1928. Exhib. RSMA from 1949 onwards (1951: 'High tides at Emsworth' and 'Rottingdean'; 1950: 'Easter Gale'; 1978:

'Moonlit bay' and 'Atlantic near Cape Cornwall'). Member of St. Ives Society of Arts since 1962. Originally intended to be a professional violinist. Lives at St. Ives, Cornwall.

BARNETT, Walter Durac (1876-c.1950s)
Oils, watercolours and pastels. Marine subjects, landscapes and portraits. Exhib. RA, ROI, RP, NEAC, etc.

BARRON, Howard (b.1900)
Oils. Marine subjects, also landscapes and portraits. Exhib. RSMA from 1954 ('Blue day, Mevagissey'; 'Morning, Australian Pacific coast' and 'The night tide') to 1961 ('Two Frenchmen in St. Ives bay'). Also exhib. RA, ROI, etc.

BARTLETT, Charles, RWS, RE (b.1921)
Oils and watercolours. Marine subjects and landscapes, also etcher. Exhib. RSMA from 1958 (oil 'Essex smacks' and watercolour 'Building a *Yeoman* class'), 1959 and 1960. Also exhib. RA, RBA, RWS, NEAC, etc.

BARTLETT, Geoffrey
Watercolours. Coastal and harbour subjects. Exhib. RSMA 1976, 1977, 1978.

BASS, Reginald
Oils. Marine and river subjects. Exhib. RSMA from 1964 to 1966 ('The white boat') and up to 1971 ('The canal').

BEALE, Mrs. H., RSMA, *see* **ELLIOTT, Aileen Mary**

BEALE, Margaret L.C., RSMA (b.1887)
Oils and watercolours. Marine subjects. Exhibited at inaugural exhibition RSMA 1946 with 3 pictures: 'All comers race, Chichester harbour', 'Sardine boats, Audierne' and 'Boat sheds, Holy Island' and many further exhibits up to 1969. Lived at Chichester, Sussex.

BECK, Stuart, RSMA (b.1903)
Oils, watercolours and acrylics. All marine subjects and some landscapes usually including lakes or rivers. Studied at Rochester School of Art. Goes to sea in any type of ship or boat whenever possible. Started painting at the age of 7 using his mother's oils on a piece of shoebox, in a cargo ship somewhere off Cape Horn. Feels that marine painting is now neglected in the important general exhibitions. Served R.N.V.R. as technical illustrator for instruction purposes 1941-46. Marine technical illustrator for many years. Exhib. at the RSMA inaugural exhibition 1946 and regularly since then. Also exhib. RBA, SGA, etc., and several one-man exhibitions. Lives at Lymington, Hampshire................ See PLATES 22 & 23

BELCHER, Frank C. (died c.1963)
Oils and watercolours. Coastal, harbour and estuary scenes. Exhib. RSMA from 1952 ('Deganwy foreshore') until 1962 (oil: 'After rain at Blackfriars' and watercolours: 'Thames at Blackfriars' and '*Woodlark* in Nelson Dock') and 2 posthumous exhibits in 1963.

BELL, F.A. Judson
Watercolours. Exhib. RSMA 1948 'Old Tunnel Pier, Wapping'. Member Wapping Group.

BENNETT, Vyvyan, ATD (b.1928)
Oils, watercolours and gouache. Seascapes with boats, harbours and coastal scenes. National Diploma Design (Painting) 1950. Keen amateur deep water sailor, e.g., cruised Plymouth to Gibraltar 1979. Particularly interested in painting the effects of skies and light over water and land. Lives at Brightlingsea, Essex.................................... See PLATE 24

BENTALL, Anthony Pearton (b.1916)

Watercolours (also pen and ink). Harbour scenes and landscapes. Yacht owner and one-time member Royal Ocean Racing Club, also Chairman Norfolk Wherry Trust. Five years R.N.V.R. Exhib. RSMA 1978. Exhib. Norfolk and Norwich Art Circle for 30 years. Lives in Norwich.

BENTHAM-DINSDALE, John, Dip. Arch. (Leeds), ARIBA (b.1927)

Mainly oils, but also some watercolours. Specialises in sailing ships and sea battles. Also paints some landscapes. Studied Architecture and Design at Leeds University. Worked in the theatre as a designer and later in television, becoming Head of Design and Construction at Tyne Tees T.V. Has always been interested in the sea and ships and is now a full-time marine artist. Work has been exhibited in London, Paris, New York, San Francisco, Vancouver, Calgary, Tokyo, Sydney, etc. Lives in Dorset.
.....................................See PLATE 25

BERRY, Roy, PS (b.1916)

Oils, watercolours and gouache. Wide variety of subjects with some emphasis towards marine painting and portraiture. Studied at Weston-super-Mare School of Art for 3 years, also Redhill, Gloucester and Derby Art Schools. Exhib. RPS and PS. Six one-man shows in and near Derby. Always paints directly from life and practices the traditional methods. His marine work tends towards harbour and coastal scenes and boatyards. Lives in Derby.....................See PLATE 26

BIGNELL, Jessie P.

Watercolours. Marine subjects. Exhib. RSMA from 1965 and 1969 ('The *Arethusa* at Upnor') up to 1973.

BILLINGS, Dorothy

Oils and watercolours. Estuary, harbour and coastal scenes. Exhib. RSMA from 1951 ('Grey day, Greenwich', 'September morning, Lowestoft' and 'Breezy day, Southwold') up to 1958.

BIRCH, David, ROI (1895-1968)

Oils. Coastal and estuary scenes, landscapes, etc. Exhib. RSMA 1959 (oil: 'Southampton Water') and up to 1966 (2 oils: 'Sailing barges, outlook unsettled' and 'Sailing barges, Pinmill'). Also exhib. RA, ROI, etc.

BIRD, Mrs. Mary Holden, SWA

Oils and watercolours (also etcher). Coastal subjects and landscapes. Exhib. RSMA 1968, 1970 and 1971. Also exhib. RA, RSA, RSW, RBA, etc.

BIRCHALL, William Minshall (1884-c.1930s)

Watercolours. Marine subjects, often sailing ships in the Thames estuary and English Channel, but also as far afield as Gibraltar. Born Iowa, U.S.A. Worked well into the 1930s. Represented in the Walker Art Gallery, Liverpool.
.....................................See PLATE 27

BISHOP, Henry, RA (1868-1939)

Oils. Coastal subjects and landscapes. Exhib. RA, RBA, RHA, NEAC, ROI, RSA, etc.

BISSELL, Osmond Hick, ARWA, PS (b.1906)

Oils and watercolours. Marine subjects, landscapes, portraits, etc. Exhib. RSMA 1958 (2 watercolours: 'Rocks and waves' and 'Wet sand') and 1961. Also exhib. RA, RI, ROI, RBA, etc.

BLACK, Andrew, RSW (1850-1916)

Oils and watercolours. Marine subjects and landscapes. Worked mostly at the end of the 19th century but also into the 20th. Exhib. RA, RSA, RSW. Lived in Scotland.

BLACK, Francis, RBA (fl.1891-1938)

Oils. Marine and coastal subjects, also landscapes. Exhib. RA, RBA, RCA, etc.

BLACK, Maureen June (b.1926)

Oils, watercolours, gouache, egg tempera and acrylics, also etching. Coastal, river and landscape subjects. Studied at Goldsmiths College and obtained National Diploma in Painting (also in advanced embroidery). Studied etching at Horley College. Joint owner, with husband, of Dutch barge 1968-78 and owner Cornish Crabber 1979. Exhib. RSMA from 1977. Work in Greenwich Print Collection, Graphotek Berlin, National Museum of Wales, etc. Founder member of Greenwich Printmakers Association. Lives at Blackheath, London....................................See PLATE 28

BLAIR-LEIGHTON, J., RBA, RP (fl.1914-1939)

Oils and watercolours. Coastal subjects, landscapes and portraits. Exhib. 1938 Marine Picture Exhibition at Portsmouth 3 works incl. 'The last of the Fishing Fleet, Emsworth'. Exhib. RA, RBA, RP, etc.

BLAKE, Miss Eileen Mary (b.1878)

Watercolours. Marine subjects, landscapes, figures, etc. Birmingham artist. Exhib. RBSA, RCA, RI, ROI, SWA, etc.

BLAKE, Frederick Donald, RI, RSMA (b.1908)

Born 7th June, 1908 in Greenock, Scotland. Acrylics and watercolours. Coastal scenes, harbour scenes and landscapes. Studied: Camberwell School of Arts and Crafts and Goldsmith's College. Many special exhibitions of his work in Los Angeles, Chicago, Rome, Hamburg, Dusseldorf, etc. Elected RI 1952. Exhib. RA, RI, ROI, RBA, RSMA, etc. His work is in many public and private collections. Lives in London..See PLATE 29

BLANCH, William

Oils. Marine subjects. Exhib. RSMA 1973: 'The taking of the *Guillaume Tell*'; 1975: 'Squally weather'; 1976: 'At the turn of the tide'.

BLATCHFORD, Conway (b.1873)

Oils and watercolours. Marine subjects and landscapes. Exhib. RA, RCA, RI, etc. Lived in Devon.

BOARD, Edwin John (b.1886)

Oils and pastel. Marine subjects and landscapes. Exhib. RA, RWA. Bristol artist.

BODLE, Robert Talbot

Oils and watercolours. Marine subjects. Exhib. RSMA from 1967 (oil: 'Fishermen off Cote d'Azure' and watercolour) to 1974.

BOND, Arthur J.F., RSMA (1888-1958)

Oils and watercolours. Estuary, coastal and other marine subjects (also etcher). Born Devonport. Served in H.M.S. *Cleopatra* of the Harwich Force in World War I. Exhib. 2 etchings of naval scenes in 'The Navy in Peace and War' Exhibition 1936. Exhib. RA, RI, RSMA and Paris Salon. Member of Wapping Group. Council member RSMA 1947 and Hon. Treasurer 1948-57. (RSMA exhibs. 1951: 'Woolwich Reach', 'Arrival at the Docks' and 'Racing at St. Mawes, Cornwall'.)

BOND, William Joseph J.C., (1833-1926)

Oils and watercolours. Mainly marine subjects, also landscapes. Liverpool artist, much influenced by J.M.W. Turner. At one time painted in Pre-Raphaelite manner, but later developed a freer style. Usually considered a 19th century artist, but lived and worked until 1926. Exhib. RA, RBA and Liverpool.
.....................................See PLATE 30

BONE, Sir Muirhead, LL.D., D.Litt., NEAC (1876-1953)
Born Glasgow. Studied at Glasgow School of Art. Oils and watercolours, also etcher. Official Naval war artist World Wars I and II. Knighted 1937. In second World War held honorary rank of Major, Royal Marines. Works are in public collections including a large number in the Imperial War Museum of both naval and auxiliary subjects. Used almost every medium effectively but is best remembered for very fine etching and drawing. Exhib. RA, RSA, RSW, NEAC, Glasgow, Liverpool, Manchester, and many other leading centres... See PLATE 214

BONE, Stephen, NEAC (1904-1958)
Son of Sir Muirhead Bone. Studied at Slade School. Served with naval forces in 2nd World War and was made official war artist as Hon. Lieut. R.N.V.R. 1942-45. Nearly 200 pictures, oils, pencil and chalk drawings, etc., incl. large number of naval subjects in Imperial War Museum. Also, naval pictures in Nat. Maritime Museum. Exhib. 3 pictures in Marine Pictures Exhibition, Portsmouth, 1938. Exhib. RA, RHA, NEAC, Glasgow, Manchester, etc............See PLATES 215 & 216

BONNEY, Richard Oliver (b.1902)
Oils and watercolours. Sea pieces, particularly the sea off the Cornish coast. Has spent most of his life in Cornwall. Member and exhibitor St. Ives Society of Artists. President, Newquay Society of Artists. Exhib. RSMA from 1970 (oil: 'Home of the sea birds') onwards; 1979 (oil: 'Rising tide, Treyarnon bay'). Lives in Cornwall.........................See PLATE 31

BORROWMAN, Charles Gordon, RSW (1892-1956)
Watercolours. Some coastal scenes, but mainly landscape and animals. Exhib. at RSMA 1948 onwards (1951: 'On the coast of Sutherland' and 'Torrisdale Bay, Sutherland').

BOVILLE, Frank William
Oils. Sea pieces. Exhib. at RSMA from 1950 ('A North Atlantic October') up to 1954 ('The finish of the Sou'wester' and 'Heavy seas, Brook ledge, Isle of Wight').

BOWER, John, *see:* **PEARCE, Leonard John**

BOWERMAN, Bernard J.W. (b.1911)
Oils and watercolours. Marine subjects, also landscapes, etc. Exhib. RSMA 1948: watercolours 'Low Tide, Burnham-on-Crouch' and 'The Saltings, Burnham-on-Crouch'. Also exhib. RA, RBA, RI, etc. Member of Wapping Group.

BOYCOTT-BROWN, Hugh, RSMA (b.1909)
Born 27th April, 1909 at Bushey, Herts. Oils. Coastal and harbour scenes (and landscapes). Studied: Frobisher School of Painting, Bushey; Watford School of Art; Heatherlys, London; Cotswold School of Landscape; and privately with Bernard Adams and in Norfolk with Sir Arnesby Brown. Art Master 1929-69 at Royal Masonic Junior School, Bushey. Exhib. at RA, RSMA, and in the U.S.A. and represented in many public and private collections. Member of the Wapping Group. Seafaring experience owning and racing 14ft. dinghies. War service as Intelligence Officer in the R.A.F. from Norway to Singapore. Contributor to art magazines. His work is greatly influenced by the French Impressionists: Monet, Sisley and Boudin. Lives in Saxmundham, Suffolk.......See PLATE 32

BRABBINS, Oliver, RI
Oils and watercolours. Marine subjects, landscapes, etc. Exhib. RSMA from 1969 (oil: 'The Fisherman') to 1972 (watercolour: 'Thames fishing boats').

BRADBURY, Arthur Royce (b.1892)
Oils, watercolours and pastels. Marine subjects, landscapes, etc. Exhib. RA, RBA, RI, ROI, RWA, etc. Served in Merchant Navy as a cadet. Lived in Dorset.

BRADSHAW, Comdr. George F., DSO, RN (Retd.), RSMA (1887-1960)
Oils and watercolours. Marine subjects. Retired from R.N. in 1922 and started painting at St. Ives. Exhib. Portsmouth 1936 'Navy Week' with 3 oils of submarines and warships at sea. Founder member of the RSMA. Exhib. RA, RSA, RWA, RSMA and Paris Salon. Exhib. Portsmouth 1938: 'Bathing in the Cove' and 'The Unfinished Pier'. Inaugural exhib. RSMA at Guildhall 1946: 'French crabbers off the Cornish coast', 'Early morning off Sunderland' (oils). Lived at 'The Ship Studio', St. Ives.

BRADY, Emmet (fl.1896-1928)
Oils and watercolours, also etcher. Marine subjects. Glasgow artist. Exhib. RHA, RSA, RSW, GI, etc.

BRANGWYN, Sir Frank, RA, RWS (1867-1956)
Oils and watercolours and skilled etcher. Marine and many other subjects. Knighted 1941. His marine work has impressed and influenced many present day artists, but his range also extended to figure subjects, industry and architecture, lithography and mural painting. A large and successful exhibition of his work was opened by the Prime Minister in 1924. He exhibited extensively, including RA, RBA, RHA, RI, ROI, RSA, RSW, RWS, NEAC and many other leading galleries. Ten marine and military works at Imperial War Museum.................................See PLATE 33

BRAZIER, A. Keeley, BWS (b.1894)
Watercolours, oils and pastels. Coastal and other marine subjects. Exhib. 1949 RSMA 3 watercolours 'The Old *Corsair*, Rhyl', 'High Tide, Rhyl harbour' and 'The Foryd veteran'. Also exhib. RWA, RCA, RBSA, UA, etc. Lived Barmouth, Wales.

BRAZIER, Walter John (b.1913)
Watercolours. Harbour and estuary scenes and some other subjects. Studied at Worthing Art School and Brighton College of Art, 1946. Pupil of Edward Wesson, 1977. Served R.N. 1941-46 in minesweepers first as Radio Operator and eventually as commanding officer. Exhib. RSMA from 1977, RBA and various Sussex galleries. Lives at Worthing, Sussex.

BRERETON, James Joseph (b.1954)
Oils. Wide range of marine subjects, both historical and present day, incl. ships at sea, coastal and harbour scenes, etc., also some landscapes and still-life. Studied: Joseph Wright Art School, Derby, also self-taught. Admires both Impressionist and representational forms of marine painting. Exhib. RSMA 1979: oil 'The outer harbour, Mevagissey, Cornwall'. Lives in Alvaston, Derby.........................See PLATE 34

BRIGGS, Mrs. Norah K.
Oils and watercolours. Marine subjects. Exhib. RSMA from 1965 to 1978 (oil: 'Fishergirl, Ibiza').

BRISCOE, Arthur, RI, RE (1873-1943)
Oils, watercolours, and etching. Marine subjects. Studied at the Slade. Played leading part in arranging series of pre-war marine exhibitions which eventually led to formation of RSMA. His etchings, which range from ships to individual members of the crew at work, are generally acknowledged as top quality material. He had practical seafaring experience in sail. Served 1914-18 as Lieut. R.N.V.R. Exhib. RSMA 1957. Exhib. RA, NEAC, RBA, RE, RI, etc.........See COLOUR PLATE 2

BROCKLESBURY, Horace (b.1886)
Oils and watercolours. Seascapes and landscapes. Exhib. RA, Manchester, etc. Lived in Hertfordshire.

BROOKER, Charles
Oils and watercolours. Coast and estuary subjects. Exhib. RSMA from 1967 (2 watercolours) to 1971 (watercolour: 'Hastings Beach').

BROOKS, J., DSC (fl.1941-1945)
Lieut. R.N. Three independently submitted watercolours of naval subjects in Imp. War Museum, e.g., 'The sinking of the *Bismarck*' 12 x 18¾ ins. and 2 of H.M. Submarine X24 in action situations.

BROOKS, Robin
Oils. Marine subjects incl. sailing ships. Exhib. RSMA 1970 ('Clipper *Cromdale*') and 1972 ('Action between *Penelope* and *Guillaume Tell*').

BROWN, Samuel John Milton (b.1873)
Watercolours. Marine subjects. Liverpool artist. Exhib. RCA, RI, etc.

BRYANT, Charles David Jones, ROI, RBA (1883-1937)
Oils. Marine subjects. Born in Australia. Pupil of Julius Olsson. Official war artist (Australian Imperial Forces) 1917. Work: 'Dazzled leave ships, Boulogne' in Imp. War Museum. Exhib. from 1910, RA, RBA, RI, ROI, and provinces.

BUCK, Albert
Watercolours. Coast and harbour subjects. Exhib. RSMA from 1958 to 1966 ('The harbour, Stonehaven, Scotland' and 'End of the day').

BUCKLE, Claude, RI, RSMA (1905-c.1973)
Oils and watercolours. Marine subjects. Exhib. RSMA from 1955 (2 oils incl. 'Seascape') until 1970 (watercolour: 'The Wash'). Also exhib. RI. Lived at Andover, Hampshire.

BURGESS, Arthur James Wetherall, RI, ROI, RBC, RSMA (1879-1957)
Oils and watercolours. Marine subjects. Born in Australia. Exhib. RA, RBA, RHA, RI, ROI and Paris Salon. Vice-President RSMA 1946. Examples of his oils: 'In the Port of London' 1946; 'Britain's Heritage' 1947; 'Sunset in Dockland' 1948; and 'Where the Mersey meets the open sea' 1951. Work in Imp. War Museum includes: 'H.M.S. *Lion* at the Dogger Bank action 1915'. Also represented in the Nat. Maritime Museum. Art Editor *Brasseys Naval and Shipping Annual* from 1922 to 1930 .See PLATE 35

BURLEY, David William (b.1901)
Oils and watercolours. Marine subjects and landscapes. Exhib. RA, RBA, RI, etc.

BURN, Rodney Joseph, RA, NEAC, Hon. RSMA (b.1899)
Born 11th July, 1899 in London. Painter in all media of seascapes and beach scenes, also landscapes, figure subjects and portraits. Studied: Harrow and the Slade School of Art. 1929-31 teacher at the Royal College of Art and Hon. Fellow 1946. 1931-34 Director of Drawing and Painting at Museum of Fine Arts, Boston, U.S.A. Elected: ARA 1954; RA 1962; Royal West of England Academy 1963. President, St. Ives Soc. of Artists 1963. Special exhibitions in London and provinces between 1920 and 1979. Three works in Imp. War Museum Limited edition reproduction of seascape 'Bembridge harbour, I.o.W.' 1979. Lives in Chiswick, London.
.See COLOUR PLATE 3 and PLATE 36

BURRIDGE, Frederick Vango, RE (1869-1945)
Etcher and painter. Coast and marine subjects and landscapes. Pupil of Frank Short. Exhib. RA, RE, etc.

BURTON, William Francis (b.1907)
Oils. Harbour and estuary scenes, sailing ships, landscapes, portraits and figure studies. Has lived by the sea and estuaries most of his life and made 2 sea voyages to Australia. Exhib. RSMA from 1976. Also exhib. from 1973 in London, East Bergholt, Suffolk, and Frinton. Fifteen special prints of his paintings have been published by Solomon and Whitehead for world-wide distribution. Rated most popular print 1967-68-69. Considers that 20th century marine artists are painting present day craft just as well as the 19th century artists painted their subjects. Lives in Colchester, EssexSee PLATE 37

BURTONSHAW, Keith, UA (b.1930)
Watercolours. Harbour and estuary scenes, also rivers, lakes, trees and large skies. Mainly self-taught but also studied at Beckenham School of Art. Exhib. RSMA from 1971 (watercolour: 'Low tide, Bosham'). Is particularly interested in the development of atmospheric estuary scenes in pure transparent watercolour. Lives at Beckenham, Kent.

BUTCHER, Arthur
Oils and watercolours. Coastal scenes. Exhib. RSMA 1951, 1952 and 1954.

BUTLIN, Donald Everard (b.1929)
Oils and watercolours. Coastal scenes (East coast of England), spritsail barges, yachts, and landscapes. Studied Northampton School of Art and under W.F. Burton. Exhib. RSMA 1977 'Dunwich Beach' and 1978 'Men of Dunwich'. Paints yachts on commission from owners. Lives at Colchester, Essex.
. .See PLATE 38

BUTSON, Alec J.
Watercolours. Thames estuary and similar subjects. Exhib. RSMA 1974 onwards; 1979: 'Westminster from South Bank'.

CACKETT, Leonard, RSMA, SGA, BWS (1896-c.1965)
Oils and watercolours. Marine subjects, also landscapes. Exhib. inaugural exhibition of RSMA 1946: watercolour 'Porthleven Boats'. Member RSMA 1949 and regular exhibitor up to 1962. Also exhib. RA, ROI, etc.

CAIN, Charles William, RSMA (fl.1893-1959)
Oils. Coastal and estuary scenes, also landscapes. Exhib. RSMA 1947-54, also exhib. RA, RSA and provinces. Served Artists Rifles World War I in Near East and worked in Baghdad after that war for one year. Lived in London (1959).

CAMPBELL, Meriel Lambart, SWA (b.1912)
Oils, watercolours, gouache and acrylics. Harbour and coastal scenes and especially Venetian scenes, also landscapes, portraits and flower studies. Studied: Royal Hibernian Academy and Slade School. Qualified art teacher. Exhib. RSMA, also RA, RHA, ROI, RI, SWA, Wildlife Soc., Portrait Soc., etc. One-man exhibitions London, 1976, and provinces. Work in permanent collections at Sunderland Art Gallery, U.S. Embassy, etc. Lives at Chandler's Cross, Hertfordshire.

CANNELL, Ashton, RSMA, ATD, UA (b.1927)
Oils, watercolours and acrylics. Marine subjects, also landscapes and still life. Studied at Isle of Man School of Art 1945-49 and Liverpool College of Art 1949-51. Qualified art teacher and at one time Senior Assessor in Art for the Metropolitan Regional

Examinations Board. Exhib. RA, RI, RSMA, RBA, Paris Salon, City of London Lord Mayor's Award, etc. General one-man exhibitions London and provinces. Work in many private collections throughout the world. Member: United Soc., Wapping Group, London Sketch Club, Langham Club, etc. Chairman, Arts Soc. of Paddington. Paris Salon: Silver Medal 1973, Gold Medal 1975. Lives in London......See PLATE 39

CAREY, Joseph W. (fl.1915-1935)
Watercolours. Marine subjects and landscapes. Belfast artist, elected an Academician of the Ulster Academy of Arts on its foundation in 1930. Exhib. RHA and has work in several Ulster museums...............................See PLATE 40

CARLIN, Miss Sandra Lorraine (b.1956)
Oils, watercolours and pastels. Harbour scenes and boats (but not under sail); buildings and some portraits. Studied: Rochdale College of Art 1973-75; Lancaster College of Art (but abandoned course after 4 months because of disillusionment with modern art and teaching techniques). Has taken R.Y.A. National Coastal Certificate Grades I and II and Yachtmaster Shore-based course. Exhib. RSMA 1978: watercolour 'Adda, Castletown harbour'. Lives in Castletown, Isle of Man.
..See PLATE 41

CARR, Henry Marvell, RA, RP, RBA (1894-1970)
Oils. Official war artist World War II. Portrait and landscape painter incl. marine personnel. Two paintings Nat. Maritime Museum and over 70 pictures, mainly military scenes and personnel, in the Imp. War Museum. Exhib. .RA, RBA, NEAC, Liverpool, etc.....................See PLATE 217

CARR, Leslie, RSMA (b.1891)
Oils and watercolours. Marine subjects. Exhib. 3 naval pictures 'Portsmouth Navy Week' exhibition 1936; also exhib. at inaugural exhibition of RSMA 1946: 3 pictures including 'The last of the cross-Channel paddlers'; 1959: oil 'The Royal Canadian Tour, *Britannia* arriving at Quebec City'. At one time was poster artist for Southern Railway.

CARTER, Peter J., RSMA (1929-1979)
Oils, watercolours and acrylics. Seascapes, sailing barges, landscapes, portraits and architectural perspectives. Originally an engineering designer, moved to Devon in 1962 and began painting. First one-man exhibition 1965. Exhib. RSMA from 1965 (watercolour: 'The Plym' and oil: 'Pilot Boat, Devon').
..See PLATE 42

CARTLEDGE, William, RI, RSMA (1891-c.1976)
Oils and watercolours. Coastal and harbour scenes, also landscapes, portraits, etc. Exhib. RSMA 1957 (3 watercolours 'The old Harbour, Portsmouth', 'The coal wharf, Portsmouth Harbour' and 'Bassin Duquesne, Dieppe') and until 1976 (2 posthumous watercolours). Also exhib. RA, RCA, RI, RBA, etc. Lived at Birdham, near Chichester, Sussex.

CATHCART, W. Atherton
Oils and watercolours. Marine subjects. Exhib. RSMA from 1955 (2 watercolours incl. 'The inner harbour, Brixham') until 1964 (2 oils incl. 'The Customs quay, Falmouth').

CAUSER, Sidney, RI, RSMA (1876-1958)
Watercolours. Harbour, coastal scenes and landscapes. Exhib., e.g., 'The harbour, Tenby' and 'The Sluice, Tenby' at Portsmouth 1938. Exhib. RA, RI, RSA, NEAC, and Paris Salon. Exhib. RSMA from 1948 (watercolours 'The harbour, Dieppe' and 'September afternoon, Hastings') until 1958.

CHAMBERLAIN, Trevor, ROI, RSMA, NS (b.1933)
Born 13th December, 1933 in Hertford. Oils and Watercolours. Marine inshore subjects (also town scenes and landscapes). Architectural Assistant until 1964 since when he has painted professionally. Exhib. RSMA from 1968. Also exhib. RA. Member of the Wapping Group. Lord Mayor of London's Art Award Winner 1976. Work featured on B.B.C. and Southern T.V. and reproduced in leading art magazines. Five special exhibs. of his work between 1971 and 1979. Work in permanent collections in Guildhall Art Gallery, London; Nat. Maritime Museum; Govt. House, N. Ireland; Hertford Museum. Lives in Hertford...............................See PLATE 43

CHAMBURY, James (b.1927)
Oils, watercolours and gouache. Marine subjects, landscapes and portraits. Studied for 6 years at School of Printing and Graphic Art, Central School of Arts and Crafts, and Sir John Cass College of Art, London. Amateur yachtsman. Exhibitor RSMA from 1976, also 'Britain in Watercolour' and London galleries. Lives near Ipswich, Suffolk.........See PLATE 44

CHAMPION, C.E.
Watercolours. Coastal and harbour scenes. Exhib. RSMA 1952 ('The harbour, St. Ives' and 'Rough weather, St. Ives') until 1957 ('Folkestone').

CHANCELLOR, John Russell (b.1925)
Oils and watercolours. Marine subjects. Served at sea (coasting Master) until 1972. First exhibition Torquay 1973 (sold out in 45 minutes). Second exhibition 1976 (sold out first day). Member of the Society of Nautical Research. Lives at Brixham, Devon.........................See COLOUR PLATE 14

CHAPMAN, Kevin George (b.1947)
Oils and watercolours. Seascapes, landscapes and figures centred on the Camel estuary in Cornwall. Born in Auckland, New Zealand. Left New Zealand 1969 and travelled around the world painting and drawing until 1973. Studied at Chelsea College of Art 1974-77. Has lived near or on the sea since childhood. Sees a kindred vista of the New Zealand coast in Cornwall and visualises a lifetime's work there. Exhib. RSMA 1978. Lived in London 1979, moving to Cornwall 1980.
..See COLOUR PLATE 4

CHARLESWORTH, Eleanor
Oils. Marine subjects, landscapes, etc. Exhib. RSMA 1954: 'At the moorings' and 'Sardine nets' and 1962: 'Plym estuary'. Also exhib. RA, RSA, NEAC, RHA, RI, ROI, RSW, SWA, etc.

CHARMAN, Rodney John Keith (b.1944)
Oils. Wide range of marine subjects and particularly of sailing ships in interesting lighting conditions, Thames scenes at the turn of the century, and Irish and Cornish fishing harbour scenes. Strongly influenced by the paintings of Montague Dawson, W.L. Wyllie and Bernard Gribble. RSMA exhib. from 1973 (3 oils incl. 'The *Cutty Sark* at Shanghai'). Protagonist of British marine artists as world leaders in this field of art. Lives in Lymington, Hampshire.................See PLATE 46

CHEGWIDDEN, Hugh (b.1913)
Oils. Marine still life, also some *trompe l'œil*, seascapes and landscapes. Has lived by the sea at Newquay, Cornwall, all his life. Exhib. RSMA from 1974. Also exhib. RBA, Armed Forces Art Soc., private London galleries, etc. Work on display at St. Ives Soc. of Artists.............................See PLATE 47

CHINN, S.
Oils. Coastal and harbour scenes, especially Mediterranean. Exhib. RSMA 1952 'Off the Costa Brava' until 1960: 'Ibiza harbour' and 'Cornish harbour'.

CLARK, R.W.

Watercolours. Coast and estuary subjects. Exhib. RSMA from 1964 ('Lymington') to 1973 ('Reflections at Portpatrick').

CLARK, Thomas Brown, RSMA (b.1885)

Born 12th August 1885 in Glasgow. Oils. Seascapes, merchant ships, harbour scenes and landscapes. Studied: Glasgow School of Art and Glasgow Royal Technical College. Early in his career he did much theatre stage designing. Exhibited in the RA and in many other countries. His work is in a number of public and private collections in the U.K. and overseas. Exhib. at RSMA from 1950 ('The harbour, Polperro', 'Fading Day'). Lives in Sussex.

CLARKE, Thomas F. (fl.1932-60)

Oils. Marine subjects and landscapes. Exhib. RSMA 1947: 'The Coming Storm' and 1948: 'Low-Tide, Shoreham'. Also exhib. RA, ROI.

CLIFFORD, Albert John Henry (b.1934)

Oils, watercolours and acrylics. Harbour scenes, boat yards, seascapes, North sea oil exploration, and landscapes. Studied at Swindon Art College. One-man exhib. Norwich, 1975 and exhib. annually at Yarmouth. Exhib. RSMA from 1972 ('Gorleston Lifeboat *Khami*') onwards; 1979 ('Yarmouth harbour welcomes the *Marques*' and 'Gorleston harbour mouth'). Work in collections in America, Canada, S. Africa, Australia, Germany, France and U.K. Lives at Gorleston, Great Yarmouth, Norfolk.................See PLATE 48

COBB, David, ROI, RSMA (President RSMA, from 1979)

Born 13th May, 1921 in Bromley, Kent. Painter in oils of 'everything, of any period, that floats'. Naval cadet at Pangbourne Nautical College 1935-37. Left Cambridge 1940 for Royal Navy. Served in Atlantic convoys as 1st Lieutenant 1941-42. Commanded MTBs 1943-45 and became Control Officer MTBs in the North Sea. Started painting professionally in 1946 at Newlyn. Moved to New Forest, Hampshire, 1954. Yacht owner and keen yachtsman with wide practical experience of small vessels both sail and power. Exhib. at RSMA since inaugural exhibition 1946; also ROI, RBA, etc. Fascinated with every aspect of the sea. Member of Royal Cruising Club; Member of Board of Governors TS *Foudroyant;* Council Member of Society for Nautical Research. Commissioned 1978 to paint 17 oils depicting The Battle of the Atlantic, and 2 further series on the Navy at War in Mediterranean and the Pacific, all for the permanent collection at the Royal Naval Museum, Portsmouth. (The total commission is probably one of the most significant of its type in the history of British marine painting.) Lives near Brockenhurst, Hampshire.
. .See COLOUR PLATES 5 & 6 and PLATES 49, 49/A & 49/B

COBBETT, Hilary Dulcie, RSMA, SWA (b.1885)

Oils and watercolours. Marine subjects, especially harbour scenes. Exhibitor at inaugural exhib. RSMA 1946 with 4 pictures incl. 'Tunny boats, Concarneau', 'Evening in the harbour' and 'Brixham harbour'. Exhib. RSMA until 1963, also RA, RI, RBA, ROI and SWA.

COCKRAM, George, RCA, RI (1861-1950)

Coastal scenes and landscapes. Exhib. RA, RBA, RCA, RI, etc. Work in Tate Gallery. Very active at the turn of the century and often thought of as a 19th century artist.

COKER, Mrs. Marion (b.1911)

Oils and watercolours. Fishing vessels, Leigh cocklers, shrimpers; also flower pictures and landscapes. Studied: Southend College of Art (4 years); also 10 years in Fleet Street advertising studios. Exhib. RSMA from 1964 (oil: 'Slack water, Leigh-on-Sea') to 1979 (oil: 'Cocklers and shrimpers') onwards. Lives in Leigh-on-Sea, Essex.................See PLATE 45

COLACICCO, Salvatore (b.1935)

Oils. Marine subjects, especially old sailing ships and paddle steamers. Born at Bellagio, near Lake Como. Studied at Brera Academy, Milan, and subsequently came to England to live and paint. Commissioned to paint series of 26 panels for Russell Cotes Museum, Bournemouth, illustrating the history and development of the paddle steamer...........See PLATE 50

COLE, Leslie, NEAC (b.1910)

Oils and watercolours, also pencil and lithographer. Marine subjects, landscapes and figures. Official war artist 1941-46 with rank of Hon. Capt. R.M. Ninety-five pictures in Imp. War Museum of wide variety of naval subjects, e.g. 'Submarine Patrol', 'Maltese Fishermen mending bombed Dghaisas and other boats', also some portraits and army subjects, incl. Burma, Ceylon and Singapore locations; 2 pictures at Nat. Maritime Museum. Exhib. RA, RBA, NEAC, etc.
..See PLATE 218

COLLINS, Patrick

Watercolours. Coastal and estuary subjects. Exhib. RSMA from 1965 ('Winter estuary' and 'Quayside') to 1968.

CONNARD, Philip, RA, RWS, NEAC (1875-1958)

Oils and watercolours. Official marine war artist to R.N. World War I, (80 works in Imp. War Museum) and contributing artist World War II. Studied London and Paris. Exhib. RA, RHA, ROI, RSA, RSW, RWS, NEAC, and many other galleries in London and provinces. His naval war pictures include cruisers, destroyers, submarines, portraits, figure studies, dramatic events, etc. Lived in Surrey...........See PLATES 219 & 220

CONNEW, Joan V.

Watercolours. Coastal scenes. Exhib. RSMA from 1957 ('Cornish crabbers' and 'Cadgwith, Cornwall') until 1966.

COOK, Alan R., RSMA

Watercolours and oils. Marine subjects, etc., especially Northumberland and Tyneside shipping scenes. Exhib. RSMA 1959 (watercolour: 'M.V. *Braemar,* North Shields') to 1974 (4 oils). Two paintings in Nat. Maritime Museum. Lived at Whitley Bay, Northumberland.

COOK, David A.

Watercolours of wild marine life. Exhib. RSMA 1976 and 1978.

COOK, Peter Richard (b.1944)

Watercolours. Harbour scenes, seascapes and aviation subjects. His family background of marine experience dates back to the late 18th century. Exhib. at RSMA from 1977 and Ferens Art Gallery, Hull, from 1978. Work influenced to some extent by John Ward of Hull and Atkinson Grimshaw. Lives at Bridlington, East Yorkshire.................See PLATE 51

COOKE, Cecil

Watercolours and oils. Marine subjects. Exhib. from 1967 RSMA (oil: 'Heading for Pompey'), 1968, 1970, 1972 (oil: 'Crossing the Solent').

COOP, Hubert, RBA (1872-1953)

Oils and watercolours. Marine and estuary subjects and landscapes. Work shows considerable talent. Had 13 pictures in RA at turn of the century; also exhib. RBSA, RBA, RCA, RI, etc. Lived Birmingham, North Wales and Devon.

COOPER, John (b.1942)

Oils, gouache and acrylics. Marine subjects, especially trawlers.

Studied at Wakefield Art College and Leeds Art College. Lives within a stone's throw of the North Sea and therefore sees the dramas of lifeboat launches, rescues, trawlers and cobbles being escorted back in gale force winds, etc. Exhib. RSMA. Also illustrator and architectural perspective artist. Lives at Bridlington, East Yorkshire.............................See PLATE 52

COOPER, Josephine Mary, SGA, UA, ARMS (b.1932)
Oils and watercolours. Paints under the name of Jo Cooper, boats of all descriptions, ports, harbour scenes and landscapes. Studied at St. Albans School of Art and then under Ken Haw and Will Raymont at Welwyn Garden City College of Further Education. Exhib. at RSMA from 1976. Also Paris Salon (Silver Medal 1974) and *Diplome d'Honneur*, Caen (1979). Rowland Prize Winner 1977. Three one-woman exhibitions at Libertys of London 1977-79 and other joint exhibitions. Work exhib. extensively in Hertfordshire and is in private collections in U.K. and many overseas countries. Lives in Welwyn Garden City, Hertfordshire..........................See PLATE 53

COOPER, Kenneth
Oils. Harbour and coast subjects. Exhib. RSMA 1972 (2 oils incl. 'Honfleur, Normandy'), 1973 and 1974.

CORNWELL, Arthur Bruce (fl.c.1946-1949)
Oils and watercolours. Marine subjects (also illustrator). Exhib. RSMA 1946 oils: 'Distressed lightship', 'Discharging merchantmen, St. Malo'; 1947 watercolour 'French Drydock'; 1948 watercolour 'Sunday at the Buoys'; 1949 one gouache and one drawing. Studied in U.S.A., England and Paris. Exhib. RA, SGA, NEAC, etc.

CORSELLIS, Jane, NEAC, ARBA, NDD
Oils, watercolours, gouache and egg tempera. Harbour scenes, winter beach scenes and fishing river scenes. Also etchings and lithographs of marine subjects. Studied at the Byam Shaw School of Art for 4 years and was awarded Jubilee Prize. Has been keen dinghy sailor. Particularly interested in the Welsh coast. Work in private collections. Exhib. RSMA from 1976. Lives in London...........................See PLATE 54

COTTINGHAM, Grenville George (b.1943)
Oils, watercolours and acrylics. A wide range of marine subjects incl. seascapes; also landscapes. Studied: Exeter College of Art (NDD) 1960-63; Liverpool College of Art (ATD) 1963-64. Employed as first seagoing artist-tutor to the Seafarers Education Service 1966-68 travelling approx. 150,000 miles on 19 ships. One-man show in Dublin 1974. Exhib. Munich 1975, Berlin, 1980. Work in collection Munich University. Commissioned for murals by Shell Petroleum, Esso, Air Ministry, Devon County Council, etc. Two years at sea gave him a unique opportunity to study the sea in all its moods and relationship to ships which has become the main preoccupation in his work. Lives in Blackheath, London.................See PLATE 55

COULING, Arthur Vivian (fl.1920-1940)
Oils and etching. Marine subjects and landscapes. Scottish artist (but born in China). Studied Edinburgh. Exhib. RSA, GI, Liverpool, etc.

COUPE, M.W.
Oils. Marine subjects. Exhib. RSMA 1975 and 1976 ('Fleetwood trawler, Lowestoft' and 'Sunday morning, Lowestoft').

COVENTRY, Miss Gertrude Mary (b.1886)
Oils and watercolours. Coastal and harbour subjects, also landscapes, portraits, etc. Exhib. RA, RCA, RSA, etc. Lived Scotland and N. Wales.

COVERLEY-PRICE, Victor (b.1901)
Oils and watercolours. Marine subjects and landscapes. Exhib. RSMA 1959-61. Also exhib. RA, RBA, RI, etc.

COX, John
Watercolours. Coast and harbour scenes. Exhib. RSMA 1958 ('Boats at quayside, Wells'), 1960 and 1971.

COX, Miss Mary Constance (fl.1892-1935)
Watercolours. Seascape subjects, also landscapes, animals etc. Exhib. RBA, RBSA, etc.

CRAMPTON, Ronald (b.1905)
Watercolours. Coastal and estuary subjects also landscapes. Exhib. RSMA 1961 'Showery evening, Suffolk estuary' and 1962. Also exhib. RI, RWS, RBA, etc.

CRIBB, Preston (1876-1937)
Oils and etchings. Marine subjects, illustrator, etc. Exhib. RA, RBA, RCA, ROI, RBSA. Studied Portsmouth; lived Birmingham.

CRICK, D.W.
Oils and watercolours. Harbour and coast subjects. Exhib. RSMA 1973 ('Chichester harbour' and 'After the storm'), 1974, 1975.

CHRISTOPHERSON, Anne (fl.1950s)
Represented at the National Maritime Museum by scenes of Greenwich done during the 1950s.

CRITCHLEY-SALMONSON, Mrs. Beryl
Oils and watercolours. Marine harbour subjects. Exhib. RSMA 1966 ('East Coast Shrimper') to 1973.

CROSS, Roy, RSMA, SAvA (b.1924)
Born 23rd April 1924 in Southwark, London. Bodycolour, oils, line and watercolour. Historical reconstructions of famous ships, sea fights, old harbours, historical sea scenes, all from the age of sail. Studied: Camberwell School of Art and St. Martin's. At one time was technical illustrator of aircraft and author of aviation books. Exhib. RSMA from 1971 ('A freshening breeze: H.M. Brig *Fantome* and consort'). Special exhibitions of his marine paintings from 1973 in London, Sweden and the U.S.A. Travels extensively on research in Europe and U.S.A. Limited editions of prints of some of his pictures published in Sweden 1977, U.S.A. 1978 and U.K. 1979. Lives near Tunbridge Wells, Kent.
.............See COLOUR PLATE 7 and PLATES 56 & 57

CULL, Alma Burlton (1880-1931)
Oils. Marine subjects, particularly naval vessels. Exhib. RA, RI, RBSA and other galleries in London and provinces. Few of his pictures are seen nowadays and it is said many were destroyed in World War II. Two paintings at Nat. Maritime Museum: 'First Battle Cruiser Squadron' 17 x 32 ins. and '*King Edward* class battleships at sea' 30 x 66 ins. He was commissioned to paint ships by King Edward VII. Exhib. RA, RI, RSA, Liverpool, etc. His 1912 RA exhibit was 'Send out your big warships to watch your big waters' commissioned by H.R.H. the Prince of Wales. He died at Lee-on-Solent on 27th January, 1931......................See PLATES 58 & 59

CUNDALL, Charles Ernest, RA, RWS, RP, NS, NEAC, RSMA (1890-1971)
Oils and watercolours. Marine subjects, landscapes and portraits. Studied in Manchester, the Slade, Paris and Italy. Official war artist as Hon. Capt. R.M. 1940-45. 21 pictures in Imp. War Museum incl. oils: 'The withdrawal from Dunkirk, June 1940' 40 x 60 ins., 'H.M.S. *Exeter* at Plymouth in 1940' 36

x 52 ins., 'The German heavy cruiser *Admiral Scheer* at Kiel' 28 x 50 ins., 1945. Also 4 pictures at Nat. Maritime Museum. Exhib. RA, RHA, RSA, RWS, NEAC and many other galleries. Also exhib. RSMA inaugural exhib. 1946: 'From the submarine depot ship H.M.S. *Cyclops*'; and exhib. up to 1972 with (posthumous) oil: 'New York harbour'.....See PLATES 221 & 222

DADE, Ernest, NEAC (1868-c.1930s)
Oils and watercolours. Marine subjects. Had some seafaring experience and later studied in Paris. His work shows much talent but is not often encountered. One picture in Imp. War Museum: 'A convoy passing Whitby High Lights' from 1914-18 war, oil on canvas 30 x 50 ins. Lived in London at the end of the 19th century but returned to Scarborough (where he was educated) in 1889 to paint on that coast. Exhib. RA, RBA, RI, NEAC and provinces......................See PLATE 60

DALISON, Lt. Comdr. J.S., DSO, RN, RSMA (fl.1938-1948)
Oils and watercolours. Marine subjects. Exhib. Portsmouth 1938: 'Grey and Gold — H.M.S. *Cornwall*' and 'Trooping Home — H.M.S. *Lancashire*'. Two naval pictures in Imp. War Museum. Member RSMA 1946 and exhib. 4 pictures inaugural exhib. incl. oils 'U.S.S. *Augusta* bearing President Truman past Eddystone and H.M.S. *Renown*' and 'In Chinese waters'. 1948: oil 'Topsail weather, barque *Pamir*'. Lived at Weymouth.

DASHWOOD, J.H.
Watercolours. Marine subjects. Exhib. RSMA 1960 ('Seascape' and 'A breezy day, Dell Quay') and 1967 ('Outward Bound').

DAVIES, David (1864-c.1924)
Watercolours and some oils. Coastal, harbours, and landscapes. Born in Australia, studied art in Melbourne and Paris. Lived most of his life in England. Painted many seascapes and harbour scenes in Cornwall and northern France. Exhib. RA, ROI, NEAC, etc. Lived in Cornwall, Gloucestershire and London between 1898 and 1924.....................See PLATE 61

DAVIES, Colonel John Alfred, OBE, RSMA (b.1901)
Born 22nd April, 1901 in Ware, Dorset. Most media but mainly watercolours. Seascapes and ships; also landscapes, aircraft, book illustration, conversation pieces and cartoons. Studied: Heatherlys School of Art and privately. Exhib. RSMA from 1962 (watercolour 'Wind freshening, sea rising'). Also exhib. RA, RI, Wapping Group, Guild of Aviation Artists, etc. Silver medallist Paris Salon. Numerous one-man exhibitions and has pictures in public and private collections in U.K. and U.S.A. Seafaring experience as yachtsman in many parts of the world and ocean racing from 1933. Member Royal Ocean Racing Club. Lives near Colchester, Essex.

DAVIES, William
Oils. Coast and harbour subjects. Exhib. RSMA 1972 onwards; 1977 'Leigh evening'; 1978 'Venetian conversations'.

DAVIS, G.H., RSMA
Member of RSMA 1947-59. Lived in Brighton, Sussex.

DAVIS, Reginald (fl.1949-1952)
Watercolours. Coastal and harbour scenes. Exhib. RSMA 1949: 'Medway — at Maidstone', 1950: 'Below Gravesend', 1952: 'Maidstone' and 'The old harbour, Teignmouth'.

DAWSON, Montague, RSMA (1895-1973)
Oils and watercolours. Marine subjects. Well known for his pictures of sailing ships under full sail on blue seas. Many signed prints in successful limited editions. Pupil of Charles Napier Hemy whose influence may be seen in Dawson's work. His

father was a sea captain and his grandfather was Henry Dawson the 19th century artist. Served in the R.N. in World War I and also contributed 10 naval pictures to Imp. War Museum. His 'clipper ship' pictures achieved wide popularity and high prices from the 1970s onwards. Lived at Milford-on-Sea, Hampshire, for many years. Exhib. RA and RSMA, also Liverpool.
........See COLOUR PLATES 8 & 9 and PLATES 62 & 223

DAWSON, Nelson, ARWS, RBA, RE, RWA (1859-1941)
Watercolours, etching, charcoal, and pen and wash. Marine and coastal scenes, also landscapes. Used soft-ground etching process, giving impression of crayon. In the 1920s made a study of craft sailing from Appledore, N. Devon. Exhib. RA, RBA, RE, RI, RSA, RSW, RWS, etc. and provinces. Work in the British Museum and V. & A. Official war artist World War I with 61 pictures in Imp. War Museum (watercolours, charcoal, etc.) ranging from naval engagements to escort duties. Worked on metal artefacts with his wife Edith, and exhib. these at RA from 1895.............................See PLATE 224

DEACON, Charles Ernest, HRWS (fl.1940-1965)
Watercolours. Seascapes and landscapes. Exhib. at RSMA 1946 with two estuary scenes on the Dee; 1947 'Hauling up the net' and 1955 'Squall on the Jersey coast'. Also exhib. RA, RBA, RI, etc.

DEAKIN, Mrs. Elizabeth, SWA (b.1929)
Oils, watercolours, gouache, and acrylics. Seascapes, harbour scenes and landscapes. Studied: Poole School of Art, also under Edward Wesson. Served in the W.R.N.S. Teaches painting incl. seascapes. Exhib. RSMA 1974: 'Refit completed' and 'A day to remember'. Lives in Dorchester, Dorset.

DEAKINS, George Richard (fl.1950-1959)
Oils. Marine subjects. Exhib. at RSMA from 1950 ('Harbour scene, Tripoli') to 1952 ('The Wharf' and 'Sails') and up to 1959 ('Junks in converse').

DEAN, Ronald, RSMA (b.1929)
Born 16th August 1929 at Farnborough, Hampshire. Watercolours and bodycolour. Scenes with sailing ships from 1850 onwards. Self-taught and has had life-long interest in ships, particularly merchant sailing vessels. Exhib. RSMA from 1966 (oil 'A sunlit arrival, the four mast barque *Olivebank*'). Several one-man exhib. including Biarritz (1975), London (1977) and U.S.A. (late 1979). Lives at Tonbridge, Kent...See PLATE 63

DE BANKS, Dennis
Oils. Coast and harbour subjects. Exhib. RSMA 1973 ('Galmpton Creek'), 1976 and 1977 ('The Pool of London').

DE LACEY, Charles John (fl.1885-1920/30)
Best known as an oil painter of the tidal Thames in a somewhat similar style and composition to W.L. Wyllie. Studied in London. One-time press artist and special correspondent *Illustrated London News*. Official artist to Port of London Authority. Served R.N. Imp. War Museum has oil painting 'The *Vindictive* at Zeebrugge — the storming of Zeebrugge Mole' presented by the artist 1918. Exhib. RA, RBA, also Liverpool and Manchester............................See PLATE 225

DELMAR-MORGAN, Curtis (fl.1947-1948)
Watercolour painter. Exhib. RSMA 1946 'North Sea convoy'; 1947 'Mud berths' and 'Canvey Island'.

DE MARTINO, Eduardo (Commander) (1838-1912)
Oil painter of marine subjects just into the first years of the 20th century. Exhib. mainly at Fine Art Society. Work in Walker Art Gallery, Liverpool and Nat. Maritime Museum. Born at Meta

near Naples; educated at the Naples Naval College; served in the Italian Navy until 1867. Became a member of the Academy of Fine Arts of Rio, and painter at the court of the Emperor of Brazil, Dom Pedro II. Came to England in 1875, and lived for the rest of his life at St. John's Wood, London and Cowes, Isle of Wight, where he used to stay with King Edward on the Royal Yachts. At one time Marine Painter-in-Ordinary to H.M. Queen Victoria.

DENHAM, Henry James, RSMA, SGA (1893-c.1961)
Oils and watercolours. Marine subjects. Exhib. 'In the Pool' and 'Sailing barges at Strood' in RSMA 1947 and thereafter until 1962 (4 posthumous watercolours incl. 'The crowded harbour, Brixham'). Exhib. RA, RI, and provinces. Member of the Wapping Group.

DENNIS, Miss Ada L. (fl.1891-1934)
Oils. Marine subjects also landscapes and portraits. Exhib. RA, RCA, RI, ROI, RBA, etc. Lived in Bishops Stortford, Hertfordshire.

DENTON, Kenneth, RSMA, FBID (b.1932)
Born 20th August, 1932 in Chatham, Kent. Oils. Sailing craft, coastal scenes, harbours, beach scenes and landscapes. Uses the subject as a focal point around which to explore the atmospheric potential of light and the prevailing weather conditions. Studied: Rochester School of Art, Medway College of Art, and privately with David Mead. Has travelled widely in British Isles and to continental ports in search of material. Exhib. RSMA from 1968. Eleven one-man exhibitions between 1967 and 1979 in U.K. and U.S.A. Lives at Kings Lynn, Norfolk.
. See PLATE 64

DESROCHERS, Michel
Oils and watercolours. Coast subjects. Exhib. RSMA 1970, 1971 and 1972 (watercolours 'Winch at Aldeburgh' and 'The Orange boat'). One picture in Nat. Maritime Museum 'Midday at Dunwich'.

DESOUTTER, Roger Charles, FRSA (b.1923)
Oils. Sailing ships, coastal scenes and estuaries, also landscapes (especially snow scenes). Life-long yachtsman, and boat owner since 1962. From 1942-45 was an engineer on staff of Sir Frank Whittle, engaged in design and testing of the first jet engines. Now Chairman of the Desoutter Engineering Company (1980). Exhib. RSMA from 1974 ('H.M. frigate *Lively*') and also Soc. of Aviation Artists from 1955. Works shown in many London and provincial galleries. Lives at Beaconsfield, Buckinghamshire.
. See COLOUR PLATE 10 and PLATE 65

DEVLIN, May (Mrs. A.F. Dale) (fl.1920-1936)
Watercolours. Coastal subjects and seascapes, also landscapes. Scottish artist. Exhib. RSA, RSW, GI, etc.

DEWS, John Steven (b.1949)
Oils and some watercolours. Marine subjects, particularly merchant and naval sailing vessels. Studied: Hull Regional College of Art. Has raced and cruised extensively along north-east coast of Britain in yachts up to 40 ft., also as Watch Officer on STS '*Sir Winston Churchill*', etc. Comes from a seafaring family with a sea history dating back to the 17th century. Several one-man exhibitions incl. James Starkey Galleries, N. Humberside, 1976, and Amoco Heritage Collection of Fine Marine Paintings, 1980, at Broadlands, Romsey, and Guildhall, Portsmouth. Work in San Francisco Maritime Museum and other Californian galleries. Lives near Beverley, North Humberside. See PLATE 66

DIXEY, Frederick Charles (fl.1877-1914)
Oils and watercolours. Marine subjects. Exhib. RA, RI, RBA, and New Watercolour Society.

DIXON, Charles, RI (1872-1934)
Oils and watercolours. Marine subjects. At one time neglected but now acclaimed as an outstanding early 20th c. artist, especially in watercolour. His Thames estuary scenes with steam and sail are particularly admired. Three major exhibitions of his work were held in 1973, which re-established his status. Exhib. RA, RI, ROI, etc. Experienced small boat sailor. Lived at Itchenor, near Chichester, Sussex.
. See COLOUR PLATE 11 and PLATE 67

DIXON, Marion
Oils. Coast and harbour subjects. Exhib. RSMA 1957 ('Land's End' and 'In a Cornish harbour'), 1959 and 1960.

DOBBS, Honor (b.1903)
Oils, watercolours and etching. Seascapes, subjects related to sea and river, and landscapes. Studied Beckenham Adult Centre of Arts and Crafts. Exhib. RSMA 1979: etching 'John Duffy'. Also exhib. RA, ROI, RI, Festival Hall, etc. One-woman exhibitions at Blackheath, 1979, and Bromley Arts Council, 1980. Lives at Chislehurst, Kent. See PLATE 68

DOBNEY, Winifred Medley
Oils and watercolours. Coastal scenes. Exhib. RSMA 1957 (watercolour 'Pembrokeshire coast'), 1958 and 1959.

DODD, Francis, RA, RWS, NEAC (1874-1949)
Oils and watercolours. Official war artist in both World Wars I and II and as such he painted many naval subjects and portraits of distinguished sailors. Nearly 200 of his pictures are at the Imp. War Museum, mainly from World War I and ranging over such subjects as 'The Engine Room, H.M. Trawler *Mackenzie*', 'The Bridge at Night, M.L.102', 'Gun's crew in action. H.M. Submarine L.3', etc., plus portraits of naval officers and some army. Mostly executed in charcoal and watercolour, pencil and wash. (Six 2nd World War subjects in Imp. War Museum are non-marine.) Better known for landscapes, portraits and narrative pictures. Exhib. RA, RSA, RSW, RWS, NEAC, Liverpool, Manchester and other leading galleries.
. See PLATE 226

DOLBY, James Taylor, RE, ARCA (fl.1930-1969)
Oils (also etching). Marine subjects in abstract. Served R.N. in World War II. Keen yachtsman. Exhib. RA, RBA, RE, etc.

DOUGLAS, Sholto Johnstone (1872-1958)
Lieut. R.N.V.R. in World War I, later specially employed as war artist. Imp. War Museum has 52 of his pictures in oils, watercolours, black chalk and pencil of which the subjects are mainly Merchant Navy ships, plus 4 portrait studies. Exhib. RA, RSA, NEAC, Liverpool, Glasgow, etc. . . . See PLATE 227

DOW, Alexander Brian Roderick (b.1918)
Oils, watercolours and acrylics. Seascapes, landscapes, figures and portraits. Studied: Brighton College of Art. Regular exhib. at Royal West of England Academy also exhib. RSMA. Lives in Bristol. See PLATE 69

DOYLE, Bentinck Cavendish (fl.1885-1928)
Oils and watercolours. Marine subjects (also flowers). Studied London and Paris. Exhib. RA, ROI, etc. Lived in Worthing from 1916.

DREW, Pamela, RSMA, SAvA, BIS (b.1910)
Born 11th September 1910 in Burnley, Lancs. Oils, also pastels

and chalks. In her marine work she has specialised in deck scenes (derricks, funnels, lifeboats) and shipbuilding. Studied: privately, also Grosvenor School of Modern Art and with Roger Chastel in Paris. Official artist for R.A.F. 1953-59. Pictures in several public collections including Belfast Municipal Gallery, Imp. War Museum, Port of London Authority, Nat. Maritime Museum, and R.A.F. Museum, Hendon. Exhibitor ROI and RBA. Lives in County Cork, Eire. Exhib. inaugural exhib. of RSMA 1946 oils 'Fleet Air Arm exercising' and 'Fitting out jetty' and frequent exhibitor thereafter. 1967: 'Arrival of Sir Francis Chichester in *Gipsy Moth* IV through Tower Bridge 7th July' lent by P.L.A.

DRING, William, RA, RWS, RP (b.1904)
Oils and watercolours. Portraits and landscapes. Specially employed as war artist to Admiralty and Air Ministry 1941-45. Over 90 pictures in Imp. War Museum, mainly portraits of sailors from Able Seamen to Naval Officers. Exhib. RA, RWS, RSA, NEAC, etc. See PLATE 228

DUCKWORTH, Captain Arthur D. (RN)
Watercolours. Coastal subjects. Exhib. RSMA 1954 (4 watercolours incl. 'Approaching storm, Kylesku') until 1969 (Eigg and Rhum, from Morar').

EARLAND, Harry T.
Watercolours. Marine subjects. Exhib. RSMA in 1960, 1961 and 1963.

EDWARD, Alfred S., RBA (1852-1915)
Oils. Seascapes and coastal subjects. Exhib. mainly in 19th century but also worked into early 20th. Exhib. RA, RHA, RBA, ROI, RSA, etc.

ELLIOTT, Aileen Mary, RSMA, NS, WIAC (1896-1966) (Mrs. H. Beale)
Oils and watercolours, also etcher. Marine subjects. Exhib. 4 pictures in inaugural exhib. RSMA 1946 incl. 'Reconversion H.M.S. *Leonian*' and 'Quayside, Poole'. Exhib. RA, RBA, RSA, SWA, and RSMA up to 1967 (posthumous exhib.).

ELLIS (Vic) Victor William, DSM, RSMA (b.1921)
Born 17th October, 1921 in Canvey Island, Essex. Oils. All types of shipping, past and present, and all types of smaller craft, sail and power, but particularly East coast types and smacks, barges, yachts, tugs, coasters, etc. Self-taught and has painted from the age of 10 years. As a native of Canvey Island has been involved with the River Thames from an early age. Lifelong experience in sailing dinghies and small yachts. Served R.N. 1939-45 including Atlantic convoys. Awarded D.S.M. 1945. Member of Wapping Group and Armed Forces Art Society. Lives at Leigh-on-Sea. See PLATE 70

ELPHINSTONE, Archibald Howard, RBA (1865-1936)
Oils. Marine subjects and landscapes. Exhib. RA, RBA, ROI, etc.

EMANUEL, Frank L., RSMA, PSGA (1865-1948)
Oils and watercolours, also etcher. Marine subjects and landscapes. Studied at the Slade and in Paris. Exhibited RA, Paris Salon, RSMA and SGA. (At one time President SGA). Examples of exhibits at RSMA incl. 'French smacks in a breeze' 1946; and 'An Iceland Fisherman at Paimpol' 1947. Council member RSMA until 1947. His last picture for the 1948 RSMA exhibition was finished on his 83rd birthday; it was entitled 'A stiff breeze'.

ENTWHISTLE, Brian Richard (b.1939)
Oils, watercolours and gouache. Marine subjects (which usually include a ship or small craft) ranging from deep sea sail to motor vessels of the 1950s. Also railway subjects incl. steam of the 1950s. Studied Liverpool College of Art, also 12 years as illustrator and visualiser. Owns a 20-ft. ketch and also goes to sea on coasters, tugs, schooners, etc. Exhib. RSMA from 1974, also Oldham Art Gallery, Boydell Gallery, Liverpool, Parker Gallery, London, etc. Work commissioned by shipping companies in U.K. and overseas. Would like to see more artists painting everyday working craft. Lives at Rhosneigr, Anglesey. See PLATE 71

ETTERIDGE, Douglas
Watercolours. Marine subjects. Exhib. RSMA 1952: 'Trafalgar graving dock, Southampton' and 1954: 'Boats at Leigh'.

EURICH, Richard Ernst, RA, Hon. RSMA, Hon. NEAC (b.1903)
Born 14th March, 1903 in Bradford. Oils and watercolours. Seascapes of all kinds, also landscapes, figure subjects, still life and some portraits. Studied: Bradford School of Arts and Crafts and Slade, London, but says that he is self-taught where painting is concerned. Has painted the sea and ships from the age of 5 onwards. Official War Artist to the Admiralty 1939-45 with rank of Hon. Capt. Royal Marines. Numerous one-man exhibitions in London at the Redfern Gallery, the Fine Art Society, and Arthur Tooth and Sons. Retrospective exhibitions Bradford City Art Gallery, 1951 and again 1979 and also London and Southampton 1980. Work in many public collections incl. Tate Gallery, Imp. War Museum, Nat. Maritime Museum, Museum of Modern Art, New York, etc. Exhib. RA from 1937 (elected RA 1953). Also exhib. NEAC, RSMA, Manchester, Liverpool, etc. Lives at Dibden Purlieu, Southampton. See COLOUR PLATE 12 and PLATES 72, 73 & 229

EVANS, Ray, RI, ARCA (b.1920)
Watercolours. Coastal and harbour subjects, etc., and landscapes. Exhib. RSMA 1968 to 1974 ('Naval vessels, Portsmouth' and 'Low tide, Jersey').

EVERETT, John (1876-1949)
Oils, watercolours, gouache and wash drawings, and etching. Marine subjects, seascapes, ships and coastal scenes, also landscapes. Studied at the Slade, with Augustus John and Orpen who became his friends. There are over 1,700 oil paintings and a larger number of drawings and engravings by this artist in the permanent collection at the National Maritime Museum, Greenwich, where a memorial exhibition of his work was held in 1964. Most of these paintings resulted from his many deep-sea voyages, the first of which was in 1898. Specimen titles incl: 'A galleon at sea', 'A cable-laying ship', 'A ship in the docks', 'Yachting at Cowes, c.1910' together with seascapes, coastal scenes etc. Started etching in the 1920s. Exhibitor at the RSA, NEAC and other London and provincial galleries. Works in the permanent collection of the Walker Art Gallery, Liverpool. Lived at Wool and Corfe Castle, Dorset, at the beginning of the century and later in London. Made many sea voyages, during which he sketched and painted, and also owned a 9-ton cutter named *Walrus*. See PLATES 74 & 75

EVERETT, R.A.L.
Oils. Harbour and coastal subjects. Exhib. RSMA 1964 ('Poole from Brownsea') and 1967 and 1969 ('Low tide').

EVES, Reginald G., RA, RI, ROI, RP (1876-1941)
Slade scholar. Mainly known for portraits, landscapes and

architectural subjects. Painted a number of portraits of naval personnel, e.g., 'The late Earl Jellicoe' exhib. at Portsmouth 1938. Specially employed as war artist in 1940 (18 portraits in Imp. War Museum, all military).

FAIRMAN, Sheila M., ARMS (b.1924)
Oils, watercolours, gouache (also pencil). Marine still life subjects, e.g., sea shells, seabird feathers, fish, shell fish, etc., also seascapes, miniatures and portraits. Studied Southend-on-Sea College of Art 1935-40. Exhibitor RSMA from 1971, also RA, RP, RMS, ROI, RI. Lives at Leigh-on-Sea, Essex.

FALCONER, Miss Agnes Trotter (fl.1916-1940)
Scottish painter, also lithographer and art lecturer. Marine subjects and landscapes. Lived Edinburgh. Exhib. RSA, RSBA, GI, Liverpool, etc.

FANNER, Miss Alice Maud (Mrs. Taite) (1865-1930)
Oils and watercolours. Marine subjects and landscapes. One time pupil of Julius Olsson. Exhib. RA, RBA, RCA, RHA, ROI, RSA, SWA, etc. Lived at Burnham-on-Crouch from 1914.

FELL, David (b.1927)
Oils, watercolours, gouache and acrylics. Harbour scenes, old buildings, landscapes and some portraits. Studied: Bradford College of Art 1948-51. Worked for several years as a graphic designer. Has developed a special watercolour technique he calls 'Waterline'. As a Yorkshireman, he has a deep love of the sea and has painted many views of Whitby harbour and its numerous vessels. Exhib. RSMA (1979 watercolour: 'Buildings and Boats'). Also exhib. RI, RBA, Britain in Watercolour, etc. 14 one-man exhibitions between 1971 and 1978, plus 2 two-man shows and one 3-man show, covering Bradford, Leeds, Batley, Huddersfield, Halifax, York, Oldham, Eccles, Bolton, Accrington, Amsterdam, etc. Work in permanent collections at Oldham, Halifax, British Embassy, Amsterdam, and private collections in U.S.A., Canada, Australia, Sweden, Holland, etc. Lives in Bradford, Yorkshire. See PLATE 76

FETERIDGE, J.F. (fl. First World War)
His painting 'Battle of Jutland 1.6.1916' is at the National Maritime Museum.

FILKE, A.W.
Painting in Nat. Maritime Museum 'Sinking of the *Bismarck* 27 May 1941' 20 x 27 ins.

FINKILL, Stanley, FSAI (b.1929)
Indian ink and pastel. Boatyards, small harbours, perspectives for architectural practice, landscapes, etc. Studied at Mechelan, Belgium, and Wiesbaden, W. Germany. Influenced by work of Aubrey Phillips. Exhib. at RSMA from 1977, also Soc. of Architectural Illustrators, and Manchester Graphic Club Centenary Exhib. 1977. Numerous one-man exhibitions in Manchester and other provincial centres. Work in collections of many large companies and privately both in Europe and N. America. Lives near Manchester, Lancashire. . . See PLATE 77

FINN, Herbert John (fl.1885-1930)
Oils and watercolours, also etcher. Marine subjects and landscapes. Studied London, Antwerp and Paris. Exhib. RA, RSBA, GI, RBA, etc.

FISHER, Roger, CBE, DSC, FRSA, Capt. RN (Retd.) (b.1919)
Oils. All nautical subjects with particular reference to the contemporary scene. Thirty-seven years service in the R.N. Still sails regularly in H.M. ships, fishing vessels, yachts, etc. Exhib.

RSMA from 1974, also Armed Forces Art Soc., Wapping Group, etc. Commissioned by Admiralty and Trinity House for paintings of Silver Jubilee Fleet Review, also by shipping companies and private collectors. Lives at Blackheath, London.
. See PLATES 78 & 79

FISHER, Rowland, ROI, RSMA (1885-1969)
Oils and watercolours. Marine and landscape subjects. Exhib. inaugural ex. RSMA 1946 4 pictures incl. 'S.E. gale, Mevagissey' and 'Drifters at Lowestoft' and exhib. thereafter up to 1969. Also exhib. RA and ROI. Lived at Gorlston, Gt. Yarmouth.

FLANDERS, Dennis, ARWS, RBA (b.1915)
Watercolours, also etcher. Coast and harbour scenes, landscapes, etc. Exhib. RSMA 1964, 1968, 1969 ('Dieppe'). Also exhib. RA, RWS, RBA, etc.

FLEMMING, Anthony (b.1936)
Oils and watercolours. Sailing ships, yachts, landscapes and buildings. Studied at Goldsmith's College, London. Has been sailing from the age of 8 in dinghies and cruising yachts; off-shore racing as skipper and watch-keeper, incl. Fastnet; and extensive cruising in own yacht to Scotland, Holland, Britanny, etc., as well as having expertise in Thames barges. Exhib. RSMA from 1978 and work shown regularly in Wimbledon and Rochester galleries. Feels that too few marine painters actually go to sea. Lives in Blackheath, London. See PLATE 80

FLETCHER, Edward (1857-1945)
Oils. Marine subjects, particularly Thames estuary scenes reminiscent of W.L. Wyllie. Incorrectly but frequently referred to as 'Edwin' Fletcher. Studied Chelsea Art School. Sometimes painted under the name of JOHN HAYES. Prolific artist but did not exhibit. Lived at Blackheath, Thames Ditton, Winchelsea (Rye) and Tilehurst, Sussex.

FLINT, Francis Murray Russell, RWS, RSW, ROI, RSMA (1915-1976)
Oils and watercolours. Coastal and marine subjects and landscapes. Lieut. R.N.V.R. World War II; 2 oils of Rocket Ships attacking off Walcheren, 1945, in Imp. War Museum. Exhib. 2 watercolours in RSMA 1947: 'Gale warning, returning fishing boats' and 'Autumn storm' and thereafter until 1976. Also exhib. RA, RWS, etc. and provinces. Son of Sir William Russell Flint, RA, PRWS.

FLINT, Robert Purves, RWS, ARWS (1883-1947)
Oils and watercolours, also etcher. Coastal subjects and landscapes. Brother of Sir W. Russell Flint. Exhib. RA, RHA, RSA, RSW, RWS, GI, RBSA, etc. Lived Edinburgh and Whitstable.

FORBES, Stanhope Alexander, RA, NEAC (1857-1947)
Oils. Coastal and harbour scenes, also landscapes, rural narrative pictures, etc. Studied in London and Paris. Founder of the Newlyn School. In Imp. War Museum: 'W.R.N.S. ratings sail-making on board H.M.S. *Essex* at Devonport 1918' oil on canvas 42 x 54 ins. Exhib. RA, RBA, RHA, ROI, RWS, NEAC and provinces. Regarded for many years as 'the grand old man of Cornish painting'. Founder member of the NEAC. His picture 'A street in Britany' was shown amongst the Post-Impressionists in the famous exhibition at the RA in 1980.

FORD, Leslie (1885-1959)
Watercolours. Marine subjects, mainly coastal and estuary. Member of Wapping Group and Langham Sketching Club. Exhib. RSMA from 1947 ('The Thames from Tunnel Pier' and 'Gateway to London' watercolours) and thereafter until 1958.

FORTY, Frank
Oils and watercolours. Marine subjects. Exhib. RSMA 1968, 1971 and 1972 (watercolour 'The Helmsman').

FOSTER, Deryck, RSMA (b.1924)
Born 1st March, 1924, in Bournemouth, Hampshire. Oils. Marine subjects, especially historical sailing vessels of all kinds. Studied: Southern School of Art, Bournemouth, and Central School of Art, London. Seafaring experience includes off-shore racing, cruising, dinghy sailing and sail training ships; also crew member for 4 years Yarmouth, I.o.W., lifeboat. Exhib. RSMA since 1957. Several one-man exhibs. in Bermuda since 1971. Work in permanent collections Russell Cotes Museum, Bournemouth, Nat. Maritime Museum, and Nat. Trust, Bermuda. Lives in Bermuda for most of year, but also has a studio in Yarmouth, Isle of Wight.
...See COLOUR PLATE 13, PLATE 81 and BACK COVER

FRASER, John, RBA (fl.1880-1927)
Oils and watercolours. Seascapes, ships, coastal subjects and some landscapes. Nearly 50 of his pictures are in the Nat. Maritime Museum, e.g., 'Lifeboat about 1920' 20 x 30 ins.; 'A tea clipper' 18 x 31 ins. and a number showing fishing boats, coast scenes, yachts, pure sea, etc. Exhib. RA, RBA, RI, ROI, RSA, RBSA and other leading galleries.

FRASER, Robert Macdonald (fl.1910-1938)
Oils. Coastal subjects and landscapes. Liverpool artist. Exhib. RA, RCA, Manchester and Liverpool.

FREEDMAN, Barnett, CBE (1901-1958)
Portrait and landscape painter. Specially appointed war artist with rank Hon. Capt. R.M. 1940-44. Went to sea in H.M.S. *Repulse* and in submarines, also recorded landings in Normandy at Arromanches 1944. Exhibitor NEAC and other London galleries. Twenty pictures at Imp. War Museum, mainly military but 3 naval.

FREEMAN, Peter H.
Watercolours. Coast and harbour subjects. Exhib. RSMA from 1970 ('Polperro harbour' and 'Port Isaac, Cornwall') to 1978 (3 watercolours).

FREER, H. Branston (fl.1905-1915)
Watercolours. Tidal Thames, coastal scenes and harbours. Lived near the Thames estuary at Rochester, Gravesend, and Blackheath between 1905 and 1914. Exhib. RA, RBSA, and Liverpool.................................See PLATE 82

FRIEDENSON, Arthur A. (1872-1955)
Oils. Coastal subjects and landscapes. Exhib. RA, ROI, RSA, NEAC, RBSA, GI, Liverpool, Manchester, etc. Lived in Yorkshire and Dorset.

FRIEND, Frank A.
Oils and watercolours. Marine subjects. Exhib. RSMA from 1957 (oil '*Clan Macfarlane* in heavy weather') until 1975 (2 oils 'Cunard *Samaria* 1920s' and 'Merlin Rocket, off Shoreham').

FROOME, Mrs. Daphne Alma
Oils. Coastal views and rock studies. Exhib. RSMA from 1974. Also writer of short stories. Lives and paints for part of the time on the North Cornish coast. Also lives at Hampton, Middlesex.
.....................................See PLATE 83

FROOME, Dr. Peter Kenneth Davy (b.1949)
Oils. Variety of marine subjects with special interest in trading schooners and ketches, also paints animals incl. cats in marine settings. Exhib. RSMA (1979: 'Ship's Cat'). Also exhib. Richmond Arts Council Jubilee Exhibition. Lives at Gravesend, Kent.................................See PLATE 84

FRUIN, Gerald Henry (Gerry) (b.1931)
Oils, watercolours, gouache and acrylics. Marine subjects, particularly modern scenes, e.g., hovercraft. Studied at Harrow College of Art 1945-49. Associate Member of Guild of Aviation Artists. Also commercial artist and illustrator. One-man exhibs. in Tring, Dunstable, Luton, etc. Exhib. RSMA 1978: oil 'Past Days'. Lives at Luton, Bedfordshire..........See PLATE 85

FRY, William Arthur (fl.1919-1931)
Oils. Marine subjects, landscapes and portraits. Exhib. RHA, etc. Lived N. Ireland.

FRYER, Wilfred Moody, RI, RSMA (1891-1967)
Oils and watercolours. Marine subjects, also landscapes. Exhib. RSMA from 1947 ('Thames side, Shadwell') and thereafter up to 1968 (4 pictures posthumously incl. 'Boat sheds, Isle of Wight' and 'Beach at Hastings'). Also exhib. RA, RBA, and provinces.

FURSE, Roger Kemble (b.1903)
Signaller R.N. World War II. Two pictures in Imp. War Museum: watercolour 'The Flag Deck H.M.S. *Nigeria*' and wash 'A sailor with his model yacht' both 1941.
.....................................See PLATE 230

GAMLEY, Andrew Archer, RSW (fl.1896-1949)
Oils and watercolours. Coastal subjects and landscapes. Scottish artist. Carnegie scholarship. Exhib. RA, RSA, RSW, GI, Liverpool, etc.

GARDINER, Frank Joseph Henry (b.1942)
Oils and watercolours. Ship portraits, sailing ships and harbour scenes, mostly historical. Studied art and architecture for 3 years at Lister Technical College. Exhib. RSMA from 1971. Professional illustrator working on archaeological sites and ancient monuments for Dept. of Environment. Watercolour artist for the Parker Gallery, London. Pictures commissioned by the P.L.A. Lives at Walton-on-Naze, Essex.
.....................................See PLATES 86 & 87

GARDNER, Derek George Montague, VRD, RSMA
Born 13th February, 1914. Oils and watercolours. 18th and 19th century ships, particularly historic sailing ships and naval actions. Sometimes paints 20th century ships and coastal scenes. Originally trained as a chartered civil engineer and became a Fellow of the Institute of Civil Engineers. Entirely self-taught as an artist. First exhibited with Kenya Art Society 1948 and with the RSMA from 1958. Seafaring experience with the R.N.V.R. from 1934. War service in the R.N. including Atlantic and Arctic convoys in destroyers. Left R.N. as a Commander in 1947. Carries out considerable research for his paintings of sailing ships. His pictures are in many private collections in the U.K. and U.S.A. and he has had several one-man exhibitions in London. Lives at Corfe Mullen in Dorset.
........See COLOUR PLATE 15, *Frontispiece* and PLATE 88

GELLER, William Jasper, SGA (b.1930)
Watercolours, gouache, egg tempera, also pen and ink. Fishing, working and estuary craft; sailing barges and yachts; harbours at low water; and landscapes. Studied in a 5 year apprenticeship, Day Release Central Schools, St. Brides, and Regent Street Polytechnic. Dinghy sailor East coast. Exhib. RSMA from 1958 also FBA touring exhibitions. Council member SGA. Work in private collections. Lives at Epping, Essex.
.....................................See PLATES 89 & 90

GIBBS, Snow (1882-c.1970)
Mainly landscape and portraits, but also painted some water-

colours of Thames estuary and coastal scenes. Exhib. RSMA 1951 and 1952 ('Evening, Thames estuary' and 'Rising tide, Woodbridge, Suffolk') and in 1954. Also exhib. ROI, RI, RCA, etc.

GILCHRIST, Philip Thomson, RBA (1865-1956)
Oils. Marine subjects and landscapes. Lancashire artist. Exhib. RA, RBA, RHA, RSA, RBSA, GI, Manchester and Liverpool.

GILMAN, Peter (b.1928)
Oils, watercolours, gouache and acrylics. Marine subjects, shorelines and landscapes. Member of the Wapping Group. Exhib. RSMA from 1971 also numerous provincial centres. Work in permanent collection Norfolk Art Centre, Buxton Mill, Norwich. Lives near Baldock, Hertfordshire.

GINNER, Charles, ARA, RWS, NEAC (1878-1952)
Oils and watercolours. Landscapes, wood engravings and some coastal scenes. Specially commissioned for a number of paintings in World War II from 1941 to 1945, 3 of which (oils) are in the Imperial War Museum including 'Building a battleship'. Founder member of the London Group and the Camden Town Group. He was a close friend of Spencer Gore and Harold Gilman and they proclaimed themselves as 'Neo-Realists'. Three works by this artist were in the 'Post-Impressionism' Exhibition at the Royal Academy, 1980. Exhib. ROI, RSW, RWS, NEAC, and many other leading galleries.
. .See PLATE 231

GLANVILLE, Roy, RSMA (fl.1950-1966)
Oils. Marine subjects. Exhib. RSMA from 1951 ('Gathering Storm' and 'Offshore Racing') and thereafter until 1966. Member RSMA from 1955. Lived in London.

GLASS, William Mervyn, RSA (1885-1965)
Oils. Coastal subjects and landscapes. Scottish artist and at one time President of Soc. of Scottish Artists. Exhib. RA, RSA, GI, Liverpool, etc.

GLEESON, Daniel, NDD, ATC, ATD, ADB(Ed.), FRSA
Oils, watercolours, gouache and acrylics. Harbour and coastal scenes, especially those calling for the detail of fishing vessels; also landscapes and industrial archaeology. Studied at South Shields, Manchester and Plymouth Art Schools. Pupil of Charles Napier Hemy's grandson. Exhib. RSMA since 1977 ('Low tide, Middle harbour, Whitehaven'), also Birmingham, Harrogate, Manchester, Rochdale, Salford, etc. Seven one-man exhibitions. Work in permanent exhibitions at Salford University, Lancs. County Council, Stockport, etc. Member of Guild of Master Craftsmen. General Secretary, National Soc. of Art Education, 1979. Lives in Rochdale, Lancashire.

GLOVER, Sybil Mullen, RI, RWA, RSMA
Watercolours. All types of seascapes, coastal and beach scenes, also architectural subjects and especially those with naval traditions. Studied privately and at St. Martin's School of Art, London. Exhib. RA, RSA, NEAC, ROI, etc., and in the U.S.A. and Sweden. Gold and Silver Medallist, Paris Salon. Elected first woman council member of the Royal Inst. of Painters in Watercolours. Work in several public collections incl. Plymouth City Gallery, Brighton Art Gallery, Sweyne School, the R.W.A. and the Mansion House at Cardiff. Several one-man exhibitions incl. Royal West of England Academy, 1977. Lives near Plymouth, Devon.See PLATE 91

GODWIN, Ronald James
Watercolours. Marine subjects. Exhib. RSMA 1970, 1971 ('The Tug') and 1973.

GOODWIN, Albert, RWS (1845-1932)
Watercolours and some oils. Although thought of as a landscape artist, he also produced many fine atmospheric coastal scenes. Friend of John Ruskin and a pupil of Ford Maddox Brown. His work has become greatly appreciated since the early 1970s. Uncle of Sidney Goodwin (q.v.). Exhib. RA, RBA, RWS, RBSA, Liverpool, Manchester, etc. Lived in Devon and Sussex.

GOODWIN, Robin (fl.1948-1952)
Oils. Marine subjects. Exhib. RSMA from 1948 ('Great Belt Fishermen' and 'Moderate to Fresh') to 1952 ('St. Peters Port' and 'Sea Urchin').

GOODWIN, Sidney (1867-1944)
Watercolours. Coastal and harbour scenes and landscapes. Prolific artist who produced numerous coastal and harbour scenes, many on the south coast incl. Portsmouth and Southampton, and some sailing ships. Nephew of Albert Goodwin. Lived at Southampton for some years. Some of his work is of very high quality. Exhib. RHA.See PLATE 92

GORDON, Jan (Godfrey Jervis) (1882-1944)
Lieut. R.N.V.R. Four oils c.1916 in Imp. War Museum showing naval wounded in different situations. Mainly a figure and landscape painter. Exhib. RA, RBA, RI, ROI, NEAC, etc.

GOULD, Alec Carruthers, RBA, RWA (1870-1948)
Oils and watercolours. Marine subjects and landscapes. Exhib. RA, RBA, RI, ROI, NEAC, RBSA, GI, Liverpool, Manchester, etc. Lived in London, Essex and Somerset.

GOURLEY, Alan Stenhouse, PROI, DA(Edin.) (b.1909)
Oils. Coastal subjects, landscapes, etc. Exhib. RSMA 1976, 1977, 1978, 1979 ('Hoo Marina'). Also exhib. ROI and many London galleries. Studied Glasgow, Edinburgh and also Paris and the Slade. Work in private and permanent collections in U.K. and overseas.

GOWEN, Aline E. (fl.1949-1964)
Watercolours. Coastal and harbour scenes. Exhib. RSMA 1949 'Up for a scrub at Wivenhoe, Essex' and 'A misty morning, Portnavas, Cornwall' and then up to 1964 'Barges on the mud'.

GRAHN, John W.
Oils and watercolours. Marine subjects. Exhib. RSMA from 1966 (oil: 'The boat menders') to 1979 (2 watercolours).

GRANT, Kenneth (b.1934)
Oils and watercolours. Sailing ships of the 19th century, harbour scenes, ships at sea, and naval actions. Sailing experience in dinghies and Thames barges. Comes from a seafaring family (father served in British Merchant Navy for 35 years). Has been drawing and painting sail from an early age. Exhib. RSMA from 1965. Work shown in galleries in Colchester, Croydon and London. Lives at Upminster, Essex.See PLATE 93

GRAY, Elizabeth
Oils and watercolours. Coastal marine subjects. Exhib. RSMA from 1968 to 1971 (oil 'Green sea to Ben Nevis') and up to 1974.

GRAY, Stuart Ian, NS, UA (b.1925)
Watercolours. Marine subjects, also landscapes and wood pictures. Served as Air-Gunner Coastal Command, R.A.F. Started painting in 1966. Exhib. RSMA, RI, FBA, NS, UA, etc., and private galleries. Council member NS from 1978. Lives at East Croydon, Surrey.See PLATE 94

GREGORY, George (1849-1938)
Oils and watercolours. Sailing ships, old wooden hulks from the Napoleonic wars, battleships, harbour and coastal scenes, also

landscapes and some continental town scenes. Born and lived in the Isle of Wight, where he died. Painted scenes in the Solent, Southampton, Portsmouth, etc., and sometimes travelled to the Continent where he painted in Germany, Holland, Belgium and northern France. Son of Charles Gregory of Cowes, I.o.W., a well-known marine artist. His work is fully described in *British 19th Century Marine Painting* as he was most active in the 19th century, but he also continued painting up to the 1930s. Has achieved considerable recognition since the publication of the above book, although he did not exhibit in London or elsewhere. The quality of his work is generally high and an excellent example of one of his oil paintings is in the Royal Thames Yacht Club, London. See PLATES 95 & 96

GREIG, Donald, RSMA, FRSA (b.1916)
Born 16th March, 1916. Son of Scottish artist James Greig. Oils and watercolours, also etching. Seascapes and landscapes. Studied: Southend College of Art. In his early years he was inspired by the atmosphere of the coast at old Leigh-on-Sea with its cockle sheds and barges. Awarded Gold Medal, Paris Salon 1966 for 3 watercolours. Exhib. RSMA from 1964. Also exhib. RA, ROI, RBA, RWA and NEAC. Work is in several public and private collections in U.K. and abroad. Lives at Kingsbridge, South Devon. See PLATE 97

GRIBBLE, Bernard Finegan, RBC, RSMA (1873-1962)
Oils and watercolours. Marine subjects. Council member and exhib. RSMA: examples of exhibits incl. 'H.M.S. *Broke* ramming the boom at Algiers harbour Nov. 8th 1942' (1946); 'Hudson in the *Half Moon* crossing the Atlantic' (1947); 'The foc's'le gun in action, H.M.S. *Champion*' (1948). Also exhib. RA, RI, ROI, RHA, RBSA, GI, Paris Salon, etc. He was Painter to the Worshipful Company of Shipwrights. Present at the surrender of the German Fleet and at their sinking at Scapa Flow. A number of his works are in the permanent collection at the Poole Maritime Museum, Dorset. Also work in the Nat. Maritime Museum. Lived at Parkstone, Dorset.

GRIER, Louis Monro, RBA (1864-1920)
Oils. Marine subjects and landscapes. Exhib. RA, RBA, RHA, ROI, RBSA, GI, etc. Lived at St. Ives, Cornwall.

GRIFFIN, David
Oils and watercolours. Marine subjects. Exhib. RSMA 1972, 1973 (oil 'S.T.A. Schooner *Sir Winston Churchill*'), 1974, 1975.

GRIFFIN, Frederick, ROI, NS, SGA (b.1906)
Oils. Coastal subjects, landscapes, etc. Exhib. RSMA 1964 to 1975 ('Quay and Lighthouse'). Also exhib. RA, RBA, ROI, NEAC, etc.

GROVES, John Michael, RSMA (b.1937)
Born 9th March 1937. Oils, also pastels. A wide range of marine subjects including: naval battles, sail and steam, merchant ships, trawlers, square riggers, life aloft and on deck, colliers unloading, shipwrecks, etc. Studied: Camberwell School of Arts and Crafts 1951-57 gaining intermediate examination in Arts and Crafts and National Diploma in Design (Illustration). Exhib. RSMA from 1971 ('Lee shore') onwards. Seafaring experience in sail cruising vessels. Keenly interested in sailing ships from childhood. Started to paint in 1969 and turned to it as a full-time occupation in 1977. Has a passion for rare 15th and 16th century charts. Feels that there are too many imitators of those marine artists who, because of their originality of conception and technique, have become well known. Lives in Catford, London. . . See COLOUR PLATE 16 and PLATE 98

GUNN, Gordon N.
Watercolours. Coastal subjects. Exhib. RSMA from 1962 ('Threatening coast: Cornwall' and 'Wavelines at Morar') to 1976.

GUNN, Captain Phillip L., DSM, RN(Retd.)
Oils. Maritime subjects, landscapes, etc. Exhibition of series of 33 paintings from his early life in the Royal Navy was held at the Royal Naval Museum, Portsmouth, 1979. Joined the R.N. as a boy seaman in 1911, served through both world wars, retired after 35 years as Captain R.N. at age of 55 and then taught himself to paint. Two one-man exhibs. at Sudbury and Bury St. Edmunds. Lives at Sudbury, Suffolk. See PLATE 99

GUY, Edna W., RSMA (b.1897)
Watercolours. Marine subjects, particularly of the London river. Exhib. RSMA from 1950 ('Thames, Misty Morning') and 1951 ('Chugging through the fog' and 'Sunset Glow, Battersea') and regularly until 1966. Also exhib. RA, RI, RSA, etc. Lived Cheyne Walk, Chelsea, London.

HAGEDORN, Karl, RBA, RI, RSMA, NEAC (1889-1969)
Oils and watercolours. Coastal, estuary and harbour scenes, also landscapes and other subjects. Born in Germany, became naturalised British and studied in England and Paris. Exhib. RSMA from 1954 (oil 'Woodbridge Quay' and watercolour 'Dell Quay') and until 1969 (2 posthumous exhibits). Also exhib. RA, RBA, RI, NEAC, etc. Lived latterly in London.

HAILSTONE, Bernard (b.1910)
Principally a portrait painter, but was in the A.F.S. and subsequently employed as a War Artist 1941-45 with rank of Hon. Capt. (P.R., War office) in which capacity he painted some Merchant Navy ships. There are 44 of his pictures in the Imp. War Museum incl. portraits, war incidents and a few merchant shipping and naval scenes, e.g., 'Loading ammunition at Hull docks, 1943' oil 25 x 30 ins. Exhib. RA and RBA.

HALE, William Matthew, RWS, RWA (1837-1929)
Watercolours and some oils. Coastal marine subjects and some landscapes. Worked mainly in 19th century but also into 20th. Exhib. RA, ROI, RSA, RWS, RBSA, GI, Liverpool, Manchester, etc. Lived near Bristol from 1916.

HALES, Gordon (b.1916)
Oils and watercolours. Marine subjects, particularly estuary, boats and harbour scenes, also landscapes, etc. Studied Leicester College of Art and Northampton School of Art. Exhib. RSMA from 1970, also RI, ROI, RBA, and PS. Paints with Wapping Group. Work in permanent collection of Watford Corporation. Lives in Watford, Hertfordshire. See PLATE 100

HALFPENNY, Richard G.L. (b.1932)
Oils. Historic steamships and naval aviation scenes, also railway pictures and some portraits. Designer and builder of model steam launch engine '*Viper*' of which design has been published. Exhib. RSMA from 1976 ('H.M.S. *Ranger*'). Lives at Worthing, West Sussex. See PLATE 101

HALL, Joseph (b.1890)
Oils and watercolours. Thames estuary, coastal and harbour subjects. Exhib. RSMA from 1950 ('Quiet river') and 1951 ('Thames barges' and 'Grey Thames'). Also exhib. RA, RI, etc.

HALL, M.O.B., Mrs.
Watercolours. Marine subjects. Exhib. RSMA from 1958 ('Entente cordiale: Brixham') until 1967 ('The *Suceava*').

HALLIDAY, Charlotte, RBA, NEAC
Watercolours. Tidal Thames and estuary subjects. Exhib. RSMA from 1960 to 1964.

HALLIDAY, Thomas Symington, MBE, RGI (b.1902)
Watercolours, also etcher. Marine subjects. Exhib. RSMA from 1954 (watercolour 'Cruiser taking supplies') to 1961 ('In the Pool of London') and 'The RNLB the *Robert* moored for her christening, June 1961, by H.R.H. the Duchess of Kent') and then until 1969 ('The birth of a ship'). Also exhib. RA, RSA, GI, etc. Lived in Scotland.

HAMILTON, John Alan, MC (b.1919)
Oils. Marine subjects, particularly historical and with emphasis on accuracy of detail. Educated at Bradfield College. Served throughout World War II with Queen's Royal Regt. (West Surrey) in India and Burma. Self-taught artist. Spent over 3 years researching and painting some 60 pictures of events at sea in World War II which are now permanently exhibited in a special gallery on board H.M.S. *Belfast* (Imp. War Museum). Engaged in 1980 in research and painting over 90 pictures of the history of the war in the Pacific, for the U.S.A. Exhib. RSMA 1964 and 1976 and onwards. One-man exhibitions in Hamburg, 1979, and London, 1980. As well as sea subjects of World War II, he specialises in sail of the period c.1760-1815. Considers that a ship is in itself a wonderful work of art. Lives in the Isles of Scilly, Cornwall.
................See COLOUR PLATE 17 and PLATE 102

HAMMOND, Alfred Vavasour, RGI
Oils and watercolours. Marine subjects. Exhib. RSMA from 1954 (watercolours 'Evening, Wells' and 'Whelk boats, Wells') and until 1973 (3 oils incl. 'Barge entering harbour').

HANCERI, Dennis John, RSMA (b.1928)
Born 7th June, 1928, in London. Watercolours and bodycolour. General marine subjects and landscapes. Studied: St. Martin's School of Art. Exhib. RSMA from 1969. One-man exhibition in Denver, Colorado, U.S.A. Work commissioned by a number of commercial firms. Permanent collections: Bracknell Corporation; Ville d'Anthony, Paris. Member of the Wapping Group. Lives in London....................See PLATE 103

HARDIE, Martin, CBE, RI, RSW, Hon.RWS, RE, RSMA, SGA (1875-1952)
Watercolours. Coastal scenes, but mainly a landscape artist. Exhib. RSMA inaugural ex. 1946 watercolour 'Summer afternoon, Blakeney' and thereafter until 1952 (3 posthumous pictures incl. 'Thames barges, Lower Halstow'). Also exhib. RA, RE, RI, NEAC, RSA, RSW, etc., and provinces. Author of well known major work of reference *Watercolour painting in Britain*.

HARDY, Dudley, RI, ROI, RBA, RMS, PS (1867-1922)
Oils and watercolours. Landscape, portraits, etc., and many coastal scenes. Also an illustrator. Son of Thomas Bush Hardy the well-known 19th century marine artist. Exhib. RA, RBA, RI, ROI, RMS, RBSA, Glasgow, Liverpool, Manchester, etc.
.......................................See PLATE 104

HARINGTON, Ernest
Watercolours. Tidal Thames, coastal and harbour subjects. Exhib. RSMA from 1951 ('Industrial Greenwich') and 1952 ('Waterside, Greenwich') and up to 1957 ('Mount Batten Castle, Plymouth').

HARNACK, (Fid) Frederick Bertrand, RSMA (b.1897)
Born 22nd July, 1897 in London. Oils, watercolours and bodycolour. Marine subjects. Illustrator for *Ships and Shipping, Yachting Monthly* and other publications. Studied at a number of London art schools. Seafaring experience includes voyage in three-masted barque from London to Gulf of Bothnia (1930), war service in R.N.V.R., and Thames estuary and Channel sailing in 3-ton gaff rigged sloop. Exhib. RSMA from inaugural ex. 1946 with oil 'North Atlantic' and regularly thereafter. Also exhib. RA, Kensington Art Gallery, Minories, Colchester, etc. Lives at West Mersea, Essex.

HARRIS, William (fl.1882-1931)
Marine and landscape painter. Repres. Nat. Maritime Museum. Exhib. RA, RBA, RHA, ROI, RSA.

HARTLEY, Francis Ralph
Watercolours. Marine subjects. Exhib. RSMA 1964 (3 watercolours incl. 'Dredger in a sea mist') and up to 1969.

HAWKEN, Mrs. Lisa Ann (b.1943)
Oils. Sailing ships. Self-taught artist who specialises in painting sailing ships. Paintings exhib. in Bodmin, Fowey and Padstow, Cornwall in 1979 and 1980. Signs her work 'Kimberley'.

HAYBROOK, Rudolf A. (b.1898)
Went to Dunkirk as a member of the A.F.S. on the Fire-boat *Massey Shaw* and his oil painting size 25 x 30 ins. showing that event is in the Imp. War Museum. Exhib. London, Paris, U.S.A. and Canada.

HAYES, A.E.
Watercolours. Coastal and harbour scenes. Exhib. RSMA 1952 ('The Boat Builders Yard, Leigh-on-Sea' and 'The incoming tide, Leigh-on-Sea') and until 1959.

HAYES, John: *see* **EDWIN FLETCHER**

HEARSEY, Nancy H. (fl.1949-1957)
Oils and watercolours. Thames and other marine subjects. Exhib. RSMA 1949 watercolour 'Tower Bridge'; 1951 watercolour 'Portuguese fishing boat'; 1952 watercolour 'Greenwich Reach'; 1955 oil 'In the Solent'; 1957 oil 'White cliffs of Dover'.

HEBBARD, Frank
Oils. Marine subjects. Exhib. RSMA from 1964 ('Boat Yard'), 1965 ('The Mayflower') to 1974.

HELM, Anthony Richard (b.1945)
Watercolours. Estuary views, small harbours and fishing sailing craft; also landscapes. Exhib. RSMA 1977 'The anchorage, Iden' and 'Squall, Brancaster'; 1978 'Brancaster Staithe'. Lives in London.

HEMY, Bernard Benedict (d.1913)
Oils and watercolours. Harbour and coastal subjects. Brother of C.N. Hemy, (q.v.), but his work is generally of a lower standard. Mainly 19th century but some work in early 20th century.

HEMY, Charles Napier, RA, RI, ROI, RWS (1841-1917)
Oils and watercolours. Marine subjects, especially fishing boats at sea in rough weather. The best known of the 3 Hemy brothers. His sea horizons tend to be placed towards the top of his pictures, and his seas are strong and often dramatic. A yachtsman himself, he lived and died in the early part of the 20th century at Falmouth. He is considered to be mainly a 19th century artist, but has influenced many 20th century painters incl. Montague Dawson. Works purchased by Chantrey Bequest. Exhib. RA, RWS, RCA, RHA, RI, ROI, RSA, RSW, RBSA, GI, Liverpool, Manchester, etc..See PLATE 105

HEMY, Thomas Marie Madawaska (1852-1937)
Oils, watercolours and gouache. Harbour and coast subjects. Another brother of C.N. Hemy, (q.v.). Some of his harbour scenes are of excellent quality but his work is rarely seen today. Considered as a 19th century artist, but lived and worked until 1937. Exhib. RA, RBA, RI, ROI, RBSA, GI, Liverpool and Manchester.

HENNELL, Thomas Barclay, RWS, NEAC (1903-1946)
Watercolours. Appointed Hon. Lieut. R.N.V.R. and specially employed as war artist 1941-46. Over 90 of his pictures are in the Imp War Museum ranging over events from Iceland to Normandy and the Far East, including a few naval and other marine subjects, e.g. 'H.M.S. *Salveda,* a salvage vessel', 'H.M.S. *Hunter,* the flight deck', etc. Exhib. at RA, RWS, NEAC, etc. He was missing presumed killed on active war artist service in the Far East, 1946.

HENTY-CREER, Deidre, UA
Oils. Some marine subjects but mainly landscapes, etc. Exhib. RSMA 1968 'R.A.N. training ship *Tingira* in her sailing days' and 1969 'The *Middlesex'.* Also exhib. RA, RBA, UA, NEAC, etc.

HESLOP, Arthur (1881-1955)
Oils and watercolours (also etcher). Marine subjects and landscapes. Newcastle artist. Exhib. RSA, Liverpool, etc.

HICK, Allanson, RSMA, FRIBA, SGA (1898-1975)
Oils and watercolours. Marine subjects. Exhib. at inaugural RSMA exhib. 1946 with 4 watercolours incl. 'Wartime Drydock', '*Onslaught* refits', 'Danish Seine nets' and thereafter up to 1975. Also exhib. RA, RSA. Lived in Hull.

HICKLING, Edward Albert (b.1913)
Oils and watercolours. Harbour scenes and landscapes. Studied at Nottingham Art School. Exhib. RSMA (from 1973), RA, ROI, RBA, and Nottingham Museum and Art Gallery. Lives in Derbyshire.

HILDER, Rowland, PPRI, RSMA (b.1905)
Born at Great Neck, Long Island, U.S.A. Painter in oils and watercolours of marine subjects, including harbour and estuary scenes, and landscapes. Also artist in pen and ink and pencil, and illustrator of many books of the sea including *Moby Dick* and *Treasure Island.* Studied at Goldsmith's College School of Art under Edmund J. Sullivan. Started making marine drawings and paintings from an early age, particularly of ships, boats and people in the Thames estuary and docks. Keen yachtsman and boat owner. Exhib. at RA, NEAC from 1923. A founder member of the RSMA and exhib. occasionally from 1946. Exhib. RI and other leading London galleries. President (1964) Royal Institute of Painters in Watercolours. Works are in many public and private collections in U.K. and abroad including works in the collection of H.M. The Queen and Prince Phillip. Particularly noted for English winter scenes and fine quality of drawing. Lives at Blackheath near London.
. See COLOUR PLATE 18 and PLATE 106

HILES, Frederick John (Bartram) (1872-1927)
Watercolours and some oils. Marine subjects and landscapes. Bristol artist, painted by mouth (held brush in his teeth) as he had lost both arms in an accident. Exhib. RA, RBA, RI, GI, Liverpool, etc. Lived in Bristol from 1908.

HILL, Philip Maurice, RSMA (1892-1952)
Oils. Coastal scenes. Exhib. RA, ROI, RBA, RSA, NEAC and Paris Salon. Member of St. Ives Soc. of Artists. Exhib. 'The Cliffs at Land's End' and 'Gibraltar' at Portsmouth, 1938.

Hon. Sec. RSMA 1948-1951. Exhib. at inaugural exhib. RSMA 1946 4 pictures incl. 'The Cornish Coast' and 'Sea Thunder' and frequently thereafter until 1951. Lived in London and at St. Ives, Cornwall.

HINE, Stewart
Oils. Marine subjects. Exhib. RSMA 1974 and 1976 ('A delight of dolphins').

HOARE, Marjorie (fl.c.1930-1950)
Painted coastal scenes and landscapes. Studied at the Slade. Exhib. RA, RHA, NEAC.

HODDS, Dennis Roy (b.1933)
Oils and watercolours. Marine subjects, harbour scenes, sailing ships, etc. Studied at Lowestoft College of Art (won scholarship at age of 12). Member of Gt. Yarmouth Guild of Arts and Crafts and Gt. Yarmouth & District Soc. of Artists. Exhib. RSMA (from 1971) also ROI. Work exhib. at Kings Lynn, Norwich and Gt. Yarmouth. Lives at Southtown, Gt. Yarmouth.
. See PLATE 107

HODGES, William H.
Watercolours. Marine subjects. Exhib. RSMA from 1950 ('Hastings Boats') and 1951 ('The new boat' and 'Low Tide') and until 1958.

HOFLER, Max
Oils. Harbour and architectural subjects. Exhib. RSMA 1947: 'Surrey Docks'; 1948: 'Mark Brown's Wharf'; 1959: 'Dock scene'. Also exhib. RA, RI, ROI.

HOGG, Peter McGowan (b.1934)
Oils, watercolours, gouache, acrylics (also pastel). Marine subjects, landscapes and portraits. Attached to marine section, R.A.F. Air Sea Rescue 1954-58. Exhib. RSMA and ROI from 1975. Also 5 one-man exhibs. and many group exhibs. Lives at Lyndhurst, Hampshire.

HOLMES, David, FSAE, FRSA (b.1927)
Oils, watercolours and acrylics, also sculptor. Harbour scenes, especially Langstone and Chichester harbours. Studied Regional College of Art, Kingston-upon-Hull, and Bretton Hall, University of Leeds, also in Paris, Florence and Rome. Has built and sailed own boats since age of 16. Fellow of National Soc. for Art Education, 1968, for original contribution to art education; Head of Art Departments in Britain and overseas; college examiner; Vice-Chairman Portsmouth European Centre; Senior Lecturer in Education, Faculty of Educational Studies, Portsmouth Polytechnic. One-man exhibs. in Hull, Bristol, Geneva, etc. Exhib. RSMA. Over 1,200 works in galleries and private collections throughout the world. Enjoys tranquil seascapes and the challenge of depicting in watercolour the changing effects of light and weather. Lives at Hayling Island, Hampshire. See PLATE 108

HOPPER, Frederick William, MBE (b.1891)
Watercolours. Mainly steam vessels of all types from 1891 to present day, mostly from plans. R.N.V.R. Dover Patrol 1918. During 38 years as General Manager and Director of Wm. Pickersgills Shipyard, Sunderland, he designed every vessel built there. Made a painting of every vessel launched at his yard for presentation to every lady launching sponsor. Self-taught artist. Exhib. RSMA 1977 'The Silver Sea'. Many pictures in private collections. Lives in Cambridge. See PLATE 109

HORTON, John Malcolm (b.1935)
Oils. Marine subjects of all periods, but particularly fishing vessel scenes on the Canadian west coast. Studied at

Bournemouth College of Art and Wimbledon Art College. Served R.N. and holds commission R.C.N.V.R. Cruising and racing yachtsman; founder of British Columbia Squadron, R.N. Sailing Association. Exhib. RSMA from 1963 (oil 'Miracle of the *Jean Gougy*'). Paintings in many corporate and private collections, and holds annual exhibition Vancouver. Now lives in Vancouver, B.C., Canada.............. See PLATE 110

HOUGHTON, Albert
Watercolours. Estuary and coast subjects. Exhib. RSMA from 1969 to 1973 ('Awaiting a tide' and 'Summer evening, Norfolk').

HOWARD, Norman Douglas, RSMA, MSIA (1899-1955)
Oils and watercolours, also illustrator. Marine subjects. Exhib. RSMA inaugural ex. 1946 4 pictures incl. 'Autumn gale at the Lizard' and 'The spud pier, Mulberry Harbour, 1944' and thereafter until 1955. Also exhib. RA, ROI, NEAC, IS, etc. Lived at Richmond, Surrey.

HOWEY, Robert L. (b.1900)
Watercolours, gouache, pastels and woodcuts. Marine and coastal subjects, particularly in the North-East of England, also landscapes. Numerous one-man exhibitions. Exhib. RA, RSA, etc.................................... See PLATE 111

HOWGEGO, J.L.
Oils and watercolours. Marine subjects. Exhib. RSMA from 1951 ('Gibraltar oiler heaving alongside repair ship during a Levanter') until 1975 ('Palma — Puerto, *Palmera y Pino*').

HOWIESON, Charles Stuart
Watercolours. Marine subjects. Exhib. RSMA 1968 ('Ghosting, Kyles of Bute') and 1969 and 1970.

HUDSON, John Leslie
Watercolours. Marine subjects. Exhib. RSMA 1975 'More Langstone profiles' and thereafter to 1979 'The Solent carriers'.

HUGHES, Robert Evans (b.1896)
Oils and watercolours. Coastal scenes, also landscapes and figures. Exhib. RSMA 1952 ('Deganwy, North Wales') and 1957. Also exhib. ROI, RCA, etc.

HUGHES, Robert Morson (1873-1953)
Oils. Seascapes, coast subjects and landscapes. Exhib. RA, RI, ROI, NEAC, Liverpool, Manchester, etc. Lived in Cornwall from 1910.

HUMPHREYS, John
Oils. Marine subjects. Exhib. RSMA 1974 ('*Safari* and *Charisma* at Cowes' and 'Cromer beach') and 1975 ('The lady of the *Cutty Sark*').

HUNT, Geoffrey William, AOI (b.1948)
Oils, watercolours and gouache. Nelsonic period ships, warships of the ironclad era, modern warships, and modern yachts. Studied: Kingston College of Art and Epsom College of Art. Owns small sloop which he and his wife have sailed to the Mediterranean. Exhib. RSMA 1977: watercolour 'North Forties'; 1978: oil 'Thirty-knotter destroyer, H.M.S. *Bullfinch*' and watercolour '13th April, 1940 — H.M.S. *Warspite* at Narvik'. Also exhib. Assoc. of Illustrators. Takes great interest in warships and has been Art Editor of both *Navy International* and *Warship* magazines. Is optimistic about the talents of the rising generation of marine artists. Lives at Wimbledon, near London.................................. See PLATE 112

HUNTER, Mason (1854-1921)
Oils and watercolours. Coastal subjects and landscapes. Scottish artists. Exhib. RA, RBA, RHA, RI, RSA, RSW, GI, Liverpool and Manchester.

HUNTLEY, Nancy (Mrs. Sheppard) (b.1890)
Oils. Mainly landscapes, figures, etc., but also some marine subjects. Exhib. RSMA from 1954 ('Boats at Ostend') until 1958 ('Cassis Fishermen'). Also exhib. RA, ROI, etc.

HURLE, Ruth (fl.1939-1948)
Marine, portrait and figure painter. The National Maritime Museum have 'Hunt Class destroyer in dry dock' in their Collection. Exhib. RA, NEAC.

HUTCHINSON, Martin
Watercolours. Marine subjects. Exhib. RSMA from 1955 ('Hastings beach' and 'At Porlock Weir') until 1960 ('The crew goes home').

HUTTON, Dorothy
Watercolours. Some marine subjects, but mostly flower pictures. Exhib. RSMA 1947: watercolours 'Before the race' and 'Oncoming squall'; 1954 'The Royal Yacht *Britannia* at anchor in the Upper Pool' and 'The return of H.M. The Queen 15th May, 1954'. Also exhib. RA, NEAC and provinces.

INNES, William Henry, PS, UA (b.1905)
Oils and pastels. Marine subjects and landscapes. Self-taught artist. Exhib. at RSMA also RA, ROI, NEAC, UA, PS, etc. Member of the Council of the Pastel Soc. for many years. Member of the Selection and Hanging Committee of United Artists Soc. 1978-79. Lives in London........ See PLATE 113

IRVING, Laurence, OBE, RDI, RSMA (b.1897)
Oils. Marine subjects and landscapes. Also stage and film designer. Member RSMA 1947 and 1948, and exhib. once more in 1975 'Barge unloading, Whitstable harbour'. Also exhib. RA and provinces.

JACKSON, Frederick William, RBA, NEAC (1859-1918)
Oils and watercolours. Marine subjects and landscapes. Lancashire artist. Exhib. RA, RBA, ROI, RBSA, GI, NEAC, Liverpool and Manchester.

JAMES, Edward Ernest (Killed in action 26th June, 1944).
Trooper, Royal Dragoons. Seven of his pen and ink/wash pictures are in the Imp. War Museum, 5 of which show tank landing craft in the Normandy landings.

JAMES, Eileen (b.1939)
Oils. Seascapes, harbours, coastal subjects, and landscapes. Self-taught artist. Exhib. RSMA 1977 ('Willing helpers' and 'Not much biting'); 1978 (4 oils); 1979 ('Final resting place'). Also exhib. ROI 1978-79. One-woman exhibition at Seaford in 1975. Lives in Rotherfield, Sussex........... See PLATE 114

JANES, Norman, RWS, RE, Hon. RSMA (b.1892)
Born in Egham, Surrey. Oils and watercolours. Coastal and harbour subjects. Studied: Slade School, and etching at Central School of Arts and Crafts and Royal College of Art. Served in the infantry in World War I from 1914-18. Elected ARE 1921. Taught at Hornsey School of Art (1928) and the Slade. Commissioned R.A.F. 1941 and served with the Naval Cooperation Wing on the Egyptian and Cyrenaican coasts to 1945. Two of his 'Tobruk 1943' watercolours are in the Imp. War Museum. Exhib. RSMA, also RA (since 1921) NEAC, RE, RWS, etc.

One-man exhibitions at Beaux Arts Gallery 1932 and 1945; also Middlesborough 1962 and Clifton 1975. Over 60 of his paintings are in public collections in the U.K. and overseas. Has painted in Britanny, Southern France, Italy, and in the fishing ports around the British Isles. Lives in Egham, Surrey.

JARVIS, W. Howard, RSMA (fl.1946-1964)
Oils. Marine subjects. Exhib. at RSMA inaugural ex. 1946 with 2 pictures: 'Offshore' and 'Midnight — Wallasey Dock (A/S Trawlers)' and regularly thereafter until 1964 (posthumous exhib.). Painted a number of famous yachts incl. *Bloodhound* and *Lutine.* Lived near Liss in Hampshire.

JEFFERIES, Wilfred Avalon, RSMA, RWA (b.1907)
Oils and watercolours, also etcher. Marine subjects, landscapes, etc. Exhib. RSMA from 1949 (watercolour 'Camber commerce, Portsmouth') until 1969 (4 pictures incl. oil 'Norderney Drifters' and watercolours 'Vospers Yard', 'Haslar Creek' and 'C. in C's launch'). Member RSMA 1965. Also exhib. RA, etc. Lived at Southsea, Hampshire.

JEPSON, Sybil F.E., Miss (fl.1929-1969)
Watercolours. Coast and harbour scenes, also landscapes. Exhib. RSMA from 1954 ('Relics of the past, Shoreham' and '*Blossom,* Seahouses') until 1969 ('Whitby', 'Littlehampton' and 'Looe, Cornwall'). Also exhib. RA.

JESSEL, Robert William Albert (b.1899)
Watercolours. Marine subjects, normally beach scenes. Specialises in figures and groups in movement. Studied chiefly in Paris and also at the Slade. One-man exhibitions in London, 1933, and Antwerp, 1945. (Antwerp exhib. commissioned by 21 Army Group as a tribute to the Belgian Resistance Movement.) Exhib. RSMA 1978. Lives at Worthing, Sussex.

JOBSON, F.M. (fl.1947-1948)
Watercolours. Marine subjects. Exhib. RSMA 1947 'The Lowestoft boat' and 1948 'Salute to Milady'.

JOBSON, Patrick Arthur, RSMA (b.1919)
Oils, watercolours, gouache and egg tempera. Marine subjects, also landscapes and pub signs. Founder member of the RSMA. President, Wapping Group. Past President, Artists Society. Studied under his father Frank Mears Jobson and also under A.E. Hayes. Served at sea in R.N. 1940-46. Exhib. from 1938 at RBA, RI, PS, etc. Exhib. inaugural ex. RSMA 1946 with 3 pictures incl. oils 'Blake in the North Sea', 'Slipping the tow' and watercolour 'The Start', thereafter regularly up to 1954. One-man exhib. 1974. Work in permanent collection National Gallery, Adelaide, Australia.................See PLATE 115

JOHNSON, Ronald Henry (b.1930)
Oils and watercolours. Marine subjects, especially harbour scenes, small boat activities with figures, boat repairing, etc., also landscapes and figure studies. Studied Hornsey College of Art and Reading University. Engages in dinghy racing and small boat sailing. Exhib. RSMA, also RA, RBA, NEAC, ROI, NS, UA, RI, Paris Salon and in Gothenburg, Hamburg, and Munich. Lives at Roydon, Essex.

JOHNSTON, Robert, RI, ROI, RSMA (b.1906)
Born 6th July, 1906. Watercolours, bodycolour and some oils. A variety of marine subjects ranging from seascapes to North Sea oil rigs. Self-taught artist. Lived in Australia for many years, where he painted landscapes. Seafaring experience as a seaman on the Australia-England run. Exhib. RSMA from 1951 (oils 'Bossiney' and 'Export') and onwards to 1968 (watercolours 'Lymington', 'The Basque coast', 'Lock gates, marina' and 'Dunkirk veteran'). Then 1976: 'North Atlantic barquentine'

and 'Long distance trader'; and 1978: 'Audierne, French west coast' and 'High and dry, Britanny'. Also exhib. RA, ROI, RBA, NEAC, RI, Paris Salon, etc. Believes that success comes to the marine artist who is bold enough and adventurous enough, with a wild kind of courage. Lives near Banbury, Oxfordshire...........................See PLATE 116

JOICEY, Richard Raylton, RSMA (b.1925)
Oils and watercolours. Modern ships, yachts, seascapes, landscapes and portraits. Studied at Sir John Cass College of Art. Served R.N. 1943-64. Exhib. RSMA since 1967 (oil 'Vickers Armstrong Shipyard') also exhib. RI, etc. Lives at Langstone, Hampshire........................See PLATES 117 & 118

JONES, E. Scott, RCA
Oils and watercolours. Marine subjects. Exhib. RSMA 1968 (oil 'Albert Dock, Liverpool') and then until 1972.

JONES, Josiah Clinton, RCA (1848-1936)
Oils and watercolours. Seascapes and landscapes. Studied Liverpool. Worked in Wales. Exhib. RA, RCA, RI, RBSA, Liverpool and Manchester.

JORDAN, R.E.
Oils and watercolours. Harbour and coast subjects. Exhib. RSMA from 1967 ('Black Eagle Wharf') to 1978 ('The Lieutenance, Honfleur').

KAY, James, RSA, RSW (1858-1942)
Oils, watercolours, also etcher. Marine coastal subjects and landscapes. Scottish artist. Exhib. RA, RSA, RSW, GI, Liverpool, Manchester, etc.

KEARNEY, Patrick Neville (b.1919)
Oils and watercolours. Marine, coast and harbour subjects. Studied Norwich School of Art. Exhib. RSMA 1954 watercolour 'Wreck on the bar, Blakeney'. Also Exhib. RBA, etc., and one-man exhibitions Norwich.

KEEL-DIFFEY, Mrs. Helen Patricia (b.1926)
Etcher and printmaker especially relating to sea shores, waves and water, also landscapes with interesting contrasts of scale, texture and tone. At one time involved in figure and portrait drawing and painting. Studied at Birmingham College of Arts and Crafts 1942-46. Teacher of art at Henley-on-Thames 1958-63. Exhib. SWA, RP, RBA, RSMA, and numerous exhibs. in the provinces. Lives at Henley-on-Thames, Oxfordshire............................See PLATE 119

KENNEDY, A.
Watercolours. Marine subjects incl. historical events. Exhib. RSMA 1970 ('The Glory of Sails — *Norman Court*') and 1971 ('Capture of the French *Reunion* by the *Crescent,* 1793').

KENNINGTON, Eric Henri, RA (1888-1960)
Portrait artist, mostly pastel, also sculptor. Official War Artist in both World Wars. Numerous pictures in Imp. War Museum, some of them portraits of sailors. Seven of his studies of sailors were published in *War at Sea* (Oxford Univ. Press 1942). Exhib. RA, ROI and other leading galleries incl. collection at the Tate.

KENT, Colin D., RI
Watercolours. Estuary, coastal and landscape subjects. Exhib. RSMA from 1969-75 ('Near Burnham, Essex' and 'Dinard, Britanny').

KENT, Leslie, RBA, RSMA, MICE (1890-1980)
Born 15th June, 1890 in Finchley, London. Oils. Principally of sailing vessels in harbours, estuaries and off the coast. Studied

under Fred Milner, St. Ives 1918-20. Many years sailing experience in small boats. Five one-man exhibitions in London between 1932 and 1968. Exhib. RSMA and RA (from 1934), RSA, RBA, ROI, NEAC and Paris Salon. Sold over 900 paintings. At one time council member of RBA and RSMA. Lived at Radlett, Hertfordshire. See PLATE 120

KEVAN, Mrs. Jean
Oils and watercolours. Coastal and harbour subjects. Exhib. RSMA from 1968 (*'Ethel Ada* Leigh marshes') to 1976.

KEYES, Phyllis (fl.1908-1919)
Principally a portrait painter and lithographer but 6 studies in pencil and watercolour dated 1919 are in the Imp. War Museum, all of W.R.N.S. activities. Exhib. Walker Art Gallery, Liverpool, and Walkers Gallery, London between 1908 and 1911. Lived in Hampton Court Palace, near London.
. See PLATE 232

KIDDER, Clive, NS (b.1930)
Oils, watercolours and acrylics. Marine coastal subjects, landscapes, etc. Studied Southend School of Art (1946-49). Exhib. at RSMA from 1973, and numerous exhibs. in London and provinces. Five one-man exhibitions up to 1979. Also book illustrator. Lives in Essex, where the marshes and skies have much influenced his work. See PLATE 121

KILPACK, Sara Louisa (fl.1880-1920)
Oils and watercolours. Coastal and seascape subjects, also landscapes. Lived and worked in Jersey, Channel Islands, and painted many scenes around those coasts. Her work is usually very small, e.g. 2 x 4 ins., and of jewel-like quality. Her larger works, e.g. 6 x 8 ins., are rarer. Exhib. SWA.

KING, Cecil George Charles, RI, ROI, RBA, RSMA (1881-1942)
Oils and watercolours. Marine and landscape subjects. Studied at Goldsmiths, Westminster Art School and Paris. Exhib. 7 naval pictures at Portsmouth 1936 and 4 at Portsmouth in 1938 incl. *'Britannia* leading at Cowes Regatta' and 'French Destroyers at Monaco'. At one time honorary official marine painter to the Royal Thames Yacht Club. Authority on history of signal and other flags and similar matters of nautical research. Official naval artist in Baltic during Armistice and Capt., London Regt., World War I. Twelve pictures in Imp. War Museum all of naval subjects. Active in organising marine exhibs. between 1935 and 1938, and a founder member of RSMA. Exhib. RA, RBA, RI, ROI, Liverpool, Manchester, etc. See PLATE 233

KING, Jeremy C.G.
Oils. Coast subjects. Exhib. RSMA 1965 ('St. Agnes, Scilly Isles') 1968 and 1970.

KING, Robert, RI (b.1936)
Oils, watercolours and gouache, also etching and lithography. Seascapes, coastal scenes (particularly on the north Norfolk coast and the Solent); landscapes and portraits. Self-taught artist. Six one-man exhibitions in Leicester between 1970 and 1980; one at Kings Lynn 1973; Burnham Market 1977; and Norwich 1978. Subject matter for these exhibitions was obtained on visits to France, Morocco, Vienna, Egypt and Venice between 1970 and 1980. Exhib. RSMA 1978 (3 oils incl. 'Evening, Southampton Water') and 1979 (2 oils incl. 'Crab boats, Cromer'). Also exhib. RA, RI, ROI, etc. Lives in Leicester. See PLATE 122

KING, William Joseph (fl.1885-1943)
Oils and watercolours. Seascapes, coast subjects and landscapes. Birmingham artist. Exhib. RBSA, RSA, RCA and Liverpool.
. See PLATE 123

KIRBY, James Alfred (b.1917)
Oils. Seascapes and some landscapes. Served R.N.V.R. from 1936 and active service with R.N. 1939-45. Has spent lifetime in the fishing industry. Exhib. RSMA from 1967 (oil 'To Grimsby from Greenland'). Work purchased by Corporation of London. Lives Cowden, Kent. See PLATE 124

KIRKPATRICK, Miss Ethel (fl.1890-1940)
Oils and watercolours. Marine subjects and landscape. Exhib. RA, RI, RBA, SWA, GI, etc. Sister of Ida Marion Kirkpatrick, (q.v.).

KIRKPATRICK, Miss Ida Marion (fl.1888-1930)
Watercolours. Marine subjects, landscapes and flowers. Sister of Ethel Kirkpatrick, (q.v.). Exhib. RA, RI, ROI, RBA, SWA, etc.

KNIGHTON-HAMMOND, Arthur Henry, ROI, RI, RSW (1875-1970)
Oils and watercolours. Harbour and coastal scenes, but mainly a landscape artist. Exhib. RSMA 1947 (oils 'A harbour near Genoa' and 'The Cliffs of Dover') also 1948 and 1949 (pastel 'Father Thames' and watercolour 'Thames from the Ship Hotel, Greenwich'), and again 1962.

KNOLLYS, Hugh (b.1918)
Oils, watercolours and gouache (also pastel). Harbour scenes, warships and landscapes. Served in R.N. for 27 years; also has considerable experience of sailing yachts. Self-taught painter. Exhib. RSMA, PS, Armed Forces Art Soc., and numerous provincial galleries. Five one-man and 6 two-man exhibs. between 1948 and 1977. Work permanently on show at H.M.S. *Nelson* (R.N. Barracks, Portsmouth, Wardroom), H.M.S. *Ambuscade* and H.M.S. *Glasgow.* Lives at Bishops Waltham, near Southampton. See PLATE 125

KNOX, Cecil Peter
Oils and watercolours. Wide range of marine subjects including sailing vessels, working ships and boats, fishing vessels and small harbours. Gained N.D.D. (painting and lithography) and A.T.D. 1963. Artist-tutor to the College of the Sea 1968-1971, travelling world-wide on merchant ships of all kinds. Work exhibited in galleries throughout the country, incl. Edinburgh and London. Three paintings in Nat. Maritime Museum. Lives in Scotland. See PLATE 126

LACKNER, Helmuth Johann (b.1929)
Oils, watercolours and gouache. All marine subjects. Studied: London Polytechnic. Exhib. RSMA 1967: oil 'S.S. *Nellore'*; 1979: watercolour 'In dry dock'. Lives in London.
. See PLATE 127

LAMBIE, Donald William (fl.1946-1954)
Watercolours. Marine subjects. Exhib. RSMA 1946 inaugural exhib. 'The Home Fleet at Scapa'; 1948 'A calm evening on the Medway; H.M. Ships *Woolston, Quantock* and *Verdun*'; 1949: pencil and wash 'Scapa Flow' and 1954: 'Cap de Fer, Algeria'.

LANG, Arthur John (b.1924)
Watercolours and sometimes oils. Estuary and coastal scenes, also landscapes and birds. Exhib. RSMA and NS 1978. Armed

Forces Art Soc. 1977-79, United Soc. of Artists and Hesketh Hubbard Art Soc. 1977 onwards. Also exhib. in provinces. Paints watercolours mostly from life and on the spot. Lives in London.

LANGMAID, Rowland, RSMA (1897-1956)

Pupil of W.L. Wyllie whose style much of his work closely resembles. Best known as an etcher, but also painted marine subjects. His subjects included many naval ships (he served as a Lieut. Cdr. in R.N.) and his Portsmouth exhibits in 1938 were 'A county class cruiser in heavy weather', 'Sweeping the seas, H.M.S. *Victory*' and 'H.M.S. *Victory, Trafalgar Day*'. A number of his World War II naval paintings are at the Nat. Maritime Museum, e.g., 'Convoy from Crete' 1941; 'H.M. the King leaves Normandy in *Arethusa*' 1944. Member of RSMA 1947-48. See PLATE 234

LAVERY, Sir John, RA, RSA, RHA, PRP (1856-1941)

Painter in oils mainly of portraits, figure subjects and landscapes but specially employed as a naval artist in World War I. Fifty-nine pictures, mostly naval subjects, are in the Imp. War Museum. Five of his naval marine war-time paintings were illustrated in a special issue of *The Studio* published in 1918. Studied in Glasgow, London and Paris. Knighted 1918. Elected RA 1921. His pictures are in many permanent collections in the U.K. and overseas. See PLATE 235

LEATH, Peter (b.1935)

Oils and acrylics. Harbour scenes and coastal and fishing vessels before steam propulsion, with particular emphasis on the different sailing fishing boats and methods of fishing. Has had a lifetime of experience in small boats. Also designed and built his own trawler in which he fished until taking up marine painting as his full time occupation. In 1979 was building another 32ft. trawler. Self-taught artist. Works shown in London, Southsea, and Newport, I.o.W. galleries. Lives at Carisbrooke, Isle of Wight. See COLOUR PLATE 19

LEE, Sidney Edward (b.1925)

Oils. Harbour and estuary scenes, also some landscapes. Studied: Harrow School of Art and Willesden School of Art. Many years experience in offshore cruising yachts. Exhib. RSMA 1979 'Dieppe harbour'. Paints subjects seen while sailing on English coast and north coast of France. At one time a graphic designer, now mainly devoted to marine painting. Lives in South Devon. See PLATE 128

LE JEUNE, James, ARHA, RSMA (b.1910)

Oils and watercolours. Marine subjects, also landscapes, etc. Studied Paris, New York and London. Exhib. at RSMA from 1948 (oil 'Fisherman's Regatta') and onwards; 1966 oil 'The rising squall'. Also exhib. RBA, NEAC, etc. Work in permanent collections Nat. Gallery, Dublin and Cardiff. Lives in Eire.

LEKE, Francis S.

Watercolours. Marine subjects. Exhib. RSMA from 1961 ('The *Westbourne* off Gravesend') until 1976 ('*Golden Sunrise* off Folkestone').

LE MAISTRE, Francis William Synge, ROI (1859-1940)

Oils and watercolours. Marine subjects and landscapes. Jersey, Channel Islands, artist. Exhib. RA, RBA, ROI, etc.

LEWSEY, Tom (fl.1946-1964)

Oils. Marine subjects. Exhib. RSMA inaugural exhib. 1946 oil '*Joyce* winning at Cowes 1946 in Force 7 gale' and frequently thereafter until 1964 with 3 exhibs. incl. 'The grand banks schooner *Bluenose* passing the Needles, 1935'.

LILLEY, Geoffrey Ivan (b.1930)

Oils and watercolours. Pure seascape, coastal scenes, skies, landscapes and forest subjects. Studied at Cambridge Art College. Lived at Polperro, Cornwall 1971-72 and concentrated on study of pure seascape. Exhib. RSMA from 1977. Four one-man exhibs. in London, Oxford, Falmouth, and Bourton-on-the-Water. Author of some 300 articles for popular press, illustrated by himself. Lives near Lewes, Sussex.

LINDLEY, Charles (fl.1936-1958)

Watercolours. Coastal scenes and landscape. Exhib. RSMA 1957 ('Bosham in April') and 1958 (2 watercolours incl. 'The Town Quay, Lymington'). Also exhib. RA and RI.

LINDNER, Peter Moffat, RWS, RBA, ROI, RI (1852-1949)

Oils and watercolours. Marine subjects, coastal scenes and landscapes. Exhib. from the 1880s in London; RA, RBA, RHA, RI, ROI, RWS, RSA, NEAC, RBSA, GI, Liverpool, Manchester, etc. Exhib. Portsmouth 1938: 'Dutch boats on the Maas' and 'The estuary, Etaples'. Lived at St. Ives, Cornwall.

LITTLEWOOD, Brian

Watercolours, also etcher. Marine subjects. Exhib. RSMA 1977 ('Gaffer off Felixstowe' and 'Essex coast') and 1978.

LIVERTON, Thomas Alfred, RBA (1907-1973)

Oils and watercolours. Coastal and estuary subjects. Exhib. RSMA 1952 (watercolours 'Peaceful shore' and 'Quiet evening') until 1958. Exhib. RA, RBA, etc. Lived at Beckenham, Kent and Sussex.

LOBANOW-ROSTOVSKY, Roxane (Mrs.) (b.1932)

Watercolours and gouache. Seascapes, sea-shells, landscapes, flowers, etc. Born in Athens, Greece. Studied at Brighton Polytechnic, also self-taught in sculpture. Has sailed extensively in Scottish lochs and on west coast of Scotland observing marine life. Exhib. RSMA, also RI, SWA, Brighton Art Gallery, Worthing Art Gallery and other provincial centres. Lives in Hove, Sussex. See PLATE 129

LOBLEY, J. Hodgson (fl.1902-1940)

Oils. Mainly figure subjects and landscapes, but also some coastal scenes, e.g., 'Old Harry Rocks, Dorset'. Exhib. Portsmouth, 1938.

LONGBOTHAM, Charles N.

Watercolours. Coastal scenes. Exhib. RSMA from 1963 to 1967 ('Beached at Amble' and 'Winter, Dungeness').

LOWRY, Laurence Stephen, RA, RBA (1887-1976)

Oils, watercolours, gouache (also lithographer). Famous for his evocative and singular scenes of the industrial Midlands and North of England, peopled by matchstick-like figures. He also painted some very fine seascapes in modern idiom, a fact which is often overlooked in the general acclaim for his townscapes. Firmly a Lancashire artist. Exhib. RA, RBA, RHA, ROI, RSA, NEAC, RBSA, Liverpool, Manchester, etc.
. See PLATES 130 & 131

LOWRY, Robert C.D.

Oils and watercolours. Harbour and estuary subjects. Exhib. RSMA from 1968 (2 oils 'Tynemouth' and 'Newcastle-upon-Tyne') to 1974.

LUDDINGTON, Leila Tansley, Mrs. (1932-1958)

Watercolours. Marine subjects. Exhib. RSMA from 1949 ('Fishing boats' and 'Welsh Fishermen') up to 1958 ('The Wreck'). Also exhib. NEAC, RBA, RSA, RSW, SWA.

LUDLOW, William Henry

Oils. Marine subjects. Exhib. RSMA from 1954 (4 oils incl.

'Out into the Solent', 'Itchenor' and 'Summer shower over Titchfield Haven') and until 1969 ('Hamble river at Bursledon' and 'The Pier at Southampton').

LYNCH, Hugh Adair
Oils and watercolours. Marine subjects. Exhib. RSMA from 1955 (watercolour 'Blue Boar Wharf, Rochester') until 1970 (watercolour 'Converted craft, Benfleet').

McCALL, Charles James, ROI, NEAC (b.1907)
Oils and watercolours, also pastels. Marine subjects, landscapes, figures, etc. Exhib. RSMA from 1957 (oil 'Ship unloading' and watercolour 'Unloading the catch') until 1964 (3 watercolours). Also exhib. RA, RSA, NEAC, etc.

McCONNELL, Charles, RCA (b.1897)
Oils and watercolours. Marine subjects and landscapes. Exhib. RSMA 1948 oil 'Ships at the Mills'. Also exhib. RSA, RBA, RCA, ROI, GI, etc.

McCROSSAN, Miss Mary, RBA (fl.1925-1934)
Oils and watercolours. Marine and coastal subjects, landscapes, figures, etc. Liverpool artist. Lived St. Ives, Cornwall from 1931. Exhib. RA, RBA, RHA, RI, ROI, RSA, NEAC, Liverpool, Manchester, etc.

MACDONALD, Oscar D. (1898-1971)
Watercolours. Coastal subjects and landscapes. East Anglian artist. Exhib. RI.

McDOUGAL, John, RCA (fl.1880-1940)
Oils and watercolours. Coastal subjects and landscapes. Exhib. RA, RI, RBA, RCA, RSA, RSW, RBSA, GI, Liverpool, etc. Lived in Anglesey from 1900.

McDOWELL, William (fl.1948-1950)
Watercolours. Marine subjects (historical naval scenes). Exhib. RSMA from 1948: 'The First British yacht *Mary*, 1660' and '*Sovereign of the seas*, 1637'; 1949: 'The morning after Trafalgar; *Victory* in tow' and '*Victory* joins the Fleet, 16 September 1805', 1950.

MACE, John Edmund, RBA (fl.1916-1948)
Oils and watercolours. Marine subjects, landscapes and flowers. Exhib. RA, ROI, RBA, RI, Liverpool, etc. . . . See PLATE 132

MACGREGOR, David R.
Oils. Marine subjects. Exhib. RSMA 1954 ('Medway barge race' and '*Lilla Dan* off Svendborg) and 1958.

McINNES, Ian
Oils. Marine subjects. Exhib. RSMA from 1958 ('Westerly gale') until 1976 ('Boat Noust').

McINTYRE, Donald, RI, RCA, RSMA
Oils and watercolours. Coastal and harbour subjects. Exhib. RSMA from 1954 (oils 'Caernarvon harbour' and 'Conway') until 1975 (3 watercolours incl. 'Home in a storm, Craster'). Lived at Bangor, North Wales.

MACKAY, Arthur Stewart, ROI (b.1909)
Oils. Marine subjects, also landscapes, etc. Exhib. RSMA from 1950 ('The Hamble at Bursledon') and 1951 ('Evening on Southampton Water', 'Boats at Keyhaven') and thereafter until 1974 ('Moored craft at Keyhaven'). Also exhib. RA, RBA, ROI, etc.

MACLEAN, Alexander, RBA (1867-1940)
Oils. Marines, incl. moonlights, landscapes and figures. Vice-President RBA 1918. Exhib. RA, RBA, ROI, RI, RBSA, Liverpool and Manchester.

MACLEAN, Mrs. Sara (fl.1902-1934)
Oils. Coastal subjects and landscapes. Lived Fowey 1914. Exhib. RA, RCA, SWA and Liverpool.

McWILLIAMS, Herbert Hastings (b.1907)
Lieut. R.N.V.R. Submitted 16 pen and wash and chalk pictures, now in Imp. War Museum, of naval subjects 1941-42. Examples: 'H.M.S. *Shropshire* Feb. 1941', 'A motor gun-boat at speed' 1942, 'An E. boat by moonlight', 'H.M.S. *Hecla* sinking off the west coast of Morocco'. Exhib. RA 1929.
. See PLATE 236

MADDEN, Admiral Sir Charles, RN
Watercolours. Coastal and harbour subjects. At one time C. in C. Home Fleet, R.N., from which post he retired in 1945. Originally taught to paint watercolours at the age of 13 by W.L. Wyllie. London exhib. of his work (with 4 other notable artists) in 1973. Exhib. RSMA 1973 and 1975.

MADDOX, Ronald A., RI
Watercolours. Marine subjects. Exhib. RSMA from 1954 ('Low Tide, Port Isaac') until 1969 ('Barges, Red Lion Wharf').

MANN, James Scrimgeour, RI, RCA (1883-1946)
Oils. Marine subjects. One-time President RCA. Lived Cheshire and Liverpool. Exhib. RA, RBA, RCA, RI, RBSA, GI, Liverpool, Manchester, etc.

MANTANIA, Fortunino, RI (1881-1963)
Illustrator and painter. Historical subjects and some seascapes. Born in Naples. Worked in Milan and Paris and came to London at the age of 19, where he worked as an illustrator on the *Graphic* and later the *Sphere*. He was a Special Artist for the British War Ministry in World War I. Exhib. RA, RI, etc.
. See PLATE 133

MARSHALLSAY, Fred
Watercolours. Coast and harbour subjects. Exhib. RSMA 1972, 1974, 1975 (3 watercolours incl. 'Yarmouth harbour, I.o.W.').

MARTIN, Ronald
Watercolours. Marine subjects. Exhib. RSMA 1968 ('The demolition barge'), 1969 and 1970 ('Launching the light tower, Newhaven').

MASCALL, Bertram William
Oils. Coastal marine subjects. Exhib. RSMA 1974 ('Sand') and onwards; 1979 (3 oils).

MASON, Barry (b.1947)
Oils. Sailing ships, historic naval events, and similar marine subjects. Studied at Exeter College of Art for 3 years. Exhib. RSMA from 1973 ('China Clippers at Foochow, February 1868') onwards. See COLOUR PLATE 20

MASON, Frank H., RI, RBA, RSMA (1876-1965)
Prolific marine painter in oils and watercolours of ships and coast scenes. Also did some good quality etchings, now difficult to find. His watercolours of English coast and harbour scenes are well known. Also painted abroad, and his Venetian scenes show a freer style. Educated at H.M.S. *Conway*. Served R.N.V.R. and as naval artist in World War I and 56 of his pictures from this period (many of them watercolours of Middle East scenes) are in the Imp. War Museum. Served in Directorate of Camouflage, Naval Division, World War II. Exhib. at the RA 1900 onwards. Exhib. RSMA from 1961. Also exhib. RBA, RHA, RI, etc. See PLATE 137

MAXWELL, Donald (1877-1936)
Oils, watercolours, pen and wash, etc. Marine painter and official naval artist (Lieut. R.N.V.R.) in World War I. Over

110 of his pictures are in the Imp. War Museum, most of them pen or pencil and watercolour, pen and ink, or chalk. They show naval operations and other incidents in the Mediterranean and Middle East theatres of war, and 4 of 'U-boat Avenue, Harwich — surrendered German submarines'. He was also a landscape artist, author and book illustrator. Exhib. at RA, also Manchester City Art Gallery and Walker Art Gallery, Liverpool. Two pictures Nat. Maritime Museum.

MAYGER, Chris, RSMA (b.1918)
Born 20th April 1918 at New Cross, London. Gouache and oils. 18th century naval subjects, 19th century clipper ships and general merchant sailing ships, naval actions in World Wars I and II, also civil and military aircraft and army land actions. Studied: Camberwell School of Art 1934-38; illustration under Eric Fraser; life drawing with Pitchforth and Cosmo Clark. From an early age he studied period naval and merchant ships both from the technical and ship handling aspects. Large proportion of his paintings are used on book covers by well known authors. Exhib. RSMA from 1971 onwards ('Oran, July 3rd 1940'). Exhib. in London and U.S.A. Book *The Marine Art of Chris Mayger* published Peacock Press, New York, 1976. Paintings in private collections in Canada, U.S.A. and U.K. Lives near Tonbridge, Kent.
. See COLOUR PLATE 22 and PLATE 134

MAYOR, William Frederick (1865-1916)
Watercolour and bodycolour. Coastal subjects and landscapes. Work sometimes shows Frank Brangwyn's influence. Exhib. RA, RSA, NEAC, RBA, GI, Liverpool, Manchester, etc.

MEADOWS, Joan Peggy
Watercolours. Coast and harbour scenes. Exhib. RSMA from 1957 ('Quay-side, Dieppe', 'Low tide, Bosham, Sussex' and 'Birdham Harbour, Sussex') until 1969.

MEADOWS, John Hardy, (b.1912)
Watercolours. Steamships of all types at sea (except container ships) war-time convoys, dock and tidal river scenes, also landscapes. Experienced in off-shore sailing and deep-sea voyaging both in small cargo ships and ocean liners. Exhib. RSMA from 1976, also Armed Forces Art Soc., Royal Cambrian Academy, Lancashire Art Soc. Concentrates on steam tramp ships of the 1920s onwards. Lives at Southport, Merseyside.
. See PLATE 135

MEAYERS, Edwin
Watercolours. Harbour and coast scenes and yachts. Exhib. RSMA from 1955 ('Poole harbour' and 'Ebb tide, Littlehampton') until 1967 ('Motor Yacht *Diana*, Yarmouth, I.o.W.').

MELLON, Campbell A., RBA, ROI (1876-1955)
Oils. Coastal subjects and landscapes. One time pupil of Sir Arnesby Brown. Exhib. RA, ROI, RBA, GI, Liverpool, etc.

MELLOR, John Hanson, Comp.TI (b.1909)
Watercolours. Harbour and estuary scenes, also landscapes. Member Birmingham Watercolour Soc. At one time Director of Design at large-scale carpet factory; Fellow Soc. of Industrial Artists; Fellow RSA; Companion Textile Inst. Exhib. RSMA from 1975, RI, Armed Forces Art Soc., etc. Lives at Kidderminster, Worcs. See PLATE 136

MERRIOTT, Jack, VPRI, ROI, PS, RSMA (1901-1968)
Oils and watercolours. Coastal and estuary subjects, but mainly a landscape and portrait artist. Exhib. RSMA from 1947 (watercolour 'Early morning, Bembridge') up to 1969 (2 posthumous watercolours 'The Tide Mill, Woodbridge' and 'Summer day

on the estuary'). At one time President, Wapping Group. Also exhib. RA, RI, ROI, and provinces. Lived at Polperro, Cornwall, and Storrington, Sussex.

METHUEN, Lord, RA, RWS, PRWA, RBA, NEAC (1886-1974)
4th Baron, Paul Ayshford. Marine, landscape and figure painter. Studied at one time under Sickert. Assistant at Transvaal Museum, Pretoria 1910-14. Served with the Scots Guards 1914-19. From 1938 to 1945, he was trustee of the National Gallery and the Tate Gallery. From 1940 to 1944, he was Staff Captain at London headquarters, as Monuments and Fine Arts officer. Represented at the Tate Gallery, Imperial War Museum, and the National Maritime Museum. His 6 pictures in Imp. War Museum include 3 oils of the West India Docks with invasion craft under construction. Exhib. RA, RBA, RWS, NEAC and many other leading galleries and public collections.

MIDDLETON, Alan J., ARIBA
Oils and watercolours. Coastal and other marine subjects. Exhib. RSMA from 1954 (watercolour 'Boat Yards, Falmouth') 1961 and 1963 (oil 'London Bridge' and watercolour 'Rouen') and 1965.

MIDDLETON, James Charles (b.1894)
Oils and watercolours. Marine, coastal and harbour scenes (also engraver and metal worker). Exhib. RSMA from 1950 (watercolour 'The *Lady Brassey* in dry dock, Dover') and 1951 (watercolour 'A quiet Cornish cove') and thereafter until 1963 (watercolours 'The slipway, Grimsby' and 'In for repairs — St. Peters Port, Guernsey'). Also exhib. RA, ROI, etc. Member of the Wapping Group.

MILLER, Richard
Oils. Marine subjects. Exhib. RSMA 1972 ('Morning sea') and up to 1979 ('Old Hastings').

MITCHELL, John Campbell, RSA (1865-1922)
Oils and watercolours. Seascapes and landscapes. Scottish artist. Exhib. RA, RSA, RSW, GI, Liverpool, Manchester, etc.

MOLD, C. Allen, RI, PS (b.1905)
Oils, watercolours and pastels. Marine subjects. Exhib. RSMA 1949 with 3 watercolours 'Ebb tide, Pin Mill', 'Refitting' and 'Midsummer, Blakeney'. Also exhib. RA, RI, ROI, PS, etc.

MOORE, Colin James (b.1924)
Oils. Square-rigged ships and working and coastal sail, barges and smacks, also steam vessels. Self-taught artist. Advocate of traditional methods of marine painting. Exhib. RSMA 1974 'Lee rail awash: Albion Lines *Auckland*'; 1978 'Trade Wind Days'. Lives at Leigh-on-Sea, Essex. See PLATE 137

MOORE, John, RI
Watercolours. Marine subjects. Exhib. RSMA from 1954 (3 watercolours incl. 'The Needles, squally weather' and '*Calshot Spit* slipped for repairs') until 1964 ('Rocks, forts and islands, St. Malo').

MOORE, Robert
Watercolours. Marine subjects. Exhib. RSMA 1977 'Brig coming into harbour' and 'Shipping at sea'; also 1978 and 1979.

MORDEN, Wilfred George
Watercolours. Marine subjects. Exhib. RSMA from 1951 ('Nelson Dock') until 1955 ('Preparing to sail' and 'Lee oh — a *Virtue* class 5-tonner on the Alde').

MORGANS, Phyllis May, RGI
Oils, watercolours, gouache, and egg tempera (also line and

wash). Marine subjects, mainly harbours and waterside, also landscapes, portraits and flowers. Studied 3 years at St. Martins School of Art. Awarded Freedom of the Worshipful Company of Painter-Stainers. Member of Royal Glasgow Inst. of Fine Art. Winner of national contest organised by *She* magazine. Works chosen 3 times for John Laing calendar. Book illustrator, art tutor, demonstrator and critic. Exhib. RSMA from 1967 (2 oils incl. 'Shrimpers Home'). Numerous one-woman exhibitions. Work in public and private collections world-wide. Feels that in modern marine painting there is too much copying of old schooners and not enough sketching on the spot to capture today's atmosphere. Lives at Walberswick, Suffolk.
. See PLATE 138

MORRIS, James (b.1908)
Signalman, R.N. Submitted work 1943-44 to Imp. War Museum and made Hon. Lieut. R.N.V.R. and official War Artist 1945-46. Thirty-four items in Imp. War Museum incl. pen and wash sketch book of about 130 pages on arctic convoy subjects. Exhib. RSMA 1979 watercolour 'H.M.S. *Gambia,* engine room, 1945'. See PLATE 238

MORRIS, L. John
Oils. Marine subjects. Exhib. RSMA 1971, 1972, 1973 (oil '*Matchless:* Cape to Rio').

MORROW, Noël (b.1915)
Watercolours. Marine subjects, harbour scenes, sea and marsh birds, sailing dinghies in action, landscapes, etc. Exhib. RSMA (1977: 2 watercolours 'Surging waters' and 'Quintet') also RI. Is an expert in typography and book design. Has been painting all his life, and in recent years has concentrated on watercolours and line with wash. Has an inherent love of the sea which is reflected in many of his pictures. Lives at Havant close by one of Britain's loveliest natural harbours, Chichester harbour, famous for its yachting and wild bird life. See PLATE 139

MORTIMER, John
Watercolours. Harbour and coastal scenes. Exhib. RSMA 1959 ('Poole harbour quay') until 1979 ('Grey day, Dell Quay').

MORTON, Cavendish (b.1911)
Exhib. RSMA 1947 oil 'In for cleaning: *Astra* and *Shamrock V,* H.M. Dockyard, Portsmouth'.

MORTON, Ronald
Oils and watercolours. Marine subjects. Exhib. RSMA 1967 (oil '*Albacores,* Plymouth' and watercolour), 1968, 1971 and 1973 (oil 'The Royal Victualling Yard, from Mount Wise').

MOSER, Oswald, RI, ROI (1874-1953)
Lieut. R.N.V.R. in World War I and has 6 watercolours in Imp. War Museum showing the handling of naval wounded and survivors, e.g., 'The survivors of s.s. *Linkmoor* coming alongside the R.N. hospital ship *Somali* after their ship had been sunk by the U.35'. He was principally a figure painter and illustrator. Exhib. RA, RI, RSA and provinces, also Paris Salon.

MOYE, E.W.
Watercolours. Coastal and harbour scenes. Exhib. RSMA from 1957 ('Ebbing tide, Benfleet') until 1967 ('Boats at Plymouth').

MUNCASTER, Claude, PPRSMA, RWS, ROI, RBA, NRD (1903-1974)
Oils and watercolours. Marine subjects and landscapes. Also etcher and author. His original name was Grahame Hall and he was the son of artist Oliver Hall, RA. He later changed his name to Muncaster. A keen sailor, he signed on as a deckhand on the windjammer *Olivebank* in 1931 and went round Cape Horn 'to learn to paint ships and the sea with greater authority'. Served

as Camouflage Officer, R.N., in World War II. During his career as an artist, he painted some 5,000 pictures. Hon Sec. RSMA 1952-57 and President 1958-73. President St. Ives Society of Artists 1955-63. Exhib. in the RA from an early age. Exhib. at RSMA from 1947. (In 1947 he exhibited 3 oils and 1 watercolour; oils incl. 'Old Timer entering Shoreham harbour' and 'Becalmed in the tropics'.) Also exhib. RHA, ROI, RWS, GI, Liverpool, Manchester, etc. Works are in many public collections. (For a life of the artist see *The Wind in the Oak* by Martin Muncaster, published by Robin Garton, 1978.)
. See COLOUR PLATE 21 and PLATE 140

MUNDAY, John
S/Lieut. R.N.V.R. Two watercolours of destroyers and M.T.B.s in action in the Adriatic 3 Dec., 1944, in the Imp. War Museum.

MURRAY, Sir David, RA, PRI, RSW (1849-1933)
Oils and watercolours. Chiefly well known for his considerable landscape achievements, but also painted some marine coastal subjects. Many exhibits including over 200 in RA.

MYERS, Mark Richard, RSMA, ASMA (b.1945)
Born 19th November, 1945, at San Mateo, California, U.S.A. Watercolours and acrylics (using oil technique). Sailing ships and ports of 18th, 19th and early 20th centuries, and sometimes contemporary vessels. Self-taught artist. Seafaring experience as Ordinary Seaman rising to Acting Mate on brigantine *Grethe* and barque *Wandia;* voyaged with Capt. Alan Villiers to Hawaiian Islands, 1965; oceanographic research schooner *Te Vega,* N. Pacific, 1966; Bos'un 17th century replica *Nonsuch* ketch in British and Canadian waters 1968-70. Sea experience combined with long study of marine art and artists led to full-time painting. BA (Hons.) Calif. for work in Maritime History and Art 1967. Moved to U.K. 1971. Exhib. RSMA from 1973. Five one-man exhibitions in U.S.A. 1967-76. Five one-man ex. in U.K. 1972-77. Work in public collections incl. San Francisco Maritime Museum, Nat. Maritime Museum, and N. Devon Maritime Museum. Hon. Sec. RSMA (1979). Lives at Bude, Cornwall. See COLOUR PLATE 23 and PLATE 140

NASH, John Northcote, CBE, RA (b.1893)
Official War Artist both World Wars and appointed Hon. Capt. R.M. 1940-41. His 31 pictures from World War I in Imp. War museum are military scenes from the Western Front, but his 3 pictures of World War II show naval subjects, e.g., 'A Dockyard fire' oil 20 x 32 ins.; 'H.M.S. *Oracle* at anchor' watercolour 15 x 21 ins.; plus 18 misc. sketches. Exhib. RA, RSA, NEAC and many other leading galleries. See PLATE 239

NICHOLSON, Ben (b.1894)
Oils. Landscapes, still-life and abstract subjects. Although not strictly a marine artist, he painted at St. Ives and, together with Christopher Wood, he 'discovered' and encouraged the primitive marine painter Alfred Wallis. Exhib. widely in many London galleries. Work in the Tate Gallery incl. abstract of St. Ives harbour.

NICHOLSON, Charles Herbert (b.1900)
Watercolours. Marine subjects. Exhib. in 1946 RSMA inaugural ex. with 'Tyne coal wherry' and regularly thereafter until 1952 ('Running for home' and 'Peaceful evening'). Qualified Master Mariner. Also exhib. RA and RSA.

NOBLE, John Edward
Oils. Marine subjects. Exhib. RSMA 1957 ('Decks awash'); 1958 ('Destroyer escort') and 1960 ('The lee rail').

NORMAN, Edward Alan (b.1930)
Watercolours. Most marine subjects, boats and environments, also landscapes, country buildings, and still life. Studied at Bolt Court, Fleet Street, and St. Martins School of Art, also trained in studios of a fine art printer. Exhib. RSMA from 1978, also RI and 'Britain in Watercolours' 1979. Lives near Haslemere, Surrey....................................See PLATE 142

NORMAN, Michael Radford, RSMA
Born 20th August, 1933, at Ipswich. Watercolours. Coastal and river scenes, also some landscapes and architectural subjects. Studied architecture at Regent Street Polytechnic and arts and crafts at Bournemouth Art School. Seafaring experience embraces 18 years racing National 12 dinghies incl. championships 1964. Exhib. RSMA from 1976 (4 watercolours) onwards. Numerous one-man exhibitions in East Anglia. Lives near Ipswich, Suffolk.

NORTON, Frank, ASTC, RSMA
Member RSMA from 1946 to 1952. Lived in Sydney, Australia.

NORTON, William Edward (1843-1916)
Oils and watercolours. Marine subjects. American by birth but lived and worked in London for many years. Oils and watercolours. Marine subjects. Exhib. RA, ROI, RBA, RI, NEAC, RBSA, Glasgow, Liverpool, Manchester, etc.
..See PLATE 143

OAKLEY-BEUTTLER, E.G. (fl.1948-1952)
Watercolours. Naval and service subjects. Exhib. RSMA 1948 'Cliff assault by Commandos'; 1949 'Frogmen clearing fouled anchors' and 'Admiral's dilemma'; 1952 'H.M.S. *Theseus*'.

OLSSON, Julius, RA, PROI, RBA, RWA, NEAC (1864-1942)
One of the great turn-of-the-century painters of sea, now unjustly neglected. His work in oils is still much praised by distinguished artists. Lived at St. Ives, Cornwall, at one time. Exhibits at Portsmouth, 1938, were 'Becalmed off the Needles' and 'Evening shower off the Needles'. Exhib. RA, RBA, RHA, RI, ROI, RSA. Elected President ROI in 1919. Work in many public collections and also purchased by the Chantrey Bequest (1911). The number of his exhibits in the RA was more than 170...........................See PLATES 144 & 145

OWEN, John
Oils. Marine subjects. Exhib. RSMA 1965 ('Dungeness Fisherman'), 1969 and 1970.

PADDAY, Charles Murray, RI, ROI (fl.1890-1940)
Oils and watercolours. Marine, coastal and landscape subjects. Lived on the south coast from 1895 at Bosham, Hayling Island and Folkestone (1928). Exhib. RA, RI, ROI, RBA. Seven pictures in Walker Art Gallery, Liverpool, also Nat. Maritime Museum, e.g. 'Yacht ashore' and 'Yacht luffing' 12 x 18 ins.
..See COLOUR PLATE 24

PADWICK, Philip Hugh, RBA, ROI (1876-1958)
Oils. Mainly landscape but also coast scenes. Exhib. RSMA from 1955 (3 oils incl. 'The inner harbour, low tide') until 1958 (2 oils incl. 'The quayside, Littlehampton'). Also exhib. RA, RBA, ROI, RCA, NEAC, RHA, RSA, etc.

PALING, Edward
Oils and watercolours. Coastal marine subjects. Exhib. RSMA 1968 (watercolour 'Net repairing, Hastings') 1971, and 1972 (oil 'Boat building, Port de Alcudia, Majorca').

PARKER, Cyril V., RI
Oils and watercolours. Marine subjects. Exhib. RSMA from 1954 (oil 'At Rotherhithe'), 1959 (oil 's.s. *Rotterdam* at Scheidam prior to her maiden voyage') and until 1964 (watercolour 'Surrey commercial').

PARKES, Oscar, OBE (1885-1958)
Surgeon Lieut. R.N. World War I. Seven pictures in Imp. War Museum, 2 oils and 5 black and white wash. Oils: 'The Smoke screen — Destroyers throwing a smoke screen around Hospital Ship *Karapara* after Hospital Ship *Dover Castle* had been torpedoed by an enemy submarine' 30 x 50½ ins. and 'R.N. Hospital Ship *Somali* off Cape Helles, 1915 — Walking cases coming on board' 30 x 50½ ins..............See PLATE 240

PARKYN, William Samuel, ARCA, ARWS, ARWA, RSMA PS (1875-1949)
Watercolours and pastels. Marine and landscape subjects. Exhib. 4 pictures inaugural exhib. RSMA 1946 incl. ('The new *Mauretania* leaving her builders yard', 'The incoming tide', 'The Horse Rock, Cornwall') and thereafter up to 1949 (posthumous). Exhib. RA, RCA, RI, ROI, etc. Lived at the Lizard and St. Ives, Cornwall.

PARSONS, Arthur Wilde, RWA (1854-1931)
Oils and watercolours. Marine subjects and some landscapes. Bristol artist. His main exhib. period was 1880-1922 and he is often included amongst 19th century artists. Strong style. Exhib. RA, RBA, RI, RWA, RBSA, GI, Liverpool, Manchester, etc.

PARSONS, Mrs. Gwendolene Frances Joy, FRSA, SWLA, SGA (b.1913)
Oils, watercolours, gouache and acrylics. Marine still-life, landscape, flowers, and wild life. Studied at provincial art schools and under Jack Merriott, VPROI, William Watkins, RI, Bernard Adams, PPROI, and Edward Swann. Tutor, Galleon Sketching Party Holidays since 1956. Exhib. RSMA from 1954 ('Pleasure trip' and 'Doris Mor, Argyllshire') onwards (1977: 'Memories of Cornwall' and 'Sea-horse frolic'). Also exhib. ROI, RI, PS, Britain in Watercolours, etc. Many one-woman exhibs. at Christchurch, Dorchester and Basingstoke. Spent 9 years living on houseboats incl. old Thames barge, converted lifeboat and converted LCA. Work in permanent collections Belfast, Bournemouth and Christchurch. Book *Painting Flowers* pub. 1964. Painted 40ft. acrylic mural at entrance to Birdland, Gloucestershire, 1971. Lives in Christchurch, Dorset.
.............................See COLOUR PLATE 25

PARSONS, John Whitehill (1859-1937)
Oils and watercolours. Marine subjects, also landscapes, portraits and miniatures. Scottish artist. Exhib. (1885-1936) RA, RHA, RBA, RI, RMS, RSA, RSW, GI, Liverpool, etc. Lived at Pulborough, Sussex from 1904.

PASCAL, Leopold, ROI, RBA, RSMA
Oils. Coastal scenes. Exhib. RSMA from 1952 ('Camber sands' and 'Seashore in Brittany') until 1958 (4 oils incl. 'Sea shore, Finisterre').

PAYNES, Vance
Watercolours. Coast and marine subjects. Exhib. RSMA 1965 (3 watercolours incl. 'Marine Store' and 'Boats at Gorran Haven'), 1968 and 1969.

PEARCE, Leonard John, MSIA (b.1932)
Oils. Historical marine subjects (particularly 19th century scenes) sail and steam, and specific narrative marine events. Studied at Sutton and Cheam School of Art and also City and Guilds, Kennington. Began career in design studio, working on architectural and graphic projects. Since 1971 has painted marine subjects in a traditional manner. Exhib. RSMA from 1978, and a number of one-man exhibs. particularly in the U.S.A. including Mystic Seaport Museum, 1977, Horton Point Lighthouse Museum, New York, 1978, Special Exhibit New York, 1979, and Swedish National Maritime Museum 1980. At one time used name 'John Bower' for earlier work. Lives in London. See PLATE 146

PEARS, Charles, ROI, PPRSMA (1873-1958)
Oils. Marine subjects. Naval artist in both World Wars, during which he painted numerous memorable pictures many of which are now in the Imp. War Museum. These number 105 paintings, watercolours and drawings, of which 99 are concerned with 1st War incidents and events and 6 with the 2nd War. Founder and first President (1939) of the Society of Marine Artists (now RSMA). Notable book illustrator, e.g. *Two Years Before the Mast* and contributor to *Punch*. In the Portsmouth, 1938 exhib. (from which the idea of the RSMA arose) he had 5 pictures including '*Revenge* comes out of a squall', 'Conrad's ship the *Torrens*' and 'The Needles'. A precise and analytical painter, he had a deep understanding of the sea; member of the Royal Cruising Squadron and holder of a Master's Certificate in Sail. Died 24th March, 1958.
. See PLATES 241 & 242

PEARS, Dion
Oils and watercolours. Marine subjects. Exhib. RSMA 1958, 1959 (watercolour 'Ocean morning'), 1968 (oil 'Singlehander'), 1969 ('*Morning Cloud*'), 1971 (oil 'The Model'), and 1973 (oil 'Icelandic incident').

PELLING, Freda (Mrs.)
Oils. Coast scenes. Exhib. RSMA from 1954 ('Low tide, Leigh-on-Sea' and 'Alley Dock, Leigh-on-Sea') until 1959 and 1970 ('After the Storm').

PEMBERTON-LONGMAN, Joanne, RSMA (1918-c.1973)
Oils. Marine still life subjects. Studied at Byam Shaw Art School. Exhib. at RSMA from 1950 ('On the sea shore' and 'Washed up'), 1951 ('Floats and things', 'Sea Urchin and whelk's eggs'), up to 1973 (2 posthumous exhibits 'Shells' and 'Along the shore'). Also exhib. RA, NEAC, RBA, RI, Paris Salon, etc.

PENTON, R.H. (fl.1947-1955)
Oils and watercolours. Sea pieces. Exhib. in RSMA from 1947 watercolours 'A breezy day, Sea Reach'; 1948 '*Pamir* sails'; 1949 'Grain ships' and 'Drifters'; 1951 oil 'A Blackwall Frigate, 1851', 1954 oil 'H.M.S. *Worcester's* last voyage'; and up to 1955, watercolour 'Sailing day, Tilbury'.

PERRY, Roy
Oils and watercolours. Coast and harbour subjects. Exhib. RSMA 1967 (oil 'Beached boats at Lanveoc') to 1975.

PHILLIPS, Frances, (Mrs.) (b.1903)
Oils. Marine subjects (also landscapes and portraits). Exhib. at RSMA 1978 and 1979. Self-taught and also studied under her father. Influenced by John Singer Sargent, Pissaro and Sisley. Considers that modern methods tend to make sea painting hard and flat, without movement and with too bright blues and greens. Lives in London. See PLATE 147

PHILPOT, Glyn, RA, ROI, RP (1884-1937)
Portrait and figure painter. Specially employed as war artist, World War I. Five naval portraits of famous sailors and the Director, W.R.N.S., in Imp. War Museum.

PILCHER, Cecil Westland (1870-1943)
Watercolours (also etcher). Marine subjects. Exhib. mainly 1920-30 in RA and NEAC.

PIPER, William F. (fl.1948-1959)
Watercolours. Coastal scenes. Exhib. RSMA from 1848: 'The Cathedral Rocks, Lands End'; 1957: 'Off the headland, Newquay'; 1959: 'A breezy day'.

PIPER, John (b.1903)
Abstract and landscape painter, etc. In World War II was specially commissioned to paint a number of pictures between 1940 and 1945, some of which dealt with Merchant Navy operations.

PITCHER, Neville Sotheby, RSMA (fl.1907-1959)
An ex-Lieut of the R.N.V.R. and painter of marine subjects (also landscapes and figures). Exhib. 'Blue days at Sea' and 'Rescued' at Portsmouth, 1938. Exhib. at RA, RI, ROI, and RWA. Inaugural exhib. RSMA 1946 exhibited 4 pictures incl. 'Galway Coast', 'Sea Harvest', 'The Grip of the Land', 'Fish Dock' and regularly thereafter up to 1958. Lived near Rye, Sussex.

PITCHFORTH, Roland Vivian, RA, RWS (b.1895)
Oils and watercolours. Mainly landscapes and architectural but also some marines. Appointed official war artist with rank of Hon. Capt. R.M. 1940-45. Over 90 of his pictures, mostly watercolours, are at the Imp War Museum and of these, 33 show naval and other marine subjects. Exhib. RA, RHA, NEAC and other leading galleries. Works are in many public collections. See PLATE 243

PLANTE, George (b.1914)
Oils and watercolours. Marine subjects. Exhib. RSMA 1948 'Man at the wheel' and 'On the bridge in convoy'. Radio officer, Merchant Navy World War II. Oil, 17¾ x 23¾ ins. 'A Rescue Ship in the Atlantic' 1943, in Imp. War Museum.

PLATT, John Edgar, RSMA (1886-1967)
Oils and watercolours, also colour woodcuts. Marine, coast and harbour subjects. Specially employed as war artist 1941-45. Thirteen oil paintings in Imp. War Museum, e.g., 'A Convoy passing the Lizard, Cornwall' 24 x 40 ins., 'War Time Traffic on the River Thames: river Mine-sweepers' 9 x 7 ins., 'The Battle of the Atlantic — a cargo ship completes another crossing' 21¾ x 26½ ins. Also 'Convoy arriving off St. Anthony, 1942' in Nat. Maritime Museum. Exhib. Portsmouth, 1938: 'The Port of St. Tropez' and 'The jetty, Sennen Cove'. Exhib. 4 pictures 1946 inaugural RSMA exhibition incl. 'V-day on the river', also 1947 and 1948 (4 watercolours incl. 'St. Anthony's Lighthouse, Convoy approaching Falmouth'). Studied at Royal College of Art and at one time Principal of Leicester College of Art. Exhib. RA, RSA, NEAC and other leading galleries.
. See PLATE 244

PLINCKE, J. Richard (b.1928)
Oils, watercolours and acrylics. Marine subjects, concentrating on traditional sailing vessels, also landscapes and experimental compositions. Trained and practices as an architect. Has also studied experimental abstract art at Southampton College of Art. Exhib. RSMA from 1976 (oil 'Low tide, Fal estuary'). One-man exhibs. at Andover 1978 and Winchester, 1980. Feels that a major part of modern British marine painting is

insufficiently adventurous, and that often the live depth of feeling is overtaken by excessive devotion to detail and tricks of technique. Exhib. RSMA and RI. Lives at Andover, Hampshire.

PONTIN, George (fl.1898-1920)
Oils (also etcher). Studied art in Australia. Lived at Southampton and Gloucester. Exhib. RA, RBA, RCA, Manchester, etc.

POUNTNEY, Jack Dennis, FRSA (b.1921)
Oils and watercolours. Marine subjects and harbour scenes, also rivers and landscapes. Self-taught artist. Exhib. RA, RBA, RSMA, Lord Mayor's Art Award, City of London Art Exhib., etc. Several one-man exhibs. incl. Greenwich 1972. Work in public and private collections U.K. and overseas. Served in R.N. World War II. Spent some years in ship-repairing industry. Father was Master Mariner. Lives at Blandford Forum, Dorset.........................See PLATE 148

PULLIN, Edgar, RSMA (fl.1946-1960)
Oils and watercolours. Marine subjects. Exhib. 3 pictures at 1946 inaugural exhib. RSMA incl. 'Margate Bound', 'A Norfolk Shipyard' and 'Southampton Water' and regularly thereafter up to 1960. Lived in Highbury, London.

RAFFAN, George, RSMA (fl.1937-1950)
Oils. Harbour and coastal scenes. Exhib. 'Boats, Ramsgate' at Portsmouth, 1938; 'A Sussex estuary' at RSMA inaugural exhib. 1946; 'Tower bridge' 1947. Exhib. RA, ROI, RBA, NEAC, etc. Lived London 1947; Sydney, Australia, 1949.

RAGON, Adolphe (fl.1872-1920)
Oils and watercolours. Marine subjects. Usually classified as 19th century, but continued into 20th. Exhib. RA, RBA, RI, ROI, Manchester, etc.

RANDALL, Mark (b.1921)
Oils, watercolours and pastels. Docks, industrial marine subjects, oil rigs, wharves, etc., and landscapes. Studied: Coventry Municipal School of Art, Hornsby School, and Central School of Arts and Crafts. Four years World War II service in R.N. as P.O. Motor Mechanic. Exhib. RSMA (1979: watercolour 'Maldon'). Also exhib. RA, RBA, ROI, PS, NS, etc. Member Essex Art Club, Islington Art Circle, Ilford Art Soc., Barking Art Soc., Assoc. Member N.S. Demonstrator and critic to numerous art societies. Lives in Ilford, Essex.
.................................See PLATE 149

RASMUSSEN, Peter Augustave, ARWA, PS (b.1927)
Oils, watercolours, gouache, and pastel. Harbour and coastal scenes, also landscapes, architectural subjects, portraits, animals, murals, book illustration, etc. Studied Brighton College of Art 1943-48. Became Head of Fine Art, Chesterfield College of Art, 1949, and left 1964 to paint full time. Exhib. RSMA 1977 also RA, RWA and provincial centres. Several one-man exhibs. from 1971 onwards, U.K. and South of France. Increasingly occupied with marine subjects from 1973 particularly in Mediterranean between St. Tropez and Monaco, also the Algarve and Spain. Lives at Ashleworth, Gloucester.
...............................See PLATE 150

RAVILIOUS, Eric William (1903-1942)
Watercolours, also engraver. Won RCA travelling scholarship. Official war artist 1939-42 with rank of Hon. Capt. R.M. Killed on active war-artist service off Iceland 1942. Twenty-seven pictures in Imp. War Museum, mainly watercolour naval

scenes, also some R.A.F. Had a distinctive modern and striking style. Exhib. in London galleries 1930-39......See PLATE 245

RAYNER, Donald, RBA, RI
Watercolours. Coast and marine subjects, landscapes, etc. Exhib. RSMA from 1967 ('Fishing boat, Kinlockbervie, Sunderland'), 1968, 1969. Also exhib. RBA, RI, etc.

REEVE, Russell Sydney, RBA, RE (1895-1970)
Watercolours, also etcher. Coast and harbour subjects, but mainly landscapes. Exhib. RSMA in 1955 ('Wet Day, Kirkwall, Orkney') also 1962 and 1964 ('Dockside scene, Lisbon'). Also exhib. RA, RBA, NEAC, etc.

REID, John Robertson, RBA, RI, ROI (1851-1925)
Oils and watercolours. Harbour and coast subjects, also landscapes and genre. Pupil of William MacTaggart. Exhib. RA, RBA, RHA, ROI, RI, RSA, NEAC, RBSA, GI, etc. Lived in Polperro, Cornwall, early in 20th century.

REID, Nina Margaret Winder: *see* **WINDER REID**

REMINGTON, Mrs. Mary, ARCA, ROI, NEAC (b.1910)
Oils. Harbour scenes, coastal subjects, landscapes, still-life and portraits. Studied: Royal College of Art, London, and Academie Grand Chaumierè, Paris. Exhib. RSMA 1972 ('The incoming tide' and 'Evening at Bosham') then 1973, 1975 and 1978. Also exhib. RA (from 1939) ROI, RBA, NEAC, etc. Works in public collections Blackpool, Brighton, Tower Hamlets, Royal Borough of Kensington, etc. Lives in Sutton, Surrey.

REMINGTON, Roger George Alexander (b.1936)
Oils, watercolours and gouache. Harbour and beach scenes, wooden-hulled boats, etc. Self-taught artist. Works in collections at Penshurst Place, Leeds Castle, Tower Hamlets, London Borough of Sutton, etc. Exhib. RSMA 1972 (watercolour: 'The beach at Deal, Kent' and 'Boatbuilders Yard, MacDuff'); 1976 (watercolour: 'Scottish Fishmarket') and 1977. Also exhib. RI, NEAC, NS, etc., and Port of London Jubilee Exhib. 1977. Considers that too much emphasis is now given to pictures of sporting yachts with every detail of rigging depicted accurately, and too little attention to moods of the sea, atmosphere, and fine old boats. Lives in Sutton, Surrey.

RENDELL, Joseph Frederick Percy (1872-1955)
Oils and watercolours. Marine subjects and landscapes, etc. Pupil of Julius Olsson. Exhib. RA, RBA, RCA, ROI, RSA, RI, GI, Liverpool, Manchester, etc.

RICHARDSON, John Frederick, ATD, Dip.Art.Hist. (London), SGA, UA, FSAI, FRSA (b.1912)
Oils, watercolours and gouache. Coastal scenes, harbours, tidal waters, fisherfolk, etc., also portraits. Studied at Camberwell Art School 1928-31 and London Day Training College (University of London). Teaching Diploma, 1932. Pupil of Cosmo Clark, Randolf Schwabe and J. Gilray. Exhib. RSMA, also RA (from 1933), RP, SGA, PS, UA, Wild Life Art Soc., etc., and RSA, RHA, and RSW. Two one-man exhibitions in Suffolk. Keen advocate of the necessity for art students to learn to draw. Lives at Sanderstead, Surrey.
.................................See PLATES 151 & 152

RIDGE, Hugh E., RSMA (fl.1949-1976)
Oils. Marine subjects. Exhib. RSMA from 1949 ('Trawlers in a Cornish harbour') and regularly up to 1977 (4 posthumous exhibits incl. 'H.M.S. *Commonwealth* 1905-1920'). Lived at St. Ives, Cornwall.

ROBERTSON RODGER, S.B. (fl.1948-1965)
Oils. Marine and coastal subjects. Exhib. RSMA from 1948:
'*Bermuda Sky Queen* forced down in the Atlantic Oct. 1947'; 1952
'Hulks at Rye harbour'; 1954 'Rainy day, Bridlington'; and
1965 'Newhaven'.

ROBERTSON, Miss Sheila MacLeod, RSMA (b.1927)
Born 7th June, 1927 in London. Oils and watercolours. Sea-
scapes and landscapes. Exhib. RSMA. Studied at Watford
School of Art and Central School, London. Favourite painting
subjects include rocks, sand, sea and sky. Travels from Shetland
to the Channel Islands in search of material. Member of the St.
Ives Soc. of Artists. Lives at Chorleywood, Hertfordshire.
. See PLATE 153

ROBERTSON, Struan (fl.1903-1918)
Watercolours and oils. Coastal scenes with fishing vessels and
figures. Scottish artist. Lived in Glasgow and exhibited at the
Glasgow Institute of Fine Arts. See PLATE 154

ROBERTSON, Tom, RBA, ROI (1850-1947)
Oils, watercolours and pastels. Marine subjects and landscapes.
Scottish artist. Exhib. mainly 1880 to 1935 at RA, RHA, RI,
RBA, RSA, ROI, RSW, GI, Liverpool, Manchester, etc.

ROBINSON, Gregory (fl.1907-1934)
Oils, watercolours and gouache. Marine subjects. Born in
Plymouth and lived at Hamble, Hants., in his later years.
Studied at the RA schools. Served at sea in World War I. Exhib.
RA, Liverpool and Walker Gallery, London. Painted many
historical sea pieces. See PLATE 155

ROBINSON, Miss Sonia, RSMA (b.1927)
Oils and watercolours. Harbour scenes, boats at anchor, boats
'at rest' on slipways or sheltered amongst rocks, etc. Also land-
scapes, mainly old farm houses in rugged settings, but mostly
subjects with marine interest such as wharf cottages. Very keen
on the structure and design of jumbled harbour buildings.
Believes that marine painting should reflect all aspects of marine
life, and should embrace both traditional and modern styles of
painting. Exhib. RA, RSMA, Newlyn Soc. and St. Ives Soc.
(member of both), RBA and many other galleries in U.K. and
overseas. Lives at Mousehole, Cornwall. See PLATE 156

RODMELL, Harry Hudson, RI, RSMA (b.1896)
Born 28th May, 1896 in Hull. Painter in all media of every type
of marine subject, also architectural landscapes. Studied at the
Hull School of Art (scholarship). Work commissioned by many
shipping companies. One-man exhibition in early 1930s at
Ferens Art Gallery, Hull. Work in permanent collections incl.
Town Docks Museum, Hull, Ferens Art Gallery, Wakefield Art
Gallery, the Library and Art Gallery at Beverley, Sewerby Art
Gallery at Bridlington, and Nat. Maritime Museum. Works
reproduced in many periodicals. Founder member RSMA.
Exhib. RA, RI, RBA, SGA, Salon de Marine, Paris, and U.K.
provincial galleries. Considers that having to work from plans is
a great help in understanding the technical aspects of ships as
distinct from their painterly qualities. Lives at North
Humberside. See PLATE 157

ROGERS, Malcolm Robert (b.1915)
Oils, watercolours and acrylics, but mainly watercolours.
Coastal and harbour scenes, with predilection for old sail lofts
and warehouses, including figures, and the effect of light.
Studied in City of London, The Old Edgeley Road School of Art
at Clapham, and Epsom School of Art. Exhib. since 1957 at
RSMA and RI, Paris Salon (awarded Gold Medal and Silver

Medal) RSA, RWA, and many travelling exhibitions from the
RBA; also Silver Jubilee Ex. at P.L.A. in 1977. Work in private
collections in the U.K., Sweden and Canada. Lives near
Brighton, Sussex. See PLATE 158

ROGERS, Stanley R.H., RSMA (fl.1945-1960)
Oils and watercolours. Marine subjects. Exhib. 3 pictures in
RSMA inaugural ex. 1946 incl. 'Shipwreck — old style' and
'Mont St. Michel' and thereafter up to 1957. Lived in New York
from 1957 and died in 1961.

ROOKE, Herbert Kerr, RBA (1872-1944)
Oils and gouache. Marine subjects. Exhib. mainly between 1894
and 1927 in RA, RBA, RI, Liverpool, Manchester, etc.

ROSOMAN, Leonard Henry, ARA (b.1913)
Oils, watercolours, gouache, etc. Landscapes and figure subjects
normally but painted some marine subjects in World War II.
Served in A.F.S. 1941-43 and was then appointed official War
Artist with rank of Hon. Capt. R.M. 1944-45 and went to Far
East with the British Pacific Fleet where he recorded events in
that area. Some of his pictures from this period are in the Imp.
War Museum.

ROWE, John Lincoln (b.1951)
Oils, watercolours, acrylics and pastels. Marine Society artist-
tutor specialising in painting on board deep sea British
Merchant Navy ships, also seascapes and landscapes. Studied
for 4 years at Duncan of Jordanstone College of Art, Dundee.
Work on permanent display at The Marine Society, Lambeth,
London. See PLATE 159

ROWE, Sydney James (b.1911)
Watercolours. Harbour scenes, seascapes and landscapes.
Mainly a self-taught artist. Took up painting after retiring from
Army. Work displayed in London and provincial galleries.
Prefers to paint the contemporary scene on the spot, from life.
Exhib. RSMA 1976 and 1977 ('At Keyhaven'). Lives in
Bournemouth, Dorset. See PLATE 160

ROWNEY, Margaret
Watercolours. Coast and harbour subjects. Exhib. RSMA from
1967 ('The *Aggie-Mack,* Walberswick') to 1975 ('Cornish cliffs
near Trevone').

RUNAGALL, Alan
Exhib. RSMA 1978: 2 watercolours 'Start of the Gravesend to
Pin Mill barge race' and '*Kestrel* at Chalkwell'.

RUSSELL, Duncan John, UA, AMNS (b.1927)
Watercolours and some oils. Marine subjects and landscapes.
Exhib. RSMA 1977, also Royal Exchange, London, and
provinces. Lives at Bromley, Kent.

RUSSELL, Gyrth, RI, ROI, RSMA (1891-1970)
Oils and watercolours. Coastal and harbour scenes, also land-
scapes (and etchings). Exhib. RSMA from 1947 (oils 'The
lifeboat slip, Mevagissey' and 'Morning mists, Mevagissey')
and up to 1970 (4 oils incl. 'Greenwich Reach' and STS *Sir
Winston Churchill* at Newquay'). Also exhib. RBA, ROI, RI,
etc., and provinces.

RUTHERFORD, A.J.B.
Watercolours. Coastal and estuary scenes. Exhib. RSMA from
1966 ('Booby's Bay') to 1975.

SAMS, Richard
Watercolours. Coast and harbour subjects. Exhib. RSMA 1975
('Fishing-boats in Ibiza harbour' and 'Spanish cargo boats')
onwards.

SARCHET, Jack
Watercolours. Coast subjects. Exhib. RSMA 1977, 1978 and 1979.

SAVAGE, Charles E.
Oils and watercolours. Marine subjects. Exhib. RSMA from 1952 (watercolour 'Getting ready, Whitstable Y.C.') until 1972 (oil 'The old cement trader').

SCARBOROUGH, Frank W. (fl.1890-1939)
Watercolours and some oils. Coastal, harbour and estuary subjects, also some landscapes. Lived in Lincolnshire from 1908. His scenes of shipping in the tidal Thames and coastal subjects are colourful and atmospheric. Exhib. RBSA, Glasgow Inst. of Fine Arts, and Nottingham Museum and Art Gallery.
. See PLATES 161 & 162

SCOTT, Henry (fl.1950-1966)
Oils. Marine subjects. Exhib. RSMA from 1950 ('The Lighthouse, Portishead, Somerset') to 1966 ('Sea area *Viking*' and 'Sea area *Dogger*').

SCUDDER, William
Oils. Marine subjects. Exhib. RSMA from 1961 ('Cat Boat') to 1966 (3 oils incl. 'Careening hard, St. Peters Port, Guernsey').

SEABROOKE, Elliott (1886-1950)
Oils. Landscapes and harbour subjects, also some still-life. Studied at the Slade; official war artist World War I ('The Bombardment of Gorizia, 21st August, 1917' oil on canvas 42 x 60 ins. is in the Imp. War Museum); exhibited NEAC from 1909 (23 pictures) and elected President of the London Group in 1943. Exhib. at many leading London galleries, Manchester, Liverpool, etc. See COLOUR PLATE 26

SEAGO, Edward Brian, RWS, RBA (1910-1974)
Oils and watercolours. Chiefly recorded as a brilliant landscape and animal painter and a much acclaimed modern artist. He was also an enthusiastic yachtsman and produced some beautiful coastal subjects and seascapes. As a young child he suffered from severe ill-health and it was at this time that he taught himself to paint. Exhib. from c.1930 RA, RHA, ROI, RCA, RSA.
. See COLOUR PLATE 27 and PLATE 163

SEARS, Dr. E.H.
Oils. Marine subjects. Exhib. RSMA 1964 ('The search is on'), 1968 and 1971 ('Embayed off the Lizard').

SEARS, Francis (fl.1907-1932)
Oils and watercolours. Marine subjects, landscapes, etc. Birmingham artist. Exhib. RBSA.

SEDGWICK, Mrs. Beryl
Oils and watercolours. General marine subjects, coastal scenes, etc. Self-taught artist. Exhib. RSMA 1975 onwards; 1979: oil 'Lamorna, Cornwall'. Also exhib. ROI, NEAC, St. Ives Society. Was a musician until 1962, and began painting in 1964. Feels that much present-day painting is too conservative in style, and would like to see a more imaginative approach. Lives at Beckenham, Kent.

SENIOR, Mark (1864-1927)
Oils. Marine subjects, landscapes, figures, etc. Yorkshire artist. Influenced by Impressionists. Friend of Philip Wilson Steer. Exhib. RA, RSA, RBSA, GI, Liverpool and Manchester.

SEWELL, Charles D.
Watercolours. Marine subjects. Exhib. RSMA 1961 ('Dock scene'), and 1971 ('Ship *Middlesex*').

SHACKLETON, Keith, PPRSMA, PSWLA (President RSMA 1974-1978)
Born 16th January, 1923, at Weybridge, Surrey. Oils. Marine wildlife, seascapes, icescapes and landscapes. (Uses gouache for field notes). Five years with R.A.F. 1941-46 and painted with Naval Coastal Forces (M.T.B.s). Civil aviation pilot and small boat sailor (several times represented Great Britain in international dinghy events and 4 times crewed winning boat in Prince of Wales Cup). Self-taught artist well-known for wildlife, antarctic and arctic subjects with emphasis on sea and sea birds. Broadcaster and author of several books. President, Soc. of Wildlife Artists; Chairman of Artist's League of Great Britain; founder member, Soc. of Aviation Artists; Vice-President, Guild of Aviation Artists. Exhib. at RA, RSMA, RBA, SWLA. One-man exhib. Tryon Gallery 1968. Permanent collections include Municipal Gallery, Birkenhead; Belfast: Nat. Maritime Museum. Lives in London. See PLATE 164

SHAW, George
Oils. Marine subjects. Exhib. RSMA 1968 ('Beating up the Channel') to 1975 ('Picking up a tow, the *Thessalus* in the Thames estuary').

SHAW, Walter James (1851-1933)
Oils. Marine subjects and landscapes. Lived in Salcombe, Devon. Exhib. RA, RI, ROI, GI and Liverpool.

SHAW BAKER, Georgina (1868-1959)
Animal painter, who specialized in painting ships' pets resulting in a book *Animal War Heroes*. Her work is represented at the Nat. Maritime Museum.

SHEPHERD, David
Oils. Coast and harbour subjects. Exhib. RSMA 1960, 1961, 1962 (3 oils) and 1963.

SHEPHERD, Hugh
Oils and watercolours. Coast and harbour subjects. Exhib. RSMA 1970 (watercolour 'Drying the nets, Mallorca'), 1971 and 1972.

SHEPPARD, Faith Tresidder, (Miss) RGI, HC (Paris Salon) (b.1920)
Mainly oils (but also watercolours, gouache and some acrylics). Harbour scenes, sailing ships, seascapes, also landscapes and townscapes. Studied at Royal Academy Schools, Chelsea School of Art, and Byam Shaw School of Art. Daughter of Scottish artist Nancy Sheppard, maiden name Huntly, with whom she painted. Exhib. RA, RBA, ROI, RSMA, etc. Works in many private collections U.K. and overseas, incl. H.M. Queen Elizabeth the Queen Mother. Paris Salon: 1970 'St. Jean Cap Ferrat' Hon. mention; Silver Medal 1975; Gold Medal 1978. Member of many art societies London and provinces. Considers that modern marine painting is generally of a very high standard. Lives in Welwyn Garden City, Hertfordshire.
. See PLATE 165

SHEPPARD, Nancy (Mrs.): *see* **HUNTLY, Nancy**

SHERWIN, Frank, RI, RSMA (b.1896)
Born 19th May, 1896 at Derby. Mainly watercolours, sometimes oils. Seascapes and landscapes. Studied at Heatherly's Art School, London. After serving in the 1914-18 war, on demobilisation in Italy, he painted stage scenery in Genoa. Well known by British Railway travellers for numerous posters painted over 20 years. Started marine painting on a visit to Concarneau, Britanny. Visited Bishop's Rock Lighthouse by

small boat, 1939. One-man exhibs. incl. Cambridge, 1939, and Worthing 1973 and 1974. Exhib. RSMA from 1959. Also exhib. RA, RBA, RI, etc. Work in permanent collections Derby Museum and Nat. Maritime Museum. Lives in Cookham, Berkshire.

SHORE, Robert S., RHA (fl.1892-1922)
Oils. Marine subjects, landscapes, etc. Irish artist. Exhib. RA, RHA, etc.

SHORT, Sir Frank, RA, PRE, RI (1857-1945)
Oils, watercolours, etching and aquatinting. Marine and coastal subjects, landscapes, etc. Noted as an etcher and engraver. Exhib. RA, RBA, RHA, RI, RE, RSA, GI, NEAC, etc.

SHORT, Richard, RCA (1841-1916)
Oils and watercolours. Marine subjects. Chiefly end of 19th century but also into 20th century. Sailor in merchant navy for some years. Exhib. RA, RCA, RBA, RHA, ROI, RBSA, Liverpool, Manchester, etc.

SHUTER, Heather Meryl, NDD (b.1918)
Oils and watercolours. Seascapes and landscapes. Studied at Southend School of Art and Colchester School of Art. Exhib. RSMA 1977. Work in galleries in Doncaster, Southend and Leigh-on-Sea. Lives at Leigh-on-Sea, Essex.

SILAS, Ellis, FRSA, RGS (b.1883, fl.1914-1935)
Oils and watercolours. Marine subjects and landscapes. Pupil of Sickert. Travelled widely, including a 3-year expedition to Papua, New Guinea. Exhib. RA, ROI, RI. President, London Sketch Club, 1930. Two pictures in the Nat. Maritime Museum: 'H.M.S. *Wave* ashore at St. Ives' and 'The price of Glory' 36 x 72 ins. Also, work in British Museum and Mitchell Library, Sydney.

SIMPSON, Alan John, RSMA (b.1941)
Oils, watercolours, gouache, and acrylics, also pastels. Coastal subjects, ports and harbours along the South, West and East Anglian coasts, with particular interest in coastal sailing craft; also landscape and architectural subjects. Studied: Municipal College of Art, Bournemouth. Exhib. RSMA and FBA and provincial galleries. Also an illustrator and designer. Lives at Wimborne, Dorset......................See PLATE 166

SIMPSON, Charles, RI, ROI, RSMA (fl.1907-1947)
Oils and watercolours. Marine scenes, also landscapes and other subjects. Exhib. 2 oils in RSMA inaugural ex. 1946: 'Waves over the quay' and 'Evening light on Carn Du, Cornwall' and 1947: oil 'Storm over Mounts Bay'. Exhib. RA, NEAC, RBA, RCA, RHA, RI, ROI, RSA, etc. Studied in Paris. Lived at Penzance, Cornwall.

SIMSON, John A. (fl.1949-1955)
Oils and watercolours. Marine subjects. Exhib. RSMA 1949: oil 'Scrubbing decks' and watercolour 'Pearl fishermen' and up to 1955: oil 'Threatening sunset' and watercolour 'Norwegian fishermen'.

SLATER, John Falconar (1857-1937)
Oils, also etching. Seascapes and coastal subjects and landscapes, also portraits. Exhib. mainly 1885 to 1936 at RA, Liverpool, Manchester, etc. Lived at Whitley Bay, Northumberland, from 1911. Large coastal seascape (oil) dated 1909 in Nat. Maritime Museum.

SMART, Douglas I., RE (1879-1970)
Best known for his etching of marine subjects but also painted watercolours of coast and harbour scenes. Exhib. RSMA 1948 'The *Loch Linnhe*' (watercolour).

SMART, R. Borlase, ROI, RBA, RWA, RBC, RSMA (1881-1947)
Oils and watercolours, also etching. Seascapes and landscapes. Pupil of Julius Olsson. Hon. Treasurer RSMA until 1947. Exhib. at the RA, RSA, RBA, RCA, RHA, ROI, RI, RSMA and Paris Salon. He was a Lieut., Machine Gun Corps in World War I and 28 drawings and sketches of Western Front scenes are in Imp. War Museum, also works in several public collections. One-time Secretary of St. Ives Arts Club. Exhib. 'Wind and Spray' and 'Farewell to the Old Wooden Walls' at Portsmouth, 1938; RSMA inaugural exhib. 1946 'The Swell of Summer Seas' and 1947 (3 oils incl. 'Moonlight, St. Ives'). Lived at St. Ives, Cornwall.

SMITH, Charles, FRSA (b.1913)
Oils. Full range of marine subjects, specialising in Rivers Thames and Medway. Studied: Camberwell School of Art, Chelsea Tech. College, and privately under David Chilchick, ROI. Exhib. RSMA 1973 ('Homeward Bound' and 'Hamble, early morning'), 1977: ('Barges at Hoo') and onwards. Works in permanent collection Sutton Borough Council, Leamington Art Gallery, etc. Member of Wapping Group, Artists Society and Langham Sketch Club, and London Sketch Club. Lives in Streatham, London.

SMITH, Hely Augustus Morton, RBA, RBC, FRSA (1862-1941)
Oils and watercolours. Seascapes, also some portraits and figure pictures. A talented marine artist whose work is little seen today. Exhib. from 1887 at RA, RHA, RI, RBA, ROI, RBSA, RSA, GI, Liverpool, etc. Member of Langham Sketching Club. Studied at Lincoln and Antwerp. Exhib. 3 pictures at Portsmouth 1938 incl. 'Battle Fleet exercising off Gibraltar'.

SMITH, J. Edward (b.1905)
Oils and watercolours. Harbours, ships, landscapes, buildings and portraits. Studied at Carlisle School of Art, Edinburgh College of Art, Regent Street Polytechnic, and Bradford College. Exhibitor RSMA, also RP and Welsh Academy. Member of Committee, Birmingham Watercolour Society, 1979. Lives at Kidderminster...............See PLATE 167

SMITH, John S. (fl.1947-1954)
Oils and watercolours. Marine subjects. Exhib. RSMA 1947 watercolour 'Day cruise'; 1949 oil 'Isle of Wight boats, Portsmouth harbour'; 1954 watercolour 'The last of the Thames Paddlers'.

SMITH, K.G.
Watercolours. Marine subjects. Exhib. RSMA 1968, 1969 and 1970 ('Thames barge').

SMITH, Robert Henry (fl.1906-1930)
Oils and watercolours, also etcher and illustrator. Marine subjects. Exhib. RA, RI, SGA, Walker Art Gallery, Liverpool, etc. He was an Able Seaman in World War I and subsequently commissioned Lieut. R.N.V.R. as a naval artist. 3 oils in Imp. War Museum incl. 2 of the Battle of Jutland (both 48 x 72 ins.) and one watercolour. Lived at Looe, Cornwall. See PLATE 246

SMOOTHY, Derrick O.
Oils and watercolours. Marine subjects. Exhib. RSMA from 1950 (watercolour 'Blue Funnel Liner in an Eastern Harbour') and until 1959 (oil 'Leigh-on-Sea bawlies').

SNELLING, John, FRSA (b.1924)
Oils and watercolours. Coastal scenes, mainly East Anglia, also landscapes of the same area. Studied: Camberwell School of Art and Regent Street Polytechnic. Numerous one-man shows and

mixed exhibitions in London, Dorking, Cambridge, Ipswich, etc. Exhib. RSMA (1977: watercolour 'Bleak day at Whitstable'). Works in private collections in U.S.A., Germany, Italy, South Africa, etc. Lives in Rainham, Essex.
............................See PLATE 168

SOMERSCALES, Thomas Jaques (1842-1927)
Oils. Marine subjects, especially sailing ships in deep blue oceans. Famous for his many fine marines including 'Off Valparaiso' bought by the Chantrey Bequest. Hull artist (but visited Chile 1865-92 and painted there). Considered 19th century artist but painted well into early 20th century. Exhib. RA, ROI, RBSA, Liverpool and Manchester.. See PLATE 169

SOUTHON, Willie A.
Watercolours. Harbour and coast subjects. Exhib. RSMA from 1955 ('Maldon, Essex'), 1959, 1970 and 1971 ('The Quay, Douglas, I.o.M.').

SPENCE, Les
Oils. Marine subjects. Exhib. RSMA 1973 'Looe hooker' and 1974 'Gaff cutter'.

SPENCER, Sir Stanley, CBE, RA (1891-1959)
Probably best remembered for his biblical scenes in modern dress and settings. Knighted 1959. From 1940-45 he was a war artist specially employed and produced 12 large panels of 'Shipbuilding on the Clyde' in sizes from 20 x 80 ins. to 30 x 228 ins. ('Bending the Keel Plate'). These paintings together with nearly 150 pencil sketches and studies for these works, are in the Imp. War Museum. Exhib. RA, RHA, RSA, NEAC and many other galleries......................See PLATE 247

SPENCER-FORD, R.F.
Watercolours. Coastal and harbour subjects. Exhib. RSMA 1968 (3 watercolours incl. 'Fishing boats, Camogli, Italy') to 1974 (3 watercolours incl. 'At their moorings, Amsterdam').

SPURLING, Jack (1871-1933)
Oils and watercolours. Marine subjects, especially ships under full sail. Went to sea and therefore knew about ships and salt water at first hand. Painted about 80 covers for magazine *Blue Peter*. Work rarely seen today as much was destroyed in last war.

STARLING, Albert (fl.1880-1913)
Oils. Marine subjects also some portrait and figure pictures. Exhib. RA, RI, ROI, RBA, RBSA, Liverpool, Manchester, etc.

STEER, Philip Wilson, OM, NEAC (1860-1942)
Oils and watercolours. Many fine coastal and marine subjects, but better known for his landscape and figure pictures. As a leading British Impressionist he was much admired by a number of his contemporaries and has influenced some of the 20th century marine artists. He himself had been influenced by artists such as Monet, Whistler, Constable, Turner and Gainsborough. Founder member of the NEAC. Studied in England and Paris. Exhib. at RA, RBA, RHA, ROI, RSA, RSW, NEAC, and numerous other galleries. Specially employed as war artist World War I, 6 of his pictures — all of Dover — are in the Imp. War Museum. Lived in Gloucester, Bournemouth and London.... See PLATES 13, 170, 171 & 248

STEWART, Alan John (b.1933)
Oils, watercolours and gouache. Sailing ships, sailing naval actions, general commissions and illustration. Studied: L.C.C., Central School of Arts and Crafts 1951-55 and Goldsmiths College 1955-56. Principal Lecturer in illustration, Manchester Polytechnic. Exhib. Manchester Academy 1958, RSMA 1979

(watercolours: '*Largiemore*' and '*Westland*'). Works in private collections in Norway, U.S.A., Canada, U.K., etc. Believes that one of the problems concerning the painting of old sailing ships today is the lack of first-hand experience and the reliance on reference material which sometimes tends to create somewhat sterotyped subject matter. Lives at Compstall in Cheshire.
............................See PLATE 172

STOBART, John, RSMA, ASMA (b.1929)
Born 29th December, 1929, in Leicester. Painter in oils of historic narrative harbour scenes, inshore shipping and ships at sea. Studied at Derby College of Art and Royal Academy Schools. Countless boyhood hours spent watching shipping in Liverpool harbour. Seafaring experience includes 21 ocean crossings to Canada, voyage round Africa, etc. Exhib. RSMA and work exhibited in Kennedy Galleries, New York, 1965, 1967, 1968, 1972, 1975 and 1979. In permanent collections including Nat. Maritime Museum; R.N. College, Greenwich; Marine Museum of Upper Canada. Would like to see aspiring marine artists getting outside, where the action is, painting from life and not using a camera. Lives and works in the U.S.A. Vice-President Emeritus, A.S.M.A. 1980. See COLOUR PLATE 28

STONE, Cyril, S.G.A. (b.1912)
Watercolours. Coastal and harbour subjects. Exhib. RSMA in 1947 ('The *Worthing* under repair, Newhaven, October, 1947' and 'On the mud, Southwick, Essex'), 1948 and 1949 ('Repairs at Mevagissey' and 'Low Tide, Newhaven'). Also exhib. RA and RBA.

STONES, Christopher (Christopher John ASSHETON-STONES) (b.1947)
Pastel artist. Harbour and estuary scenes, also landscapes, especially rivers and lakes. Studied Exeter College of Art and Bournemouth College of Art. Council member, Pastel Society. Exhib. RSMA from 1973. Lives in London.

STOREY, Terence Lionel, RSMA (b.1923)
Born 17th April, 1923, in Sunderland. Mainly oils, but also other media. Seascapes, river scenes, yachts, trawlers, sailing ships, supertankers, etc., as well as portraits, landscapes, industrial scenes, aircraft. Studied at Sunderland Art School and Derby College of Art. Exhib. RSMA from 1970 ('Harbour view, Sunderland'). Also exhib. at ROI, RBA, NS, NEAC, SWLA. Work in permanent collections P.L.A. and Nat. Maritime Museum and many private collections overseas. Would like to see artists painting what they see and not what someone else saw. Lives in Derby.
......See COLOUR PLATE 29 and PLATES 173, 174 & 175

STRAIN, Hilary (Miss) RSMA (1884-1960)
Oils and watercolours. Marine subjects and portraits. Exhib. 2 pictures inaugural exhib. RSMA 1946: oil 'The Old Implacables, 1939'; watercolour 'St. Valentine and the Terns of the Sea'; thereafter until 1958 mainly marine portraits and figure subjects. Married marine artist Harold Wyllie (q.v.). Exhib. RA, RCA, RSA, and provinces. Lived in Portsmouth and Scotland.

STURGEON, Josiah John, RSMA, RI, FRIBA (b.1919)
Oils and watercolours. Practising architect, tutor and demonstrator. Specialises in working craft of all kinds, at sea and along the shoreline; his particular favourites are fishing boats and sailing barges. Trained at School of Architecture in drawing, painting and visual arts, and studied under a number of eminent artists. Member of Wapping Group of Artists of which he is a Past-President. Grew up within sight and sound of ships and shipping in a nautical family environment of tugs,

sailing barges, ships, boatbuilding and pilotage. Early years spent afloat, learning from professionals the skills of handling and navigating craft on the tideways and estuary of the once busy London River. Gained an intimate knowledge of a wide variety of craft, both coastal and ocean-going. Has experienced North and South Atlantic in winter and summer in peace and war. Exhib. RI, RSMA and other major London exhibitions. Lives at Great Bookham, Surrey............See PLATE 176

SUTTON, John (b.1935)
Oils, watercolours and gouache. A wide range of marine subjects incl. harbour and estuary scenes, sailing and steam ships, seascapes and landscapes. Studied 6 years at Norwich School of Art and Brighton College of Fine Art. Long line of mariners in his family. Spends much time travelling and collecting material with sketch book, also research in museums. Believes in the need to continue the long-established traditions of British marine painting. Exhib. in London and provincial galleries. Lives near Norwich, Norfolk.
...............See COLOUR PLATE 30 and PLATE 177

SUTTON, Kingsley
Oils. Coast and harbour subjects. Exhib. RSMA 1966 ('Lymington'), 1967 and 1971.

SYKES, John Gutteridge (fl.1895-1936)
Oils and watercolours. Marine subjects and landscapes. Exhib. RA, RI, GI, Liverpool, etc. Lived at Newlyn, Cornwall from 1915.

TAYLOR, Albert (b.1913)
Watercolours. Marine subjects, Norfolk and Suffolk creeks and harbours, landscapes, and buildings. Spent 2 years at art school from age 13 to 15 but mainly a self-taught artist and he developed his painting whilst in the Army in India in World War II, whilst on leave in Kashmir and Tibet. Member of Wapping Group of Artists. Exhib. RSMA from 1962 ('High and Dry, Hastings' and 'Entrance to Regent Canal dock'). Lives at Watford, Hertfordshire.

TAYLOR, Leonard Campbell, RA, ROI, RP (1874-1963)
Lieut. R.N.V.R. World War I; 4 works in Imp. War Museum: 3 pen and watercolours of scenes in Liverpool docks and 1 oil portrait of Rear-Admiral Sir Walter Henry Cowan. He was a portrait and figure painter — not a marine artist. Exhib. at RA, RHA, RI, ROI, RSA, etc.

TAYLOR, Maurice (b.1917)
Oils. Ships, especially tugs, harbour scenes, coasts and landscapes. Self-taught artist. Exhib. at RSMA from 1974. Thinks that modern British marine painting is having some difficulty in shaking off the wind-jammers. Lives near Bristol.
.......................See PLATE 178

TAYLOR, Robert (b.1945)
Oils. Marine subjects of many kinds, incl. sailing ships, war ships, naval events, yachts, seascapes, etc. Studied at Bath School of Art. Exhib. RSMA 1978 and 1979. Work is in marine and military exhibs. in Europe and North America, incl. Imp. War Museum, London, and many naval stations. Lives in Bath, Somerset.

THALBEN-BALL, Miss Pamela
Oils. Marine subjects. Exhib. RSMA 1955 ('Frutti di mare'), 1959 ('Ostende'), 1960 ('Sanpan, Hong Kong'), 1962 ('St. Ives'), to 1968 ('Fishing boats, Chioggia').

THEODORE, Frank (fl.1920-1925)
Oils. Marine subjects incl. warships. Served R.N. for several years after World War I. Exhib. RA in 1925.

THOMAS, Albert Gordon, RSW (1893-1970)
Watercolours, also oils. Coastal subjects, landscapes, etc. Exhib. RSMA from 1954 (watercolour 'A few reflections — Tarbert') until 1963 (2 watercolours incl. 'Western port — Loch Fyne'). Also exhib. RSA, RSW, etc. Lived in Scotland.

THOMAS, Walter, RCA (1894-1971)
Oils and watercolours, pen and ink. Marine subjects and posters. Liverpool artist. Exhib. RI, RCA, and Liverpool.

THOMPSON, Stephen Frederick (b.1948)
Oils, watercolours, gouache, acrylics. Luggers, sailing trawlers, harbour scenes, docks, ships at sea, schooners, Thames barges, ketches, tugs, brigs, etc., also coastal scenes and landscapes. Studied at Exeter College of Art for 2 years but says he is mainly self-taught from observing other artists and developing personal technique. Work exhib. in London and provincial galleries. Lives at Lyme Regis, Dorset...............See PLATE 179

THORN, Raymond Stanley (b.1917)
Oils and watercolours. Seascapes, tidal waters, coastal scenes, etc., also landscapes and architectural views. Studied under George H. Downing and other professional artists. At one time member of the Royal Naval Scientific Service. Exhib. RSMA since 1970. One-man exhib. Hitchin 1976. Work in Hitchin Museum and private collections. Lives at Baldock, Hertfordshire........................See PLATE 180

THORP, William Eric, PS, RSMA (b.1901)
Born in London. Oils and other media. Marine subjects. Studied art under Herbert Dicksee and Herbert Schroder. Youngest member ever elected to Artists' Society at age of 17. Joined Langham Art Club, 1917. Founder member of the Wapping Group 1947 and President for 5 years. Work commissioned by many shipping companies and in many private collections. Exhib. at the RA, RSMA, Pastel Soc., etc. Work in permanent collections at Guildhall Art Gallery, Nat. Maritime Museum, Imp. Institute. Work purchased for reproduction in limited print editions by several leading firms. Member Artists' Society and Langham Sketching Club, Wapping Group. Past. Pres., London Sketch Club. Lives in London.
........................See COLOUR PLATE 31

TOLLEMACHE, The Hon. Duff (1859-1936)
Oils and watercolours. Marine subjects from battleships to pure sea. (Up to 1896 he painted portraits then went over to sea pieces.) Exhib. RA, RBA, ROI, RI, RSA, RBSA, GI, Liverpool and Manchester.

TOMPKIN, Alfred P.
Oils. Coastal subjects. Exhib. RSMA from 1961 ('Harwich old harbour') to 1967 ('Portofino'). Also exhib. RA. Lived in London.

TRACEY, Christopher
Watercolours. Marine subjects. Exhib. RSMA from 1959 ('Force 5-6') until 1966 (3 watercolours incl. 'The tall ships race').

TRACY, Charles D., OBE, RSMA (fl.1908-1947)
Oils. Marine subjects. Exhib. 2 pictures RSMA inaugural exhib. 1946 'Out of the Night' and 'September Moonlight'; 1947 'The Gulf Stream' and 'The North Atlantic'; 1948, 2 posthumous oils incl. 'Coastal seas — Cornwall'. Exhib. RA and London Salon. Lived in Sussex and Ipswich.

TREVETT, Victor William (b.1930)
Oils and watercolours (mainly oils). Marine and coastal subjects, also landscapes and some portraits. Studied at Bromley College of Art. East coast yachtsman and owner of sailing cruisers since 1961. Exhib. at RSMA from 1974, also exhib. ROI, NEAC, etc. Work exhib. regularly in London and provinces and one-man exhibition Chislehurst, Kent, 1979. Lives at Bexley, Kent......................See PLATE 181

TRIMNELL-RICHARD, E.
Lieut. R.N.V.R., submitted 2 marine studies 1942-43 to Imp. War Museum: 'Coxswain Davey, Icelandic Patrol' (oil 22 x 17 ins.) and 'Leading Seaman Taylor, D.S.M.' (watercolour 14⅞ x 11¼ ins.).

TRIPP, Sir Herbert Alker, CBE, RSMA (1883-1954)
Oils. Marine subjects. Exhib. 4 oils in RSMA inaugural Exhib. 1946 including 'A Fisherman's haven'; 'Low tide in the harbour' and 'Morning sun on a Suffolk shore' and thereafter up to 1952. Also exhib. RA, RI, ROI and provinces. Lived at Thames Ditton in Surrey.

TUCKER, Gerald Edwin (b.1932)
Watercolours. Thames sailing barges and coastal scenes. Studied at Harrow Art School, Regent Street Polytechnic, and the Slade. At one time owned a Thames sailing barge in Suffolk and converted it into an art gallery. Exhib. RSMA from 1970. Lives in London........................See PLATE 182

TUFNELL, Cdr. Eric Erskine Campbell (1888-1978)
Watercolours. Marine subjects, mainly ships and especially battleships. Served in the R.N. from 1903 onwards and through World Wars I and II in a number of branches including submarines and the Fleet Air Arm. He finally retired from the R.N. in 1946. Self-taught artist whose work has great charm and accuracy. A large amount of his prolific output over the years was handled by the Parker Gallery, London.
...............................See PLATES 183 & 184

TUKE, Henry Scott, RA, RBA, RWS, NEAC (1858-1929)
Oils, watercolours and pastels. Marine subjects, especially nude boys bathing, sitting on rocks, etc., and delicate drawings of ships. Member of the Newlyn School, and lived in Falmouth for some years. Exhib. from 1879 and therefore usually included in 19th century but, in fact, was not elected R.A. until 1914. Paintings bought by Chantrey Bequest. Exhib. RA, RBA, RHA, RI, ROI, RSA, RSW, RWS, NEAC, RBSA, GI, Liverpool, Manchester, etc..........See PLATES 185 & 186

TURNER, Charles E. (1883-1965)
Oils and watercolours. Marine painter and illustrator. Numerous illustrations for *Illustrated London News* on a wide variety of maritime subjects. In 1942 did series of paintings for Churchill Cigar Boxes. Eight paintings in National Maritime Museum incl. 'H.M.S. *Malaya*', 'Sinking of the *Bismarck* 27 May, 1941' and 'Sinking of the *Scharnhorst* 26 Dec., 1943'. Exhib. RA, Manchester and Liverpool. Was a Capt. R.A.F. in World War I and there are 2 pictures in Imp. War Museum of Handley Page bombers attacking Zeebrugge and a 'P' boat exploding a mine..................See PLATES 187 & 249

TURNER, Michael
Watercolours. Marine subjects. Exhib. RSMA 1974: 'One for the *Scharnhorst*', 'Lifeboat rescue' and 'Yacht racing at Cowes'.

TURVEY, Simon David (b.1957)
Oils and watercolours. Sea birds, wildlife and landscapes. Studied Ravensbourne College of Art. Exhib. at RSMA from 1977. Also exhib. RA and Soc. of Wildlife Artists. One-man exhib. at Winchester, December, 1979. Lives at Orpington, Kent.

TWAITS, H.E. (fl.1949-1957)
Oils and watercolours. Marine and estuary subjects. Exhib. RSMA 1949 oil: 'National *Swallows*' and frequently thereafter until 1957: oils 'Woodbridge, Suffolk' and 'The slipway, Bawdsey, Suffolk'.

TYSON, Kathleen, RSMA, SWA (fl.1927-1977)
Oils. Coastal and harbour scenes, also landscapes and miniatures. Exhib. 2 oils in inaugural ex. RSMA 1946: 'King and Queen Rocks' and 'North Landing' and regularly thereafter until 1972. Also exhib. RA, RBA, ROI, NEAC, SWA and provinces.

TYSON, Rowell, RBA, ARCA (b.1926)
Oils, watercolours and acrylics. Seascapes, fishing boats and landscapes. Studied at Tunbridge Wells School of Art, Beckenham School of Art, and Royal College of Art (awarded continuation 4th year). Exhib. RSMA from 1976 (oil 'Sky, sea and surf'). Work in a number of collections incl. Kent County Council, Carlisle City Art Gallery, Shell Petroleum, etc., also in London and provincial galleries. Also exhib. RA, RSA, RBA, NEAC, etc. Lives in Ramsgate, Kent........See PLATE 188

VALE, Sydney
Oils and watercolours. Coastal and tidal Thames subjects. Exhib. RSMA from 1963 (watercolour 'The Crouch, Althorne'), 1976 (3 watercolours incl. 'Leaving the Docks' and 'Old Trader') to 1978 (oil).

VANNET, William Peters, RGI (b.1917)
Oils and watercolours. Marine subjects. Exhib. RSMA 1968 (watercolours 'Old Trawler, Fraserburgh' and 'Masts and spars, Fraserburgh') to 1972. Also exhib. RSA, RSW, GI, etc. Lived in Scotland.

VERITY, Colin, RIBA, RSMA (b.1924)
Oils, watercolours and bodycolour. Marine subjects in general with particular emphasis on mercantile and naval steam ships of the 19th and 20th centuries; also landscapes, railway subjects, traction engines, and aircraft. Trained as an architect, otherwise no formal art training. Keen student of 19th and 20th century shipping. Has constructed many scale model ships. Work in public and private collections. Regular exhibitor for many years at RSMA Guildhall and Boat Show exhibitions. Also exhib. Ferens Art Gallery, Hull, Beverley Art Gallery, Armed Forces Art Soc., etc...............................See PLATE 189

VIDEAN, John A.
Oils and watercolours. Marine subjects. Exhib. RSMA in 1951 (oils 'Yachts at Cannes' and 'On the Stocks') and 1952 (watercolour 'Wharves at London Bridge').

VINALL, Joseph William Topham, RSMA, ARCA (1873-1953)
Oils and watercolours. Estuary and coast scenes, also landscapes, etc., and teacher and writer. Exhib. 2 watercolours in RSMA inaugural exhib. 1946 'Limehouse Reach, and Golden Oslo boat' and 'The Pool from Tower Bridge' and thereafter up to 1950. (A pastel on brown paper of a funeral procession in 1918 is in the Imp. War Museum.) Exhib. from 1908 at RA, ROI, RBA, RHA, RI, RSA, etc.

VORHEES, Mrs. D. Lawrey
Watercolours. Coast and harbour subjects. Exhib. RSMA 1971 ('Boats, Woodbridge' and 'Quiet water — Southwold'), 1973 and 1974.

WADSWORTH, Edward Alexander, ARA, NEAC (1889-1949)
Oils, watercolours, tempera, gouache, etc. Marine still-life and modern sea shore pictures, landscapes, etc. Also engraver and portrait painter. Served in R.N.V.R. in World War I. Studied Munich, Bradford and the Slade. Exhib. RA, RSA, NEAC, Manchester, etc. Work in many public collections.
. See PLATES 190 & 191

WALES-SMITH, Douglas, RSMA (b.1888. fl.1929-1947)
Oils and watercolours. Marine subjects, particularly portraits. Self-taught artist. Exhib. 4 oils in RSMA inaugural exhib. 1946, all portraits of distinguished sailors incl. Admiral the Earl Mountbatten of Burma, and 2 pictures in 1947 incl. 'Minesweeping trawlers'. Exhib. RA, RI, ROI, RSA, etc.
. See PLATE 250

WALKER, L.H.
Watercolours. Coast and harbour subjects. Exhib. RSMA 1968 ('Newhaven'), 1969 and 1971.

WALLACE, Ruby (Mrs.)
Oils. Coastal and harbour subjects. Exhib. RSMA from 1951 (oil 'The Cobb, Lyme Regis') until 1955 (oil 'Poole harbour') and 1973 ('Still life lobster').

WALLIS, Alfred (1855-1942)
Oils. Marine subjects in a primitive style. Self-taught after a career at sea. Considered by some collectors to be a natural genius and his work is therefore sought after.
. See PLATES 192 & 193

WALSH, William R.
Watercolours. Marine subjects incl. historical. Exhib. RSMA 1971 ('Foretop H.M.S. *Victory*'), 1972 (2 watercolours incl. 'A Third Rate with a fair wind').

WARD, Thomas William, RWS, RE, ARCA
Oils and watercolours, and etcher. Marine subjects, landscapes, etc. Exhib. RSMA 1970 ('*Fairy Queen*' and '*Lilac* in for refit'), 1971 and 1972. Also exhib. RA, RWS, RBA, NEAC, etc.

WASLEY, Frank (fl.1880-1914)
Oils, watercolours and black and white. Marine subjects, especially harbour scenes. A British post-Impressionist of considerable talent whose achievements have become recognised since the 1970s. Considered to be a North Country artist but moved from Whitby to Weston-super-Mare (1903), Littlehampton (1908) and Henley-on-Thames (1914). Exhib. RA, RI, RBSA, Liverpool, etc. See PLATES 194 & 195

WATKINS, William A., RI (b.1885)
Oils and watercolours. Some marine subjects, but mainly landscapes. Exhib. RSMA 1947 watercolour 'Moody's shipyard, on the Hamble' and 1948 'Trafalgar Day celebration, October 1948'. Exhib. RA, RBA, RI, ROI.

WATKISS, Christopher David (b.1911)
Oils, watercolours and gouache. Period ships of historic interest, harbour scenes, some modern yachts, also landscapes. Studied at Hornsey College of Art 1927-32. Exhib. RSMA from 1972, also NEAC and RBA and several one-man exhibitions. Does not like the photographically inspired aspects of modern marine painting. Lives at Winterbourne, near Salisbury, Wilts.

WATSON, Leslie Joseph, MBE, ARCA, RSMA (b.1906)
Born 6th July, 1906 at Harrogate, Yorkshire. Oils and watercolours. Coastal scenery. Studied at Leeds College of Art (1926-28) and Royal College of Art (1928-32). Seafaring experience going to sea with herring drifters from Scarborough

in 1930s, also as crew of 30ft. yacht out of Ramsgate and holidays as passenger in cargo ships to Mediterranean and elsewhere. Largely responsible for the survey work and boundaries of all the National Parks and Areas of Outstanding Natural Beauty. Founder member RSMA. Served 1939-45 at Directorate of Camouflage and was particularly concerned with airfields. Exhib. RA, ROI, NEAC, RSMA. Work in many private collections. Believes that modern marine painting relies on excessive use of photography and there should be more work direct from nature. Lives at Twickenham, Middlesex.
. See PLATE 196

WATT, Frances
Oils. Tidal Thames and other scenes. Exhib. RSMA 1957 ('The Thames at Chelsea'), 1958 and 1959.

WEAVER, Roy Kingsley Ettwell (b.1916)
Oils and watercolours. Harbour and coastal scenes, mainly Dorset. Studied with Mabel Wickham, RI, and at Bournemouth and Poole Municipal College of Art. Exhib. RSMA from 1977. Works purchased by South Dorset Tech. Coll. and Bournemouth Corpn. Lives at Weymouth.
. See PLATE 197

WEBB, Barbara (b.1933)
Watercolours, also etching and silk screen. Sailing ships and seascapes. Also art teacher. Studied Corcoran School of Art, Washington, U.S.A. and (printmaking) at the Camden Institute, London. Related to Captain Webb, the first man to swim the English Channel. Exhib. RSMA 1977. Work on show at Business Art Gallery (Royal Academy), Heals, London, and in Cambridge. Lives in London.

WEBB, Kenneth, ARWA
Oils. Marine subjects. Exhib. RSMA 1957 (3 oils incl. 'The Black Lugger') and 1958 to 1963 (oil 'Harbour pattern, Portavogie').

WEBSTER, John Morrison, Capt. RN (b.1932)
Oils and watercolours. Marine subjects incl. warships, yachts, other deep water vessels (not clipper ships) also coastal, estuary and landscape. Self-taught artist. Exhib. at RSMA from 1954. Also exhib. ROI, FBA, NEAC. Joined R.N. 1951 and still serving as Capt. R.N. 1979. Keen yachtsman. Several one-man exhibs. U.K. (also Nova Scotia 1976) and work in numerous private collections. Believes that there are some excellent painters who understand the sea and a lot of bad 'clipper ship' painters who cash in on public demand. Lives in Hampshire.

WELLS, Timothy Waite (b.1942)
Oils. Marine subjects of all kinds, but particularly historical sailing ships and especially American schooners; also landscapes and some still-life. Studied: University of Hartford (Connecticut) Art School; portraiture under Felix Dicassio, Phoenix School of Art, New York; Porto Romana School, Florence. Worked on art studies in England, France, Italy and Spain. Extensive yachting experience incl. R.O.R.C. racing, cruising in English Channel and on New England coast, U.S.A.; represented U.S.A. in world and international dinghy racing. Exhib. U.S.A.: Bruce Museum, Greenwich, Conn., 1972 (one-man show); Stamford Art Assocn. 1973-74; Essex, Conn., 1975; Greenwich Library 1977; and permanent exhib. Crossroads of Sport Art Gallery, New York. Paintings in many collections in U.K. and U.S.A. incl. Joseph H. Hirschhorn and Boston Historical Society. U.S. born but now permanently resident in England. Lives in Lymington, Hampshire.
. See PLATE 198

WESSON, Edward, RI, RBA, RSMA (b.1910)
Born in Blackheath, London. Oils and watercolours. Coastal, estuary and harbour scenes, small boats and landscapes. Self-taught artist. Prolific watercolourist. Great admirer of the work of Boudin by whom he has been most influenced. Teaches and writes on art. Twenty one-man exhibitions since 1958 in U.K. and Europe. Exhib. at RA, RI, ROI, RBA, NS and RSMA. Works in many private and public collections incl. City of London Guildhall, Maidstone Municipal Gallery and Nat. Maritime Museum. Lives at Guildford in Surrey.
.......... See COLOUR PLATES 32 & 33 and PLATE 199

WEST, David (fl.1890-1936)
Watercolours. Coastal marine subjects and landscapes. Scottish artist. Exhib. RA, RI, RSA, RHA, RSW, GI, Liverpool, etc.

WHALLEY, Peter
Radio Officer, Merchant Navy. Two wash drawings of scenes on the Bridge of a merchant ship, 1943, are in the Imp. War Museum.

WHEATLEY, John, ARA, RWS, NEAC (1892-1955)
Although known as a portrait and figure painter, there are 55 paintings and drawings of naval subjects from World War I in the Imperial War Museum, e.g., 'Repairing a fracture in a tor-pedoed merchant ship' oil on canvas 42 x 30 ins., also 'H.M.S. *Vindictive* at Ostend' pen and coloured chalk 14 x 20 ins., and studies of service men. He was first of all a Sergeant in the Artists Rifles and later a War Artist. Studied at the Slade and with Sickert and Stanhope Forbes. Director of National Gallery of S. Africa 1925-37 and subsequently Director of the City of Sheffield Art Galleries 1938-47. Exhib. RA, RE, RHA, RSA, NEAC, etc. See PLATES 251 & 252

WHITAKER, Charles
Watercolours. Coast and estuary subjects. Exhib. RSMA 1965 (2 watercolours incl. 'Sheringham boats') up to 1972.

WHITE, Archie (1899-1957)
Watercolours. Marine subjects. Exhib. RSMA 1946-48, also RBA and RI. Lived at West Mersea, Essex.

WHITE, Arthur (1865-1953)
Oils and watercolours. Marine coastal scenes and landscapes. St. Ives artist. Exhib. ROI, etc.

WHITEHEAD, Miss Elizabeth (fl.1880-1930)
Oils. Coastal and harbour scenes, landscapes, flowers, etc. Leamington Spa artist and sister of F.W.N. Whitehead the land-scape artist. Exhib. RA, RI, RBA, ROI, RBSA, GI, Liverpool, etc.

WHYTE, Duncan Macgregor (1866-1953)
Oils and watercolours. Marine subjects, landscapes and por-traits. Scottish artist. Exhib. RSW, RSA, GI and Liverpool.

WIDGERY, Frederick John (1861-1942)
Oils and watercolours. Coastal subjects and landscapes. Exeter, Devon, artist and son of William Widgery the landscape artist. Exhib. RA, RI, ROI, Liverpool, etc.

WIGGLESWORTH, Kathleen Lindsay
Oils and watercolours. Coast and harbour scenes. Exhib. RSMA from 1958 (2 oils) until 1963 (1 watercolour).

WILCOX, Leslie Arthur, RI, RSMA (b.1904)
Born in Fulham, London. Oils, watercolours and bodycolours. Marine subjects including historic naval events. Self-taught artist. From 1918 to 1939 he was employed in commercial art, and slowly turned to full-time marine painting after 1945. One-man exhibitions at Parker Gallery, London (1973) and

Bethseda, Washington, U.S.A. (1976). Picture painted for H.M. Queen Elizabeth now hangs in R.Y. *Britannia*. Four pictures painted for H.R.H. Prince Philip. Works in permanent collections incl. National Maritime Museum, Libertys in London, Navy Club, Pilgrim Society, Mass., U.S.A., etc. Exhib. at RI, ROI, RSW, RBA, RSMA, etc. Past Hon. Sec. RSMA. Lives at Rustington, West Sussex.
.......... See COLOUR PLATES 34 & 35 and PLATE 200

WILKINSON, Norman, CBE, PRI, ROI, RSMA, HRWS (1878-1971)
One of the best known of British 20th century marine artists and generally accepted as an outstanding painter. Painted in oils and watercolours and also used dry point. Was also a landscape artist and illustrator. Naval artist in both World Wars (a large collection of his pictures under the title 'The War at Sea' 1939-1945' is housed at the National Maritime Museum). At one time marine painter to the Royal Yacht Squadron. A founder member of the RSMA and a council member up to 1959. Exhib. 4 pictures at the Portsmouth, 1938, exhibition and 3 at the 1946 inaugural RSMA ex., and thereafter regularly in the RSMA until 1970. Also exhib. RA, RBA, RI, ROI, RWS, RBSA, GI, Liverpool, etc. Elected President RI in 1937. Lived in London...................... See PLATES 20 and 253

WILKINSON, Rodney N.
Oils. Estuary and coastal scenes. Exhib. RSMA 1952 ('London River' and 'The River Ouse') until 1969.

WILLIAM-POWLETT, The Hon. Mrs. Katherine
Watercolours. Coastal and estuary subjects. Exhib. RSMA from 1965 (2 watercolours incl. 'Bembridge harbour') up to 1972.

WILLIAMS, Miss Mary, RWA, SWA
Watercolours. Harbour scenes, also landscapes, architectural subjects, flowers, etc. Studied at Exeter School of Art and also privately under Claude Muncaster, c.1928. First marine work exhib. in Paris Salon 1938. Exhib. RSMA from 1958 ('Lyme Regis, windy day' and 'Fishing boats, Beer, Devon') and onwards (1977: 'Summer morning, Poole harbour'). Also exhib. RI, RWA, SWA, etc. One-woman exhibs. at Sidmouth in 1959, 1963 and 1976, also R.A.M. Museum and Art Gallery, Exeter, 1974. Work in permanent collections in Exeter, Sunderland Museum, and R.W.A., Bristol. Lives at Sidmouth, Devon.
...................... See PLATE 202

WILLIAMS, Terrick John, RA, RI, ROI (1860-1936)
Oils and watercolours. Marine, especially harbour subjects, and landscapes. One time President RI and Vice-President ROI. Studied in Antwerp and Paris. His distinctive and free style of painting shows some Impressionist influence. Has been re-acclaimed since the early 1970s. Exhib. RA, ROI, RI, RBA, RCA, RHA, RSA, NEAC, RBSA, GI, Liverpool, Manchester, etc. Born in Liverpool; died in Plymouth.
...................... See COLOUR PLATE 36

WILLIAMS-LYOUNS, Herbert Francis (fl.1910-1923)
Oils and watercolours. Marine subjects and landscapes. Exhib. RA, RHA, RCA, RSA, ROI, Liverpool, etc. Lived in Devon from 1914.

WILLIS, David
Oils. Coast and harbour subjects. Exhib. RSMA from 1964 (2 oils incl. 'Brixham harbour') to 1968.

WILLIS, John Christopher Temple, RI, RSMA (1900-1969)
Watercolours. Coastal and harbour subjects. Exhib. RSMA from 1958 (4 watercolours) until 1970 (2 posthumous watercolours). Also exhib. RA, RBA, RI, RSA, etc. Lived at Parkstone, Dorset, and Farnham, Surrey.

WILLS, Ernest Frank
Watercolours. Coast and harbour subjects. Exhib. RSMA from 1958 (4 watercolours incl. 'Gathering cockles, Poole' and 'August morning, Hastings'), 1959, 1960 and 1961 (2 watercolours 'Rye harbour' and 'Fishing at Dover').

WILSON, Geoffrey
Oils. Marine subjects. Exhib. RSMA 1960 ('Herring drifters, Scarboro' and 'Scarboro harbour, a wet day'), also 1964 and 1965.

WILSON, Maurice, RI
Watercolours. Marine subjects. Exhib. RSMA 1972 (3 watercolours: 'The Oil Rig *Sea Quest*', 'The *Pamir* in a rainstorm' and 'A Brixham Trawler') and 1973. Also exhib. RA, RI, etc.

WINCH, Simon Anthony Bluett
Watercolours. Marine life subjects. Exhib. RSMA from 1965 (2 watercolours incl. 'Seahorses') to 1972.

WINDASS, John (fl.1884-1920)
Oils. Coastal subjects and landscapes. York artist and teacher. Exhib. RA, RBA, RBSA, Liverpool and Manchester.

WINDER REID, Miss Nina Margaret, RSMA (b.1891 fl.1911-1969)
Oils. Marine subjects, especially pure sea. Exhib. 3 pictures at RSMA inaugural exhib. 1946 incl. 'The crested wave', 'Atlantic Rollers' and 'Atlantic' and thereafter up to 1969. Exhib. RBA, RCA, RHA, ROI, RSA, SWA, etc. Lived in Eastbourne, Sussex.

WINKFIELD, Frederick A. (fl.1875-1920)
Oils and watercolours. Coastal subjects and landscapes. Exhib. RA, RBA, RI, RHA, ROI, RBSA, Liverpool, Manchester, etc.

WINTER, Alexander C. (b.1887 Ex.1938-1952)
Oils and watercolours. Marine subjects and landscapes. Exhib. RSMA 1948 oils: 'Brancaster Regatta — before the Start' and 'Brancaster Regatta — the Start' and in 1952 oil 'Boats at Burnham, Overy Staithe'. Also exhib. RSA and Goupil Gallery.

WITHAMS, Brian
Oils. Marine subjects. Exhib. RSMA 1975 'The surrender' and 'Death of a sea hurricane'; 1976 'New York bound'.

WOOD, Christopher (1901-1930)
Oils. Landscapes, and figures, latterly harbour and fishing boat subjects. Friend of Ben Nicholson and, with him, visited St. Ives where he found and encouraged Alfred Wallis, the untaught primitive genius who painted his seafaring memories in a naïve manner. Wood's work was undoubtedly influenced by Wallis. Studied in Paris. Exhib. in London galleries.

WOOD, David Innes Sandeman (b.1933)
Oils and watercolours. Seascapes, ships and landscapes. Self-taught artist. Served in the Merchant Navy for 12 years. Grandson of Frank Watson Wood (q.v.). Exhib. RSMA 1977 and in Edinburgh, Perthshire, and East Anglia. Lives at Dedham, Essex....................See PLATE 203

WOOD, Frank Watson (1862-1953)
Mainly watercolours. Marine subjects, also landscapes. Specialised in naval ships and scenes, often travelling abroad with the Fleet and accompanying Royal visits. Work purchased by Royalty including British Royal Family and also the Czar of Russia when visiting Cowes. Studied in London and Paris. Exhib. RA, RSA, RSW, and GI. At one time headmaster of Hawick School of Art.

WOOD, Peter MacDonagh, RSMA
Born 30th April, 1914, at Twickenham, Middlesex. Mainly oils (but also watercolours and bodycolours). Present-day port and harbour scenes and sailing vessels and historic ships. Studied at Southend-on-Sea School of Art, Slade School, and Hornsey School of Art. Slade Diploma of Fine Art, and Art Teachers Diploma. Seafaring experience from an early age in racing dinghies and own 3-ton cutter, also in a Finnish 3-masted barque. 1939-45 in R.A.O.C. and A.E.C. Post-war adviser on ships to the film industry; specialist in square-riggers. Member, Soc. for Nautical Research; ship model maker (awarded silver and bronze medals Model Engineer exhibs.) One-man exhibitions at Studio Club, London (1938); Medici Galleries, Liverpool (1972); Medici, London (1972). Exhib. RA, RI, ROI, RWS, RBA, NEAC. Works in permanent collections at Merseyside Museum, Bagshaw Art Gallery, Batley, Nat. Maritime Museum. Lives at Barnes, London.
...............................See PLATES 204 & 205

WOODS, Harold J. (fl.1920-1938)
Mainly watercolours. Harbour and coastal scenes. Picture entitled 'Southampton Docks' at Portsmouth, 1938, exhibition. Exhib. at RA and RBA.

WORKMAN, Harold, RBA, ROI, RCA, RSMA (1897-1975)
Oils and watercolours. Coastal and estuary subjects, also landscapes, etc. Exhib. RSMA from 1958 (oil 'The harbour, Concarneau') until 1975 (2 oils). Also exhib. RA, RBA, NEAC, RCA, RI, ROI, etc. At one time President of U.A. Lived at East Molesey, Surrey.

WORSDALE, John
Watercolours. Estuary and coastal subjects. Exhib. RSMA 1970, 1972, 1975 ('A passing gleam, Paglesham').

WORSLEY, John, RSMA (Vice-President RSMA from 1979)
Born 16th February, 1919, at Liverpool. Almost all media. Ships and other marine subjects incl. seascapes. Also illustrator, portrait painter and sculptor. Studied at Goldsmith's School of Art. Seafaring experience in R.N.V.R. from 1939 in armed merchant cruiser, then destroyers on Atlantic convoys, and cruiser H.M.S. *Devonshire*. Official War Artist on C. in C's. staff Mediterranean from 1942. Taken p.o.w. in partisan operations November, 1943; constructed dummy for escape project subsequently featured in film 'Albert R.N.' Concealed his paintings and drawings of p.o.w. life in Red Cross milk tins, and over 60 of his paintings, watercolours and drawings are now in the Imperial War Museum. Yachtsman and one-time owner of 21-ton yacht. Exhib. 2 pictures in 1946 RSMA inaugural ex. and exhib. regularly thereafter. Also exhib. RA, NEAC, etc. One-man exhibitions include Mall Galleries (1971) and 600 paintings for Anglia TV at the Mall Galleries (1972). Work in permanent collections incl. Imp. War Museum, Nat. Maritime Museum, and U.S.A. Lives at Putney, near London.
..........See COLOUR PLATE 37 and PLATES 206 & 254

WRIGHT, Bert, RSMA, MBIM, FRSA (b.1930)
Oils and watercolours. Thames river scenes, coastal scenes, harbours, cliffs, etc. Studied at Nottingham School of Art 1946-50. Sailing experience in Holland, North Sea, Solent area, etc. Exhib. RSMA, RA, ROI, RI, etc. Member of Wapping Group

of Artists. Number of one-man exhibitions. Specialises in the traditional methods of painting marine subjects, particularly watercolours. Lives in Ealing, London. See PLATE 207

WRIGHT, Joseph Franklin, ISA, SMP, VANS (b.1924)
Oils, watercolours and acrylics. Harbour scenes, sailing ships and seascapes. Diploma in Fine Art Painting from the Famous Artists School, Westport, Connecticut, U.S.A. 1971. Exhib. RSMA from 1977 and ROI 1979. Work in Nova Scotia Marine Museum collection. Builds ship models of fishing schooners, 3 and 4 masted tern schooners, and square riggers. Lives at Port Hawkesbury, Nova Scotia. See PLATE 208

WRIGHT, Paul Anthony John (b.1947)
Oils, watercolours and egg tempera. Marine subjects and landscapes. Also art teacher and book illustrator. Studied at West Surrey College of Art and Design 1962-67. Exhibitor at RSMA. Paints commissions for Royal Navy, shipbuilding firms, etc. Prefers to paint steam and warships period c.1862 to 1980 (also sailing ships, although he feels that everybody now paints sailing ships). Lives at Liphook, Hampshire. See PLATE 209

WYLLIE, Charles William, RBA, ROI (1853-1923)
Mainly oils. Coastal scenes, harbours and landscapes. Although included amongst 19th century painters he continued into the early years of the 20th. Brother of W.L. Wyllie, (q.v.), but painted in a freer style. His pictures show great talent but are not easily found. His painting of figures in coastal scenes is usually excellent. Exhib. RA, ROI, RI, RBA and other London and provincial galleries. Works in Tate Gallery and Nat. Maritime Museum.

WYLLIE, Harold, Lt.Col., OBE, RSMA, AINA (1880-1975)
Oils, watercolours and etchings. Painter of marine subjects but often better known for his etchings of these scenes. Son of W.L. Wyllie, (q.v.) Council member RSMA and became Vice-President 1958-73. Exhib. 3 pictures in Portsmouth 1938 exhib. incl. 'H.M.S. *Royal Sovereign,* Portsmouth 1935' and '*Victory,* Portsmouth, 1935'; 4 pictures in RSMA inaugural exhib. 1946

incl. oil: 'Hawke's great victory of the Quiberon' and watercolour '*Hesperus* and *Cornwall* off Purfleet' and exhib. thereafter up to 1974 (posthumous exhibit, oil 'Drake at Gravellines — sending in the fireships'). Also exhib. RA, RI, GI, etc. Painter to the Royal Victoria Y.C., Ryde. Lived at Portsmouth in early part of century.

WYLLIE, William Lionel, RA, RI, RE (1851-1931)
Oils and watercolours, also etching, dry point, pencil, etc. Marine and tidal Thames subjects. Acknowledged as one of the leading marine artists bridging the 19th and 20th centuries, his work is much in demand. Started exhibiting at RA in 1868. Exhib. RA, RHA, ROI, RI, NEAC, RSW and many other galleries in London and provinces. Work in public collections incl. Nat. Maritime Museum, e.g., '2nd Cruiser Squadron' 26½ x 44½ ins.; 'Fishing boats returning to Portsmouth' 30 x 60 ins. Painted large Trafalgar Panorama in *Victory* Museum, Portsmouth. Father of Harold Wyllie (q.v.) and brother of C.W. Wyllie (q.v.). Lived and painted for many years at Portsmouth where his studio overlooked the harbour.
. See PLATES 210 & 211

WYNN-WERNINCK, Maj. Bryan Vansittart (b.1918)
Oils and watercolours. Warships, ship portraits, sail and power yachts, open sea and coast. Studied at Radley College Art School and also self-taught. Apprenticed to Thornycroft's Shipyard, Southampton, as marine engineer 1936. Commissioned R.A.S.C. 1940 and served Western Desert, Italy, France, Korea and Singapore. Transferred to maritime branch R.A.S.C. and commanded military vessels at sea for 6 years, retiring as Major in 1963. Maritime staff officer Royal Corps of Transport until 1977. Member Nautical Institute. Yacht owner and sails in ocean yachts. Sailed in numerous Merchant Navy vessels incl. s.s. *Mauretania,* and commanded MLs and LCTs in U.K. waters and Mediterranean. Exhib. RSMA 1979 oils 'H.M.S. *Hermes* at sea' and 'H.M.S. *Cavalier* overhauling H.M.S. *Rapid* in race for title of fastest ship in the Royal Navy, July, 1971'. Numerous pictures in Army Messes and private collections. Lives at Salisbury, Wiltshire. See PLATE 212

List of Colour Plates

General Index

Index to Names of Ships and Craft
Mentioned in this Book

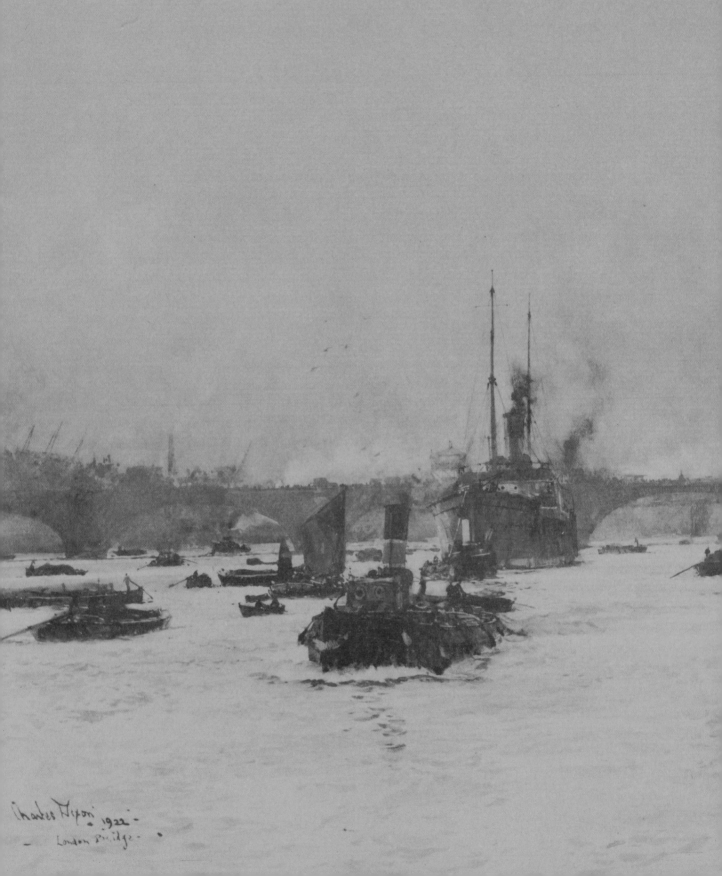

Charles Dixon 1922 -
London Bridge -